RODIN

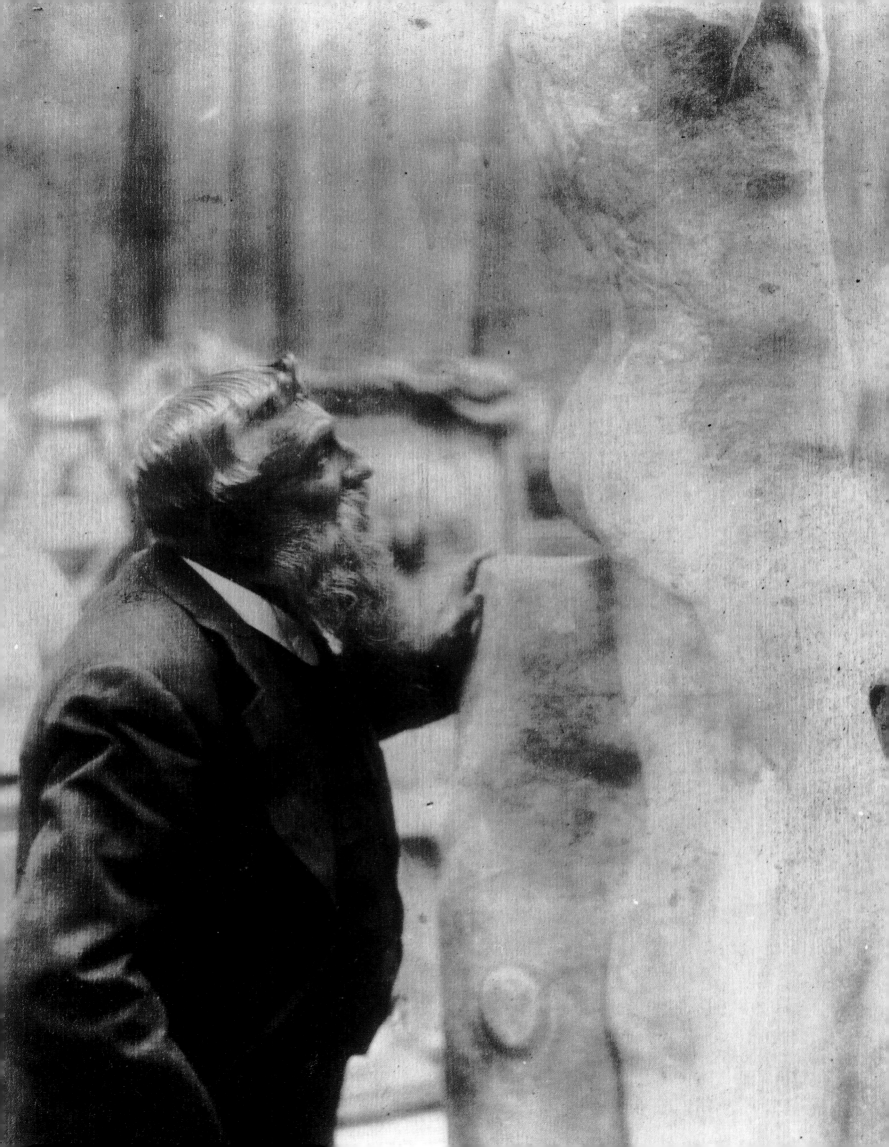

RODIN

Eros and Creativity

Edited by
Rainer Crone
and Siegfried Salzmann

With contributions by
Jacques de Caso, Rainer Crone and David Moos,
Ginger Danto, Ursula Heiderich, Claudie Judrin, Alain Kirili,
Siegfried Salzmann, and Kirk Varnedoe

Prestel

Originally published in German on the occasion of the exhibition
"Genius Rodin: Eros und Kreativität"
held at the Kunsthalle, Bremen (November 3, 1991 to January 12, 1992),
and the
Städtische Kunsthalle, Düsseldorf
(January 24 to March 22, 1992)

Contributions by Claudie Judrin and Alain Kirili translated
from the French by Jean Marie Clarke
Contributions by Ursula Heiderich and Siegfried Salzmann translated
from the German by John Ormrod

Front cover: *Danaid*, 1889-90 (plate 30)
Back cover: *Sapphic Couple* (plate 73)
Spine: *Torso of "The Centauress"*, c. 1884.
Terracotta, height 8½″ (21.5 cm). Musée Rodin, Paris (S. 990)
Frontispiece: Rodin examining an Antique statue.
Photograph by Ch. Gerschel

Prestel-Verlag, Mandlstrasse 26, D-8000 Munich 40, Germany

Distributed in continental Europe by Prestel-Verlag,
Verlegerdienst München GmbH & Co KG,
Gutenbergstrasse 1, D-8031 Gilching, Germany

Distributed in the USA and Canada by te Neues Publishing Company,
15 East 76th Street, New York, NY 10021, USA

Distributed in Japan by YOHAN-Western Publications Distribution Agency,
14-9 Okubo 3-chome, Shinjuku-ku, J-Tokyo 169, Japan

Distributed in the United Kingdom, Ireland and all other countries by
Thames & Hudson Limited, 30-34 Bloomsbury Street, London WC1 B3QP, England

Offset lithography by Brend'amour, Simhart GmbH & Co., Munich
Typeset, printed, and bound by Passavia Druckerei GmbH, Passau

Printed in Germany

ISBN 3-7913-1185-9 (English edition)
ISBN 3-7913-1153-0 (German edition)

Contents

Foreword

Auguste Rodin, born in 1840, belongs among those few artists in the history of art whose acclaim is based equally upon public recognition and scholarly evaluations, which can only confirm his prowess as genius. This unanimous reaction among all audiences, from the casual museum-goer to the experienced connoisseur, indicates that there is a profundity in the sculpture of Rodin so deep that one is compelled to return to it, continually seeking a more solid understanding. And since truly great art always enriches, when we return to it as if seeing it for the first time, we are never disappointed by the range of feeling and insight that it awakens in us.

When, after renewed looking, a scholar and a curator confront Rodin's sculpture with the intention of thinking and writing about it, the task of focusing this enormous range of feeling is best addressed by concentrating on one thematic current that unites his gigantic oeuvre. The immediate aim of this book is to trace the discourse on the erotic that informs – sometimes almost obsessively – Rodin's sculpture and drawing throughout the various phases of his career. The implications of this theme, of this idea that evokes and gives shape to complex notions of sexuality, indulgence, transcendence, experience, love, passion, and denial, affect our thinking and feeling today. Society at large can only benefit from sustained considera-tion of that which Rodin describes in his sculptures. His work succeeds in overturning conventional notions of the "modern," of the twentieth century, because, historically, this sculptor-genius remained firmly rooted in the social and cultural traditions of the nineteenth century. Rodin, perhaps more than any other artist before or after him, has demonstrated in his art an intense and a valid temporal mobility that is as startling as it is impressive.

Sculpture – in bronze, marble, plaster, and clay – occupies space and thus possesses a degree of physical presence not matched by other artistic media. The central purpose of *Rodin: Eros and Creativity* is to explore sculp-tural presence and its determinants, to investigate how photography can approximate, and make available in book form, the feelings of actual observation. Since sculpture demands and commands an experience in its observation, and since observation is a temporal perceptual process that

is often personally conditioned, this book aspires to grant the reader a high degree of latitude in his or her apprecia-tion of the works. The presentation of each carefully selected sculpture in a multiplicity of views allows Rodin's work to be perceived in terms that are equivalent to actual viewing, and that even surpass it in ways that only photog-raphy permits. By employing photographic liberties, the images in this book attempt to invade the space of certain sculptures, focusing upon details with an almost excrutiat-ing precision and obtaining high and low perspectives through extreme spatial manipulation. In some rare cases, which reveal the limitations of these occasionally fantas-tic distortions, one is able to experience the intimacy of certain details – such as a hand or a breast – in a photo-graphic way that renders the rest of the sculpture illegible and, were it not for the accompanying images, unintelli-gible. Reliance upon more than one image of a single work refines and focuses our understanding of the whole as we learn about details that are investigated with an almost sacrificial intensity.

If this method of procedure seems radical at times, it receives justification from the way in which Rodin him-self, in his sculpture, formulated his ideas of the erotic; for the concept of the fragment, and the broader notion of fragmentation, unfolds in his work as a dramatic element that both promotes and subverts description of the erotic. When the fragment is isolated in an image of a sculpture, its disjunct urgency as one aspect of a holistically conceived work serves to underline the thematic context. Where its function is to delineate the technical styling of a detail that is worthy of closer attention, the fragment emerges as a basic element of impact, giving full expression to the significance of an omnipresent theme. Indeed, the vast spectrum of erotic intricacies delved into by Rodin can be grasped, either summarily or completely, only through attention to details, to fragments divorced from their wholes. The photographs reproduced here provide elo-quent testimony to Rodin's consummate artistic care and skill, because the camera shows no difference in scale between the objects photographed. It is thus the reader's special privilege to be able to witness the precision of Rodin's hands as they worked extremely small objects,

such as *Torso of Adèle* (height 6¼″), and to compare this refinement with the imposing grandeur of such a monument to human intercourse as the six-foot-high marble *The Kiss*.

Rodin's masterly rendering of the erotic can be sampled in its purest and most direct form in a selection of his drawings and watercolors that show the human body governed by sexual energy. Countless drawings and watercolors, most of them produced after 1900, give explicit – for some, perhaps too explicit – information on how the artist conceived the human body, permitting excess and revelling in revealing its "jouissance." As they are nothing less than pure, genuine representations of the body, intended for no other eyes than the artist's own, Rodin's drawings articulate themselves immediately as autonomous visions, free of the contrived decadence of an Egon Schiele or a Gustav Klimt.

We are indebted above all to Jacques Vilain, director, and Nicole Barbier, curator, of the Musée Rodin, Paris, whose generosity and cooperation permitted us to rephotograph those major sculptures by Rodin that speak most eloquently of the erotic. Our thanks are also due to Parisian photographer Bruno Jarret, who reacted with such sensitivity to the suggestions of Rainer Crone and David Moos, directors of the photography in the Musée Rodin. In five separate sessions, cooperation on camera positions, lighting, and areas of focus resulted in a coherent series of photographs that binds the images together in an interpretative pictorial essay.

We would also like to gratefully acknowledge the assistance kindly provided by the Rodin Museum at the Philadelphia Museum of Art and by the Department of Nineteenth-Century Sculpture at the Metropolitan Museum of Art, New York.

The division of labor between us was as follows. The concept for this book, and for the exhibition that it originally accompanied in its German edition, was developed by Rainer Crone over a period of four years of intensive research. He selected the essays to be included in it. Siegfried Salzmann was coordinator of the exhibition and made the final selection of works to be shown in it.

Rainer Crone
Siegfried Salzmann

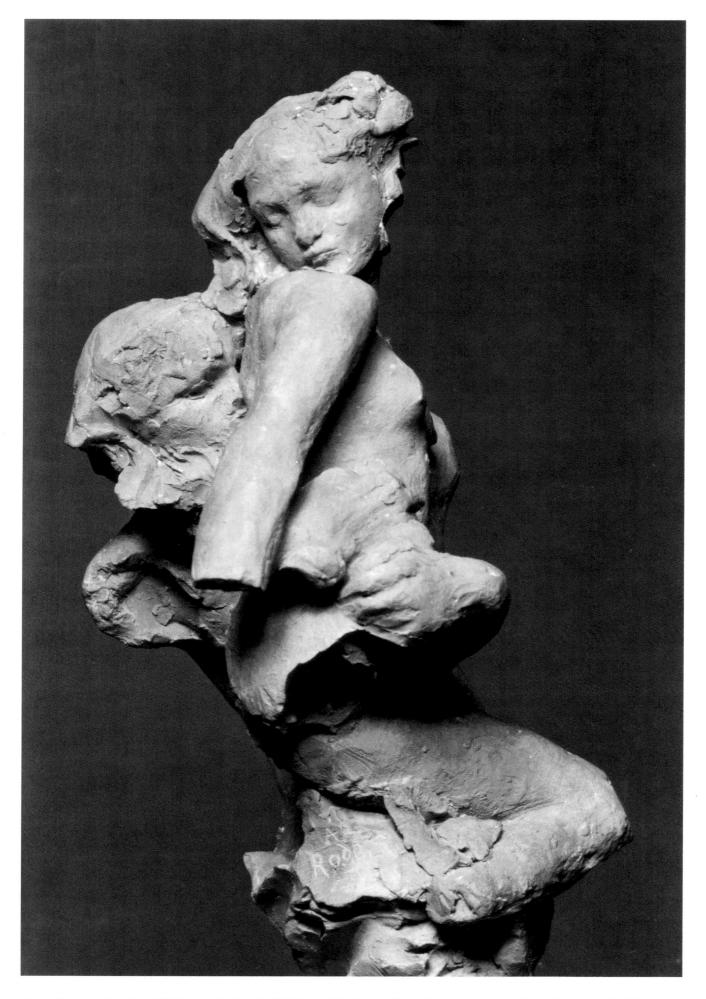

Fig.1 *Triton and Nereid*, c.1893. Terracotta, height 16″ (41 cm). The Metropolitan Museum of Art, New York, Rogers Fund, 1910

Rainer Crone · David Moos

Trauma of the Divine

*The Critique of Convention: Fragments in the Work of
Auguste Rodin and Friedrich Nietzsche*

"The awakened and knowing say: body am I entirely, and nothing else;
and soul is only a word for something about the body."

Friedrich Nietzsche, *Thus Spoke Zarathustra*, 1883

"Because we are human and live in the somber perspective of death
we know the exacerbated violence of eroticism."

Georges Bataille, *The Tears of Eros*, 1961

I

*For Leah Dickerman,
who was instrumental in moving this project
from idea into reality*

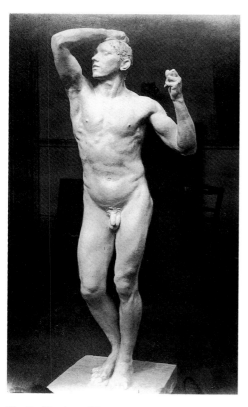

Fig. 2 *The Age of Bronze*, 1876. Plaster.
Photograph by Eugène Druet

The figure (Fig. 2 and plate 15) incites in us the fantasy of our deepest erotic
inclinations. In its self-containment that threatens to invade our expectations, to
overcome its own repose, the nude youth holds our gaze through its indifference to our
presence. The supreme, yet uneven harmony of proportion and dimension challenges
us, awakening the potential of humanity with a singular gesture. The left arm is raised,
but not extended. It does not exert itself; rather than expressing desire it sinks, as if
recalled by thought dawning. The face is marked by an awareness that is only
beginning to articulate itself. Ambivalence permeates the pose and its counter-possi-
bility of motion that would disturb the pose. A transitional bivalence operates
throughout the figure, questioning each observation with its manifest inversion.
Masculinity comes into definition through the feminine; classical proportion is offset
by vigorous modeling; the innocence and vulnerability of youth conceals the maturity
of piercing insight; and the erotic ... the erotic here inscribed within the tender bounds
of anticipation is delivered in its most fragile configuration. The ephemerality of all
desire must eventually incarnate its objective, or vanish into what it is no longer.
Perhaps it is, in the musing words of Rodin, "the awakening, the slow returning from
an intoxicated dream, expressed in the dreamy pose and gesture."[1]

In keeping with the ambiguous subtlety of this young male figure, Rodin's first
life-size sculpture acquired a variety of titles, each one proclaiming thematic priority.
Most commonly known as *The Age of Bronze*, this seminal work was first exhibited in
1877 in Belgium (Cercle Artistique de Bruxelles) as *The Conquered Man*. It was
subsequently known as *Man Awakening to Nature*, *The Stone Age*, *The Golden Age*,
and *The Awakening of Humanity*. This profusion of titling reflects the multifaceted
thematic potential that this figure incarnates. Its constitution allows us to embrace
connotations that have eternal consistency. Harking back to the birth of human
consciousness in evolution when humanity emerged from the kingdom of the beast, this
figure triumphs in its completion of form, its perfection of an ideal. We are reminded
of classical Greece, the golden age of early civilization. We return to the Renaissance,
when man awoke to his surroundings and fashioned comprehension out of wilderness,
embarking upon a project of learning and knowledge. And finally, we are afforded a
prescient glance into the future, a forward gaze into the potential of an uncertain
humanity. This figure symbolizes all of these aspects that profoundly surround the
human quest for fulfillment. It compresses the lessons of history into the desirous
present, where we are impelled only by our aspirations to the future. *The Age of*

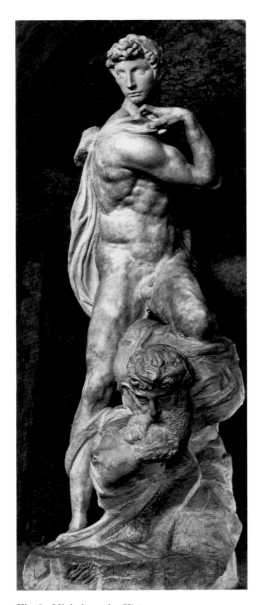

Fig. 3 Michelangelo, *Victory*,
after 1525-30. Marble, height 102¾″ (261 cm).
Palazzo Vecchio, Florence

Bronze permits access, through its form, to the field of possibility of what humanity might accomplish and tell of itself.

The figure transfixes our interest through its absolute disclosure as a human form that we are able to approach as individuals. In our own personal way, somewhat reminiscent of what Rodin himself must have experienced, we regard this work of art as one that uneasily succumbs to our own intentions. In fact, the lassitude that it embodies as a vicissitude inflicts upon us a responsibility. As a figure, this work of art is able to pronounce only what we are willing to make it divulge: what kind of person will it become? "In its unblemished nudity it bears the sign of no one epoch; it is the eternal man touched in his innermost sensibility by something of which he knows not the cause. Is it his soul, is it his flesh that trembles? One does not know. No knowledge comes without suffering."[2]

The appearance of this work in the Paris Salon of 1877 provoked a deluge of controversy.[3] Stunned by the imposition of this male body, displayed in all its evident complexity, critics accused Rodin of casting from life. Holding an overwhelmingly transitory pose, *The Age of Bronze* struck the connoisseur and public alike as a work that confounded interpretation through any conventional system. Submitting to no formulaic depiction of the body and only distantly recalling precedents in the history of art (a faint echo of Michelangelo's *Victory* [Fig. 3]), the figure declared its independence from any familiar narrative. It lacked attributes or identifying details that might supply it with a social identity.[4] Rodin relied solely upon the nude body, upon the purest manifestation of the erotic, to bear the weight of his artistic conception. And it was this emphasis upon the erroneously perceived "realistic," the naturalistic, that governed perceptions of the figure. Leading first the eyes and then the mind of the viewer over the voluptuously described shadows and highlights, crevices and bulges, exploring the musculature in the context of delicate resignation, this sculpture signaled a possibility in art that no longer depended upon the primacy of subject matter, narration, or mimesis. As is evidenced in the monumental figure of Jean de Fiennes (Fig. 4 and plate 43), the meaning has been summoned away from the function of describing an episode or event and returned to the constitution of the artwork itself, where it supports the idea underlying its existence.

Fig. 4 *Jean de Fiennes*, 1885; cast 1969.
Bronze, height 28″ (71 cm).
The Metropolitan Museum of Art, New York,
The B. Gerald Cantor Collection

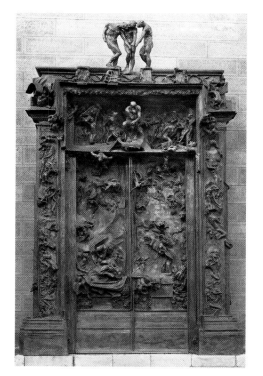

Fig. 5 *The Gates of Hell*, fourth bronze cast, 1942-48. 294 x 156″ (747 x 396 cm). Kunsthaus, Zurich

Fig. 6 *The Thinker*, 1880-81. Plaster. Photograph by Victor Pannelier or Charles Bodmer

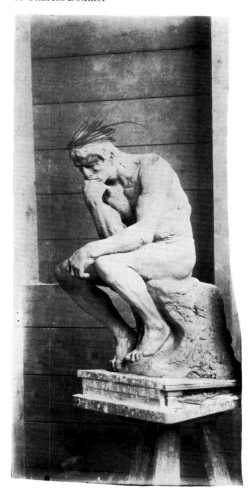

In 1889 Rodin reflected upon the composition of *The Gates of Hell* (Fig. 5), the most spectacular large-scale sculpture of the nineteenth century. He noted that "there is no intention of classification or method of subject, no scheme of illustration."[5] When we as viewers look at *The Gates* we cannot help but see in the work of art what art history has taught us. The quest to understand the work as a whole is determined by the convention of breaking it down into constituent parts, of reading those parts as clues to the content, aspects of a larger narrative. Regions are divided into smaller ones, which upon further analysis yield iconographic details, intimating an undercurrent of another, more removed, symbolic narrative. This process relies upon our ability to gather information about each part, following the linear assumption that compilation of smaller iconographic parts will eventually yield a whole that provides us a unified meaning.

The conventional art-historical approach would take into consideration information about why the work was made and for what purposes – in this case, the circumstances surrounding the commission. And inquiry into Rodin's artistic intentions, seeking out salient aspects of his conception for this awesome project, would become important to any consideration of how his working methods supported and reflected his modes of thought. Because it is believed that Rodin directly drew thematic inspiration from episodes described in Dante's *Inferno*, the underlying text of that Renaissance epic would warrant analysis. As this method of investigation focused on ever more refined details, it would enable us to recognize specific figures that appear elsewhere in the sculptor's oeuvre: *Je suis belle* (1880; plate 3), *Avarice and Lust* (1880-82; plate 35), *The Thinker* (Fig. 6), *Falling Man* (1882; plate 31), and many more. Our comprehension of these figures as they appear in *The Gates* would surely be conditioned by their previous presentation as unique and discrete sculptures. In what eventually reveals itself as a circuitous task, all these figures could be explored in their infinite individual complexity so as to furnish insights regarding their positioning in *The Gates*.

While following this approach firmly committed to the works themselves, comprehension could also be enhanced through a biographical study of the artist's life. Descriptions of the artist, of his studies, travels, journeys to influential monuments, living conditions, personal relationships, artistic aspirations – in short, the entire compendium of "relevant" information regarding an artist's life – would then influence the assessment of his work. And above these laboriously recounted details, it is understood that there is no more powerful tool available to interpretation than those words spoken by the artist himself. For hearing his voice alters what we see. Recalling Rodin's commentary on *The Gates*, we can listen: "There is no intention of classification or method of subject, no scheme of illustration." The final objective – according to standards set by art history – would be to interpret these words in order to comprehend modes of production, to gain entry into the mysteries of artistic inspiration, and, most prominently, to understand the "final" intentions of the artist as manifest in his artwork. Thus has art history's methodologically historicizing emphasis upon archival material instructed us to gather information in order to forge comprehension, attempt interpretation, and, perhaps, even cultivate meaning.

But given this approach, what could be the nature of the interpretation that will be arrived at? What are the ultimate aims of its construction? And will the reading that one is eventually able to generate bring a significance other than that which is plain in the facts and arguments studiously presented? By raising these fundamental issues, even before our analysis of refined topics in the oeuvre of Rodin, it becomes apparent that we must question – and even challenge – the very nature of art history.

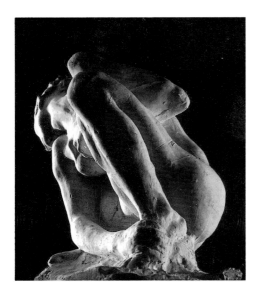

Fig.7 *The Crouching Woman*, 1880-2.
Plaster, height 13″ (33 cm).
Musée Rodin, Meudon (S.2396)

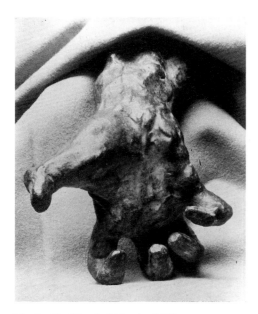

Fig.8 *The Clenched Hand*, c.1885.
Bronze, height 18½″ (47 cm).
Photograph by Eugène Druet

By interrogating our methodology before we begin merely another routine application, we may be able to redirect our approach so as to yield different results. We should be capable of adjusting it to the degree that art history as the known method of inquiry no longer needs to be the single name given to our investigations – despite our respect for the historical and the artistic. Because of the limitations inherent to the historical method (even when history is written as literature), any inquest into the past requires a certain amount of factual familiarity. Yet the past is, of course, only a notion that makes sense to us because we invest belief in it, regenerating the resemblance of occurrences that have transpired in previous time. This belief is determined by how we are able to understand the present, to comprehend the origins of forms as they surround us. With this investment made in the "facts" of the past, we become enmeshed in a discourse that seems historical, even at times art-historical. But before we rush to assign titles to our investigations, let us cast a critical eye on the motive for our retrieval of supposed fact. Construction of the facts in scholarly terms, placement of them in an argument, and defense of this argument under the aegis of an interpretation, will variously influence the nature of fact and reposition the available potential of what we want to express. How are we able to pass through time and return through history's unending forward flow to arrive at a moment when creation, creator, and viewer are united in one place? Should we entertain the need of such positivistic "fictions" or forsake this resolute impossibility and be content with a contemporary vicarious and interpretative fusion?

As the title of this essay indicates, we are concerned here with the critique of convention, both in art and its histories. By liberating our approach from the confines of an organized and entrenched methodology, we can begin to think beyond immediate access to the commentary of interpretation. Meaningful insight into the essences of Rodin's work and artistic methods can be gained when specific sculptures are situated both within and beyond their close context. Through detailed descriptions of what the sculpture actually is, and by locating each work within the context of his vast oeuvre, an initial close reading of the work can be formulated. But such a reading accrues greater significance when regarded in the wider scope of the ideas that it embodies. Consideration of Rodin's cultural context will provide direction toward certain concepts which consistently preoccupied his artistic thinking. Only after having gained entrance to the foundation of ideas motivating Rodin's work will we be able to undertake the more complex discussion of meaning. Meaning is here understood to be that level of literal comprehension that allows the observer to awaken in thought ideas or concepts that specifically exist through interactive exchange with a given work of art. Meaning will emerge as a sector of insight unmistakably premised on the artwork, but also having a life beyond it, because its true essence returns to ideas – to the intangible framework of experience recoded in sculptural thought. The construction of this scholarly process may be elusive and unpredictable, sometimes following a tight historical path while in other cases stepping outside the immediate parameters of physical history. And it is to this double-bound latitude of the fully awakened human mind at work that we direct our intellectual gaze, allowing it to deflect off the artwork and into the cumulative realm of hermeneutic certitude.

Our critique of convention, as applied to the work of Rodin, is most forcefully assisted by turning to the philosopher, and contemporary of Rodin, Friedrich Nietzsche. His writings, especially from the late 1880s, provide us a model in methodological, social, and thematic terms. With Nietzsche, the interrogation of convention does not rely merely upon refutation, but rather emerges as that which surmounts its obstacle by replacing it with further propositions. The self-reflexiveness inherent to his thinking evidences a framework of productive destruction that leaves in its wake an entirely new model. Conventional structure is emptied out, discarded.

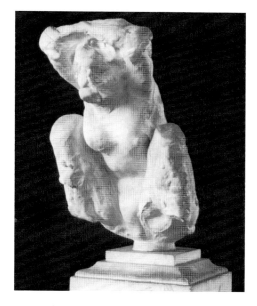

Fig.9 *Crouching Nude*, 1900-12. Plaster, height 23¼″ (59 cm). Musée Rodin, Meudon (S.704)

Fig.10 Detail of Fig.9

From Nietzsche we will be able to understand the essence of change; to elucidate the notion of transformation in its most intimate contexts; to trace the nature of intrinsic shortcomings; to follow the dispensation of excesses through diremption; and to realize the ultimate conquest of delusion through the exertion of man's "will to become," to realize himself. We are enriched by the thoroughness of his critique, the degree to which his unified conception of life allows him to connect divergent discourses. Morality, religion, organization of society, culture, history – all these topics so central to Nietzsche's philosophical enterprise will prove informative to our meditations upon the work of Rodin, as will be revealed throughout the course of this essay.

III

Fig.11 Rodin with a nude by Andrieu d'Andres and Jessie Lipscomb, c.1887

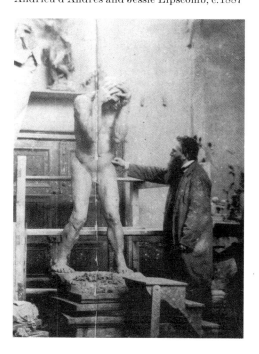

Our first critical point of departure concerns the work of art in itself. Discourse detached from the art object will remain sequestered precisely in the sphere of discourse, becoming its own tautological triumph (that may or may not inform the work of art). In this self-critical fashion, we are able to motivate true suspicion through Nietzsche – who was a skeptic, a dis-believer, a maker of certainty only out of that which could yield no other alternative. The degree of precision required for a new beginning must preclude and exclude all other possible and available pathways. It must be *the* way (not necessarily singular) which induces sophisticated results. Nietzsche begins his preface to *On the Genealogy of Morals* (1887) with a profoundly introspective paragraph. And it is from this book, especially from the first essay, entitled "Good and Evil," "Good and Bad," that insight will be gained into the domain of morality and convention which, with an almost crystalline bitterness, applies directly to Rodin. Nietzsche reflects upon himself as creator, discussing the limits of what he will be able to produce: " We are unknown to ourselves, we men of knowledge – and with good reason. We have never sought ourselves – how could it happen that we should ever *find* ourselves? So we are necessarily strangers to ourselves, we do not comprehend ourselves, we *have* to misunderstand ourselves, for us the law 'Each is furthest from himself' applies to all eternity – we are not 'men of knowledge' with respect to ourselves."[6]

By turning the discourse so pointedly upon himself, and upon his endeavor as thinker, Nietzsche begins with a challenge to the nature of his essence. By stating what eludes him, ascribing an evasive center to his task, he proposes the object of his quest which – implicitly – does not emerge as a necessary requisite for fulfillment to be attained. For the "man of knowledge" to know himself would render the man useless to his project, would remove the compelling absence of desire that drives him forward, pushes the mind past its boundaries where it possesses no further possibility than that which demands itself. "Each is furthest from himself" – here, in the dictum that applies for all eternity, we recognize precisely the binding factor involved in the making of a discourse. The premium is placed upon disclosing other knowledge.

From these reflections we are able to posit some of the initial parameters of genius, to discover a sense of genius that is directly applicable to Rodin. We shall draw on Nietzsche's definition of what the artist should strive after, a late nineteenth-century notion descriptive also of the venue of enlightened creation itself. The genius will be one who sets the object of his quest beyond his attainable reach. He must outlive his own life by transferring the essence of experience into a realm that can only be incarnated through his creations – and the acts of creation – as they appear and take form. If there is an experience involved, then it will be fleeting, transitory, ephemeral. Genius knows only that which it cannot gain, that which eternally eludes it. This is its nonparadoxical imperative: to know of that which can never be known. The genius is able to intimately connect conception to creation by means of the artistic.

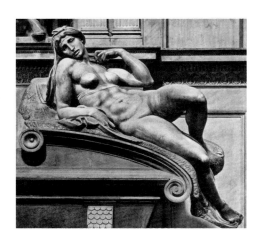

Fig. 12 Michelangelo, *Dawn*, 1524-31.
Marble, length 81" (206 cm).
Medici Chapel, San Lorenzo, Florence

Without digressing into metaphysics, we can begin to understand the splintering of the self that the genius affects in order to detach himself from his work. In Rodin this progress finds its origin early in the artist's career. His travels to Florence, Pisa, and Rome – where, in the spring of 1876, he was first exposed to the work of Renaissance masters Donatello and Michelangelo – left a lasting impression upon him. Study of these illustrious predecessors powerfully influenced the creative vision of Rodin, enabling the articulation of a conceptual shift.[7] The impact of Michelangelo's work in the Medici Chapel of San Lorenzo becomes clear. The majestic figures of Dawn and Dusk, of Night and Day flanking each tomb of the Medici brothers powerfully impressed Rodin (cf. Fig. 12 and Fig., p. 44): "I have studied Michelangelo, and I believe the great magician will probably reveal a couple of his secrets to me Nights, in my room, I have been making drawings, but not after his works – of the scaffoldings I have been building in my imagination in an attempt to understand him."[8]

Fig. 13 Rodin, c. 1891-93.
Photograph by Nadar

Many years later, Rodin was able to articulate these "secrets," which had to do with a fundamental duality of thought that became a constant in his art. In conversation with Paul Gsell in 1910, Rodin reflected upon his early visit to Italy, viewing the lessons he had learned there as important in molding his artistic vision in syntactic and formal terms, as well as his vision of himself as creator. From the vantage point of a fully developed major talent, Rodin's late reflections upon *The Age of Bronze* articulate the absolutely advanced nature of that early sculpture. The Italian visit interrupted work on the sculpture. When Rodin returned to it, the entire process was infused with an ideal of grandeur that would henceforth permeate the project. Rodin recognized aspects of Michelangelo's work that now strike us as a precise description of the essential criteria in *The Age of Bronze*: "We notice that his [Michelangelo's] sculpture expresses the painful withdrawal of the being into himself, restless energy, the will to act without hope of success, and finally the martyrdom of the creature who is tormented by his unrealizable aspirations."[9]

The Italian model functioned both as example to be learned from and as precedent to be rejected.

From the Mannerist Michelangelo, an artistic mind in transformation rather than a Renaissance mind in perfect harmony, Rodin gained experiential artistic impetus.

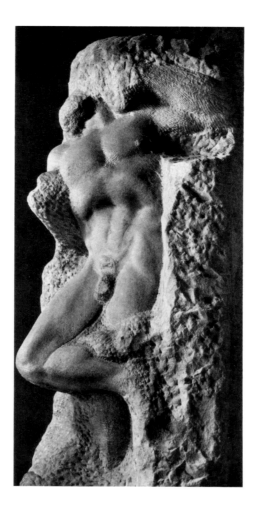

Fig.14 Michelangelo,
The Awakening Giant, 1530-33.
Marble, height 108¼″ (275 cm).
Accademia, Florence

Through viewing Michelangelo's sculpture, Rodin was able to discern what the six-teenth-century sculptor-genius also expressed in words. In one of his many sonnets, the aging voice of Michelangelo laments with melancholy the genius that is leaving him. The life-essence that has flowed for so long threatens to exhaust itself in the crises of its conclusion:

> …
> The good I pledge myself, the bad I reject
> Hide, O my lady, beautiful, proud, divine
> Just thus in you, but now my life must end
> Since my skill works against the wished effect.
> …
> If at the same time both death and pity
> Are present in your heart, and my low skill,
> Burning, can grasp nothing but death from it.[10]

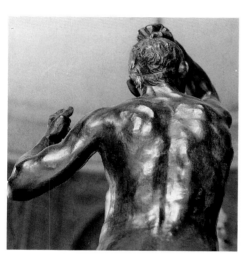

Fig.15 *The Age of Bronze*, 1876, detail.
Bronze, height 70¾″ (180 cm).
Musée Rodin, Paris (S.986)

Out of an unrelenting urge to carry the world further into the art that man creates, the polarized vengeance of the gifts of the genius in the end encroach upon the person, the artist.

The Age of Bronze is the first major work that evinces, with startling and complete prescience, an awareness of both the conceptual power of genius and of the ambivalent qualities that inhere in its efforts – the contrapposto distribution of flesh, the alter-nately smooth and rippled, compressed and extended flanks, the expression of such precise ambiguity (Fig.15). The imbalance of the figure constantly interacts with impending forces, thriving on the exchange, the test of the will, rather than seeking resignation in a balanced solution.

Fig.16 Rodin, c. 1914.
Photograph by Manuel

"*My Conception of a Genius* ... The great human being is a finale ... The genius, in work and deed, is necessarily a squanderer: that he squanders himself, that is his greatness. The instinct of self-preservation is suspended as it were; the overpowering pressure of outflowing forces forbids him any such care or caution ... He flows out, he overflows, he uses himself up, he does not spare himself – and this is a calamitous, involuntary fatality, no less than a river's flooding the land."

Friedrich Nietzsche, *The Twilight of the Idols*, 1888

IV

In order to comprehend Rodin's proposition of genius and what the idea could have meant to him in the late nineteenth century, it is useful to juxtapose two sculptures that initially appear to be very different in nature. *Avarice and Lust* (1881; plate 35) and *Christ and the Magdalen* (1894; Fig.17 and plate 17) present discrepant notions within an artistic vision that manifests conceptual consistency through a central thematic bond – the eroticized idea of the creative genius.

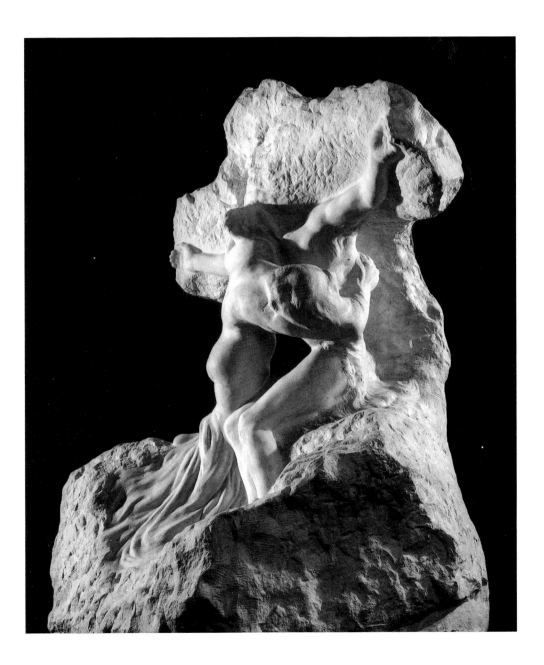

Fig.17 *Christ and the Magdalen*, 1894.
Plaster, height 40¼″ (102 cm).
Musée Rodin, Meudon (S.1136)

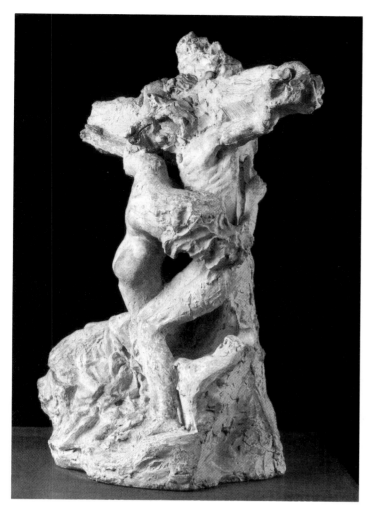

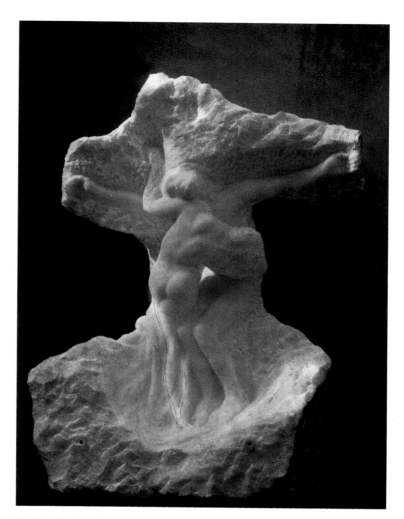

Fig.18 *Christ and the Magdalen*, c. 1892.
Plaster, height 33¼″ (84.5 cm). Musée Rodin, Paris (S.1097)

Fig.19 *Christ and the Magdalen*, 1903. Marble, height 40¼″ (102 cm).
Photograph by Jacques-Ernest Bulloz with penciled emendations by Rodin

Fig.20 *Christ and the Magdalen*, 1894, detail.
See Fig.17

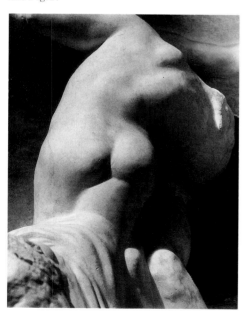

Considering the number of titles that *The Age of Bronze* has acquired, it comes as no surprise that the sculpture most commonly known as *Christ and the Magdalen* has alternatively, and perhaps more appropriately, been titled *Prometheus and The Oceanid* and *The Genius and Pity*. The sculpture affords us unusual latitude in our interpretation of genius. Religious subject matter, extremely rare for Rodin, comes into deeper resolution through the mythological and the modern.

When questioned about the rarity of religious themes in his sculpture, Rodin replied: "Well, to be honest, the group that you are referring to is more likely to be *Prometheus and The Oceanid*. At the time, I was certainly interested in making religious sculptures, but they require a lot of drapery, and I had done so much of that with Carrier-Belleuse that the nude automatically – and always almost irresistibly – presented itself to me as a subject."[11] The triple twining of themes can be taken as representative of Rodin's many depictions of the artist in the throes of a creative burst. Again, his ability to subvert a fixed narrative reading serves his desire to resist the constraints of a definition that would deplete his work of generative power. Unable to rest our eyes within the security of a definite subject, or to remain within the confines of pure subject matter, we as viewers are forced to return to the sculpture itself, to make our looking discern details that will lend strength to a particular interpretation. By breaking the conventional boundaries of the determination of subject matter in art – which has so tiresomely been mimicked throughout the evolution of art history –

Rodin allows a range of possible conclusions that the viewer will be able to construct in accordance with subjective inclinations. This seemingly technical point has wide-reaching implications, echoing Nietzsche's conception of the genius: " He flows out, he overflows. " The work of art is pregnant with connotations.

In a perceptive article concerning Rodin's humanization of the muses, Rosalyn Jamison observes:

Rodin most clearly stated the intrinsically tragic nature of creation, a view that permeated his images of creators and informed his notion of the muse. While Christ, Prometheus, and the artist were commonly identified with one another during the nineteenth century, Rodin added the element of the self-portrait. The merging of all of these levels of meaning along with the theme of creation was new. In this, one of Rodin's rare religious works, he did not reduce mythic and modern symbols to a Christian absolute, as did his contemporaries. Instead, by syncretizing the religious, mythic, and modern creative genius, Rodin brought to light some basic truths about his own experience of the creative role: it led not only to enlightenment but to tragic suffering and martyrdom as well. Rodin's view of creation, then, the Magdalene, the Oceanid, and Pity were fused into one to play the role of consoling muse.[12]

A comparison of two plaster versions of this sculpture is revealing. The later one (Fig. 20) displays a degree of refinement that typifies the end stage of Rodin's evolutionary working method. In contrast, the earlier one (Fig. 18) everywhere reveals the direct touch of the sculptor's tools guided by his hands. The immediate ferocity of modeling is evident; the agitated, nearly viscous sculpting of sharp and furrowed sections in the woman's hair flows downward, falling over her shoulder, mirroring the reach of her arm that rises up to support and assuage the pain in the male's back. The curves of the hair describe the intensity of her devotion, which we need not see on her face to understand. The shape anticipates the entire erotic twist of her supple body, which has cast off its robes in order to gain absolute access to the body that it consoles. Despite her necessary offering of profound nudity we detect a selflessness and self-immolating desperation in her efforts, which may not be sufficient to redeem the spent state of the genius. Only able to deliver her body in all its maddeningly beautiful grace that bears the energy of total conviction, her efforts seem tainted by an aura of desperate grief. The contortion activating her approach awakens in its exhaustion of gesture the erotic that is born from futility, out of the resignation of the corporeal being crushed beneath its unrealizable hopes for redemption and regeneration. Indeed, the languid and truly pitiful man shows not even a glimmer of life. The contortions of his face, which the earlier plaster version so tellingly illustrates in its expressive imprecisions, speak of an eternal end that continually approaches. The conflict between the soft evenness of the woman's skin and the lacerated agitations of the man's sinking thighs and his nearly scarred arms speaks of a conflict that life itself cannot contain. The rift separating these two individuals becomes apparent in the deep fissure that divides the world of the living from those who no longer partake of mortal experience.

The three different possibilities in titling, in the designation of narratives that run in fantastic harmonic contradiction (as we shall see), finds a neat analogue and thorough articulation through the transitions in medium. The two plaster versions of this work, and one in marble (Fig. 19), impose factors of medium that intuit subtle shifts in the narrative context. Rodin deliberately exerted a power over his creative processes in order to invoke variant themes through selected and specific materials. The multifarious views of existence, a state of being – if this is indeed the definite theme that all three versions share – supply shades of meaning in an intertextual fashion that culminates through exchange. What we are here confronted with is the genius, the Promethean, worked through and into a modern program that pays homage to the religious. Pity surrounding the descent of Christ (already a conflation of

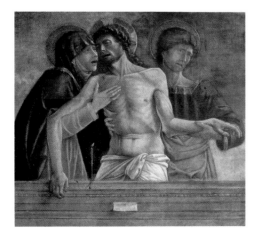

Fig. 21 Rogier van der Weyden, *Crucifixion Triptych*, c. 1440-45, detail of central panel. Oil on panel, 39¾ x 27½" (101 x 70 cm). Kunsthistorisches Museum, Vienna

Fig. 22 Giovanni (?) Bellini, *Pietà*, c. 1472, detail. Tempera on canvas, 45¼ x 124¾" (115 x 317 cm). Palazzo Ducale, Venice

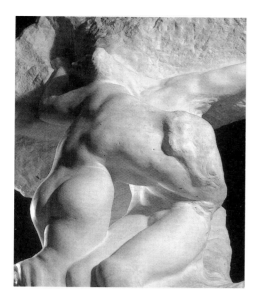

Fig.23 *Christ and the Magdalen*, 1894, detail. See Fig.17

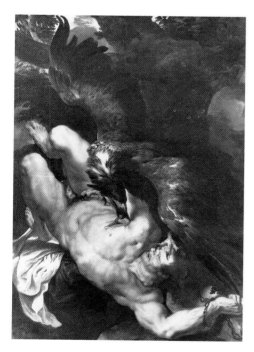

Fig.24 Peter Paul Rubens, *Prometheus Enchained*, 1611-12, detail. Oil on canvas, 96 x 82¾" (244 x 210 cm). Philadelphia Museum of Art

sentiment!) ignites the erotic, augmenting a difficult desire to empathize with the desperate, tragic moment of embrace between man and woman. Or perhaps the sculpture professes none of these ideas, denying the explicit in favor of an implicit confrontation with its maker. Through the annihilation of subject matter, the demolition of the single view, Rodin returns the final focus of his artistic labors to the object. The work addresses the constitution of the creative essence in life. It denotes a pure manifestation of the artist's deeds.

The genius of Rodin reveals itself in this understanding of life-essence, where death is merely an imminent prospect but not an achieved status. The later plaster makes this distinction less prominent. It is a less intricate and intimate rendition, maintaining a remove that results from decreased sculptural investment. It becomes more abstract, as the force motivating gesture in the figures is buried deeper within the limbs. Light plays over the surfaces in generalized, smooth washes, denying sharp indents of shadow, the peaked interjections of form that make the earlier plaster such a vivid example of the expression that eludes description. While the earlier version seems to lend itself initially to the thematic reading of Christ and the Magdalen, the male figure assuming that slackness of energy familiar from depictions of the Descent from the Cross and *Pietà* images (see Figs. 21, 22), the later one supports mythological readings. The enlarged base of the sculpture and the massive upper support for the man's outstretched arms resemble the solidity of a rock formation. Visions of grottoes, of ancient caves, animate the imagination of our viewing, transforming the woman into an adoring, pitying nymph. The way in which her left arm and shoulder support the sunken male head (Fig.23) evokes the tragic emotion of loss that is so poignantly brought to life in classical Greek drama.

Of all composite visions concerning the character of Prometheus, as it was successively elaborated upon by various Greek poets, Aeschylus' emerges as most applicable. Prometheus, the supreme trickster who shunned the authority of the gods, champions the realm of the human mind. It is he who brings to man fire and civilization, insuring that advanced cognition will find the necessary ground for development in the arts and sciences. Prometheus, chained to a rock, his immortal liver habitually devoured by an eagle, exemplifies the responsibilities of knowledge. He represents the hero who must be held accountable for his deeds.

Despite the bodily tribulations that he is subjected to as retribution for his acts of enlightenment, Prometheus triumphs by the merit of his deeds and by his capacity for endurance. In Rodin's depiction, the immanent punishment of Prometheus acquires an erotic dimension, which strikes us as a conscious remembrance of Rubens's large-scale painting of the colossal Prometheus held down by the fierce talons of the eagle (Fig.24). In both renditions of the Promethean theme, the erotic is embodied in the way that the hero is visually and conceptually submerged beneath the weight of his actions, as the form yields to greater forces. Both artists consummate the erotic physicality of the human form undergoing transformation by juxtaposing the corporeal to its inanimate surroundings. In Rodin's sculpture, this is pronounced through the wedding of stone and flesh, Prometheus' upper body dissolving into the stone – the material of nature upon which art depends.

The story sets up a complex of dialectical power relations in which creation triumphs over absence, and knowledge overcomes ignorance. Within the world of Greek tragedy, Prometheus presents us with the fate of the individual who must overcome a circumstance greater than himself: "A relationship between one who is a tyrant [Zeus] and one who is a slave [Prometheus], a slave subjected to torture as only slaves could be. But there are slaves and slaves, and Prometheus contrasts the willing servitude of Hermes, servant to the tyrant, and his own condition: 'For thy servitude rest assured, I'd not barter my hard lot, not I.'"[13]

To conflate cultural mythologies, forcing the Christian to commune with the ancient, we might envision Christ as a slave. As such, he is closest to the "willing servitude" of Hermes, for he is the designated Son destined, from inception, to serve his tyrant, God, and faithfully to die on the cross for Him. Christ is the sacrificial offering, the impotent servant who cannot control his fate, demonstrating the abdication of reason in the face of the preordained. The story of Christ does not conform to the Greek narrative of the hero who has incurred the servile role as consequence of having overstepped his hierarchical status. It is specifically the hero's individuality that provokes the tyrant to punish him, the transgressor. And by assuming responsibility for deeds achieved, the servant bears the weight of his "hard lot"; it is he himself who creates his fate of being chained to the rock. Creation itself becomes the reward for the enactment of transgression.

It is from the metaphorical exchange between man and the gods in the ancient world that a strong conception of Rodin's sculpture is forged. The Christian reading is one that refutes individuality, subsuming the self in a tale of involuntary sacrifice, a helplessness of the body which the soul may or may not be able to redeem. Rodin's vision denies the limitations of a fixed interpretation, returning us to the actual bodies of the selves involved. The sculpted reality of the figures provides them sufficient substance; they need not pay homage to removed religious spheres to account for their actions. They are sufficient unto themselves, and this is their achievement. The power of the tragedian's drama exposes this idea of the responsible self.

Here, then, are the defining strictures of the modern conception of the individual – in this case, the creative artist – and what he could aspire to in the culture of late nineteenth-century France. The conservative positions taken toward society by the Catholic church were in sharp contradiction to the vision that Rodin had evolved by the 1890s, as even a cursory comparison of *Christ and the Magdalen* and Bernini's *The Ecstasy of Saint Teresa* (Fig. 25) indicates.[14] Despite his previous membership in a Christian order, the self-assured, mature sculptor – now at the height of his powers – displays in *The Genius and Pity* a fusion of thematic currents that repeals the conventions of his day. The underlying construct motivating *The Genius and Pity* describes the role of the artist in society, and the artist's ability to reorient historical knowledge toward a subjectively secured present that will speak crisply for the future.

In Nietzsche, this move of tapping into the history of culture and religion as a resource in the forging of the present is everywhere manifest. It emerges as the critique of convention that harnesses that convention's power, as it carries Nietzsche's idea of genius beyond the mundane. From Nietzsche's analysis of the origin and status of Christianity we are able to glean ideas that are of overriding utility in understanding Rodin's sculptural treatment of a supposedly religious theme. Nietzsche's idea of genius feeds on the power of Christianity in order to refute it; the genesis of this idea must be examined and situated within the context of Nietzsche's overall philosophy. In order to arrive at a formulation of what the genius must do, we should take into consideration the diatribes against Christianity in the *Antichrist* and comprehend the depth of Nietzsche's resentment of the European social structure, which he believes to be entirely predicated upon the self-serving appetite of Christianity. In Nietzsche's philosophy, the role of genius is akin to that of Zarathustra, the enlightened individual who brings foreknowledge of an existence freed from the constraints of bogus salvation, hollow myth, dead ritual, and decadent morality:

It is certain, at any rate, that the *Greeks* still knew of no tastier spice to offer their gods to season their happiness than the pleasures of cruelty. With what eyes do you think Homer made his gods look down upon the destinies of men? What was at bottom the ultimate meaning of Trojan wars and other such tragic terrors? There can be no doubt whatever: they were

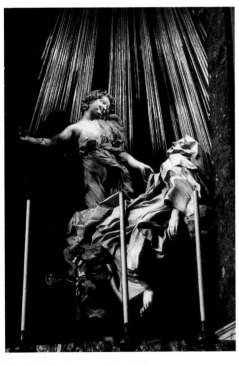

Fig. 25 Gianlorenzo Bernini,
The Ecstasy of Saint Teresa, 1645-52. Marble.
Cornaro Chapel, Santa Maria della Vittoria,
Rome

intended as *festival plays* for the gods; and, in so far as the poet is in these matters of a more "godlike" disposition than other men, no doubt also as festival plays for the poets [cf. Fig.26].

It was in the same way that the moral philosophers of Greece later imagined the eyes of god looking down upon the moral struggle, upon the heroism and self-torture of the virtuous: the "Heracles of duty" was on stage and knew himself to be; virtue without a witness was something unthinkable for this nation of actors. Surely, that philosophers' invention, so bold and so fateful, which was then first devised for Europe, the invention "free will," of the absolute spontaneity of man in good and in evil, was devised above all to furnish a right to the idea that the interest of the gods in man, in human virtue, *could never be exhausted.* There must never be any lack of real novelty, of really unprecedented tensions, complications, and catastrophes on the stage of the earth: the cause of a completely deterministic world would have been predictable for the gods and they would have quickly grown weary of it – reason enough for those *friends of the gods*, the philosophers, not to inflict such a deterministic world on their gods! The entire mankind of antiquity is full of tender regard for "the spectator" as an essentially public, essentially visible world which cannot imagine happiness apart from spectacles and festivals.[15]

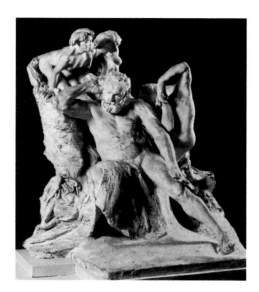

Fig.26 *Monument to Victor Hugo,* before 1897.
Plaster, height 44″ (112 cm).
Musée Rodin, Meudon (S.53)

Pity is that sentiment that must be cast off by the genius. It must be refuted, discarded, and challenged with the new convictions that guide the self-conscious individual. Rodin's depiction of "The Genius and Pity" is the modern illustration of this theme, deeply rooted in the Antique and the religious, yet productive of a variant fusion. The Promethean connotation inspires classical sentiments of grandeur. The Christian version infuses the modern with a conflict in search of resolution. But it is, in fact, through the conflation of the religious and the modern that our deepest understanding is reached. Through Nietzsche's emphasis upon the Greek roots of European culture, and through his reading of Christianity as a corruption of classical ideals, we arrive at a view of the modern as possessing no other option than one of vehement eschewal. Although a return to ancient ideals cannot be affected, the task must be rekindled, its light cast upon new surroundings. Christianity must be overthrown, its blinding light extinguished, and there must emerge a new order of man who is able to follow in the footsteps of Zarathustra.

The Zarathustra that Rodin offers to us is his vision of the genius – a man who has undergone enormous tests of his will and exerted his energies to the fullest. This effort has exhausted him, left him spent, a mere shadow of his former corporeal self, as the marble version (Fig.19) aptly reveals. We now regard the interaction between male and female not as one of communion, but rather of uneasy conflict, of denial. Despite the ceasing of the life-spirit in the male, the Genius, this crucified Antique hero made modern, still exudes enough power to shun the approach of woman, of the supplicating nymph appearing as Pity. Despite the generic Christian guise that the Magdalen has donned, her transformation into the holiest emotion of Pity (in Nietzsche's thinking, "Christianity is called the religion of *pity*"[16]) is not enough to ingratiate herself into the bodice of the genius. The freed modern genius must prevail in a world that knows no recourse to the sacred, must believe in no divinely inspired talent but only in his own consummate version of reality incarnated through triumphant creation. In the work of art, overcoming societal and cultural superstructures, genius finds the strength to assert itself. The arms of the genius will never close to embrace the figure, who yearns for nothing more than this touch.

Fig.27 *Torso of Ugolino's Son,* 1882; cast 1980.
Bronze, 9½″ (24 cm).
The Brooklyn Museum, New York,
The B. Gerald Cantor Collection

> "To make *love* possible God must be a person; to permit the lowest instincts to participate God must be young. To excite the ardor of the females, a beautiful saint must be placed in the foreground, and to excite that of the men, a Mary – presupposing all along that Christianity wants to become master on soil where some aphrodisiac or Adonis cult has already established the general conception of a cult. The requirement of chastity strengthens the vehemence and inwardliness of the religious instinct: it makes the cult warmer, more enthusiastic, more soulful."

<div align="right">

Friedrich Nietzsche, *The Antichrist*, 1888

</div>

V

The proximity of philosophical thinking to the artwork is remarkable. It lends support to statements that acquire greater significance through this enlarged framework of reference. As the focus of our inquiry shifts toward the erotic, we shall be able to expand our understanding of that extraordinarily satisfying visual and cerebral experience.

For the erotic to incite itself within the imagination, there must be an imbalance of essential forces. How one is able to measure or assess the necessary and operative inequity is perhaps less important than being able to sense that fluctuations regarding the drive of eros may be minute or catastrophic, ranging from the nearly imperceptible to full-blown visions of terror. The erotic becomes present and validates itself by being generated in the imagination of the viewer; it cannot be verified in the details of a given object – in this case, the sculpture itself. The fact of the required, active imagination allows for explosive potential, departing from predictable convention and coming to liberate anticipation from what it was – an underdeveloped aspiration.

The essence of eros, as it was successively formulated in Rodin's artistic vision, can be regarded as one of – if not *the* – major unifying trait within his vast production of sculpture and drawing. The increased ferocity with which the erotic sensibility gains an almost profligate insistence in his later drawings is beautifully anticipated in certain early sculptures. *Cupid and Psyche* (Fig. 28) and *Avarice and Lust* (Fig. 29 and plate 35), first cast in 1881, are remarkable examples of the excesses and delicacies that the early Rodin brought to the idea of the erotic.

It is to the refinement of the moment that we must turn our attention when we wish to detect an instance of the erotic. With Rodin we can observe an emphatic conservation of a moment between or among figures that contains the vibrancy of immanent potential. Avarice and Lust are not caught in any verifiable act. They articulate a momentary condition rather than existing as narrative illustration. The artist's major objective of transcending the crass and "profane" act of sensual indulgence becomes clear when this sculpture is decoded in its small essences.

As Avarice reaches to enclose the languid body of Lust, her lithe body, head turned to the side, face shyly hiding, becomes prone as an almost anxious anticipation accentuates her movement. Indeed, she is in motion, however slow and specific it might be. Her hair, half covering her face, has fallen forward. Her arms stretch along her body; her hands rest slightly upon the loins they no longer feel. With tense, curling, nearly abandoned force, the fingers of her right hand open, as if in a murmur the climax of expectation had already begun to overwhelm her (Fig. 30). The left hand, clutching in anticipation, its palm opened to the viewer, rests upon the left leg, intensifying the angle at which that leg indulges the crevice being formed. Could it be that the sculptor had in mind an idea that transcended the forms of his figures? One leg overreaches the boundaries of the base, and the other flexes backward to the revealed center of the female form. Anticipation becomes excruciating as the ankle sliding with the heel creeps toward the exposed core of a vulnerable female body. And

Fig. 28 *Cupid and Psyche*, before 1886.
Marble. Dimensions and whereabouts unknown.
Photograph by Pierre Choumoff

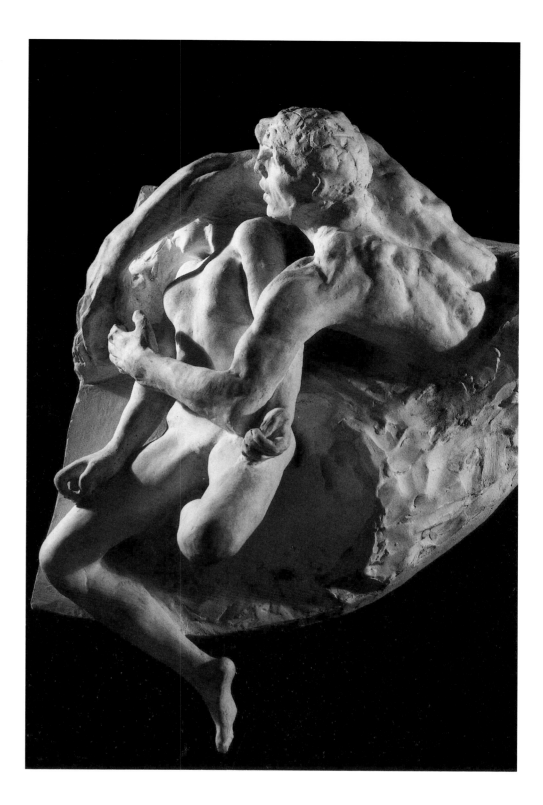

Fig. 29 *Avarice and Lust*, 1881.
Plaster, height 9¾″ (25 cm).
Musée Rodin, Meudon (S. 2152)

this potential becomes all the more tangible when the right leg, slackened already as if to imply the expected outcome, is noticed at its culminating detail: the sensuous, nearly bulbous heel resting in sorrowful abandon.

The strain of desire compels a certain anatomical contortion that permeates the female body. An exposed shoulder thrusts upward, allowing the left breast to rise, to become that poignant second focal point of femininity which holds our attention. We reflect upon its curvaceous, swollen softness and come into immediate conflict with the lax, yet hard bulges of the man's arm muscles. They express a force that does not exert

itself directly on the encircled fragility of the feminine. An arm reaches over, bends at the elbow to touch the right arm of Lust. It is the arm that touches without activating, precisely in accord with the other, that gropes to feel the mass of hair. Both hands of Avarice treat what they feel as a discovery, while at the same time they offer the smallest amount of encouragement needed to impel Lust further and deeper into her supine desire. The sculpture appears to illustrate, if not animate, Baudelaire's poem "Une Charogne" (Carrion) from *Les Fleurs du mal*. One can imagine the illicit rapacity of the experience that the figures yearn to embody:

> And heaven watched the splendid corpse
> like a flower open wide –
> you nearly fainted dead away
> at the perfume it gave off.[17]

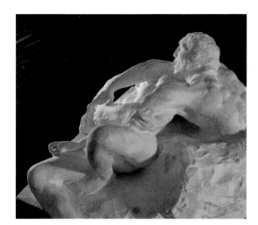

Fig.30 *Avarice and Lust*, 1881.
See Fig.29

Avarice – with his beautiful, wide-open eyes, gaping mouth, and sensual flowing hair – becomes an accessory to an act that Lust lunges for in a diffident way.

In the early 1880s Rodin moved away from Dante's *Inferno* as a source for inspiration and came under the strong influence of Baudelaire. In poems like "Une Charogne" the full reign of eroticism verging on excess becomes plain. If a poem about the ecstasy of sexual experience could end in such blasphemous defeat – as does "Une Charogne" – then it was to the dark visionings of Baudelaire's mind that Rodin had to address himself. Here is the disastrous ramification of love felt too deeply, drunk too sweetly:

> Yes, you will come to this, my queen,
> after the sacraments,
> when you rot underground among
> the bones already there.
>
> But as their kisses eat you up,
> my beauty, tell the worms
> I've kept the sacred essence, saved
> the form of my rotted loves![18]

Fig.31 *Avarice and Lust*, 1881, detail.
See Fig.29

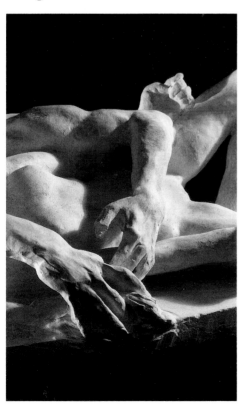

Does love finally conclude in death, or are we able to savor the erotic for a longer moment than death itself could know? The sculpture *Avarice and Lust* is one that still exists today in its state of always-becoming possibility. At this point we should note that it is not the pose that generates the erotic but the manly, muscular arms lying over the woman's body. The touch itself, the tangible transference of what it feels like to be involved – even in a tentative way – is what excites the erotic. Neither the pose, the yearning, or availability of her body constitutes what we refer to as the erotic. It is the nonexertive quality of the masculine presence that amplifies both the sculptural action and the immanent presence of act. When we describe what we are looking at, the experience of the words overtakes its own conclusion in the example of form that the artist has offered us in subtle and complete complexity. We are able still to read the ripples of muscle in the back of Avarice, to follow his urgent drive toward conserving the moment in his lover, the moment when all her pleasure will be sensed and lived.

The body is an accessory to an urge. Its constitution is justified only through an explanation that permeates its form. Lust is anticipation made flesh, embodiment of forces that overwhelm her as she appears in the displayed state. Lust is consumed by an interior yearning, a burning urge that determines the relationship between her and Avarice. His approach to her is governed by the recognition of what she is experiencing. His touch alone – a touch that does not direct itself to her point of focus – is enough

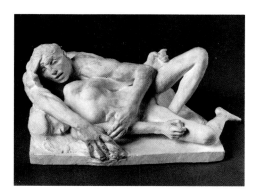

Fig. 32 *Avarice and Lust*, 1881.
See Fig. 29

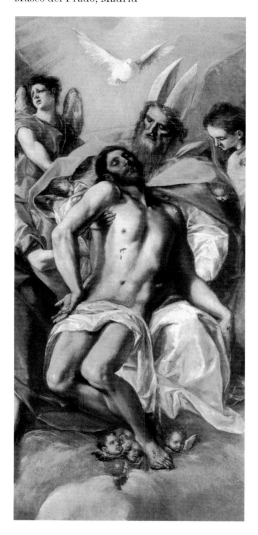

Fig. 33 El Greco, *The Holy Trinity*, 1577-79.
Oil on canvas, 118 x 70″ (300 x 178 cm).
Museo del Prado, Madrid

to set her on fire. The faint pressure of his chest on her back, his arm upon her head, the slight, slight touch of his hand on her arm – these are hints of her dream of climax. His hair does not fall upon her, and his grasp of her hair is so distanced that she does not feel it. Her potential fulfillment – it is only potential, always becoming but not yet realized – is presaged by the definite power that Avarice possesses. His body is surging with the inert yet ferocious force within. Veins illustrate his hands, muscles flex without being put to use.

Avarice descends upon Lust in the way he knows best suits her. In a gesture that purports to console her desire, he caresses her while dispelling her doubt with a whisper, an utterance that forms itself without the aid of articulating lips. A sound wells from within, faintly, softly calling her forth. This moment of supreme anticipation is one that permeates Rodin's thinking about the erotic.

Rodin created an integrated unity of two figures that delivers a statement in lucid terms, embodying in even its smallest details (see Fig. 31) – or omissions of detail – an expression of energies privileging the erotic above any other demand. With *Avarice and Lust* Rodin inaugurates the strong sequence of cultural blasts that announces an artistic stance that is decidedly counter-convention. Not mere depictions, but incarnate conceptions of the body – the most traditional subject matter in the history of sculpture – proclaim the radicality with which he was consumed by the need to express his vision of the human body, deploy the erotic against convention. By sculpting the forms of the body in the manner that he has (as extensively described above), Rodin affects a most sophisticated subversion. The main proposition concerns less the subject matter of damned souls than the liberating way in which the figures have been constructed. As a sculpture, a work of art, the figures unrelentingly drive toward exemplification of a single idea: the erotic, the total urge of sexuality. This is the move against the uniform facade of tradition in art concerning the human body. Throughout human history the body in art has undergone enormous contortions, from the trials of torture, the exaltation of ecstasy, the banalities of labor, the delight of the common person. Yet in all of art history we are hard pressed to uncover one work that so forcefully surges toward a break with the body while at the same time maintaining that very subject matter.[19] (Michelangelo, Tintoretto, and El Greco [see Fig. 33] present notable exceptions.) Rodin's radicality conceals itself without declaration. *Avarice and Lust* appears to be a completely "conventional" and wholly unified depiction of two figures. And that is how convention can be regarded, as a whole.

The tradition of centuries in art makes for a seamless continuum of consolidated comprehension, a series of additive adoptions of the supposedly radical. To break the superstructure of this monolithic network of history, the combative artist must neither fracture nor deny it. The artist must accept the parameters and make a new beginning elsewhere, in the serenity of another remove. In this way he is able to make a fragment that may potentially grow into a new whole, resolve itself in reference to that which it denies. In the way that genius works, with the displacement of integrative desire, the fragment is that piece of inceptive creative effort which allows the artist to postpone a new whole and experiment in the terrain of possibility. The fragment acts out its prospect as an idea coming into definition through one deliberate venue of the creation that it encompasses, the idea that it grapples to define.

The erotic is understood here to be an idea, a cerebral sensibility directly provoked through visual inspection of an artwork. Although the erotic incites an array of specific notions in the mind of each viewer, its status as stimulant makes it intriguing as an idea, an elusiveness constantly seeking a manifest outlet. When triggered, the erotic demands to know how exactly it is embodied as idea, whether in language (as in discourse), in artworks (as in sculpture), or in thinking (as in philosophy). The erotic is only a potential bound up in what it is, but lacking definition until it finds full

Fig. 34 Rodin, Meudon, c. 1908

formulation in the medium that carries it. The sculpture's grounding sequence ultimately gives the idea its attainable and substantive definition, becoming as important to its intrinsically elusive content as the material employed and the mind that worked to shape that material in its own individualizing way.

Our method of description concerning certain of Rodin's sculptures which we consider to be erotic gives voice to one register in the sounding of the erotic. Through the telling of what we are looking at and how we see it, at least one manifestation of the idea becomes revealed. In order to attain a more comprehensive embodiment, however, a variant approach (or approaches) to the concept should be deployed. By allowing expressive media to interact, the possibility of the cross-referential liberates the idea from its chosen form, returning the investment of expression back to its source. The alternative approach of philosophy provides the double incitement to delve into both the form and format of what ideas are. It affords us the luxury of investigating how fragments of thought play into streams emanating from a whole that is in constant resituation; ceaseless self-seeking change arrives out of the impact of each new definition.

Fig. 35 *Two Female Figures*, date unknown.
Plaster, height 13¾″ (35 cm).
Musée Rodin, Meudon (S. 2122)

"I have many stylistic possibilities – the most multifarious art of style that has ever been at the disposal of one man."

Friedrich Nietzsche, *Ecce Homo*, 1888

"There are among the works of Rodin hands, single, small hands which, without belonging to a body, are alive. Hands that rise, irritated and in wrath; hands whose five bristling fingers seem to bark like the five jaws of a dog of Hell."

Rainer Maria Rilke, *Auguste Rodin*, 1903

Fig. 36 *Female Torso with Hand of a Skeleton*, 1883-84. Plaster, height 8¼″ (21 cm). Musée Rodin, Meudon (S.678)

Fig. 37 *Meditation (The Inner Voice)* without arms, 1883-84 (?). Plaster, height 21¼″ (54 cm). Musée Rodin, Meudon (S.680)

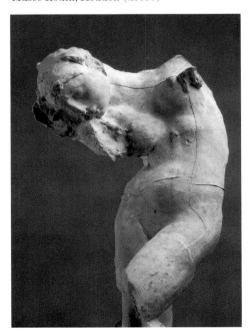

VI

Insights into the nature of Rodin's erotic and often overtly sexual world can be attained only through an assessment of details, an understanding of how Rodin the artist realizes his most refined conceptions in small fragments of sculpture.

Rodin's oeuvre is consistently marked by the existence of so-called "incomplete" sculptures. *Female Torso with Hand of a Skeleton* (Fig. 36), *Assemblage of the Head of Pierre de Wissant and a Female Nude* (plate 6), and *Meditation (The Inner Voice)* without arms (Fig. 37) are some of the most obvious examples. But there is another category of work which amplifies this "incompletion," in which we see a further aspect of Rodin's method of thought. Such works as *Head of the Tragic Muse* (1885), *Torso of a Seated Woman Grasping her Thigh* (c. 1890), and the well-known collection of "pieces" in the Metropolitan Museum of Art, New York, reveal a degree of conceptual latitude in his style of production that is unrivaled for its time. These pieces of sculpture, such as a hand or an arm, elements of the body (Fig. 39), cannot be read as disjunct studies or isolated experiments. This becomes especially clear when these small pieces are considered in the perspective of the larger "unfinished" works, when we are able to reconcile fragmented renditions of the human figure – however elaborate or reduced they may be. All are fragments.

But what is a fragment? Conventionally understood to be a broken or disjunct piece of a larger whole, the fragment as it was conceived and employed by Rodin takes on a significance that did not exist prior to his method of presentation. In the writing of Nietzsche the "fragment" plays a central role, precisely because it is not that which it appears to be. To access the intimate sphere of creative thought we must discard our memory of what we suppose the fragment to be.

Many analyses of Nietzsche's writing techniques fixate dramatically and repetitiously on the function of the aphorism.[20] More than any of his contemporaries, Nietzsche boasted a stylistic arsenal of expressive writing that formally ranged from the philosophical treatise to the literary, the poetic, and the polemic. Yet of all these writing modes, the aphorism stands out as most potent and original. The concise statement of a principle, the summary yet dense formulation of a truth, the aphorism is that crisp collection of words (from one line to whole paragraphs in length) that, through compression of diversity, achieves an expanded breadth of expression. Alexander Nehamas's insights elucidate the density of Nietzsche's stylistic approach: "Hyperbole is in fact particularly well suited to the aphoristic style because it helps the aphorism attract attention and, in its startlingness, reveals quite unexpected connotations. But the aphorism is an essentially isolated sentence or short text, and precisely because of its isolation it disarms the hyperbole as, at the very same time, it highlights it."[21] The aphorism confronts all other options of formulation through the entirety of its constitution, while subsuming the concept of brevity into the whole that it implicates through delivery. It presses for a reconsideration of what we regard the

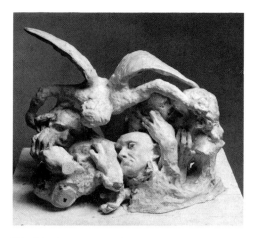

Fig. 38 Assemblage of heads and hands from *The Burghers of Calais* surmounted by a winged figure, c. 1900. Plaster, height 9½″ (24 cm). Musée Rodin, Meudon (S. 403)

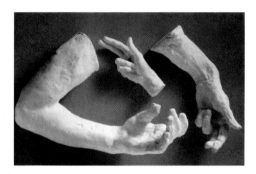

Fig. 39 *Fragments*, 1912.
Plaster, length of arm 8¾″ (21 cm).
The Metropolitan Museum of Art,
New York, Gift of the artist, 1912

Fig. 40 *Torso of "The Centauress"*, c. 1884.
Terracotta, height 8½″ (21.5 cm).
Musée Rodin, Meudon (S. 990)

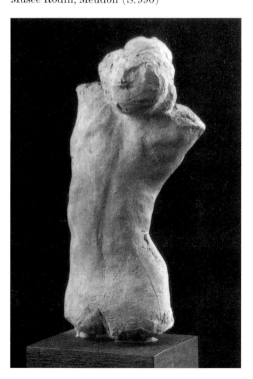

fragment to be, questioning the concordance between language and thought. The prolix vanishes, becoming an awkward trait, disintegrating under the strain of one thought – one thought that includes all of those that have come before it and all of those that it will inspire. In view of this realization, of the complete stature of the aphorism, we turn anew to the notion of the fragment in Rodin's oeuvre. As we shall see, the fragment for Rodin and Nietzsche alike plays a crucial role of stylistic comprehension. Confrontation with the fragment demands from us as viewers that we contribute and attribute our own emotive sequence of response to the artwork, beyond the constraints of any implied narrative (see Fig. 40). We are able to presume that an inconclusive narrative might be conclusive. This presumption liberates our rapport with the work of art, allowing subjective readings to validly circumvent the dogmatic. The viewer is thus encouraged to interrupt the conventional attitude of consummate appreciation and to instead adopt the stance of a collaborator. Artistically and aesthetically, the fragment enjoys a privileged status in comparison to other aspects of the artwork, ultimately becoming an autonomous activator of meaning, a role previously equalled only by that of technique.

The fragment carries with it the conceptual weight of a major vision. This is perhaps best demonstrated through analysis of how the fragment took root in Rodin's artistic method. By the early 1880s, after completion of *The Gates of Hell* (Fig. 5), Rodin extracted individual figures and groups of figures for enlargement and transfer into an independent context. *Avarice and Lust* (Figs. 29–32 and plate 35) is one such example, evidencing how Rodin was simultaneously able to integrate and balance ideals of grandeur with those of intimacy. The truncated back of Avarice appears as a technical consequence of its extraction from *The Gates* but also functions when the sculpture is seen on its own as a factor in the refinement of sculptural focus. That the legs and lower body of Avarice have been omitted is of no essential consequence for the thematic potency of the erotic moment. It signals, however, inceptive recognition of what the fragment would come to embody in Rodin's oeuvre: a depiction of the human body that is not dependent upon all its parts, either carefully or even sketchily displayed. There is in the sculpture *Avarice and Lust* not the slightest indication of the man's legs; they simply need not exist.

This extreme liberty with the truncated allowed Rodin to probe further into the consequences of a whole that is made up of fewer parts than had been assumed to be required for its entirety, leading him further toward the brisk intentionality of the fragmentary. Perhaps the artist's close study of Antique sculpture, commonly extant only in fragmentary form, inspired him with the confidence required to present his own work in various degrees of formal completion. The plaster *Meditation* without arms (Fig. 37), later known as *The Inner Voice* (Fig. 41 and plate 16), does not require corporeal completion to perform its task of eliciting visions of creation. In fact, the figure's inconclusive form adds furor to the need of making her whole, demanding a compassion from her viewers, who must invest their energies into recuperating her entirety. We are compelled to question the excess of material upon which she rests her head, wondering if this is the material of her becoming that thus displays itself, displacing our anticipation about the necessity of her completion. The artist's decision to privilege selected aspects of the body above others has taken over any urge to fulfill the criteria of convention.

This quest for independent creation, freed from the usual constraints, finds a pure incarnation in the terracotta *Torso* (Fig. 42), which displays the brutal consequences of Rodin's need to distill, purify, and purge his sculpture of superfluous elements. By forcing the fragment in the way that he has, ripping away the limbs and head (as the volcanic imprint of the missing neck shows), Rodin demands that no mistake be made about his vision and concrete version of the body. The body may be constituted through

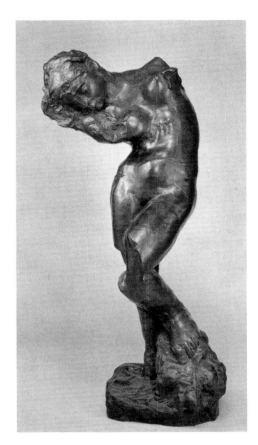

Fig. 41 *Meditation (The Inner Voice)*
without arms, 1896-97; cast 1983.
Bronze, height 57½" (146 cm).
The Metropolitan Museum of Art, New York,
The B. Gerald Cantor Collection

Fig. 42 *Torso*, c. 1880-89. Terracotta,
height 9¼" (23.5 cm).
The Metropolitan Museum of Art, New York,
Gift of the artist, 1912

any of those essential parts that instigate a continuum of discourse within the imaginations of the artist and the viewer, augmenting the dialogue that transpires between creation and reception. Fragmentation, which here connotes aspects of destructive rearrangement, results in conscious stylization of the artistic method. Lacerations made with the sculpting tool punctuate the midsection, the clay buckles as if struck by force, the tactile surface agitated under the pressure of factors preventing the smooth finishing of the skin's surface ... all these aspects speak to a realm other than the depictive, carrying the idea away from its subject matter into the vicious sphere where talent, idea, and genius collide.

Through this rejection of the historical convention of presenting the human body in its entirety, the fragment partakes of another unity. It compresses a vision of a whole, the power of which specifically depends upon the tacit absence of missing components; its presumed excerption magnifies the possibility of the whole it no longer requires. It does not merely connote one aspect of a larger narrative or vision (as single, fully developed figures do), but rather encloses within itself the elaborate range of aspects that are encompassed within a totalizing vision. Without the weighty bulk of accessories, the fragment can speak succinctly for a major concept, one that can apply to an entire field of sculpture, a whole venue of creation. *Meditation* and *Torso* allow for a fundamental reformulation of what a body, a human form, actually is, and for what purposes representations of it conform to conventions. These works, when considered in reference to others by Rodin that are not characterized by fragmentation, complete the cohesiveness of his vision as an artist: the constant comprehension of what it means to fashion the body, what a body can convey, and finally what energies motivate the core of human action in the face of its obverse.

"*Thoughts,*" writes Nietzsche in an aphorism, "Thoughts are the shadows of our feelings – always darker, emptier, and simpler."[22] Are thoughts the darker shadows of feeling, or does thought, through its confrontation with feeling, dwindle and escape from what it originally was, the reasoned reflection of emotion? The process of the intellect moves toward a reduced essence, a succinct form with the trace of feeling which presents itself conclusively. The written words as they appear aphoristically are the result of what the meditation itself is, formally retaining the substance of its presentation. The self-elucidating brilliance of the thought contained within this aphorism's constructed form is in itself a cogent summation of plan and outcome; the original vision (a yearning for expression caught at its earliest waking moment) is explained as resolute reckoning with how it becomes manifest. These words of Nietzsche's denote the supreme embodiment of the fragment, taking as topic its own subject, making as object the summary of all essence before, during, and within coming comprehension. The fragment is all of these as it is each, and only because of this conclusiveness does it demand attention, require the scrutiny of those who quest to uncover the meaning of the whole.

Rodin's *Triton and Nereid* (Figs. 1, 45) can be considered an apt response to the enormity of these ideas. A small-sized terracotta, it is a late sculpture displaying both Rodin's direct technique and his most sophisticated treatment of the fragment. The sea god Triton and the wonderful nymph Nereid rise from an extended branch of clay. To their faces we must always look; we cannot help but be rapt by the marvelous, intensely focused faces of these figures. But away from their faces we must turn, for we should first explore their complex embrace so as to understand the overcoming of yearning that they partake of, that their bodies begin to luxuriate in. This sculpture seems to demand a different language, a choice of words, some assemblage of syllables that could match the intelligence with which Rodin has modeled the clay.

The right arm of Triton, vanished energy unnecessary for the discontinuous embrace, encircles Nereid with more passion than any arm, human or mythological,

could ever exert. Removal of the arm from the visual sequence heightens the spiral of this dizzying embrace, the conviction with which Triton yearns for the hold that overwhelms him with its truth, with its reality that is the tangibility of his imaginings. Allowed to engage with the force swelling from his partial right shoulder (its urge still evident, even as it is "fragmentary"), we sense what the shoulder muscles must have felt – an incomplete part unable even to support another omission – the right arm, an invisible arm. This missing component is made all too profound in its absence by the full inclusion of the right hand, the upper hand, the first hand that clasps its dream. Our minds and eyes wander free through the absence of the right arm, its imagined fantastic, slender, corporeal distance. We pass over the details of how it might have appeared and indulge the supreme sensation of how it must feel. The shoulder becomes a missing fragment of something that it could never be, either in the world of bodies or the universe of sculpture, because Triton's "right arm" crosses through the broken extended arm of Nereid. And these fragmented arms of the imagination exist beyond ideas of arms, for they alone know what it must be like to be so close to another person that that person's touch recedes within the flesh of one's own. Yes, it is this touch that Triton and Nereid partake of; this is the consequence of their embrace that demolishes any order of being or form that could further express their experience.

His hands wrap her stomach and thighs tightly yet gently, aware of the sensations they incite and receive, immersed in holding onto what is being held. The power igniting under these hands is the pure essence of the erotic breaking free from what it was supposed to be, fracturing off into an excess of potent energies that, like the embrace here expressed, denies any familiar form. It gives way to the scaffolding of the sculptural reality which supports this thematic urgency. We pierce with an unexpected view the material base supporting this vision given form. The rods within and the hollow space that supports the center, the erotic foundation of all fancy, is displayed for us as Rodin created it. By the absence of Nereid's leg we see within her source, while with the same explosive glance we are unable to avert the sexual curve of her thigh outside; a trembling, cadenced, sheer summit of form. The absent arms have made way for this fantastic view, as the leg's loss has given way to the interior, a doubly triumphant conceit that Rodin was well aware of … indeed, a tour de force afforded only by the fragment. Here the interweaving coalescence of views, redolent with motivating forces beneath, provides for almost overripe precision – the incarnation of what has been revealed without the overt desire of needing to display more. The signature of the artist is emblazoned directly beneath this imploded intersection of total illusory presence existing in the sublime restraint of absence.

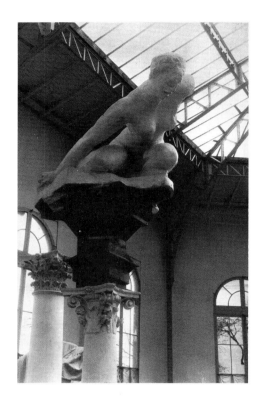

Fig. 43 *The Tragic Muse*, before 1900. Plaster. Photograph by Jacques-Ernest Bulloz

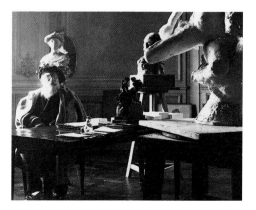

Fig. 44 Rodin in the Hôtel Biron, c. 1914. Photograph by Eugène Druet

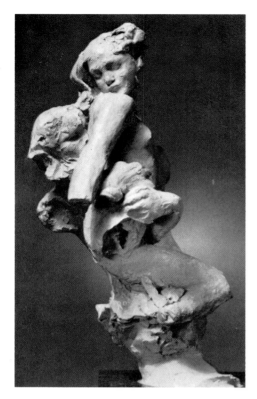

Fig. 45 *Triton and Nereid*, c. 1893.
Terracotta, height 16¼″ (41 cm).
The Metropolitan Museum of Art, New York,
Rogers Fund, 1910

Her leg is broken off at its base, her beautiful leg is missing! Oh, her beautiful leg that must have twisted toward ecstasy, the anxious delight of being consoled by the true fantasy of her Triton rupturing with love as he holds onto her, holds her closer, ever more closer. No, her leg is not missing; it cannot be; it never needed to be there. The anguish of pursuit, the tedium of denial, the sorrow of being unable to experience, the thrill of imagining what it would be like, the doubt ... every fear has fallen away, dissolved into Triton and Nereid as they revel in the realization of their attainment. The distortive negative of any possible apprehension perishes under the consuming reality of this embrace.

The curl of her hair descends to touch the forehead of Triton, indicating that this passion will yield to greater heights. Toward the shadow in his eyes, filling up with the disbelief of her vision as he deeply inhales the divineness of the feminine scent, Nereid directs her downturned surrendering eyes. The slight rise in her lips, wanting to form an utterance of assurance, imparts enough of a silent whisper, an audible throaty moan, to propel this inflamed lock of bodies forever forward into complete union. No force of fragmentation could ever tear this embrace apart.

This is the dream that the mind seeks: an exertive bond of form so strong that when submitted to the counterforces of destruction – even after having undergone the fracturing tests of devastation – it does not crumble or succumb to the loss of unified comprehension. The fragment, which subsumes the notion of fragmentation, emerges as Rodin's one great stylistic trait enabling access to the nucleus of his artistic enterprise. It features the talent of making, quest of conception, and theme of the narrative experience, each as a potential partial element within a completely defined but not fully described whole of sculpture. With the fragment Rodin impinged upon cornerstone tenets of the creative pursuit that would occupy artistic minds of the future. His method announces the moment in early modernism when style not only becomes substance but actually *is* substance. This transfusion of content into personality, plurality of narrative into the singular, and the conceptual into the material, contains in root – fragmented – form the vital network of ideas that the art of the twentieth century would spend successive decades trying to reconcile.

"This alone is fitting for a philosopher. We have no right to *isolated* acts of any kind: we may not make isolated errors or hit upon isolated truths. Rather do our ideas, our values, our yeas and nays, our ifs and buts, grow out of us with the necessity with which a tree bears fruit – related and each with an affinity to each, an evidence of *one* will, *one* health, *one* soil, *one* sun."

Friedrich Nietzsche, *On the Genealogy of Morals*, 1887

VII

Where style and fragment intermingle imperceptibly in the work of Rodin we have been able to observe the most refined moments of the erotic, to speak about the erotic in elusive terms appropriate to its ephemerality. Because the erotic may ignite as quickly as it is dispelled, we have tried to enclose its appearance in sculpture within a framework of ideas that conserves its essence. The unfathomable powers of genius in creation have been balanced by descriptions of what failings might bring – dissolution into the incomprehensible, the unrecognizable. The rigors of refined and intimate subjective results have been brought into wider resolution through objectified descriptions, allowing access at a broader level of insight. And the nineteenth-century context

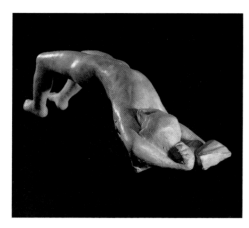

Fig. 46 *Reclining Man, Back Arched*
(*Kneeling Man*), before 1889.
Patinated plaster, height 13¼″ (33.5 cm).
Musée Rodin, Meudon (S. 824)

in which Rodin lived has been referenced backward in history with the intent of recuperating some underlying impetus for the creative decisions he made.

All these issues surrounding the artist at work have found concrete reflection in the writings that mirror the thought of Nietzsche. Both the content and the structure of his writing have informed our inquiry into how ideas acquire significance in the medium in which they appear. Nietzsche has provided a compelling comparative point of reference, because his preoccupations with craft, combined with his talents as author, have brought the issue of style to the forefront of this discussion of the artistic quest. For Nietzsche himself maintained a highly self-conscious and self-critical understanding of aestheticism in his work. Alexander Nehamas explains that "this aestheticism results from Nietzsche's effort to bring style into the center of his own thought and to repeat once more what he took to be the great achievement of the Greeks and the Romans: to make of 'the grand style no longer mere art but ... reality, truth, *life*.' [Nietzsche, *Antichrist*]"[23]

Equipped with this aphoristic knowledge, we can comprehend the project of interpretation as that which must find its conclusion in a region beyond our immediate scholarly aims. Our desire for meaningful interpretations of art makes sense to us if, in the end, we are provided a discursive array of thought that radiates past our immediate milieu. The density of genius in history is formidable, still masquerading in complex opacity, lingering in shadows of thought like feeling that might have been possessed before slipping into darkness. But the light with which we ignite our current inquisitive looking allows us to see. It casts a glow over imagination inspired by the genius' works, radiant flicker of previous creation still dawning in moments like the erotic.

Fig. 47 *Fallen Angel*,
c. 1895. Marble,
height 16½″ (42 cm).
Musée de Lille

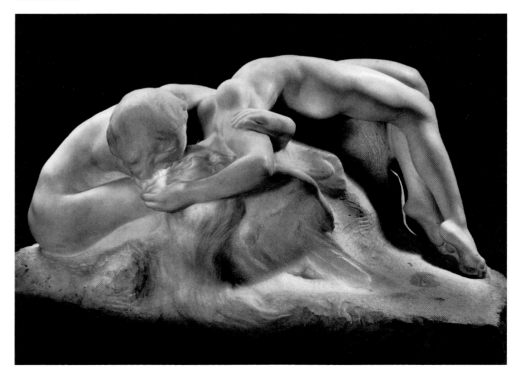

Notes

1 Rodin, letter to the director of the Bremen Kunsthalle, January 29, 1906, quoted in Emil Waldmann, *Auguste Rodin* (Vienna, 1945), p.73.

2 Judith Cladel, *Rodin: The Man and His Art* (New York, 1918), pp.68-69.

3 For the most comprehensive account of this controversy, including excerpts from statements made in defense of Rodin, see John L. Tancock, *The Sculpture of Auguste Rodin: The Collection of the Rodin Museum, Philadelphia* (Philadelphia, 1976), pp.344-53.

4 Much is often made of the fact that Rodin carefully selected a Belgian soldier to pose for him. Preliminary drawings reveal that the model originally held a spear that supported the left arm, and, as is still evident from the faint indent on the hair, at one point the figure wore a filet. By removing both these potentially narrative devices from his sculpture, Rodin deliberately augments the ambiguous universality of the work. In a 1907 letter to the director of the Staatliche Kunstsammlungen, Dresden, Rodin wrote: "Originally, I gave him a spear, but this obscured the outlines." Henri Lechat, "Sculptures de Rodin," in *Bibliothèque des Musées de Lyons* (Lyons, 1919), p.8.

5 Truman H. Bartlett, "Auguste Rodin, Sculptor," a series of articles first published in *The American Architect and Building News* 25 (1889), here quoted from Albert E. Elsen, *Auguste Rodin: Readings on his Life and Work* (Englewood Cliffs, NJ, 1965), p.69.

6 Friedrich Nietzsche, *On the Genealogy of Morals* (1887), trans. Walter Kaufmann and R.J. Hollingdale (New York, 1967), p.15.

7 The visit to Italy must have put Rodin's academic and somewhat conservative artistic education into an unfamiliar perspective. Until the mid-1870s Rodin had followed an unremarkable artistic path. His very early sculpting style was overwrought with eighteenth-century mannerisms, which led to his rejection by the Ecole des Beaux-Arts, to which he applied three times. In 1858 he found work helping various decorators and commercial sculptors. After four years of this routine and one year with the Order of the Fathers of the Holy Sacrament, Rodin seriously questioned his decision to become a sculptor. It was not until 1863 that he resumed somewhat pedantic studies of form through intensive, personally motivated drawing, studying anatomy of animals at the Musée d'Histoire Naturelle and human anatomy at the Ecole de Médicine. From 1865 to 1871 Rodin was employed as one of about twenty assistants to the arts-and-crafts sculptor Albert Carrier-Belleuse. In this workshop Rodin perfected his technical skills in various media. By 1873 he was collaborating with Antoine Joseph van Rasbourgh on architectural sculptures, making landscape paintings and drawings in his spare time. Slowly, from this time onward, Rodin, who still frequently was working for other sculptors, began to focus on his own work. Only by 1876 was he equipped to tackle such an ambitious and major work as *The Age of Bronze*, which is an exceptional tribute to his nascent powers.

8 Undated letter from Rodin to Rose Beuret, in Alain Baeusire and Hélène Pichet (eds.), *Correspondance de Rodin*, vol.1, *1860-1899* (Paris, 1985), no.13.

9 Rodin, *Art: Conversations with Paul Gsell* (Berkeley, 1984), pp.91-92.

10 Gilbert Creighton, *Michelangelo: Complete Poems and Selected Letters* (New York, 1963), p.88. The full text of the original poem reads:

Non ha l'ottimo artista alcun concetto,
Ch'un marmo solo in sè non circonscriva
Col suo soverchio; e solo a quello arriva
La man che ubbidisce all'intelletto.

Il mal ch'io fuggo, e'l ben ch'io mi prometto,
In te, donna leggiadra, altera e diva,
Tal si nasconde; e perch'io più non viva,
Contraria ho l'arte al disiato effetto.

Amor dunque non ha, nè tua beltate,
O durezza, o fortuna, o gran disdegno,
Del mio mal colpa, o mio destino o sorte;

Se dentro del tuo cor morte e pietate
Porti in un tempo, e che'l mio basso ingegno
Non sappia, ardendo, trarne altro che morte.

Sämtliche Gedichte Michelangelos in Guasti's Text mit deutscher Übersetzung von Sophie Hasenclever (Leipzig, 1875), p.178.

11 Rodin, quoted in Gustave Coquiot, *Rodin* (Paris, 1915), p.36.

12 Rosalyn Frankel Jamison, "Rodin's Humanization of the Muse," in *Rodin Rediscovered*, ed. Albert E. Elsen, exhibition catalogue (Washington, D.C., National Gallery of Art, 1981), pp.109-10.

13 Pierre Vidal-Naquet, "Aeschylus: The Past and the Present," in *Myth and Tragedy in Ancient Greece*, trans. Janet Lloyd (New York, 1988), p.272.

14 For an excellent account of Rodin's views on religion, see Jacques de Caso's essay in the present volume.

15 Nietzsche, *On the Genealogy of Morals*, p.69.

16 Nietzsche, *The Antichrist* (1888), in *The Portable Nietzsche*, trans. Walter Kaufmann (New York, 1967), p.572. In these early passages of *The Antichrist* Nietzsche, by invoking the full range of tropisms and by flaunting his literary agility, produces numerous vehement, polemical versions of this single idea: "What is more harmful than any vice? Active pity for all the weak: Christianity" (p.570), "In our whole unhealthy modernity there is nothing more unhealthy than Christian pity" (p.574).

17 Charles Baudelaire, *Les Fleurs du mal*, trans. Richard Howard (Boston, 1982), p.35. The original reads:

Et le ciel regardait la carcasse superbe
Comme une fleur s'épanouir.
La puanteur était si forte, que sur l'herbe
Vous crûtes vous évanouir.

Baudelaire, *Les Fleurs du mal*, ed. Antoine Adam (Paris, 1961), p.35.

18 *Les Fleurs du mal*, trans. Howard, p.36. The original reads:

Qui! telle vous serez, ô la reine des graces,
Après les derniers sacrements,
Quand vous irez, sous l'herbe et les floraisons grasses
Moisir parmi les ossements.

Alors, ô ma beauté! dites à la vermine
Qui vous mangera des baisers,
Que j'ai gardé la forme et l'essence divine
De mes amours décomposés!

Les Fleurs du mal, ed. Adam, p.36.

19 Even as notable a rupture in the sequence of representational depiction as that which announced the autonomy of still-life painting in the late sixteenth century can be considered here as a less dramatic departure, because its innovative aspects are due to a total shift in subject matter. Nascent still-life painting, such as Caravaggio and early seventeenth-century Dutch examples, draws radicality from its self-assertiveness as a "new" genre, but can here be regarded as less revolutionary, because it does do not uncoil convention by overcoming it within its own terms, using its own vocabulary and tools of construction – all factors Rodin massively modified without denying or destroying. Accommodation of convention, its inclusion through its breaking, constitutes the most advanced summation of the radical.

20 The most notable of these studies are Maurice Blanchot, "Nietzsche et l'écriture fragmentaire," in *L'Entretien infini* (Paris, 1969), pp.227-55; Jacques Derrida, *Spurs: Nietzsche's Styles*, trans. Barbara Harlow (Chicago, 1979); and Sarah Kofman, *Nietzsche et la métaphore* (Paris, 1972).

21 Alexander Nehamas, *Nietzsche: Life as Literature* (Cambridge, Mass., 1985), p.23.

22 Nietzsche, *The Gay Science* (1887), trans. Walter Kaufmann (New York, 1974), p.303.

23 Nehamas, *Nietzsche*, p.39.

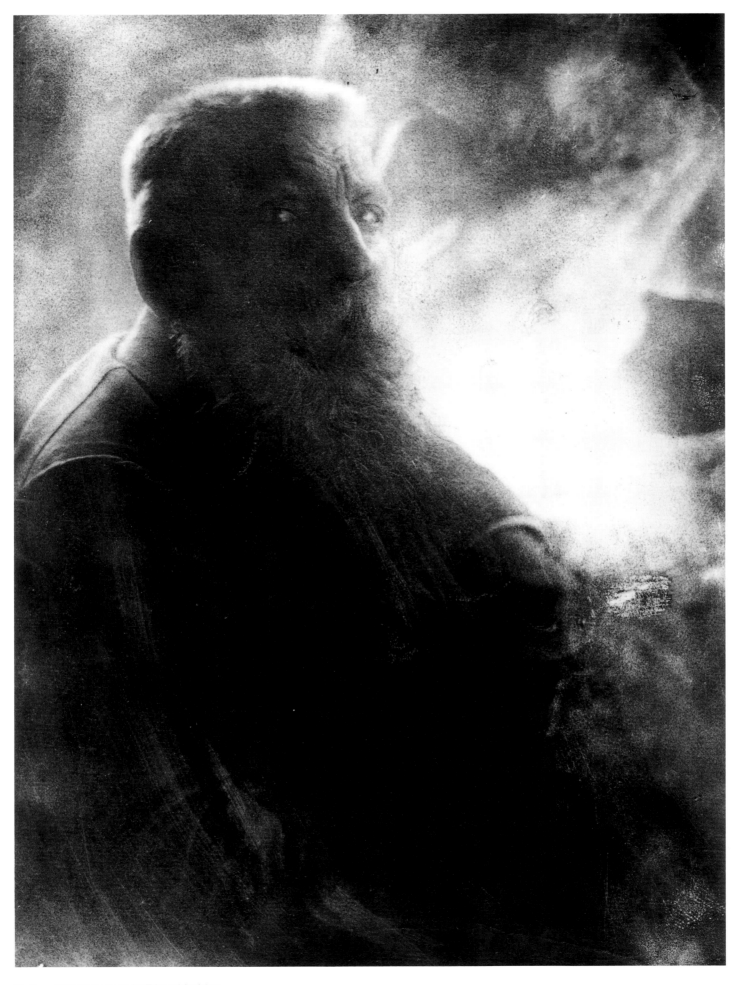

Rodin, c.1908. Photograph by Edward Steichen

Rainer Crone · David Moos

A Biographical Narrative:

Auguste Rodin, 1840-1917

The story of Rodin's life is by now a familiar one, made known to us through numerous biographical studies and outlines. We can recall the most satisfying and comprehensive versions to fashion a composite and seemingly complete rendition of the facts of that life. Judith Cladel's detailed biography, which she began writing in 1902 with the cooperation and even tacit collaboration of Rodin himself – who was then sixty-two years old – remains the cornerstone work on Rodin's life. The nearly novelistic tone of the book makes it remarkable (Judith Cladel, *Rodin: The Man and His Art* [1903], trans. S.K. Star [New York, 1918]). The other early notable biography was written by Frederick Lawton: *The Life and Work of Auguste Rodin* (London, 1906). Among the more recent scholarship, Albert E. Elsen's *Rodin* (New York, 1963) proves useful because it blends artistic analysis with thorough recollection of biographical circumstance, providing a comprehensive

overview of Rodin's work and life. Finally, for the reader interested only in the bare facts, Ernst-Gerhard Güse's *Auguste Rodin: Drawings and Watercolors* (New York, 1984) contains an illustrated chronology, summarizing the artist's life through quotation from a variety of source material.

The following biographical fiction differs from previous accounts of Rodin's life more with regard to form than substance. In no way does it claim, or even aspire, to deliver a "complete" account of Rodin's life (Ruth Butler's long-awaited updated biography should occupy that terrain). Rather, it attempts to give the reader an idea as to who Rodin was as an artist, how he went about his artistic work, what preoccupied him in sculpture, and, finally, what kind of man he "actually" was! Such ambitious designs seemed best realizable through a generous fusion of fact and storytelling, history and interpretation.

"Rodin was solitary before fame came to him. And fame, when it came, made him perhaps even more solitary. For in the end, fame is nothing but a constellation of all the misunderstandings that have gathered about a new name."

Rainer Maria Rilke, *Rodin*, 1903

The twelfth of November, **1840**, which was a Wednesday, began in Paris as a foggy day. The early morning was damp, still wet from rains fallen in the night. The moist chill of fog cast the capital into a kind of wan light that concealed the shape of the sun, obscured the far shadows of a tree. By mid-morning, when the weather had begun to clear, Jean-Baptiste Rodin, a simple man who had come to the city from the Normandy countryside a decade previously, had become the father of his first son, François-Auguste-René Rodin. Being a man of subdued character, he took the birth calmly in his stride.

With no record of Auguste's earliest years we are left to wonder what they were like, to speculate as to whether or not early childhood experience played any overtly significant role in the formation of his creative mind. Perhaps, when he was very young, his parents would walk the short distance from their house in the rue de l'Arbalète to the Luxembourg gardens, would allow their child to explore the mannered forms of nature and compare them to the imposing grandeur of the palace. An image: the young child gazing into the reflecting glass of the palace windows (a portico inside), turning back to the gardens to measure the vista, to ponder the

Jean-Baptiste Rodin, the artist's father, 1855. Photograph by J. F. Jouin

left:
Self-Portrait (?),
c.1860 (?).
Pencil on
buff-colored paper,
3⅛ x 2⁷⁄₁₆″
(8 x 6.2 cm).
Musée Rodin,
Paris (D. 95)

right:
Rodin, 1862.
Photograph by
Charles Aubry

Luxembourg
gardens, c.1923-26.
Photograph by
Eugène Atget

plan from the low vantage point that child-hood alone knows.

By the age of nine, in **1849**, Rodin was attending a boarding school in Beauvais that was administered by his uncle. This educational opportunity – exceptional for a family of modest means – was not ideal for Rodin, who felt estranged and unhappy being away from home. At the end of his five-year stay, the diffident and somewhat docile child, who had displayed little academic promise, began to discover a desire to express himself in a way that refuted the scholastic. He would spend hours alone, sitting on a ledge in the stairwell, looking out the window, drawing the courtyard of the school. In these private moments of quiet respite, removed from the voices of other children, he would hunch close to the paper and with his hands dream about a way of expressing himself. Ink traveling over paper gave him the greatest pleasure. As if

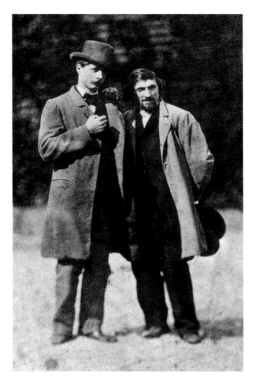

Rodin (right) with Léon Tourquet, 1862.
Photograph by Adolphe Braun

entering water for the first time, he was drawn more and more deeply into the unfamiliarity of his imagination; a demand that necessitated immersion.

On his return to Paris in **1854**, Rodin followed an instinct that led him away from the aspirations of convention. "What appealed to him most," his biographer Frederick Lawton noted, "was the life of the Latin Quarter, half-academic, half-bohemian, the daily contact with the world of letters and art that surrounded him."[1] By enrolling at the Petite Ecole, a local drawing school, Rodin commenced pursuit of a goal that would elude him for years. Three years of diligent work passed; mornings at the school focused on the techniques of sculpture, while afternoons and evenings were passionately devoted to drawing. By the standards of mid-century, Rodin did not appear to possess virtuoso talent, nor had he acquired an outstanding artistic facility through training. His instructors and peers assessed his work as too conventional, perhaps even slightly saccharine, in its recollection of tired eighteenth-century trends.

Oriental Scene with Rearing Horse, before 1870 (?). Pen and brown ink on buff-colored paper, 3⅛ x 4½" (8 x 10.3 cm). Musée Rodin, Paris (D.176)

Life Drawing, 1854/57 (?). Charcoal on buff-colored paper, 23¹¹⁄₁₆ x 17¹⁵⁄₁₆" (60.2 x 45.6 cm). Musée Rodin, Paris (D.5107)

Antique Villa, before 1870 (?). Pencil and watercolor, 6½ x 11¹³⁄₁₆" (16.6 x 30 cm). Musée Rodin, Paris (D.105)

After being refused entry to the Ecole des Beaux-Arts for the third time, in **1857**, the aspiring sculptor was thrown into a phase of introspection that weighed heavily on his ambitions. Rodin's dejection stemmed less from the rejection by the bastion of the artistic establishment than from the tensions that arose between himself and his young colleagues, who had urged him to make his third application. Their lively, rowdy exchanges at the cafés were now tainted by the ill-feeling that competition curiously breeds. Long nights Rodin would stay awake, lying in bed or looking out of a darkened window, searching himself for the reasons behind his ambition. Afternoons spent in the Louvre lacked the intoxicating excitement he had known as a student; the Antique statuary that had so enthralled him only a year previously had become fragments of a history that needed to be cast off, manipulated into a modern context. Yet how could he find the strength to go on; what force could he summon that would

Plant Ornament, before 1860 (?).
Pencil on buff-colored paper, 2³⁄₁₆ x 5¹¹⁄₁₆″
(5.9 x 14.4 cm). Musée Rodin, Paris (D.362)

lend purpose to his explorations of form, of contour, shape, and volume? How could he gain acceptance of his ideas about surface, how forge a unity out of the sculptural and the architectonic?

Although the answers to these major questions were slow in coming, the young Rodin found solace in a job that, although he initially deemed it menial and degrading, proved to be of revelatory significance. Wanting both to financially assist his family and to utilize his skill as a sculptor, Rodin conceded to the compromise of working for various decorators and commercial sculptors. Drifting among several studios, he aided sculptors on large commissions by executing repetitive details as an ornamentalist. Paradoxically, it was this apparently debased manner of work that proved to be of profound importance to the young Rodin.

The ornamentalist is one who concerns himself with the traceries of foliage and flowers, with grotesque heads and caryatids that function as the accoutrement of architecture. Although this phase of his existence, from **1858** through **1862**, could be regarded as the nadir, a retrospective comment made by the artist displays constructive remembrance

about this difficult early experience: "I thought too that I was undertaking something quite inferior. I had to advance a long way before I discovered the erroneousness of my opinion."[2]

Overcoming presumed humiliation, Rodin attacked his chores with a dedication that surpassed what was expected from him. Wandering off from the workshop he would walk to nearby gardens, sit and study the intricacies of foliage, examine the particularities of individual leaves. Squinting into the sun, Rodin noted each effect that light produced on the surface – a consequence of his position or that of the leaf? Or was nature only jesting with him, doubting his senses, his abilities as draftsman, as artist? In his mind he saw how structure remained consistent, how the veins of each leaf divided, tracing the whole form of the tree on a reduced scale. By bringing back this observed detail of the specific, and incorporating it into his work as ornamentalist, Rodin invented ideas of order concerning the decorative that transcended the familiar. So precise were his points of departure that each of his small creations in plaster could bear extravagance without looking distorted. As leaf subsided to leaf, joined together in long sequences, the well-worked details of vein and stem, flesh and form, came alive. As sculpted by Rodin, nature was infused with a brilliant character, granted it by a hand that was guided by the mind – his hand, and his alone. Any attempt at mimetic reproduction of detail was countered by an artistic will beginning to assert itself, however modest the context.

These insights into the intimate complexities of a single subject proved crucial to Rodin's thinking as an artist and would come to play a formative role in his conception of the human body, in how he understood the relationship between external, visible musculature and internal, determining structure. Yes, nature was the source of all fertile refinement in human thought about creation, about how man could overcome his situation

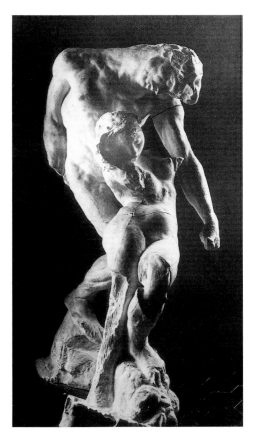

The Large Shade and *Meditation* (*The Inner Voice*), plaster, in Rodin's Meudon studio

and fashion from it a comprehensive equivalent that transcended emulation. Extensive artistic observation of nature served to privilege the mind above the wealth of detail recognizable in such wrested cadences as a flower's color, the lean contours of a leaf, or the rigid designs of foliage trained to support architecture. There must have been a fragrance that escaped from the sculpting of so rich a form.

Amidst this order fell the great shock of loss which brings with it the plummeting threat of darkness. The premature and sudden death in **1862** of Rodin's sister, Maria, two years his senior, unsettled the young artist to a degree that resounded so deeply within his

Galloping Rider, before 1870 (?). Pencil and watercolor on buff-colored paper, 4³⁄₁₆ x 4⁹⁄₁₆″ (10.6 x 11.6 cm). Musée Rodin, Paris (D.152)

soul as to challenge the very mettle of his artistic purpose in life. Unable to work or to reconcile himself to this tragic turn, Rodin sought solace by joining the Order of the Fathers of the Holy Sacrament. Throughout the year he was taken by fits of grief. He would contemplate his destiny for long hours into the night, abide by the regime of holiness, and meditate upon his human capabilities. Father Pierre-Julien Eymard, founder of the order, showed consideration for Rodin's situation, offering himself for consultation to the young man who was just beginning to feel his way amidst the ebb and flow of life's complicated forces. While Rodin fashioned a plaster bust of the priest, the two men would punctuate the long periods of silence with short sentences. Father Eymard, observing how Rodin looked at him, how he pierced inward behind the appearance of his eyes, soon recognized the extent of Rodin's powers. Disconcerted, he was nonetheless secretly impressed by the strength of the young sculptor's convictions, his consummate engagement with his craft.

Indeed, Rodin's devotion to his artistic project outweighed his dedication to the brotherhood, and he left it – not necessarily in a polite way, despite the fact that the departure was based on mutual understanding. The moment when he looked into Father Eymard's eyes to tell him that he would not be taking the final vows was the moment when Rodin declared that the task of his grief had been overcome. He had managed to apply the vast superstructure of theology to his personal situation, fashioning from the conflict of sacred and secular forces a synthesis that ful-

Rodin and his sister, Maria, c.1859

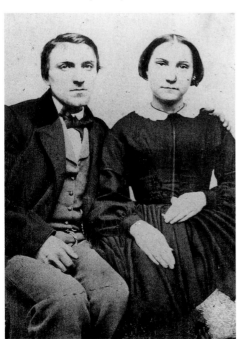

Rodin working on the bust of Father Eymard, 1863.
Photograph by Adolphe Braun

filled his anxious yearning for resolution in and through art. One year of strict religious obedience served to resolve an inner struggle with roots grown deep in the artist's childhood. Rodin's mother had instilled in him a vigorous bias toward the church. In her humble, admonishing way she had always spoken strongly in favor of church doctrine, seeking refuge in God when confronted with swift, yet oppressive twists of fate. For Rodin, however – especially after communing with Father Eymard – the complexities of desire and its consequences could not be explained by a monolithic deity, Christian or other. If a hidden order prevailed in the divine, then in man it must be manifested through creation, and the artist should seek out this phrasing of the rational. "The most important thing," Rodin used to say, "that God thought of when He created the world was its modeling,"[3] and, as Judith Cladel reports, he put his artistic creations on the same level as God's works.

The small beard he had worn in his days as student and assistant soon grew back. With renewed confidence in his decision to become a great sculptor, Rodin, who was confined by modest means, took a small studio in the rue de la Reine Blance and commenced intensive work. In 1863 he joined the prestigious Union Centrale des Art Décoratifs, whose members included Delacroix, Ingres, and Horace Lecoq de Boisboudran, who had been Rodin's teacher at the Petit Ecole. It was the same year that he commenced his first extant masterpiece: *Man with the Broken Nose*. The tormented expression on this man's face, augmented by the distortion of his broken nose,

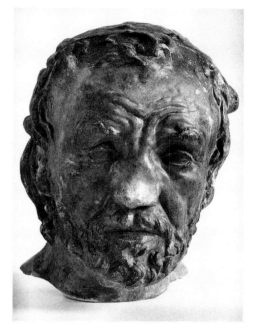

Man with the Broken Nose, 1864.
Patinated plaster, height 10¼" (26 cm).
Musée Rodin, Meudon (S.1440)

mimicked the privations of Rodin's nascent career that had been marked more by defeat than by triumph: an acquaintance with Jean-Baptiste Carpeaux, a major, well-established sculptor, went awry, and *Man with the Broken Nose* was refused by the jury of the 1864 Salon.

Rodin found regular employment as an assistant in the studio of Albert Carrier-Belleuse. One among many assistants to this prodigious sculptor of reasonable acclaim, Rodin benefitted from this experience insofar as it gave him ample opportunity to work in clay. And although Rodin's job consisted of copying and enlarging the master's "sketches," Carrier-Belleuse was not adverse to assimilating in his work independent contributions by Rodin, as long as they did not contradict his own style. Working in this imitative manner, Rodin remained in Carrier-Belleuse's studio for about six years. In 1871, at the height of the Franco-Prussian War, he accompanied his master to Belgium to undertake ornamental work on the Palais de la Bourse in Brussels.

Rodin on the coast of Guernsey, 1897

Landscape in Belgium (?), 1871/77 (?). Red chalk and pencil,
heightened with white, on buff-colored paper, 3⅝ x 6⅞″ (9.2 x 17.4 cm).
Musée Rodin, Paris (D.71)

The landscape of Belgium, regularly clad in dense veils of mist and fog, offered itself to seeing eyes as it had in previous centuries to Netherlandish artists; in the creative mind it was associated with visions of Ruisdael, with drawings and oils by Rubens. Curious effigies of a crucified Christ lingered across the blue dying-moon-lit-scape of the low countries. It was here, in this northern land of the pious, that Rubens had seen the Savior crucified on a mysteriously erected cross. Rodin's sketches of the landscape, executed on afternoon walks across the countryside, eschewed such narrative elements. In his vigorous drawings and murky paintings he quested after an order in nature as it appeared to the eye, rather than submitting the landscape to the rules of a human design. The young French sculptor drew visions of the earth as it presented itself to him, not as transmitted by historical formulas.

Rodin, c.1873

Rodin, c.1870. Photograph by Benque

Rodin, 1879.
Photograph by Etienne Carjat

The early **1870s** were spent alternately in Brussels and Paris, where Rodin found work assisting and sometimes fully collaborating with various sculptors whose respect he had won. The hardships of living had not abated, as the struggle for independence and acceptance still raged on. But Rodin, in his mid-thirties, was doing in life what he had elected to pursue. His name was known among those men and artists whom he had chosen as his colleagues. And the reward of slow recognition was recompense enough for the arduous pursuit of his ideal. By **1877-78** Rodin, finally settled back in Paris, had commenced such major sculptures as *Saint John the Baptist* and *The Call to Arms*. This was the beginning of a satisfying time in his life.

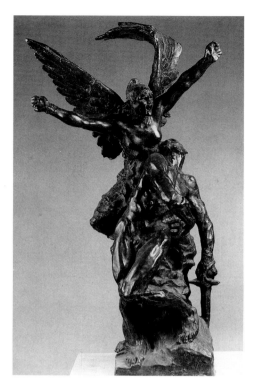

The Call to Arms, 1879.
Bronze, height 44″ (112 cm).
Musée Rodin, Paris (S. 469)

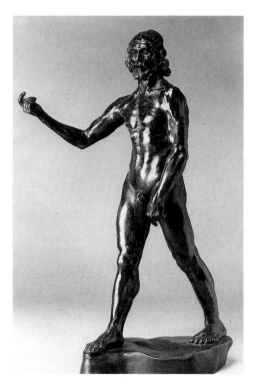

Saint John the Baptist, 1878.
Bronze, height 79″ (200.5 cm).
Musée Rodin, Paris (S. 639)

Camille Claudel (left) at work in
Rodin's studio, c. 1888

Camille Claudel, c. 1883.
Photograph by César

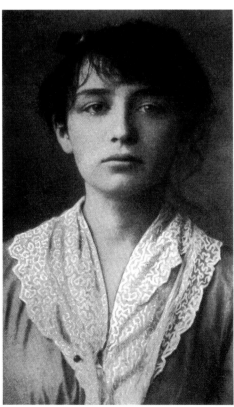

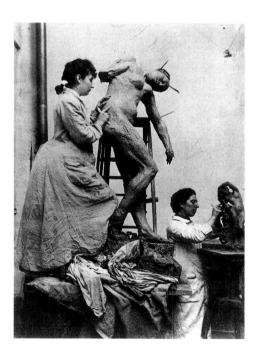

Already the look in her eyes displays a kind of confidence that could easily escalate into competition, if not outright rivalry. Signs of the self-assured, the unhindered: allowing hair to drift in strands across her forehead, the line of her lips concealing rather than revealing an expression, and her unequal eyes that hold the camera coldly in precise unintimidated view – she is aware of all this. She is dressed simply, indicating that her main concerns are those that lie beyond mere appearance. Camille Claudel was after a deeper, intrinsic substance, both in her own artistic endeavors and in her multifaceted, often tempestuous relationship with Auguste Rodin.

The character of this woman, nineteen years old when she met Rodin in **1883**, was marked by a somewhat ferocious blend of energies and ambitions. Rodin's biographer Bernard Champigneulle recounts how she would terrorize her younger brother Paul (later to become a poet of considerable renown), teaching him "to despise traditional values, and the ties of family and religion. She read Shakespeare aloud to him and put him in a state of ecstatic transport. And she gave him feelings of inferiority, since without ever having enjoyed artistic training she knew how to model in clay."[4] But it was this woman, from an ambitious family of artists, who fell under the spell of Rodin, who was consumed by his soft-spoken greatness. Her deference to him was a means of partaking in his artistic project, of drinking in the potent forces of art. As student, model, and mistress, she embarked upon a relationship that, over a period of fifteen years, would shape Rodin's

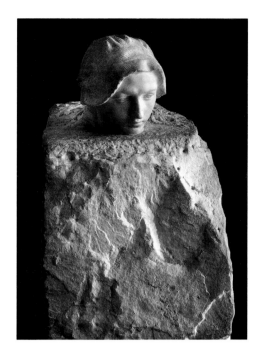

The Thought (Portrait of Camille Claudel),
c.1893-95. Marble, height 29″ (74 cm).
Musée Rodin, Paris (S.1003)

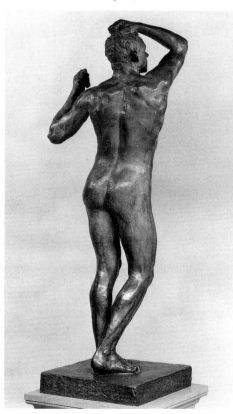

The Age of Bronze, 1876. Bronze, 70¾″ (180 cm).
The Metropolitan Museum of Art, New York,
Gift of Mrs. John W. Simpson, 1907

conception of woman, form his vision of the feminine.

The initial impact of Claudel's presence is displayed in the marble sculpture *The Thought (Portrait of Claudel)*, in which we are able to register a trace of the profound, infused with the introspection of sorrow. While paying homage to the shape of creative inspiration, Rodin depicts the tenuousness of loss, the heavy burden incurred. The carefully sculpted visage leans sullenly upon the marble from which it has come, upon the mass of stone so much greater in proportion. Is it that the thought is greater than its concrete embodiment, or has the thought been stopped short, cut off prior to full formulation – abandoned in suspension? The sculpture functions as a paradigm for the exchange, an object made for the muse.

Rodin's relationship with Camille contrasted sharply with that which he shared with Rose Beuret. Rose, the daughter of farming people from the banks of the Marne river; Rose, who in **1866** gave birth to Rodin's son (a disappointing failure in the eyes of the great sculptor); Rose, who accompanied Rodin to Brussels in the early **1870s** when, struggling to find his individual creative voice, he worked as assistant to senior sculptors – modest Rose never abandoned the man she believed in, even when their union evolved into a detached one of the spirit. Rose did not mind what the sculptor had to do, whatever the sculptor must do …

Camille Claudel was more demanding, more assertive, and, indeed, more exhilarating. She befriended the Rodin who had commenced working on the monumental *The Gates of Hell* (Fig. 5, p. 11), who had traveled to London and gained acceptance there, who had triumphed with the purchase of *The Age of Bronze* (plate 15) by the French government, which had it installed in the Luxembourg gardens. Yes, throughout the **1880s** Rodin and his mistress, twenty-four years his junior, would take walks through those finely kept gardens to view the work that announced his maturity as an artist. In the evening light of fading autumn they would approach the regal sculpture. Rodin would stop at a comfortable distance, while Camille, stepping up to the sculpture, would begin to touch the man's lithe ankle. Turning, with a slight smile, she would pose a question to Rodin or make an observation that was intended at discovery. "It feels more like surface than flesh, looks more material than one would have thought possible with bronze," she would say. And he might stroke his beard or draw his coat closer around himself before releasing a reply. Perhaps the fragment of a Baudelaire poem would shine in his mind – one of those from *Les Fleurs du mal* that he had completed illustrations for by **1888**:

Rose Beuret, c.1875.
Photograph by E. Graffe and A. Rouers

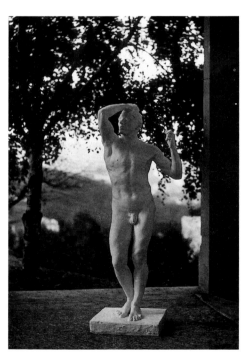

The Age of Bronze, plaster,
in the garden of Rodin's Meudon studio

Luxembourg
gardens, c.1923-26.
Photograph by
Eugène Atget

below: Rodin with
Antique statues
in his studio,
1910.
Photograph by
Albert Harlingue

It would begin to drizzle lightly. But Rodin, wearing his hat and in good spirits – still feeling strong after having finished the plaster of *The Eternal Idol* (plate 23), satisfied with how he had succeeded in fusing the profile of the man's face with the contour of the woman's breast and belly – did not allow himself to be distracted by the rain. In fact, the weather aided his meditation on surface, augmented the possibilities. He paused, visibly enthralled with the way that drops of water formed on the chest of the bronze man. "At this moment," Rainer Maria Rilke wrote in the early years of the twentieth century, "Rodin had discovered the fundamental element of his art ... the surface, this variously extensive, variously accented, precisely delineated surface, out of which everything was to be made. From this time on, this was the subject of his art, on which all of his effort was expended, that for which he watched and

Incessantly, at my side, the Demon accompanies me;
swimming around, as if in an impalpable air;
Swallowing his scent that burns my lungs
he fills me with eternal desire, eternal guilt.

Sometimes, because he is privy to my love of Art;
Sometimes, he appears as the most seductive of women;
and, in the special costumes of despair,
he accustoms my lips to vile appetites.[5]

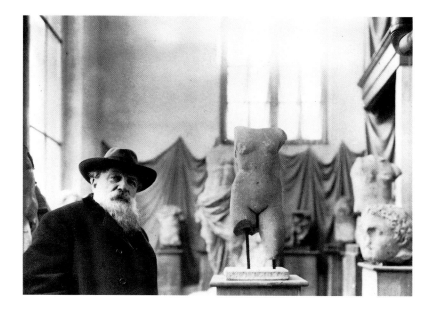

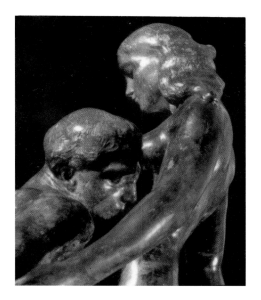

The Eternal Idol, 1889, detail.
Patinated plaster, height 28¾ (73 cm).
Musée Rodin, Meudon (S.1044)

suffered There was no arrogance in him."[6] This might have been the sequence of Rodin's meditations, observations eventually guiding him toward his future path. Thinking was enough of a reply for his inquisitive mistress, and she – sensing the power of thought and perhaps even its substance – let go of the ankle, to rejoin him. Together they walked once around *The Age of Bronze* and then out through the ordered allées formed by the trees, leaving the towers of Saint Sulpice behind.

Walking away from the odd asymmetry of those towers, Rodin became conscious of Camille's arm resting in his. The pressure of her hand, he felt, was meant as an assurance. She wanted to impress her presence upon him, but she also wanted to let him know that

she was aware that he was still deep in thought, responding somehow to what she had suggested. Her gestures possessed such power of implication. They seemed to be governed by energies that lent them greater significance than that which they purported to express. In fact, as Rodin reflected upon this woman holding close to him as they both walked along the darkening paths – the light now beginning to turn gray – he looked for a thought that could unify what he expected out of life. The palace, the church, his sculpture, this woman, the trees; his art was at the center of this constellation. For a moment the rain ceased to fall. "The darkness grows lighter; it becomes chiaroscuro The forest of pillars divides the nave into spaces of shadow and light. It is the order of nature which knows nothing of disorder."[7]

Thoughts like this, drawn from intensive observation and study in the cathedrals of France, found their concrete manifestation in moments of coincidence. Such moments gathered together the various pursuits of the mind, the most powerful emissary of which was the hand, the creative hand. Yet the hand that makes is also that which destroys, a servient human tool alternately conforming to

Study after Michelangelo's "Dawn", c.1887 (?). Charcoal on buff-colored paper, 19 x 24¹¹⁄₁₆″ (48.2 x 62.7 cm). Musée Rodin, Paris (D.5117)

both malevolent and benevolent designs, intentions needing to be reconciled, harnessed. Rodin recalled the opening lines of his book about cathedrals, a general remark about the necessary structure of those transcendent edifices. He had written: "Cathedrals impose a sense of confidence, of assurance, of peace. How? By their harmony. Harmony in living bodies results from the counterbalancing of masses that move. A Cathedral is built on the principle of living bodies. Its concordances, its equilibriums, exactly follow general laws

After leaving the gardens, Camille and Rodin might have gone to a café, a warm haven where, sheltered from the weather, they could talk to each other in peace. But this was not their destiny. By the winter of **1894** Rodin was not feeling well. Once again, he had contracted a case of the flu. It was not a major crisis, but a lingering impediment to important work. Public reception of his monument to Balzac, whom Rodin admired so much, emerged as another hindrance. Critics considered it an affront to the public, to the

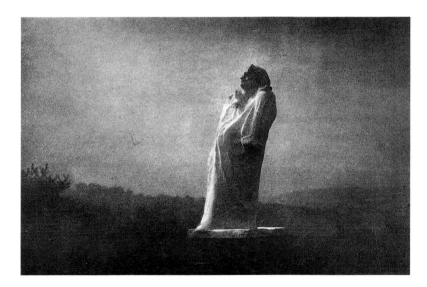

Study of Molding, date unknown. Pen and brown ink, 7¹⁄₁₆ x 4⁷⁄₁₆″ (17.8 x 11.3 cm). Musée Rodin, Paris (D.5837)

Balzac: Toward the Light, Midnight. Photograph by Edward Steichen, 1908, of the plaster *Balzac*

according to nature's order."[8] Rodin's first journey to Italy, in the winter of **1874-75**, to study the works of Michelangelo and Donatello, and his experience with the works of the Renaissance in general, perfectly confirmed the insights he had gained in the cathedrals of France. Tenets of order offset by proportioned imbalance permeated his understanding of the human body, of its definition in sculpture. Nature was to be awakened and respected in all areas of human enterprise, regardless of their size or complexity. Nature was to be confounded by living in what was to be a vicarious medium of survival – the solid creations of man.

Academy, perceiving it as an erect phallus standing in the open air. The derisive view that this monument represented a narcissistic Balzac masturbating covertly beneath his cloak was among the more imaginative of critical quips that this masterpiece provoked. The vituperative press accorded the first versions of the commission fueled Rodin's reputation as a controversial artist, but the outcry demanded that he defend himself, which drained him of energy and robbed him of the calm hours necessary for work.

In his studio the sculptor would occupy himself continually. Regardless of who was visiting, Rodin, holding small pieces of clay

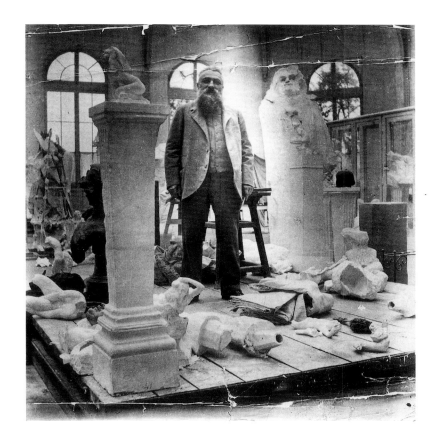

in his hands and seeming to fidget with the excessive energy born of anxiety, would model miniature figures. Hundreds of statuettes littered the surfaces of the studio, emanations of thought caught in the fleeting embrace of hands working together, fingers touching each other as they worked over the smooth and rough surfaces of clay held in the palm. People surrounded him, but visions of them lay within him, buried in his mind in a place he was struggling to uncover. Secret after secret must be told in sculpted form.

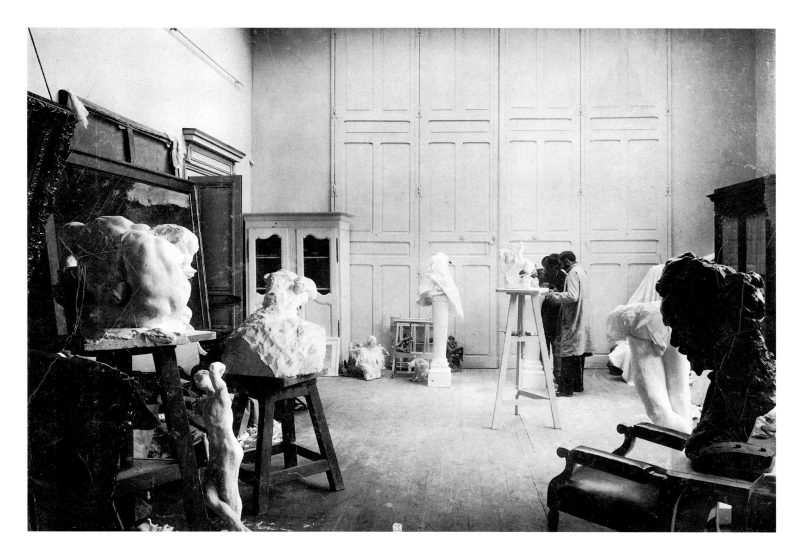

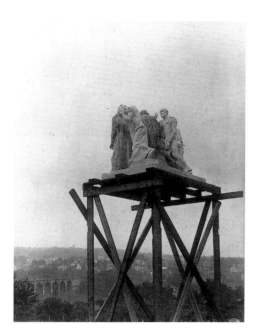

The Burghers of Calais, plaster,
on a plinth erected by Rodin at Meudon

The Burghers of Calais, bronze, in Calais, 1904

In **1895** *The Burghers of Calais* was installed in a manner contrary to Rodin's instructions. A photograph shows the sculpture mounted on a pedestal that seems more appropriate to a tombstone than to a great bronze. The dainty, low iron fence surrounding it denies observers direct communion with the sculpture, belittling its massive figures. Rilke wrote that "a low socle was considered unsuitable at Calais. And Rodin proposed a different placing of it. [He would stroke his beard, deep in thought, deep in the ruse of a brewing rage.] He suggested a square tower built close by the sea, as broad as the base of the statue, with plain hewn walls two stories high, and upon this the six burghers were to be placed in the solitude of wind and sky. As might have been foreseen, this proposal had no better chance of acceptance."[9] By this time, however, Rodin's energies were directed elsewhere. Although he was, indeed, often preoccupied by the reception and treatment of his works, he had by now come to see the recalcitrance of bureaucracy and the establishment – its arbiters of taste, the critics, notoriously opposing artistic change – for what it was: the mask of ineptitude and inherent lack of understanding. Rodin acquiesced less in a spirit of capitulation than in the knowledge that history would amend the wrongs brought about by contemporary artistic myopia. Let the *Burghers* be confined today, for in another time, in a coming era, they shall rise high and mighty in places imaginations of the future will build.

As if in recollection of a photograph that does not exist – as if this were possible – we can see the young Rodin (c.1861) sketching leaves in a Paris park, can picture the alternately steady and tremulous movements of his hand over paper. We can fuse this image with a surviving one of the old sculptor drawing in Marseilles in the sunshine of **1906**. Poised on a narrow wooden bench, the well-dressed man, the artist, appears becalmed as he works. The eyes concealed under the rim of an elegant hat, the straightened back, the slanted neck, the downward concentration – here we see the artist immersed in his world of drawing, caught for an instant of reflection, pen lifted to see what he has done. In this photograph we can discern a man in the background who casually looks on, intrigued by the artist and his subject – an adolescent dancer from Cambodia who maintains a rigid, somewhat regal stance, with arms outstretched. This trip to Marseilles was specially arranged for Rodin so that he could sketch members of a visiting Cambodian dance troupe; they posed for him in the park. Here we recognize the man who, when young, had sat for hours in the Louvre, drawing Antique statuary, copying Renaissance engravings.

The perfume worn by these women did not suit their placid countenance, which ensnared the imagination in an olfactory embrace that neither scent of tobacco from France nor opium from the East could rival. These women had an air about them that penetrated deeper than any sensory recollection. And this was not simply the impact of the unfamiliar, the exotic. Rather, it concerned their inner constitution, their manners, their lack of trust in speech, their uninhibited presentation of their bodies: these were female bodies that had learned other languages of motion and form.

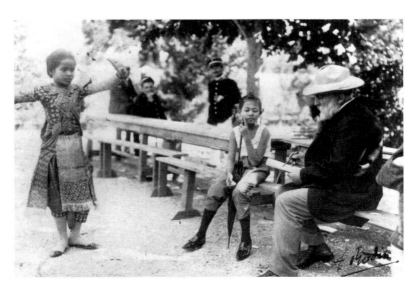

Rodin drawing
a Cambodian dancer
in Marseilles,
1906

In **1909** the huge *Monument to Victor Hugo* was installed at the Palais Royal. One can see the extended arm of the genius deep in thought as an extension of Rodin himself. The naked power of the man who dreams in visions beyond the scope of his natural talent – that is the essence of this marble portrait of the creator, brooding like a colossus in surroundings to which he is confined but from which, at the same time, he is removed by his inner concentration. The sound of the wind in the trees rustling, the footfall of a passerby, the angular wing of a bird taking off: life moves around a center in thought, a thought that slowly recedes from what it made.

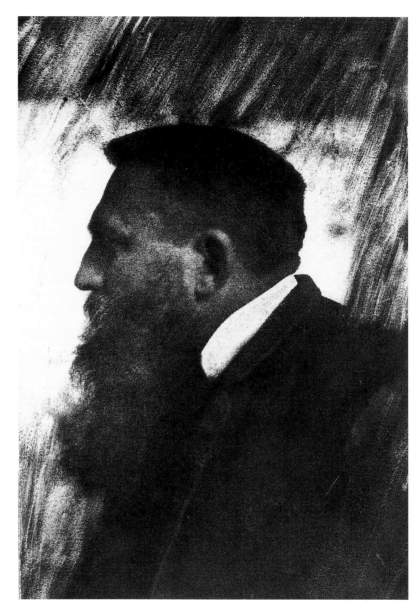

Bust of Victor Hugo on a column in the garden of Rodin's Meudon studio. Photograph by Jean-François Limet

Rodin, c.1887. Photograph by Ch. Gerschel

Monument to Victor Hugo, plaster, on show at the 1897 Salon. Photograph by Eugène Druet

Unveiling of *Monument to Victor Hugo* in the gardens of the Palais Royal, 1909. Rodin is immediately in front of the monument

This also applies to *Balzac*, especially as photographed in **1914** by Edward Steichen. Situated in the somber darkness of night and seen from below so as to tower over the horizon, this human form of the creator obscures the landscape that seems to flounder in the shadows below. The figure confronts the histories that Rodin went backward in time to trace; it confounds each aspect of his travels to Italy, England, Holland, wherever he had ventured to study the great art of the past. Balzac clad in the long cape is seen here to draw all these magnificent journeys within his grasp, which we intuit beneath.

Balzac, 1908. Plaster. Photograph by Edward Steichen, 1914

Rodin's Meudon studio, 1904-5. Photograph by Jacques-Ernest Bulloz

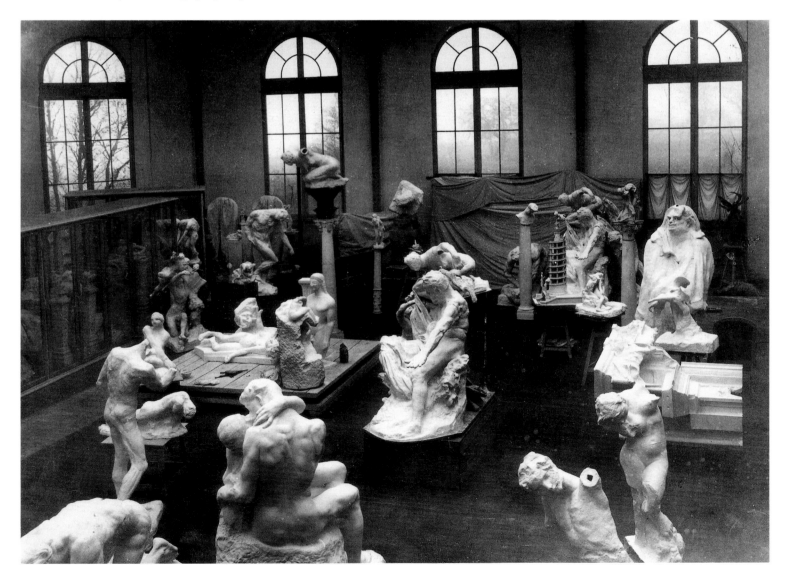

Rodin in the Hôtel Biron, c.1915. Photograph by Lemery

Rodin in the dining room at Meudon, c.1897

with Rodin, telling of how his person ignited in her an unimagined passion:

Rodin was short, square, powerful with close-cropped head and plentiful beard. He showed his works with the simplicity of the very great ... he ran his hands over them and caressed them. I remember thinking that beneath his hands the marble seemed to flow like molten lead. Finally he took a small quantity of clay and pressed it between his palms In a few moments he had formed a woman's breast that palpitated beneath his fingers He gazed at me with lowered lids, his eyes blazing, with the same expression that he had before his works, he came toward me. He ran his hands over my neck, breast, stroked my arms, ran his hands over my hips, my bare legs and feet. He began to knead my whole body as if it were clay, while from him emanated heat that scorched and melted me. My whole desire was to yield to him my entire being.[10]

Rodin and the harpsichordist Wanda Landowska at a *soirée musicale* in Meudon, 1905

A time came when Rodin's reputation spread across land and sea, securing him the status of preeminent artist, that of a sculptor-genius working in twentieth-century France. His work had ventured beyond the boundaries established by any of his contemporaries. The retrospective of his work shown in Paris in connection with the Exposition Universelle of **1900**, the exhibition in Prague in **1902**, that in Vienna in **1903**, and the major showing of his sculpture in Düsseldorf in **1904** catalyzed his international renown. Deluged by a flurry of commissions and orders for casts, the studio of Rodin became one where royalty vied with international collectors, admirers, and museums in voicing requests. Prince Eugene of Norway and Sweden was a frequent visitor; the King of Greece munificently extended open invitations to the sculptor; and King Edward VII of Great Britain became an enthusiastic acquaintance, as did Pope Benedict XV, who took advantage of Rodin's **1915** excursion to Rome to sit for his portrait.

Aside from the plethora of dignitaries and statesmen who sought the favor of the genius-sculptor, Rodin attracted the admiration of other artistic luminaries. As his fame erupted, his works permeating nations he would never visit, there came to him a stream of contemporary creators wishing council with a man alive who could express in art almost every dreamed of desire. Isadora Duncan, the preeminent modern choreographer, who elevated dance beyond its classical traditions, vividly recounts her first encounter

Rodin drawing the Duchesse de Choiseul in the Hôtel Biron, c.1905-10

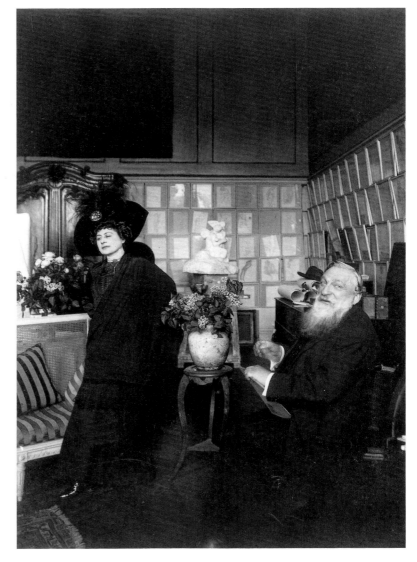

Rodin with *The Thinker* at the opening
of the exhibition of contemporary French art
in Strasbourg, 1907

View of the Rodin exhibition in Prague, 1902. Photograph by Rude Braunel-Dubrak

Rodin at his exhibition in Düsseldorf, 1904

The Hand of God
in the Rodin exhibition in Vienna, 1903

Rodin,
Rome, 1915.
Photograph by
John Marshall

Rodin gathered together these human forms, invoking the whole sweep of a cultural impetus that had spread from the Antique to Dante's *Inferno* and the Renaissance and, via the Baroque, to the sublime energies of a new century unfolding. He was the last in a centuries-long succession of men who created versions of themselves in art. With Rodin we recognize a juncture, or perhaps a plurality of innovative escapes that have led us to address and reassess the certainty with which we observe ourselves in nature, as in this world.

Rainer Maria Rilke at his desk
in the Hôtel Biron, 1906

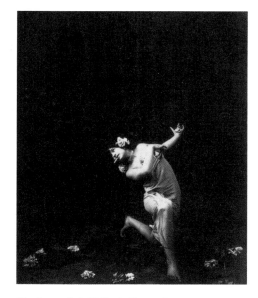

The dancer Loïe Fuller in the garden
of the Hôtel Biron, c.1913

1906 was the year Rodin dismissed the young poet Rilke, who had served him as secretary for six brief months. In Pamplona they had seen the running of the bulls and had journeyed on through Spain, visiting Madrid, Toledo, and Seville. But perhaps the pressures of travel were too heavy a strain on their relationship, for these, after all, were two artists of different temperaments who were also separated by many years in age. " Each artist must go his own way, so let those who work with words do as they will; in my work I will pursue not what I know, but rather what I am beginning to learn." Although Rodin did not express this in these words, some thought akin to them must have sent a chill of respect through the poet, whose awe only increased with the severity of Rodin's reasoning.

Rodin: chasing down a trace of form, improvising from the figures flitting around his studio – those spirals before him who were receptive to his every pose-modifying word or phrase. Yes, they wanted to take up that particular position that the genius envisaged. Models revelled in it.

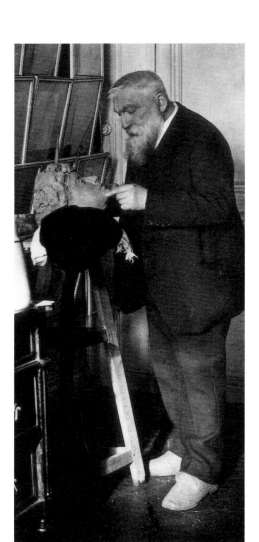

Rodin working on the bust of
Mrs. Simpson, 1902

Rodin with his portrait head of
Lady Sackville-West, 1916.
Photograph by Pierre Choumoff

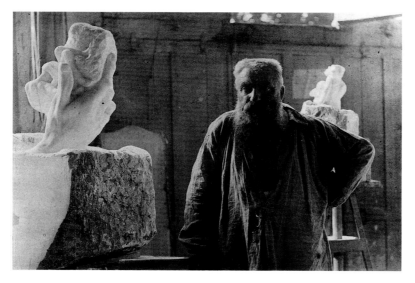

Rodin with *The Hand of God*, 1898. Marble, height 26¾″ (68 cm)

right: Rodin and Mademoiselle Coltat (?) in front of the Château d'Issy.
(The reconstructed façade of the château was later incorporated in Rodin's tomb;
see illustration overleaf)

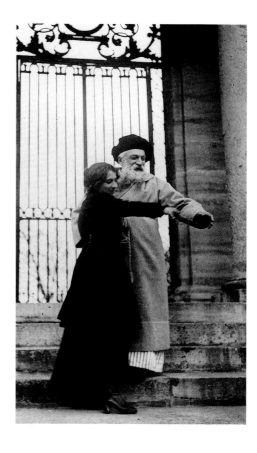

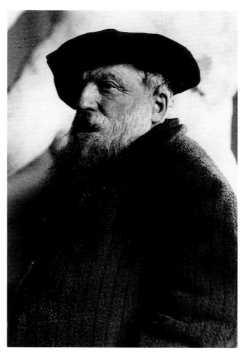

Rodin, March 1910. Photograph by Laurent Vizzavova

Ecole des Beaux-Arts model

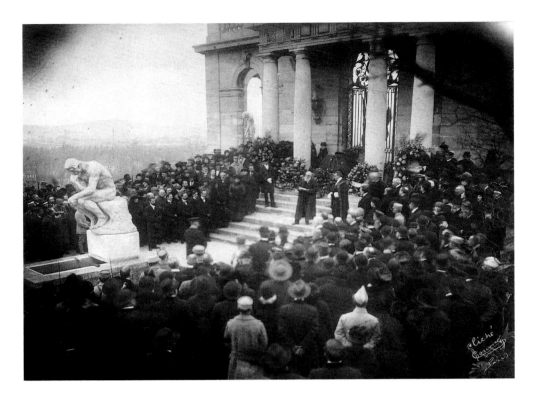

Rodin's funeral at Meudon,
November 24, 1917

Each form was fashioned by his hands, those hands that had worked to extremes, held the feeble tools of craft, moved incessantly, stroked the cheek of Camille or the beloved softness of his wife, lending assurance to their emotion, reached down to lift the heavy bronze cast of a head or a hand of marble, *The Hand of God* (plate 40). It was not a lament, merely a reflection on the fact that he had given himself over entirely to visionary pursuit of necessity, when Rodin said: "My fight for sculpture uses up all of my time and strength, and even then I lose."[11]

But this was a life; one well enjoyed as it was lived, and one that continues.

Of pneumonia – only because of the dampness and chill pervading again in November, the seventeenth – day of cloud, like a shroud over his house, the Hôtel Biron.

Rodin on his deathbed, 1917.
Photograph by Pierre Choumoff

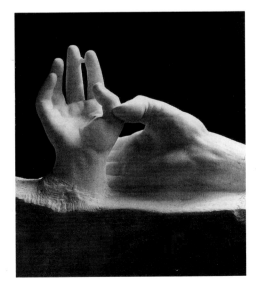

Lovers' Hands, date unknown.
Marble, height 17½″ (44.3 cm).
Musée Rodin, Paris (S.1108).
Photograph by Jacques-Ernest Bulloz

Notes

1 Frederick Lawton, *The Life and Work of Auguste Rodin* (London, 1906), p.12.
2 Quoted *ibid.*, p.21.
3 Judith Cladel, *Rodin: The Man and His Art*, trans. S.K. Star (New York, 1918).
4 Bernard Champigneulle, *Rodin*, trans. J. Maxwell Brownjohn (New York, 1967), pp.157-58.
5 Charles Baudelaire, *Les Fleurs du mal*, trans. Richard Howard (Boston, 1982), p.299. The original reads: "La Destruction": "Sanse cesse à mes cotés s'agite le Démon; / Il nage autour de moi comme un air impalpable; / Je l'avale et le sens qui brûle mon poumon / Et l'emplit d'un désir eternel et coupable. / Parfois il prend, sachant mon grand amour de l'Art, / La forme de la plus séduisante des femmes, / Et, sous de spécieux prétextes de cafard, / Accoutume ma Lèvre à des philtres infâmes." Charles Baudelaire, *Les Fleurs du mal*, ed. Claude Pichois (Paris, 1972), p.146.
6 Rainer Maria Rilke, *Rodin*, trans. Robert Firmage (Salt Lake City, 1979), p.23.
7 Cladel, *Rodin*, p.237.
8 Auguste Rodin, *Cathedrals of France* (1914), trans. Elisabeth Chase Geissbuhler (Boston, 1965), p.3.
9 Rainer Maria Rilke, "The Rodin-Book: First Part (1903)," in Rainer Maria Rilke, *Selected Works: Volume I, Prose*, trans. G. Craig Houston (New York, 1967), pp.129-30. This translation is more accurate than that by Firmage (see note 6), p.62.
10 Isadora Duncan, *My Life* (New York, 1928), pp.99-100.
11 Cladel, *Rodin*, p.135.

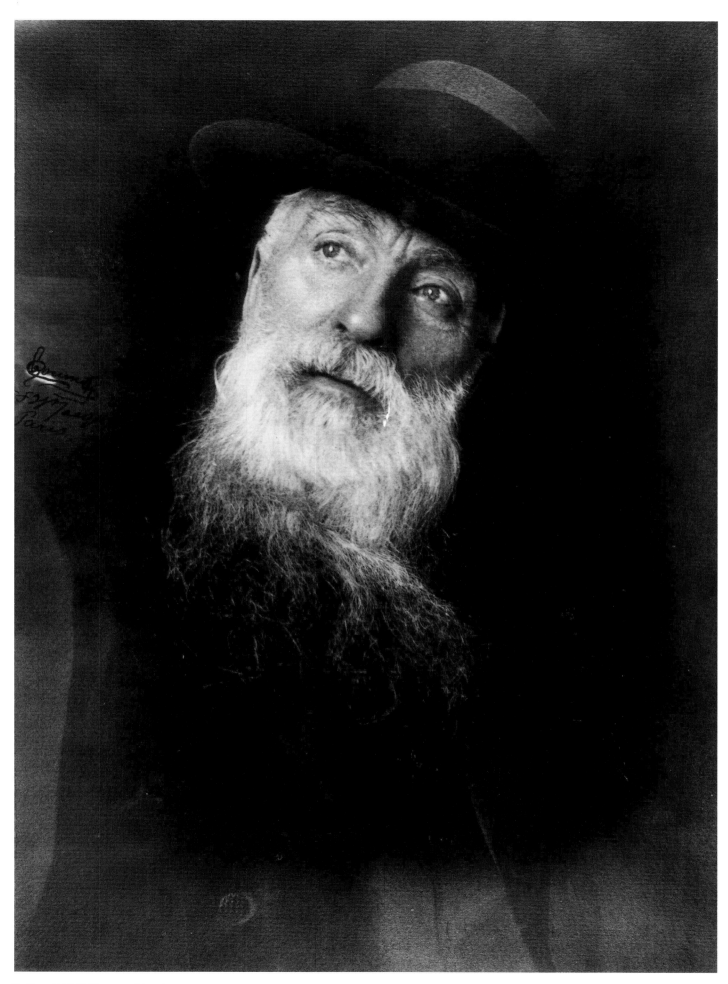

Rodin, c.1916-17. Photograph by Pierre Choumoff

RODIN

Ses sculptures sont des fleurs
du mal de ciel et de terre.
Ses sculptures sont d'inquiétantes déshabillées
parfois même des nudités,
des vignes magnifiques et géantes
à la barbe soignée.
Ses sculptures sont des échos de perennité,
des baisers endormis
sur des mains de mort,
des méduses aux bottines vernies à boutons
du siècle des valses.
C'est un immense arrièrefaix de la Renaissance,
un project d'érotomachie
pour confirmer l'origine,
loin de l'érotomachie mécanique de notre siècle.

Jean Arp

PLATES

Rainer Crone · David Moos

Views of the Sculptural Gaze:
A Visual Interpretation

The group of approximately fifty sculptures that appears in this volume has been specially selected because of the works' depiction and delineation of erotic tendencies in the oeuvre of Auguste Rodin. For an artistic career that spanned six decades and witnessed the production of literally thousands of more or less finished works, fragments, and sketches, it would be naive to assume that any representative selection could encompass the entire complexity of Rodin's massive artistic project. The erotic is a tendency that finds an early and explicit incarnation in such major works as *The Age of Bronze* (1875-76; plate 15) and *Je suis belle* (1882 [?] ; plate 3) and then continues with uninterrupted – indeed, unrelenting – consistency until the artist's death in 1917. Seminal works, such as *Avarice and Lust* (1881; plate 35), *Eternal Springtime* (1884; plate 1), and *Orpheus and Eurydice* (1893; plate 29), as well as certain lesser known ones, have been rephotographed for this book by Parisian photographer Bruno Jarret, under the direction of Rainer Crone and David Moos, in order to explore the variant thematic depictions of erotic interaction that Rodin envisioned. Our primary intention was not to deliver to the reader another assortment of documentary photographs, but rather to use photography as a tool with which to elicit and expound particularities of the erotic as Rodin conceived of it in the making of sculpture.

Late nineteenth- and early twentieth-century Paris was the capital of a culture enraptured by a diversity and experimentation which allowed the limits of social and sexual *mores* to be explored while being broken. Oriental exoticism, native decadence, and the adventuresome quest for liberation from an established hierarchical social structure infused the cultural environment with a radicality that was at times reckless, even subversive, in its displays of opulent and antagonistic desire. Rodin's eroticism takes over aspects of this decadent underworld, but mediates such excess through personal views on the nature of morality and through a powerful artistic vision that contends with the history of Western art. Although conversant with, and sometimes enamored of, the erotic, as his drawings and watercolors of nudes profusely demonstrate, Rodin possessed insights into the sexuality of the human body that transcend any ephemeral or sensational pursuit of spectacle. His respect for, and complex physical and mental understanding of, the human form surpassed contemporary experimental trends in society, culture, and art, implicating a deeper, almost atavistic, justification of appearance and structure. The sexual thrust and seemingly profligate depiction of Christ and the Magdalen (1894; plate 17) gives expression to a composite intricacy that Rodin intended his sculpture to contain. Whether this work is read as religious allegory, thematic recollection of the Antique, or as part of the contemporary discourse concerning the demands placed upon the artist as creator, it is through the erotic that we gain access to the most intimate essences of this sculpture and obtain a unified reading.

It has been our intention in rephotographing the sculptures to accentuate and appreciate the way in which Rodin relied upon, and often emphasized, erotic aspects of the human form to depict primary themes in his thinking as an artist. Many of the images in this section have deliberately omitted views of whole works in order to gain closer access to details of the erotic. Often the focus of the camera has approached or impinged upon works at such close range that, were it not for immediately adjacent

comparative views, the reader would be hard put to determine which sculpture had actually been photographed. By using this technique of highly selective details, we have aspired to delineate the precise workings of the erotic in Rodin's varied oeuvre. The visual essay that emerges from these photographs is at once subjective and accessible – occasionally random, yet totalizing in its intimacy. Many of the photographed works, most of them from the Musée Rodin, Paris, are of an intensity that demands careful scrutiny, sustained looking over time from various angles, distances, and heights. Only through such engaged sequences of looking does the discursive precision of Rodin's sculpture come poignantly to life.

We have attempted to recreate in photography the experience of what one is compelled to do before a sculpture by Rodin – to circulate through its forms, to focus on an idiosyncratic facet of its making, to locate the intricacy of a specific moment of the erotic. The reader, then, like the viewer of the sculpture itself, can explore the expression of a woman as she evades a kiss, revel in the embrace of a man as he captures his love, and rejoice in the passion of a creator who expresses himself in the smooth curvature of a body. The three-dimensional temporal process of looking has been mimicked in photography by the use of extreme and occasionally distorted views, enabling the reader to stand in close proximity to the essence of the works. It is our hope that this assemblage of photographs will further an understanding of the creative process that the artist and his audience undergo when in the presence of art, when engaged in the exploration of a specific theme, such as that of the erotic.

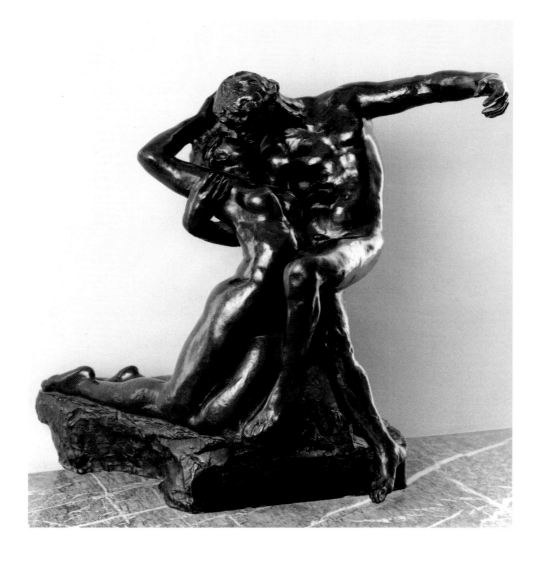

1

Eternal Springtime
L'Eternel printemps
1884

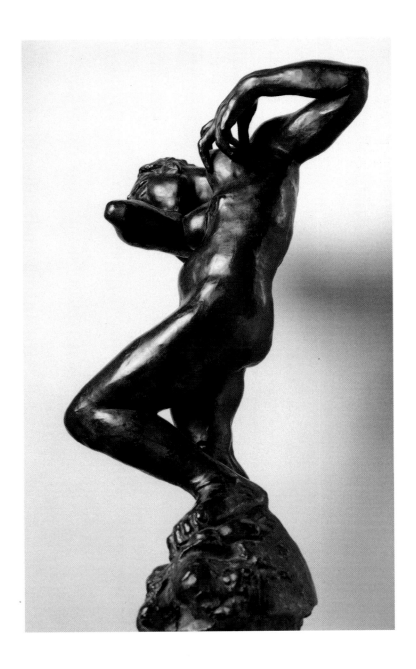

2

Meditation (The Inner Voice)
Méditation (La Voix intérieure)
1896-97

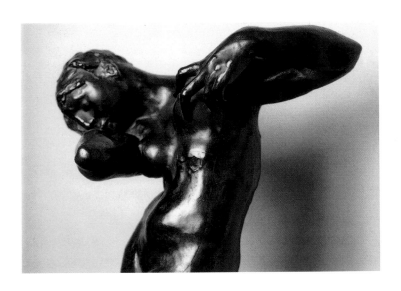

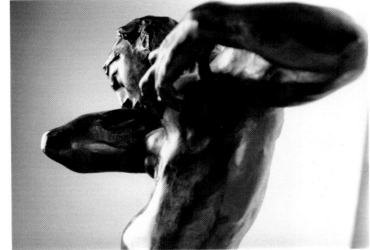

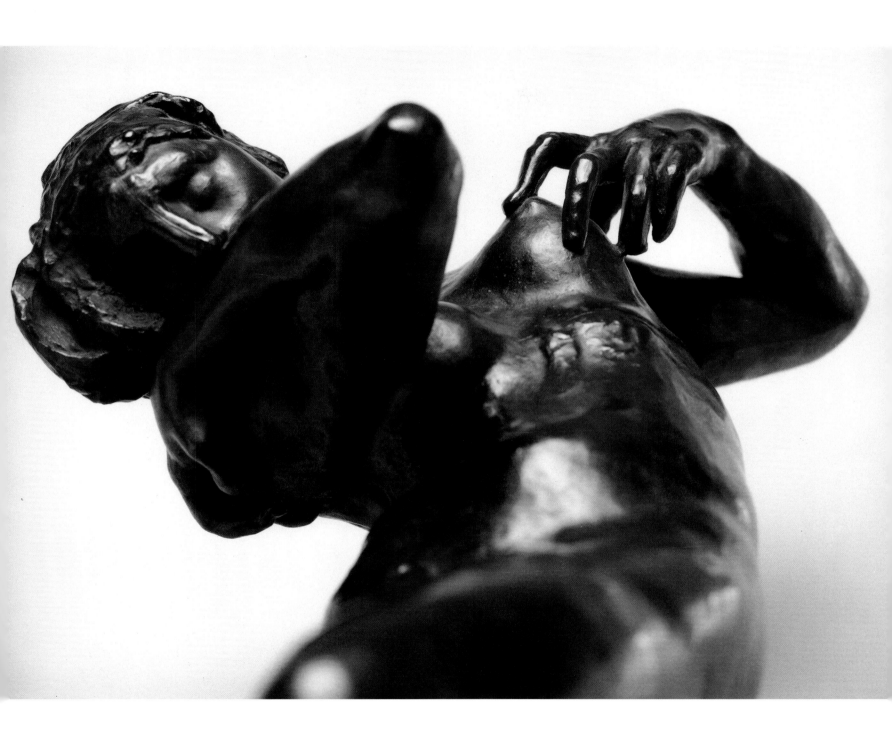

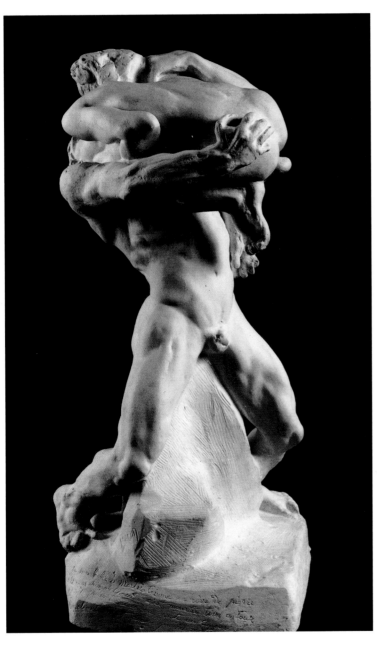

3

I Am Beautiful
Je suis belle
1882 (?)

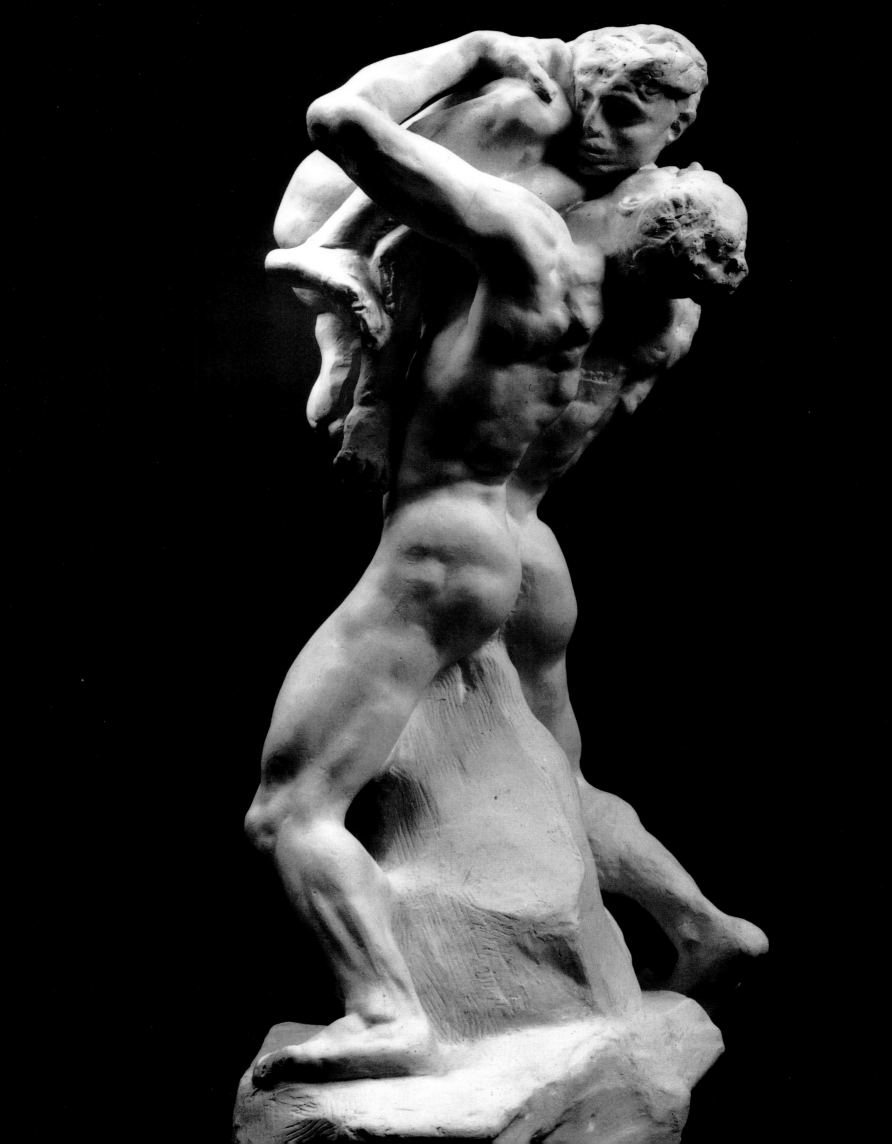

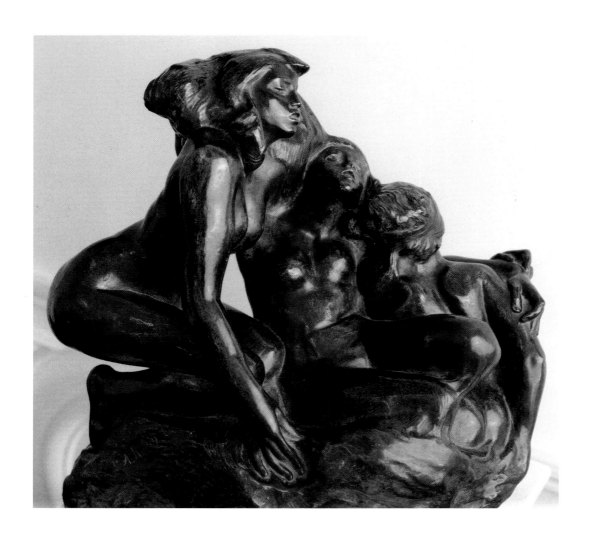

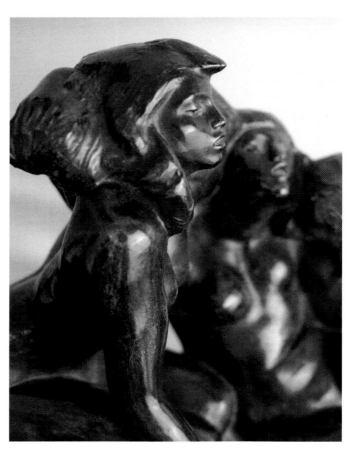

4

The Sirens
Les Trois Sirènes
1886

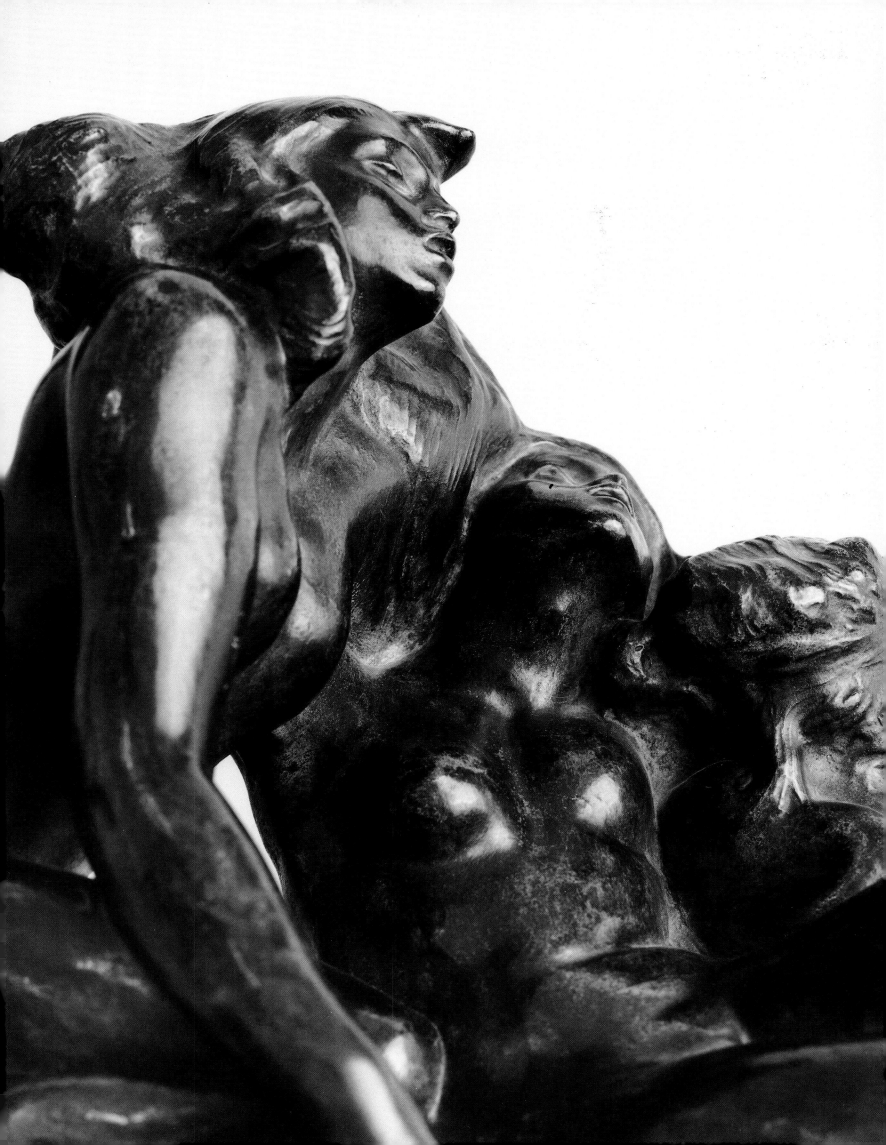

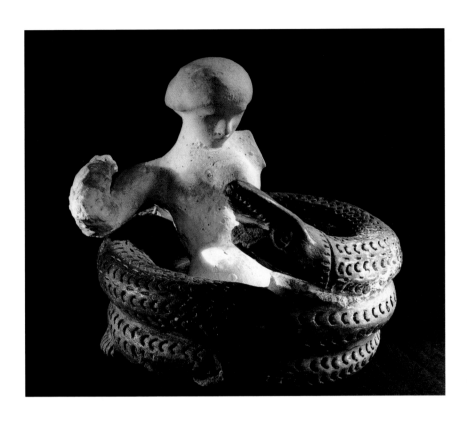

5

Assemblage of a Female Torso
and Coiled Snake
*Assemblage: Torse féminin
et serpent lové*
1895-1905

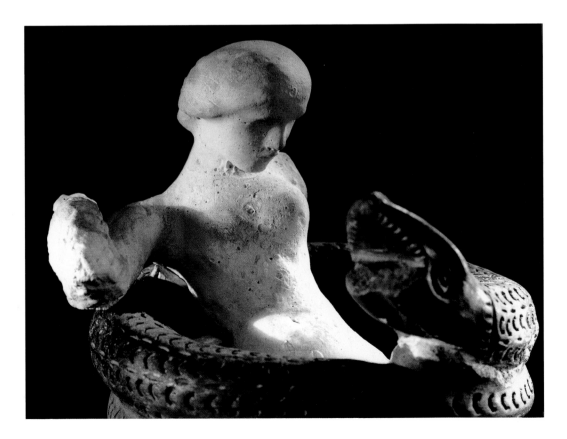

6

Assemblage of the Head
of Pierre de Wissant and
a Female Nude
*Assemblage:
Tête Pierre de Wissant
et nu féminin*
after 1900

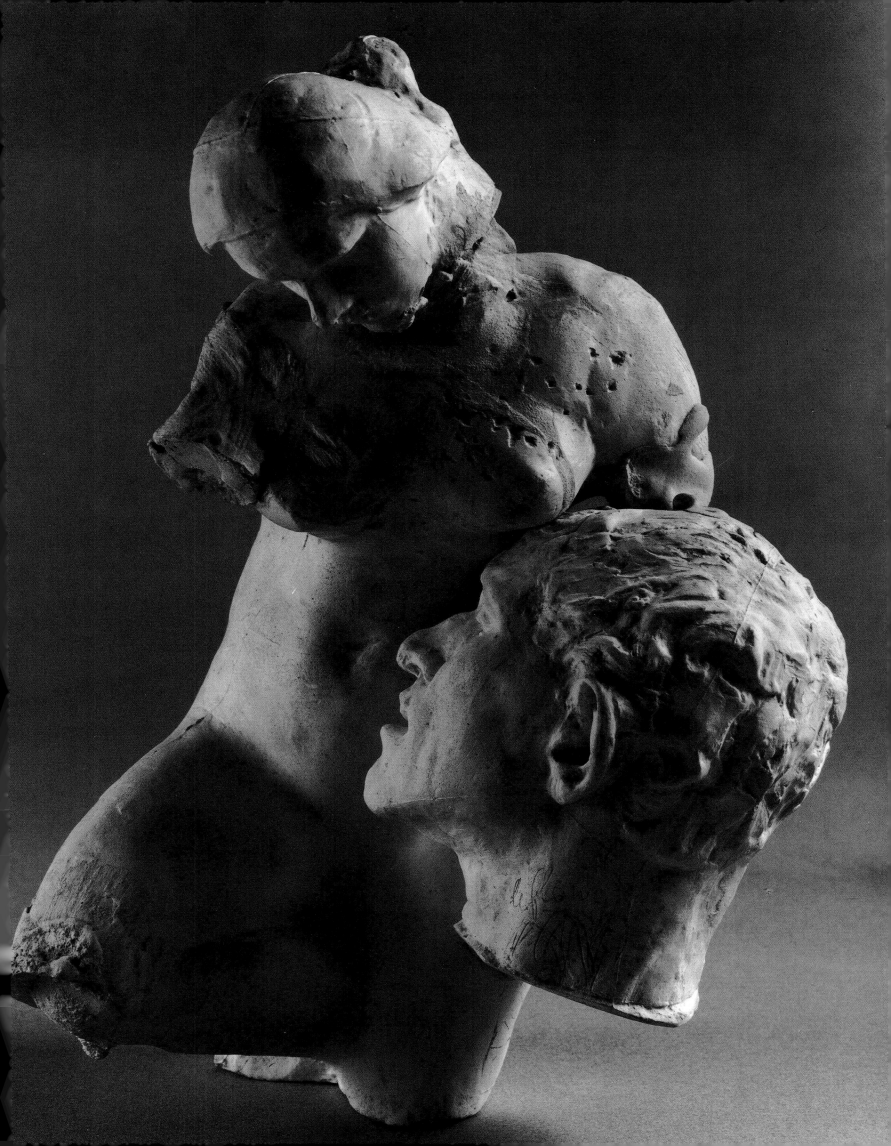

7
The Creation of Woman
La Création de la Femme
1894

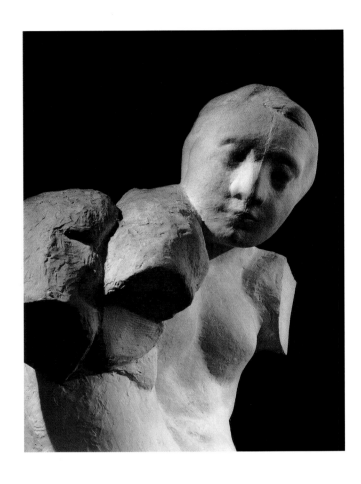

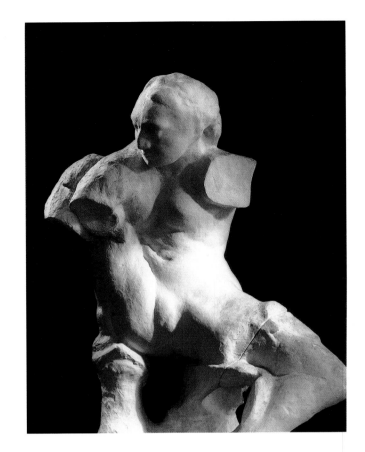

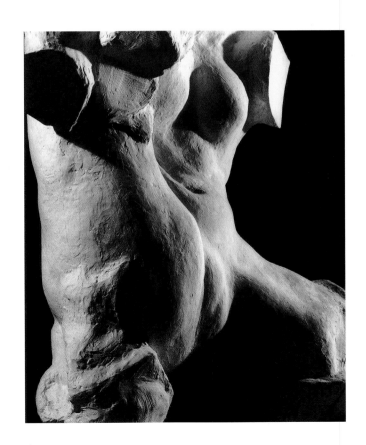

8
Iris
1903

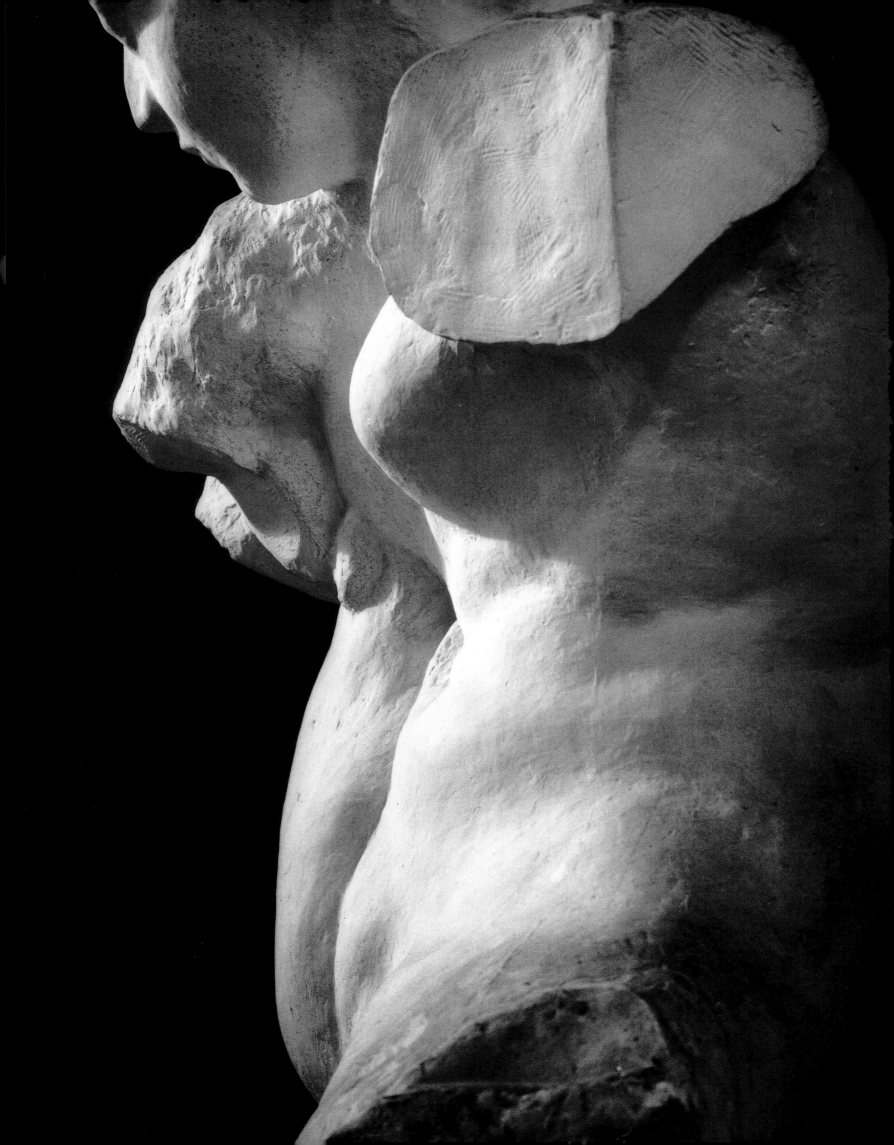

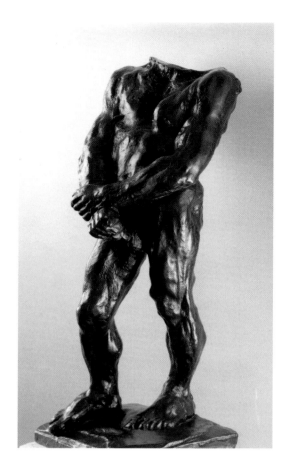

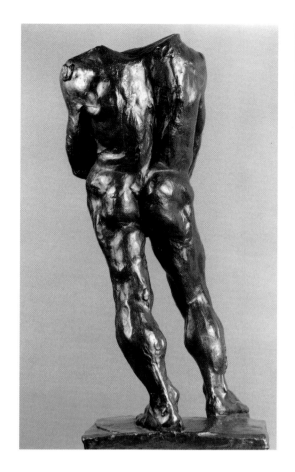

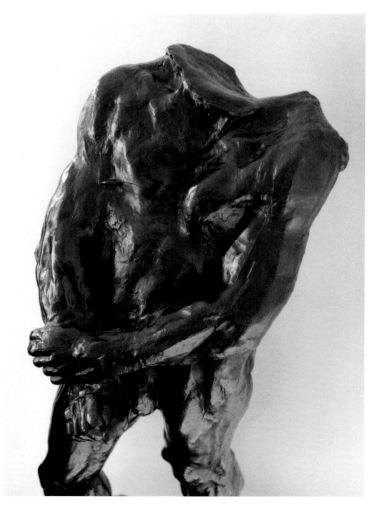

9

Naked Balzac
Balzac, étude de nu dite un athlète
1896

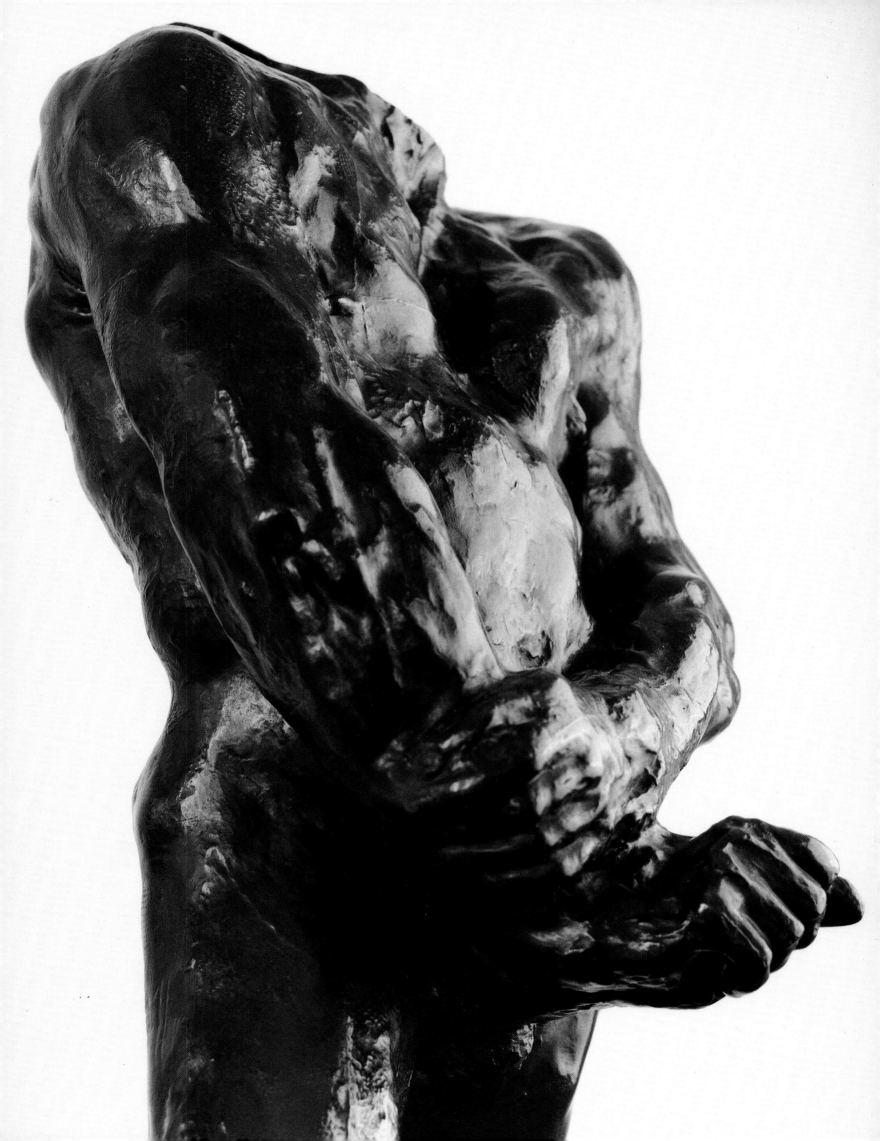

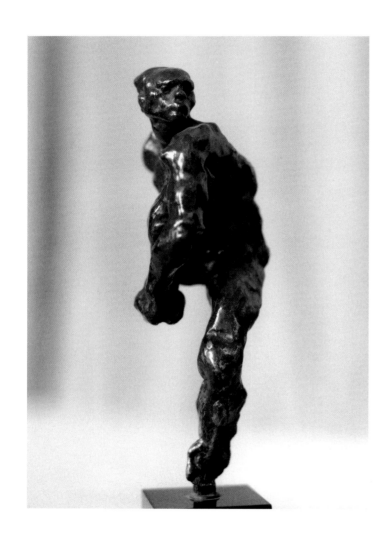

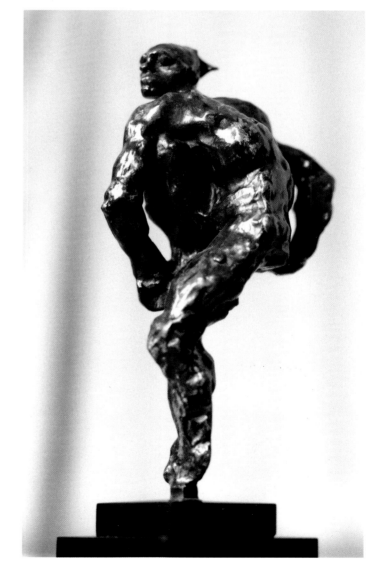

10
Nijinsky
1912

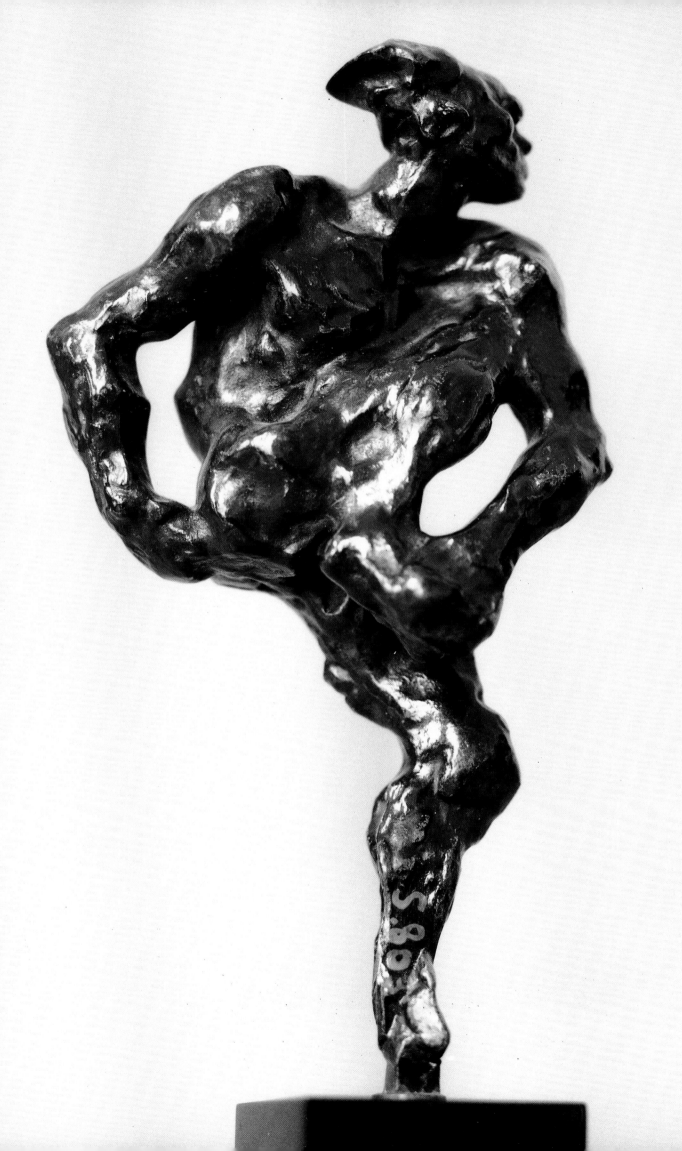

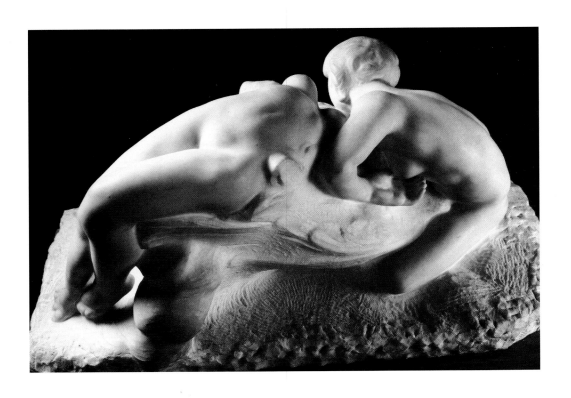

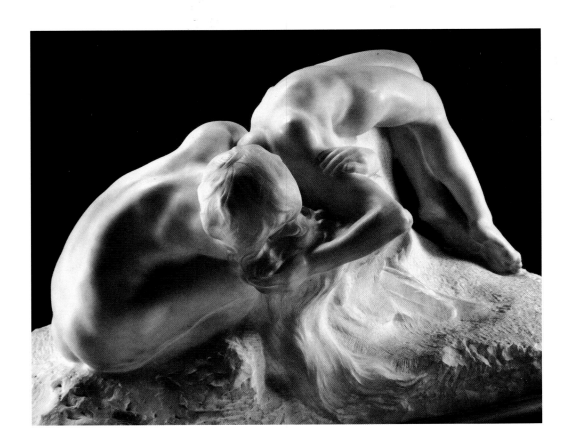

11

Fallen Angel
Chute d'un ange
c. 1895

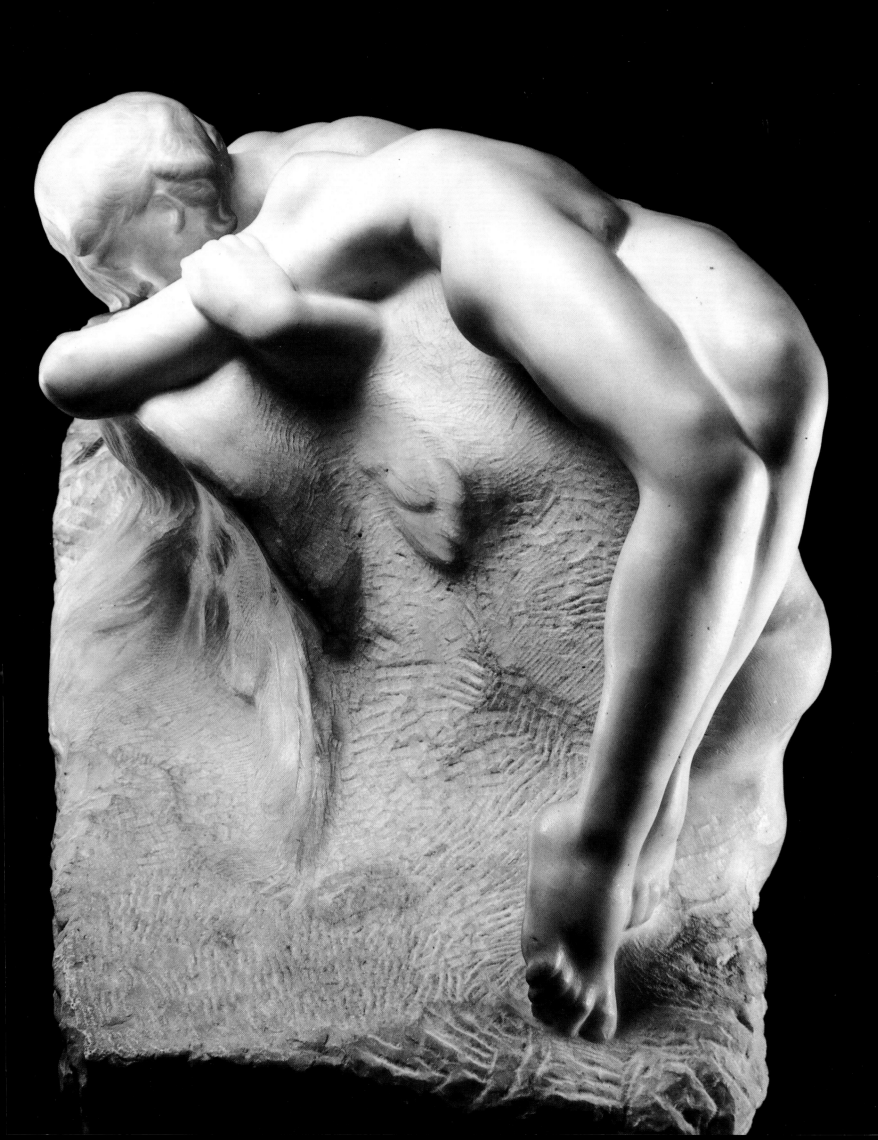

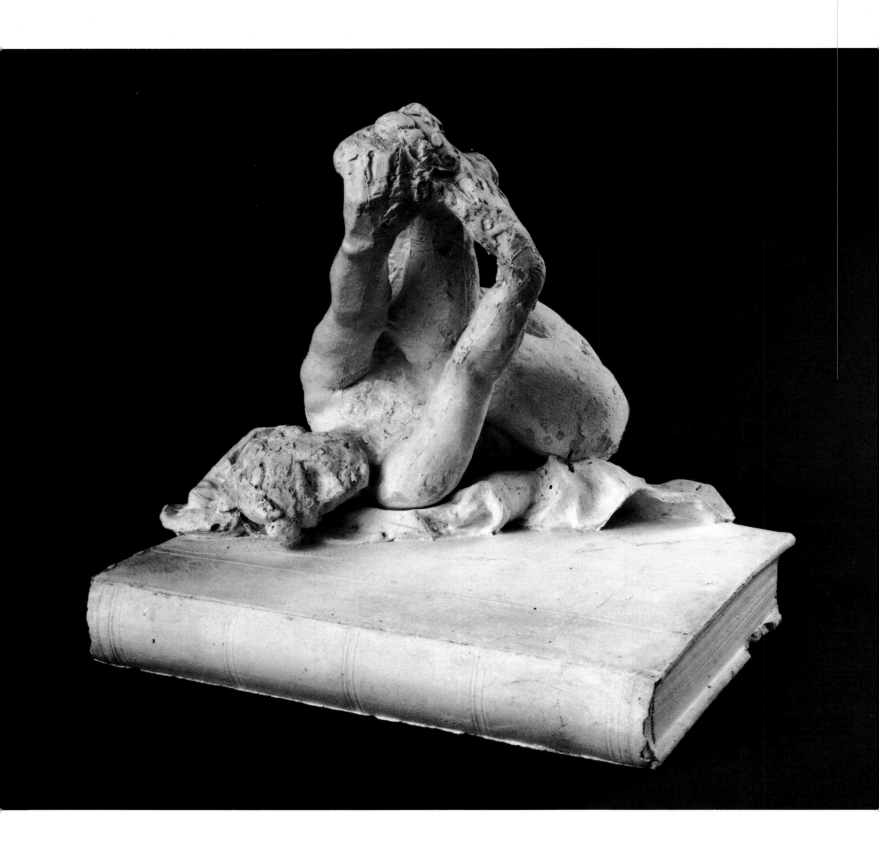

12
Ecclesiastes
L'Ecclesiaste
before 1898

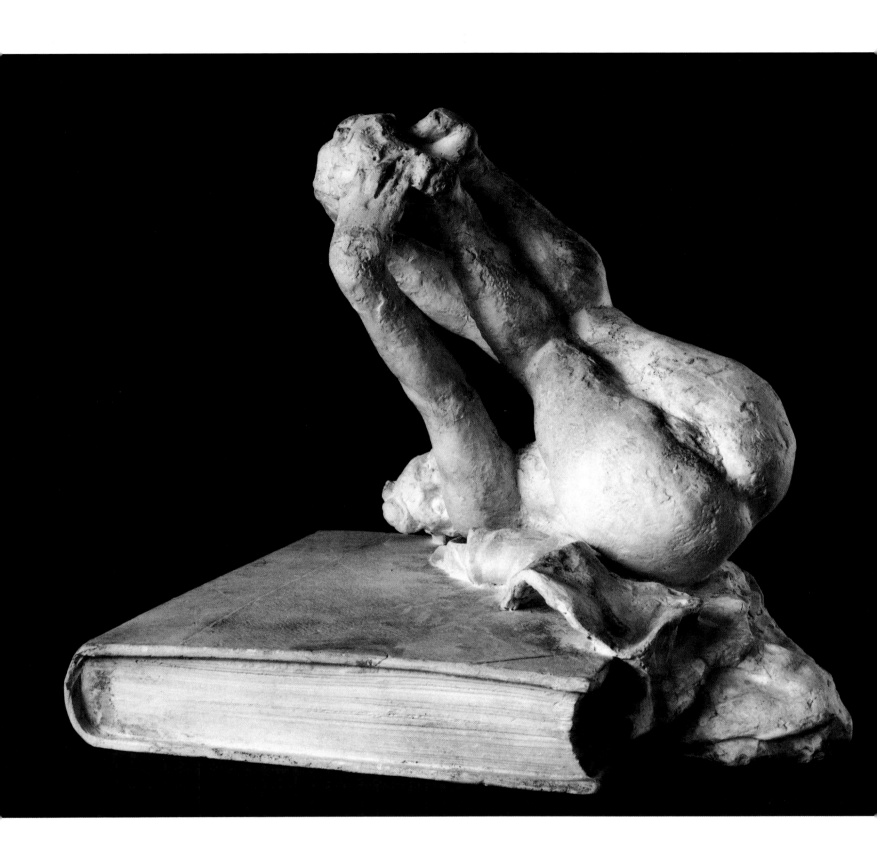

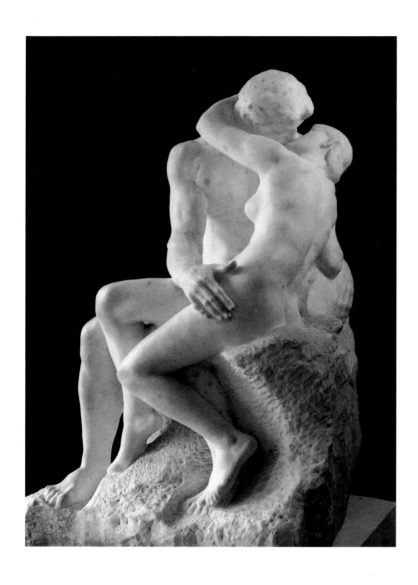

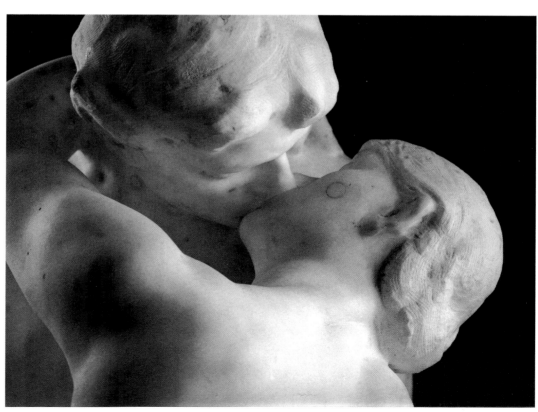

13

The Kiss · *Le Baiser*
1888-98

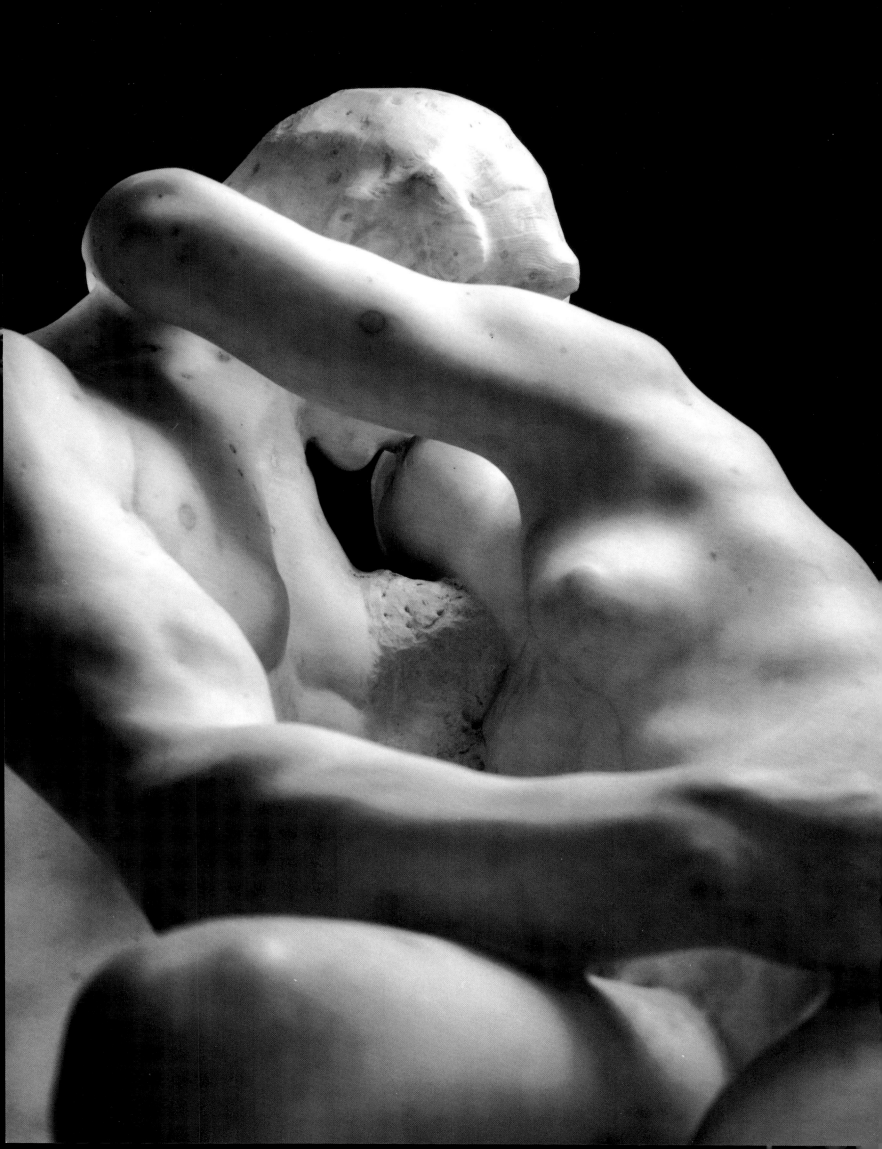

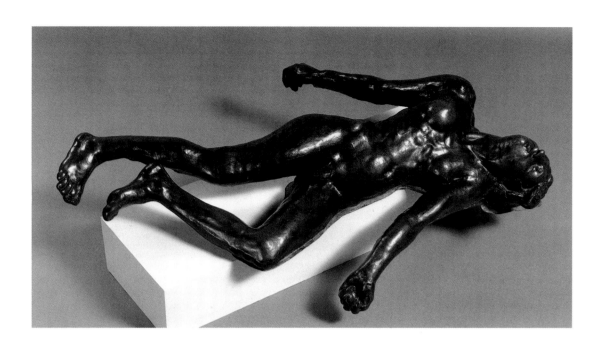

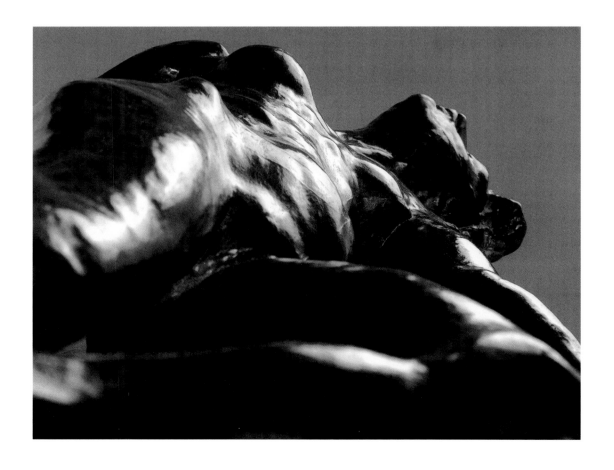

14
The Martyr
La Martyre
1885 (?)

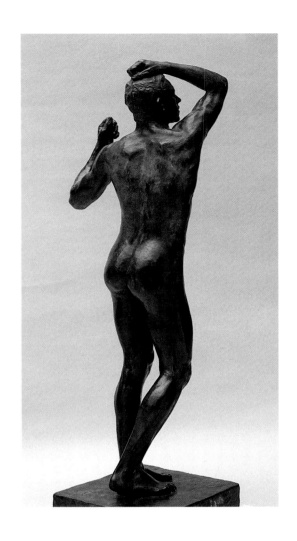

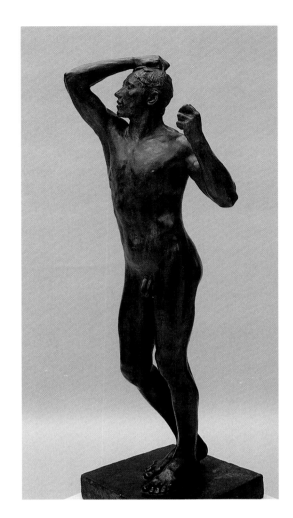

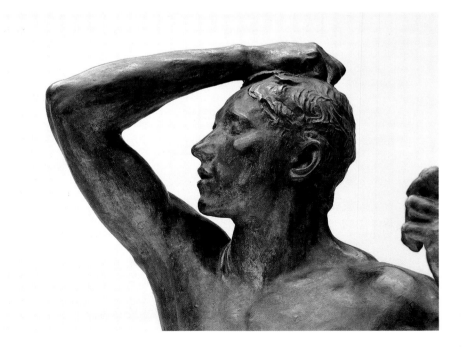

15

The Age of Bronze
L'Age d'airain
1875-76

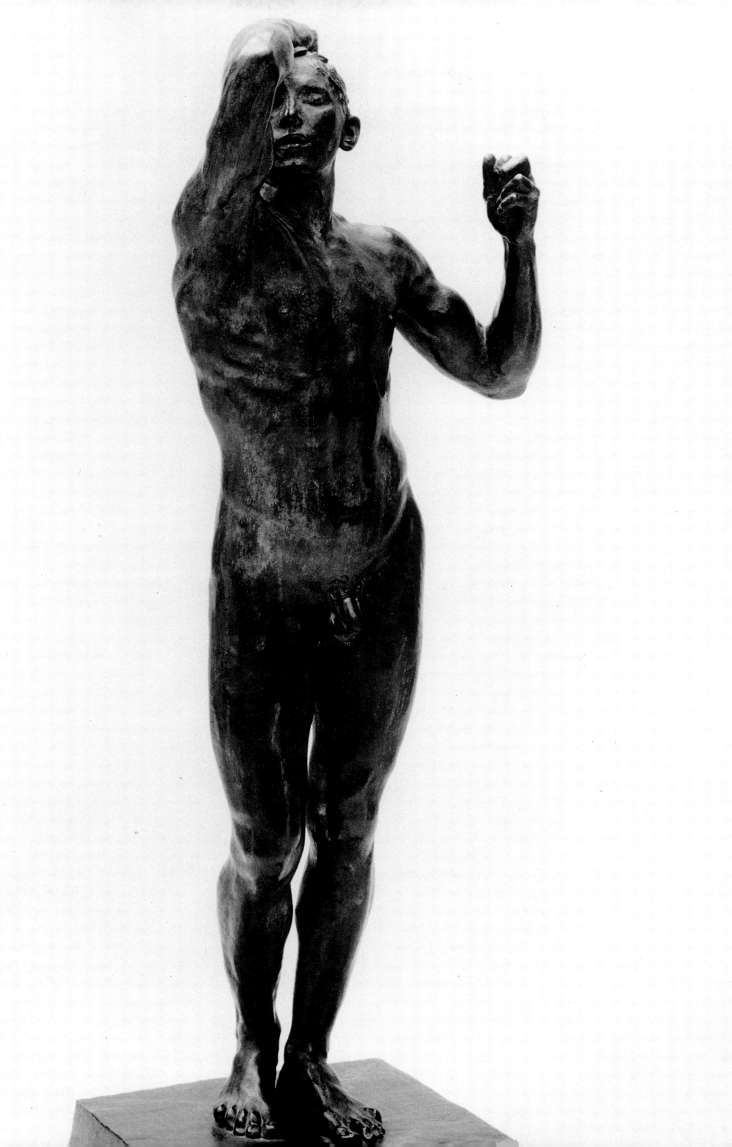

16

Meditation (The Inner Voice) *without arms*
La Méditation (*La Voix intérieure*) sans bras
1896-97

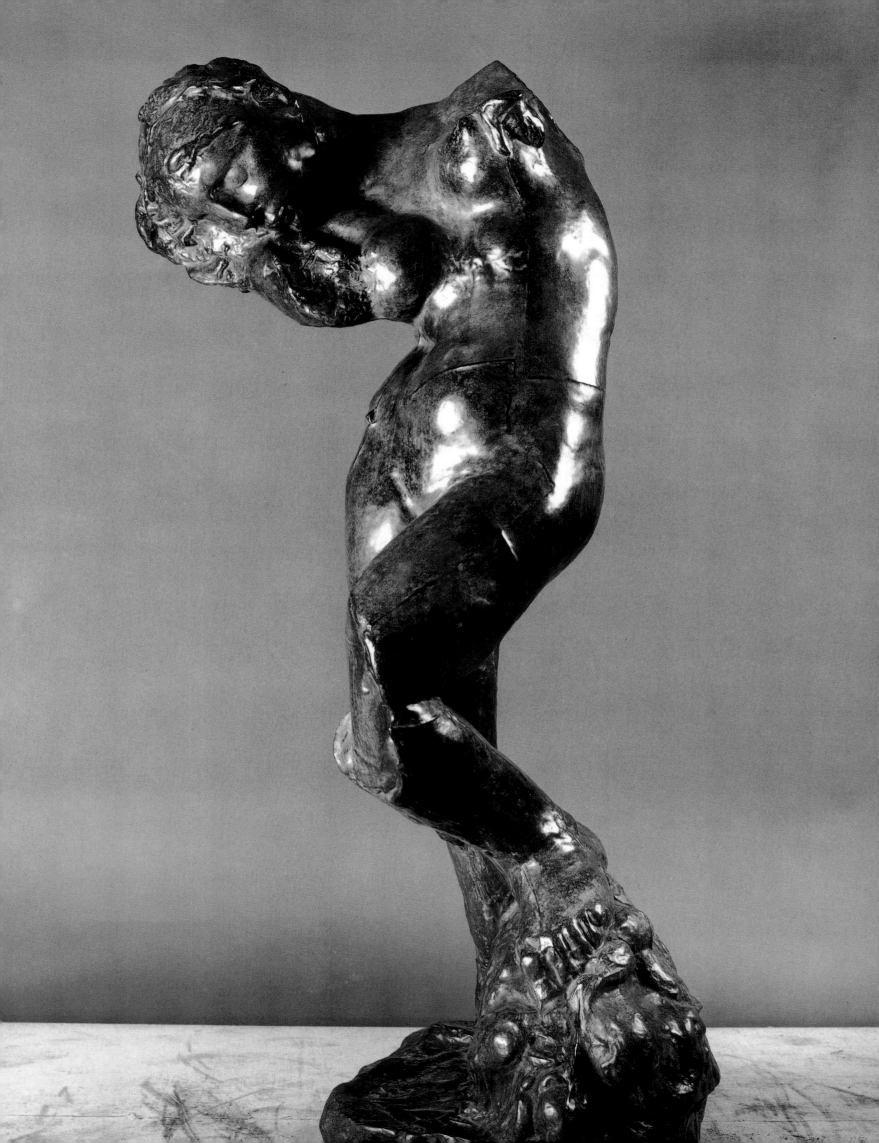

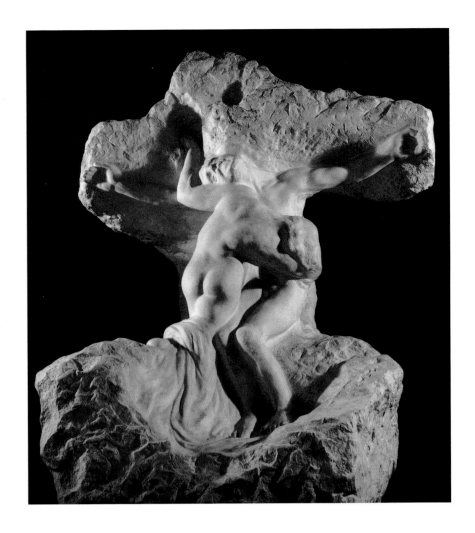

17
Christ and
the Magdalen
*Le Christ
et la Madeleine*
1894

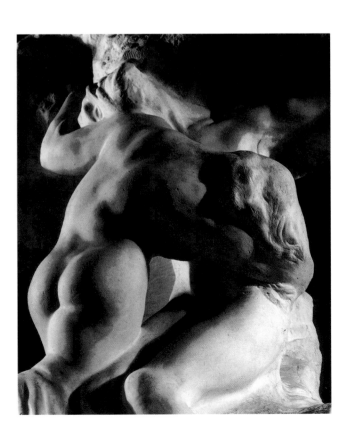 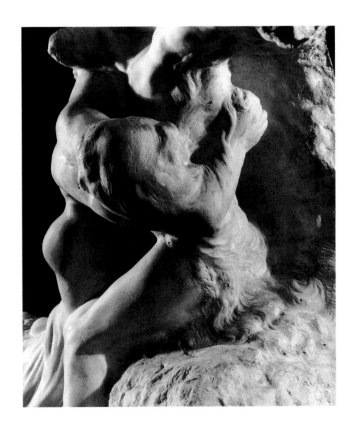

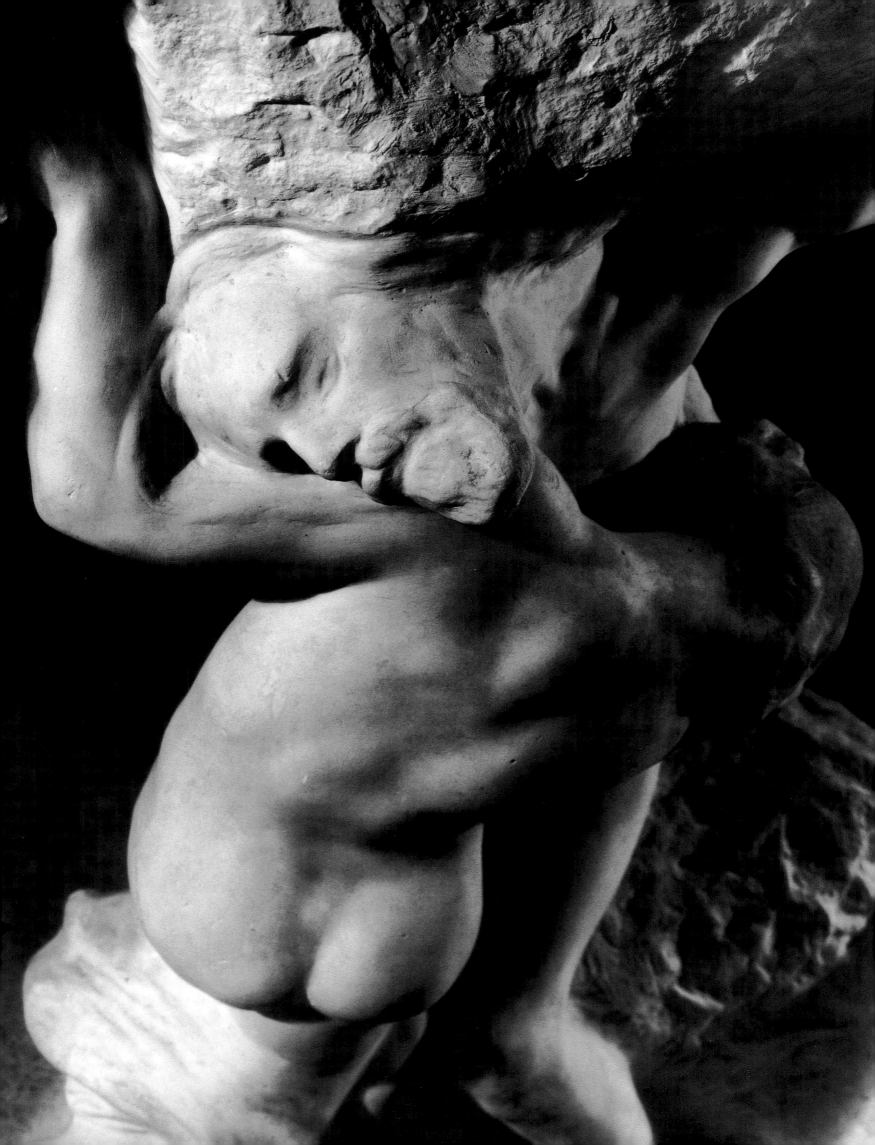

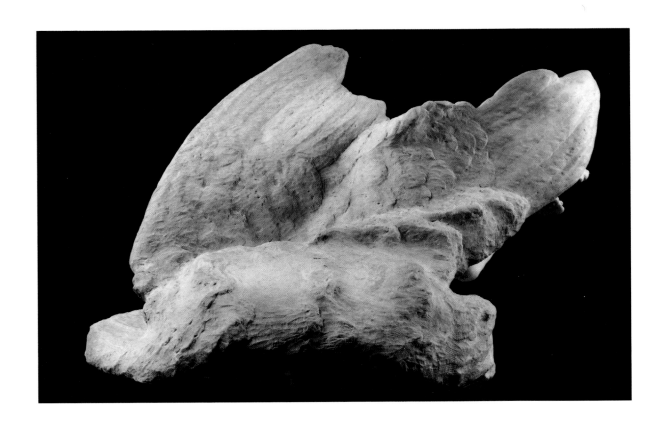

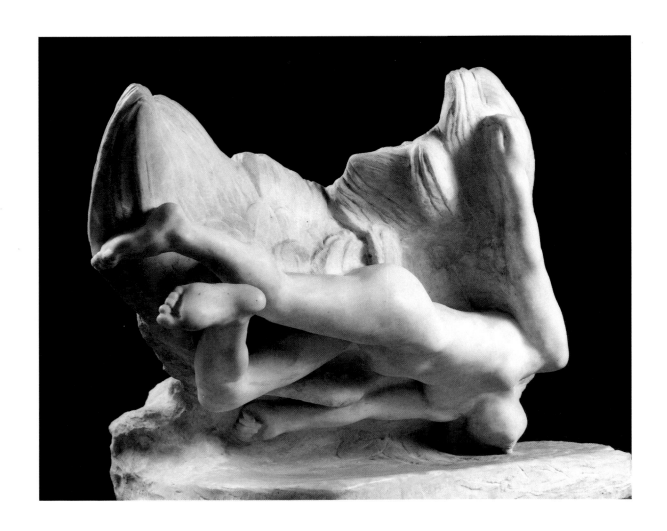

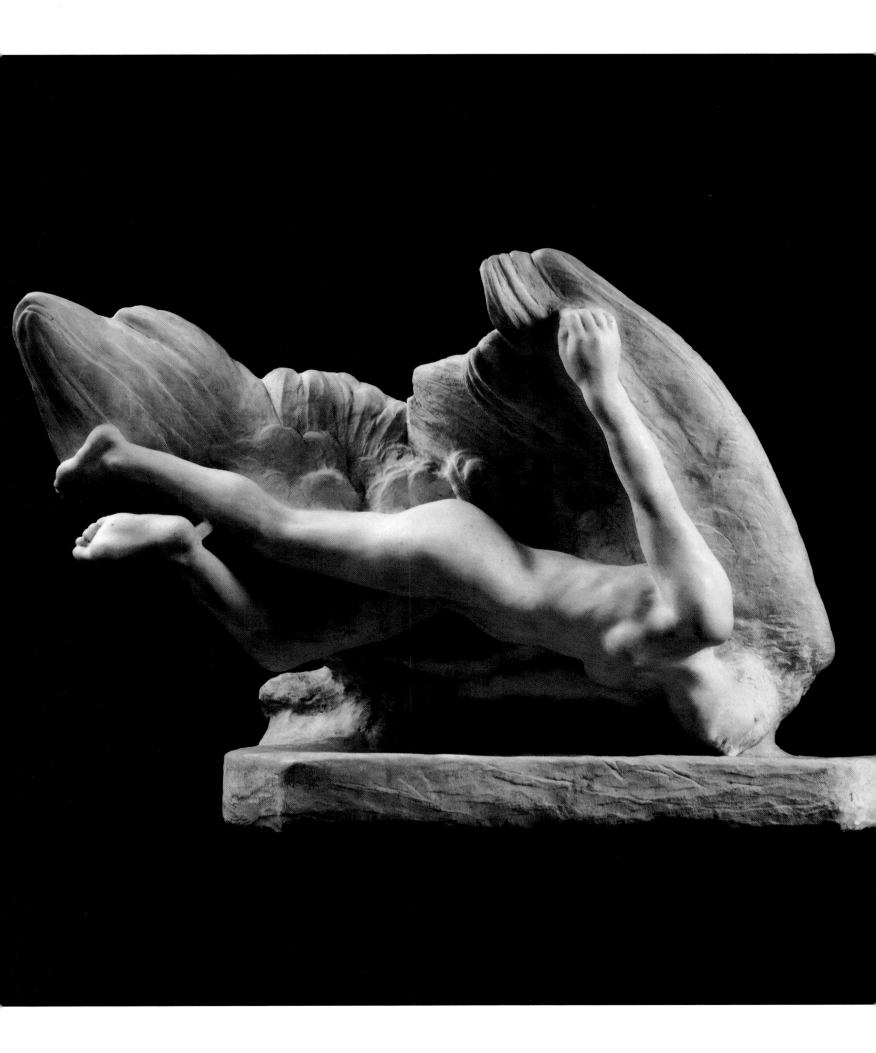

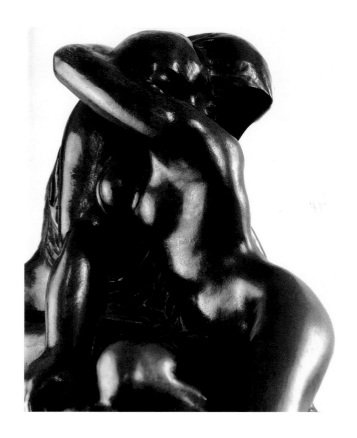

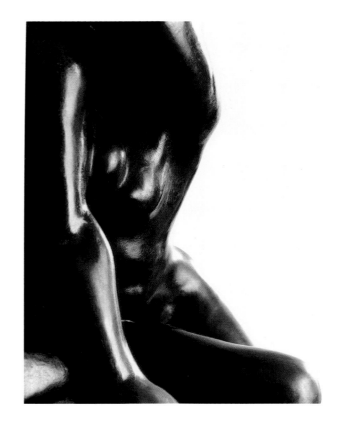

19

The Good Spirit
Le Bon Génie
c. 1900 (?)

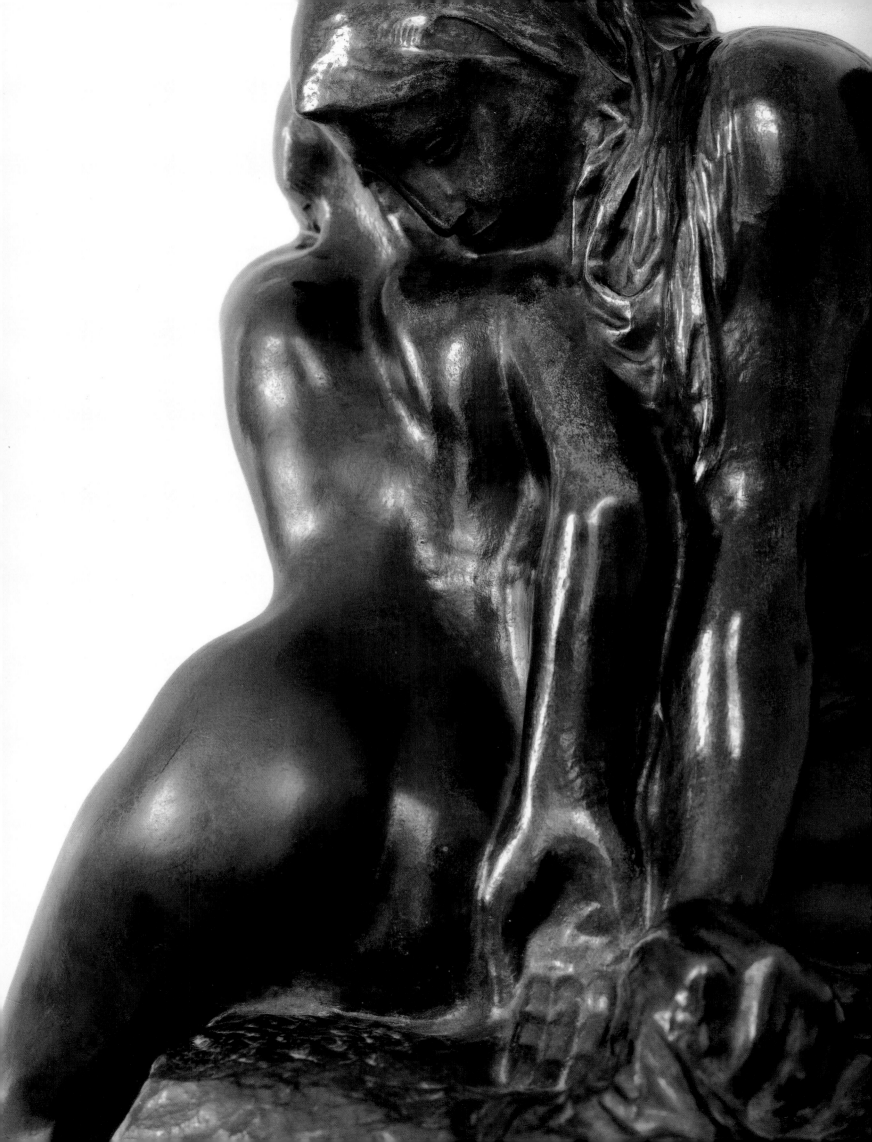

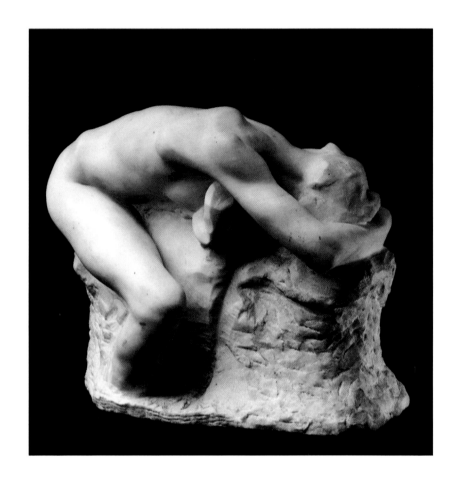

20

Andromeda · *Andromède*
1885

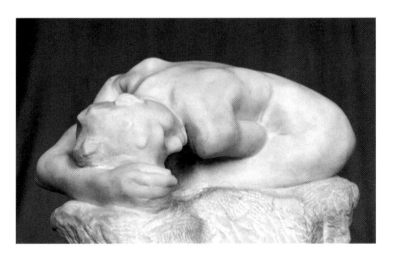
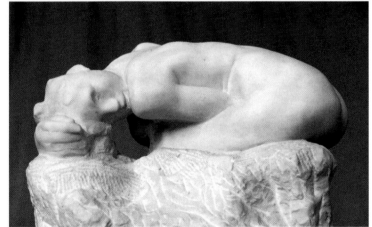

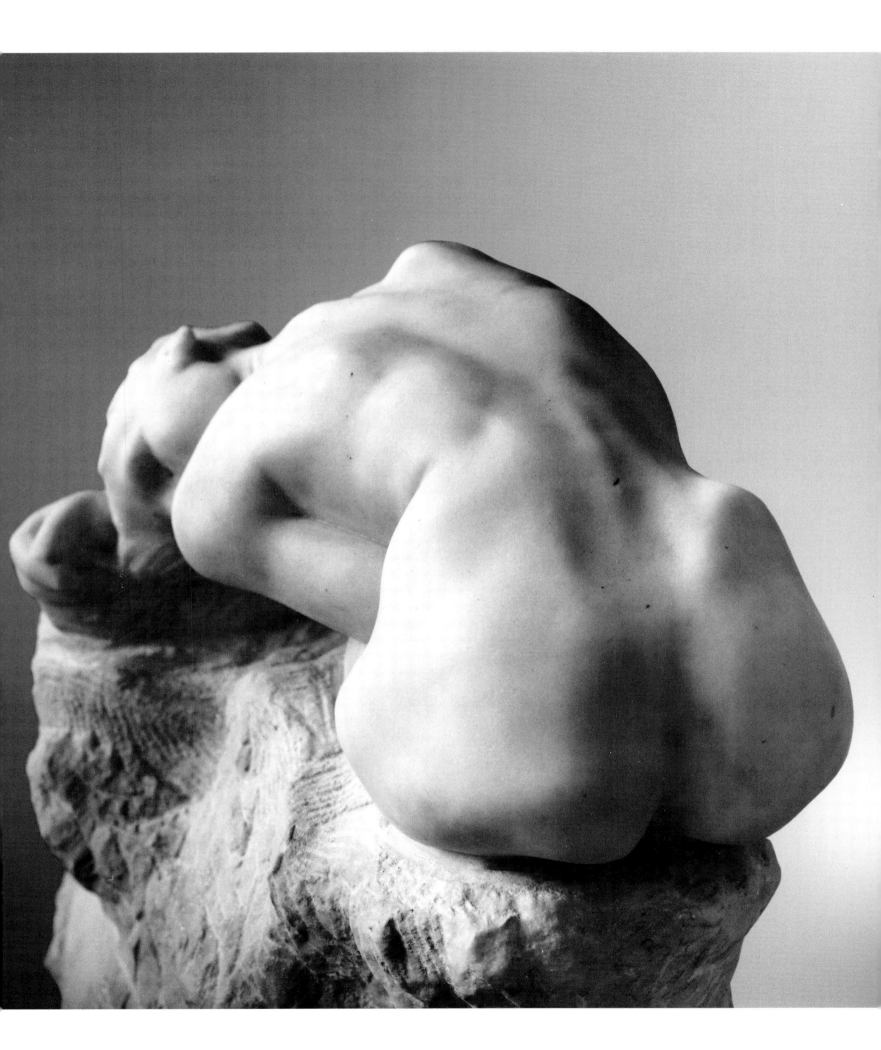

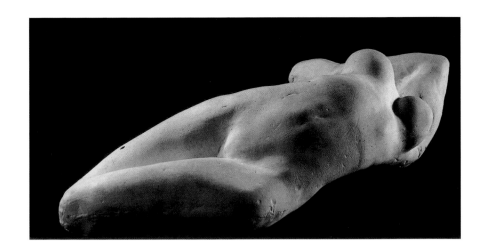

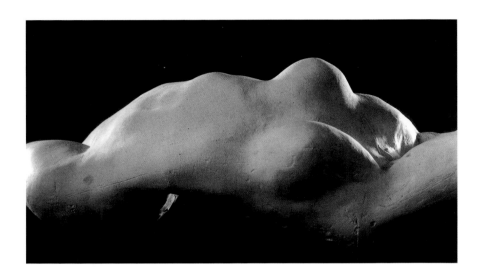

21

Torso of Adèle
Torse d'Adèle
1882

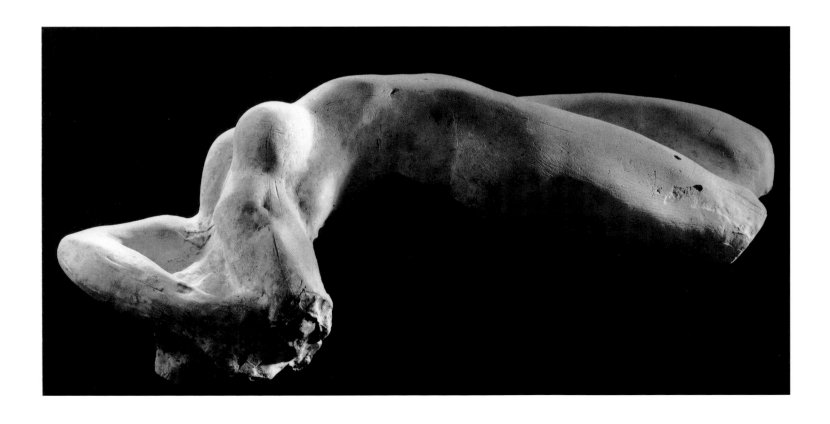

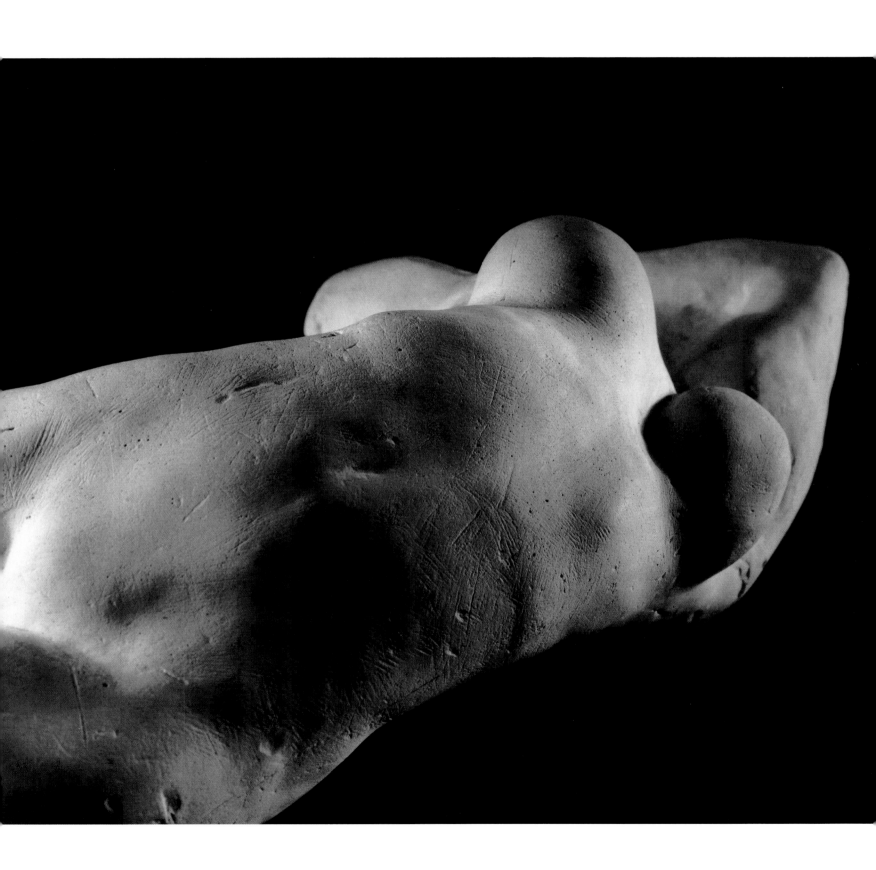

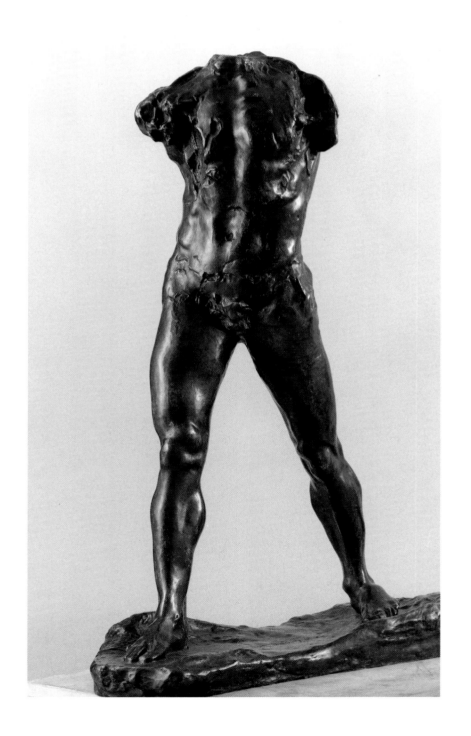

22

The Walking Man
L'Homme qui marche
1900

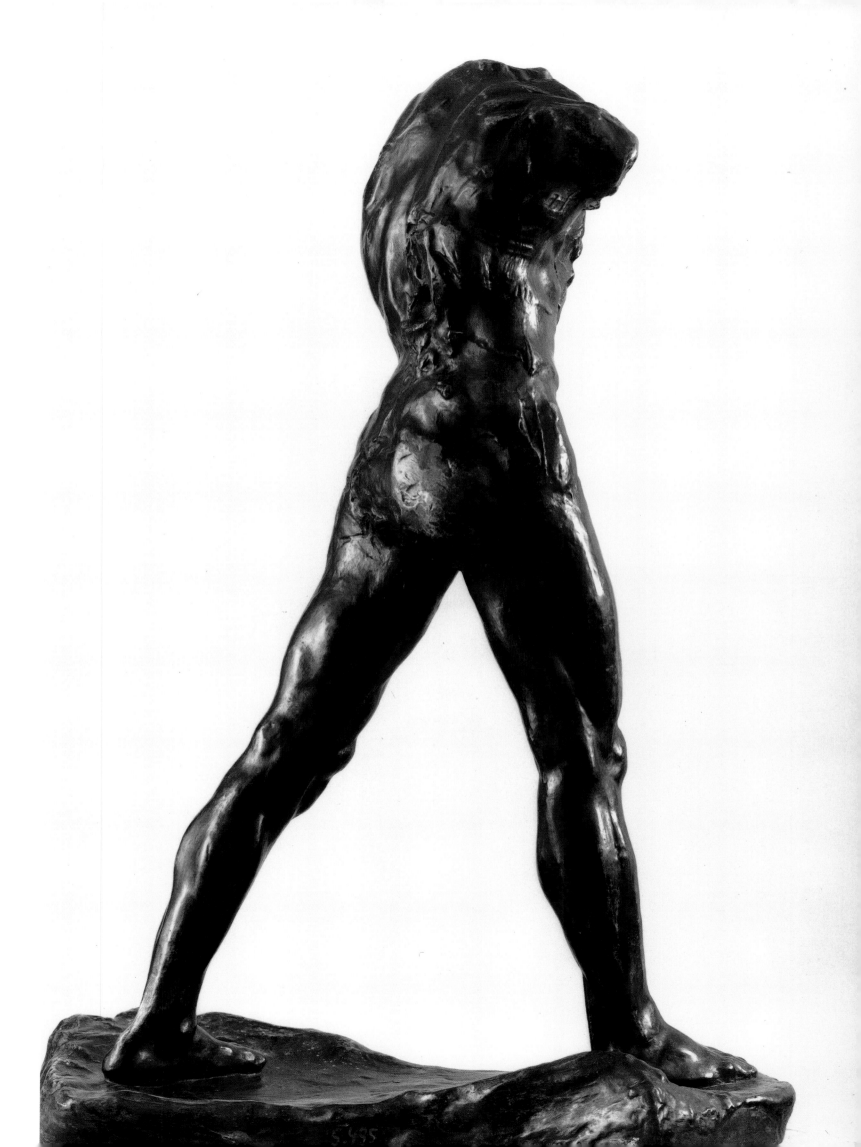

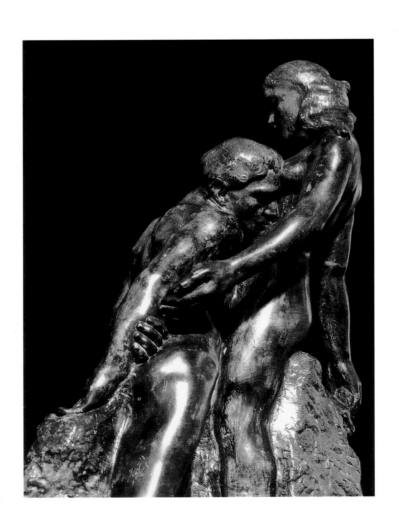

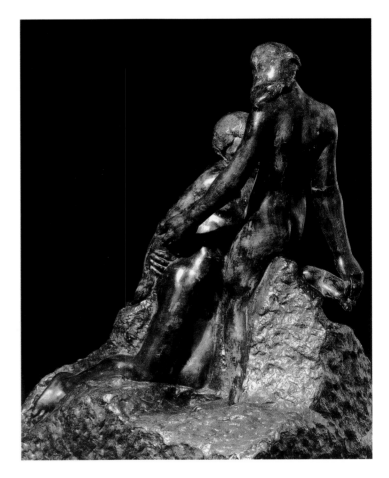

23
The Eternal Idol
L'Eternelle Idole
1889

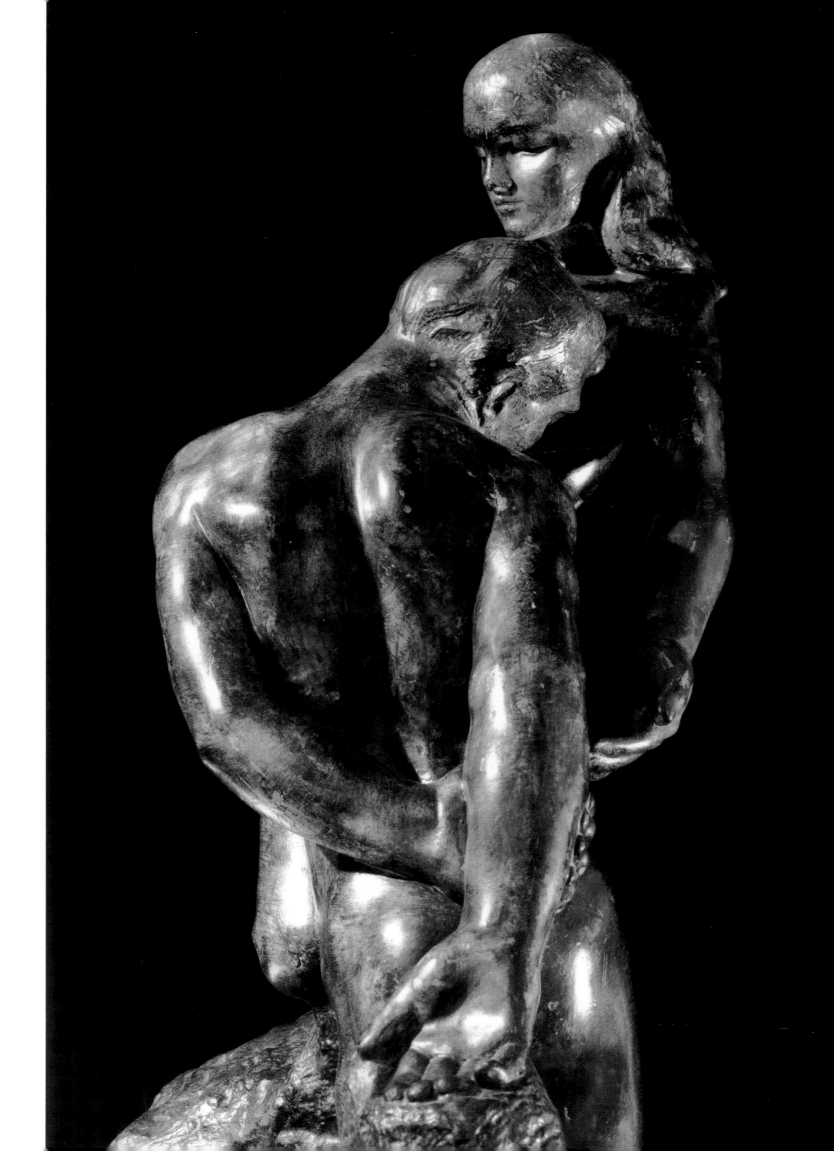

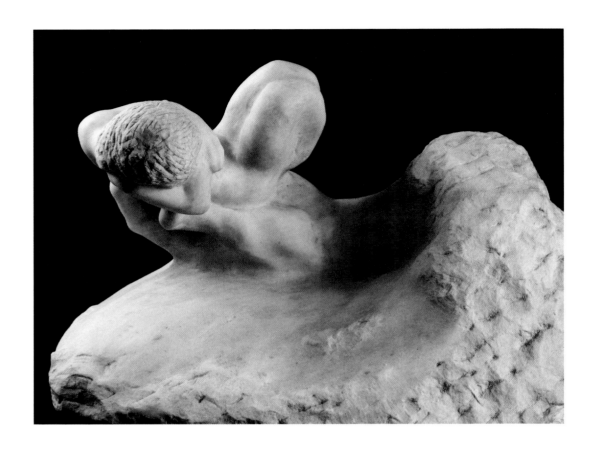

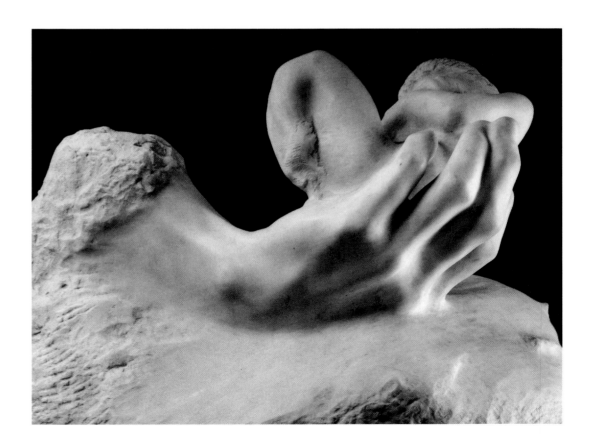

24

The Hand of the Devil
La Main du Diable
c. 1902

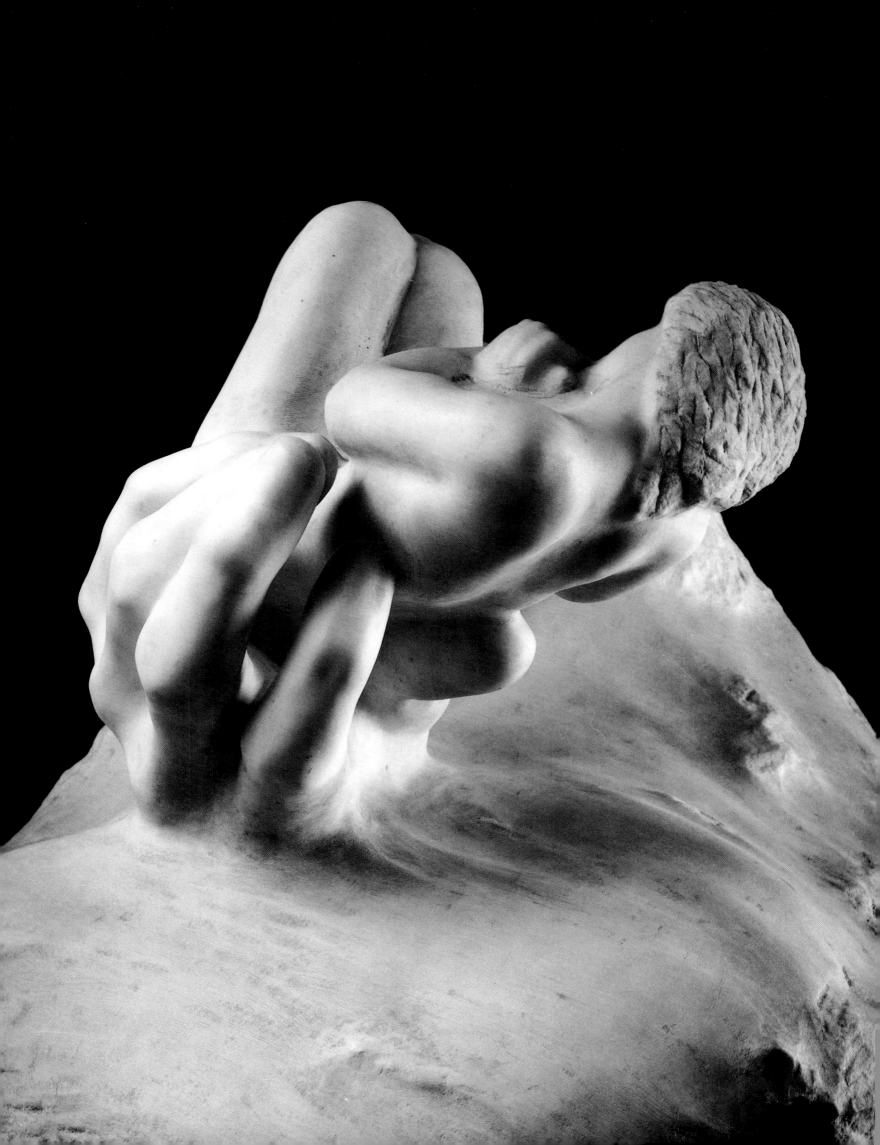

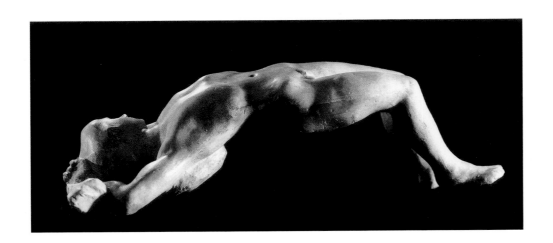

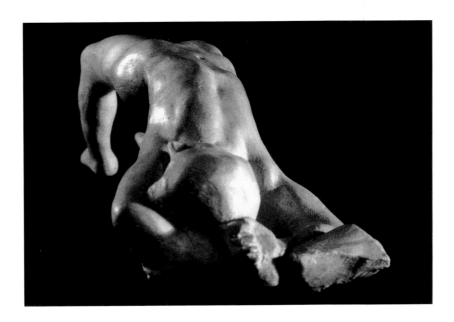

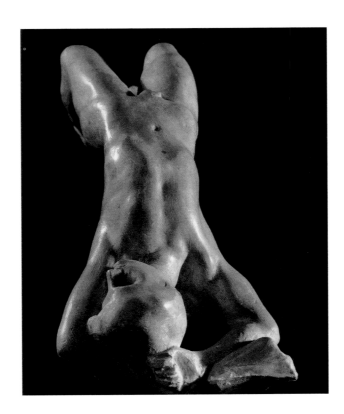

25

Reclining Man, Back Arched
(Kneeling Man)
Homme à genoux
before 1889

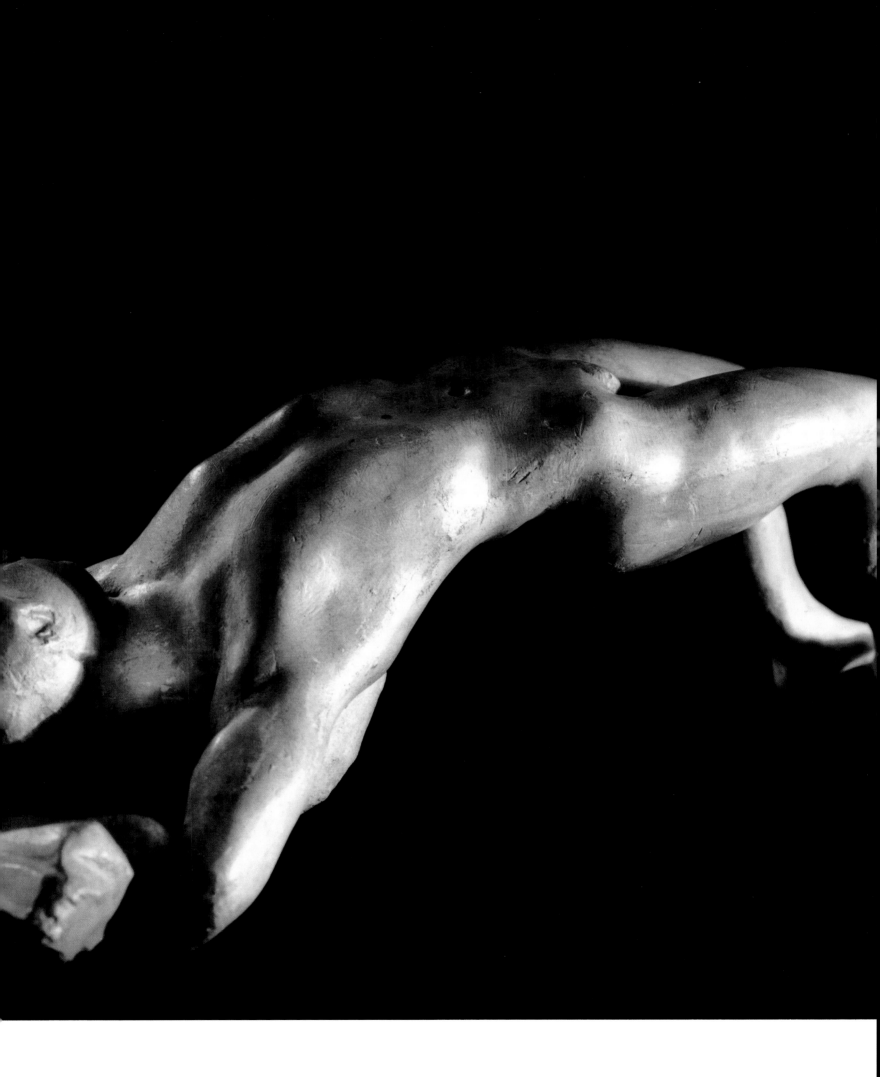

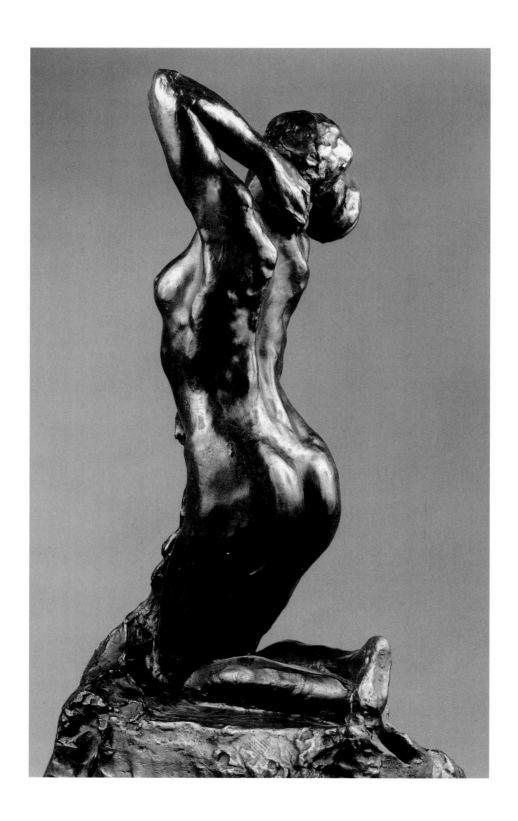

26

Kneeling Fauness
Faunesse à genoux
c. 1884

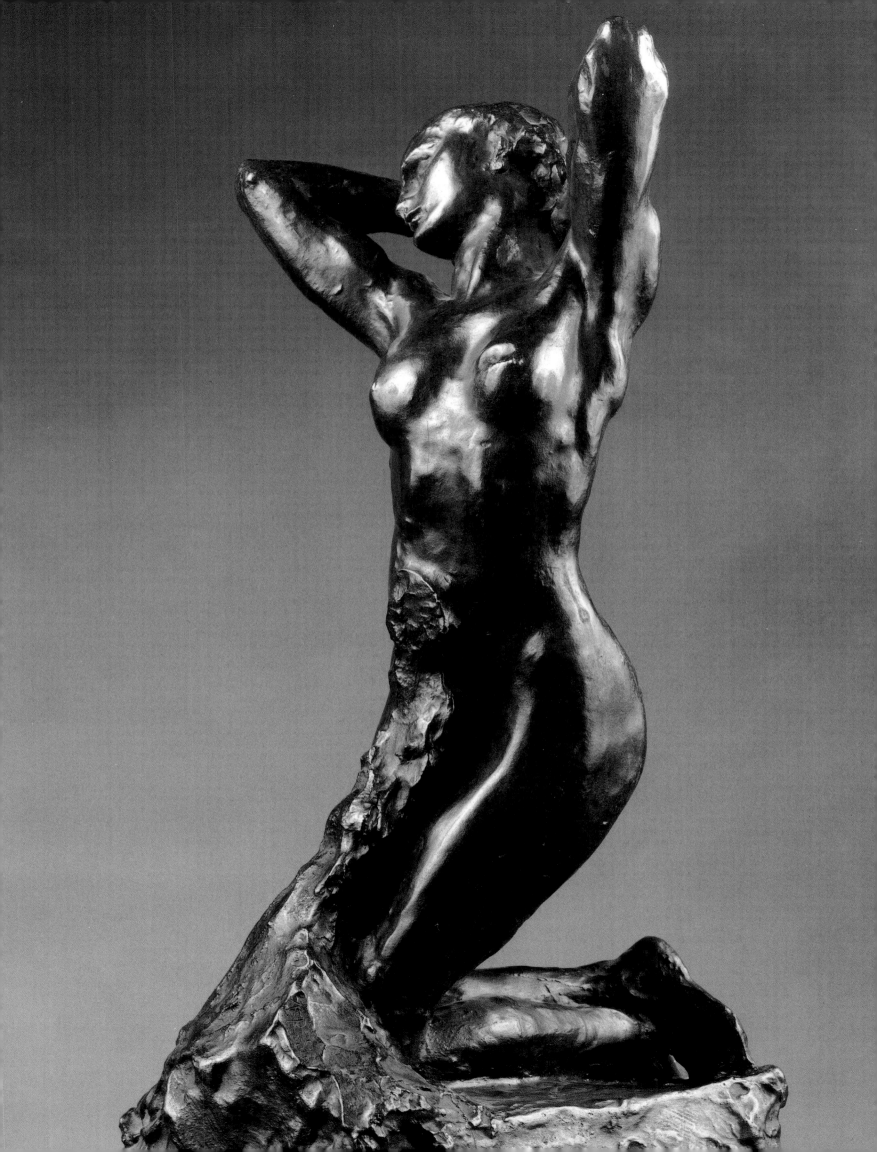

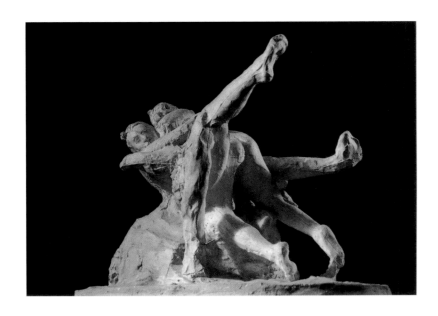

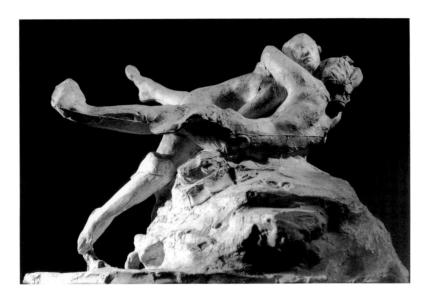

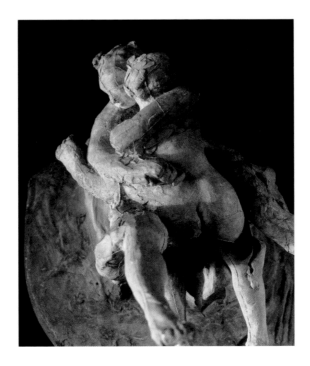

27
Two Women Embracing
Deux femmes enlacées
date unknown

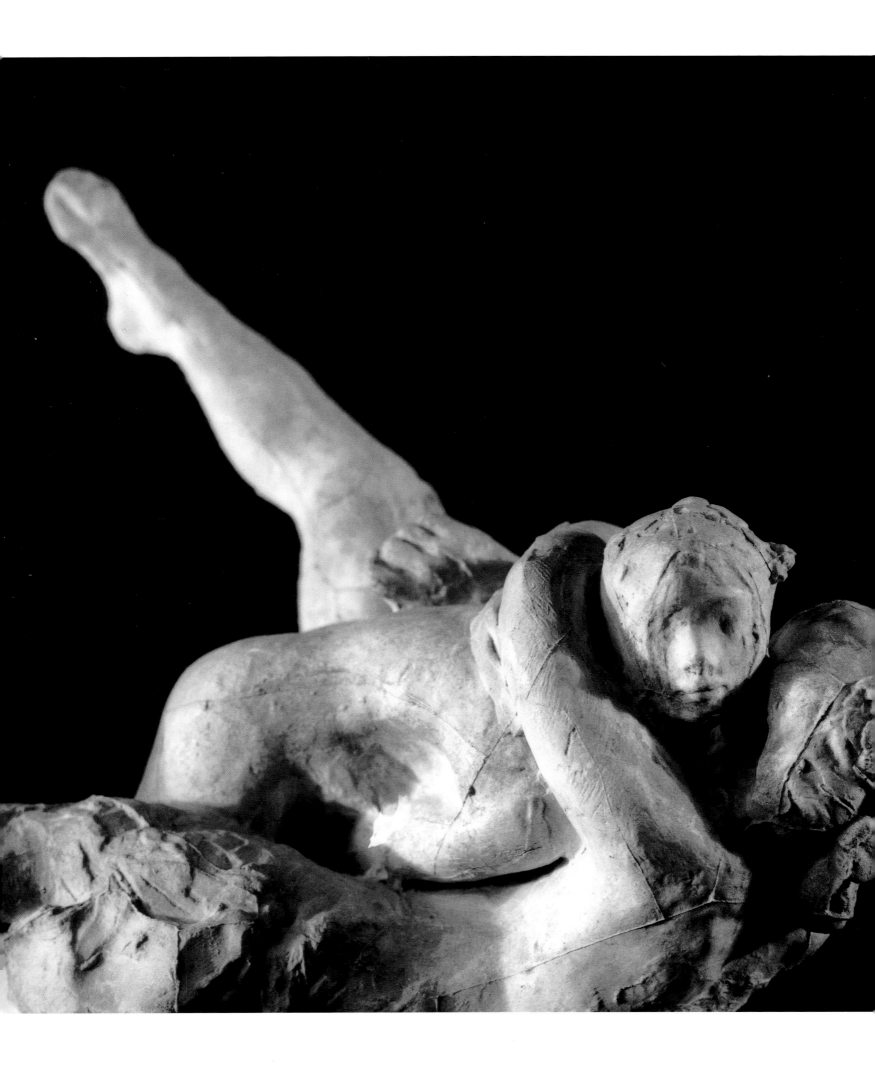

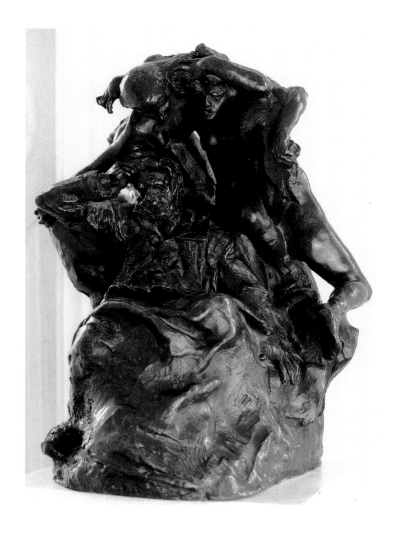

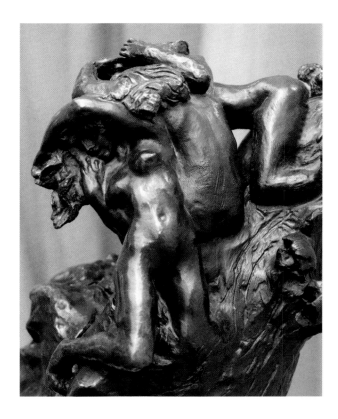

28

Monument to Victor Hugo (second maquette)
Monument à Victor Hugo (deuxième projet)
1890

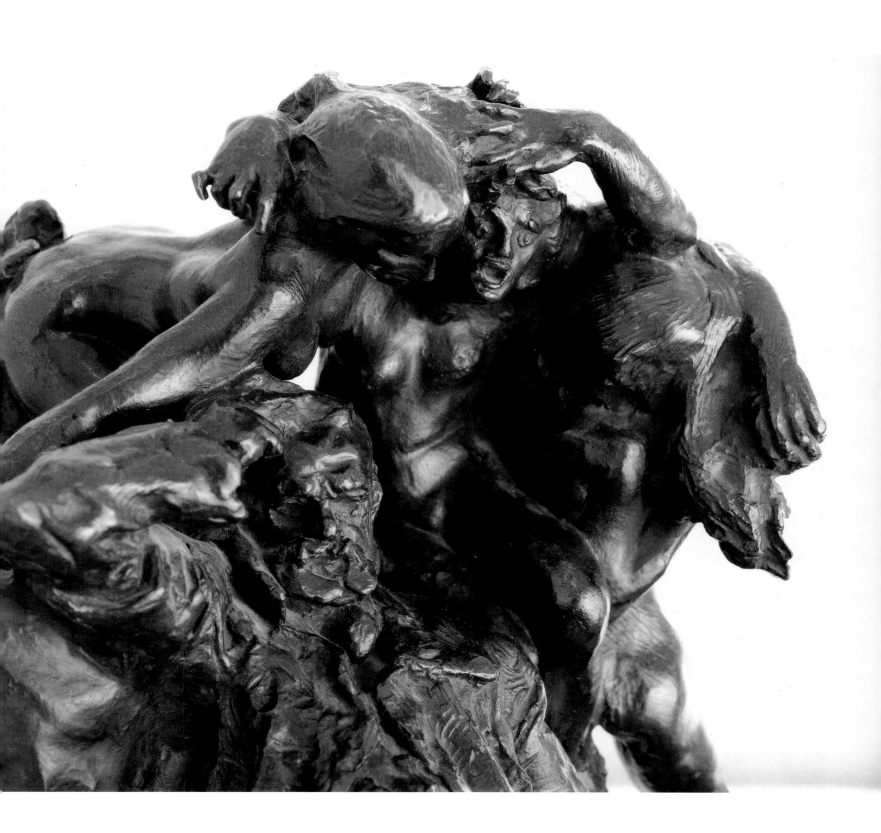

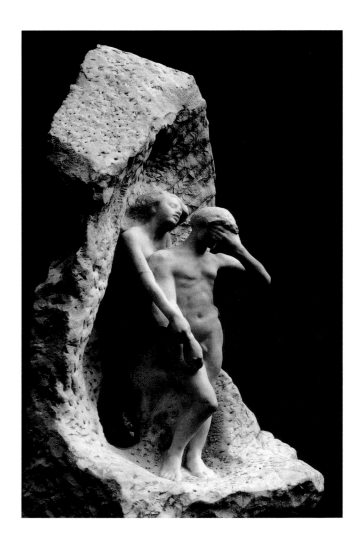

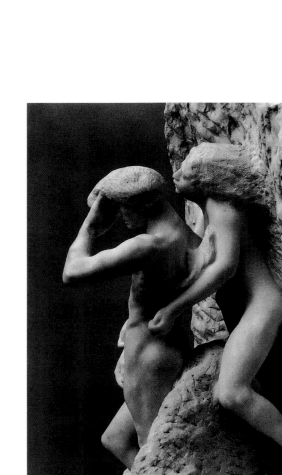

29

Orpheus and Eurydice
Orphée et Euridice
1893

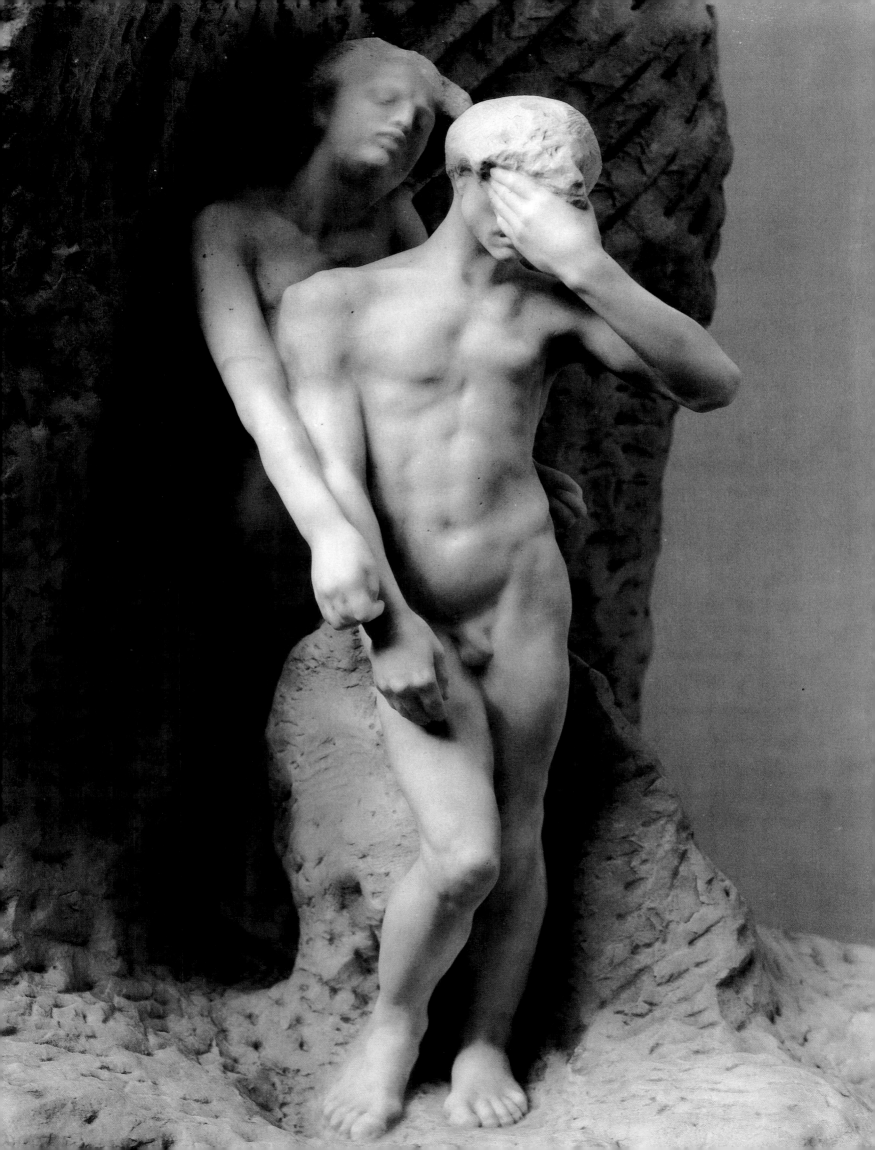

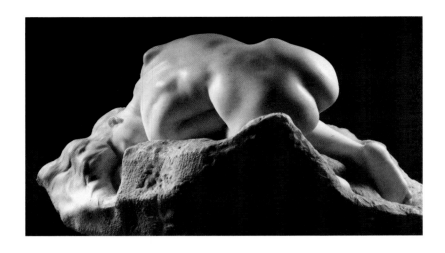

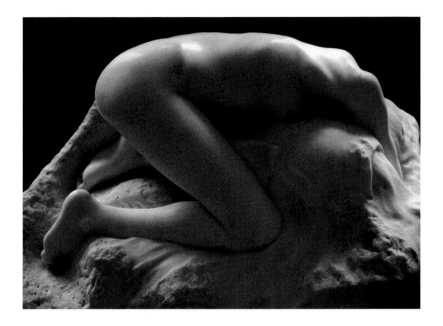

30

Danaid · *La Danaïde*
1889-90

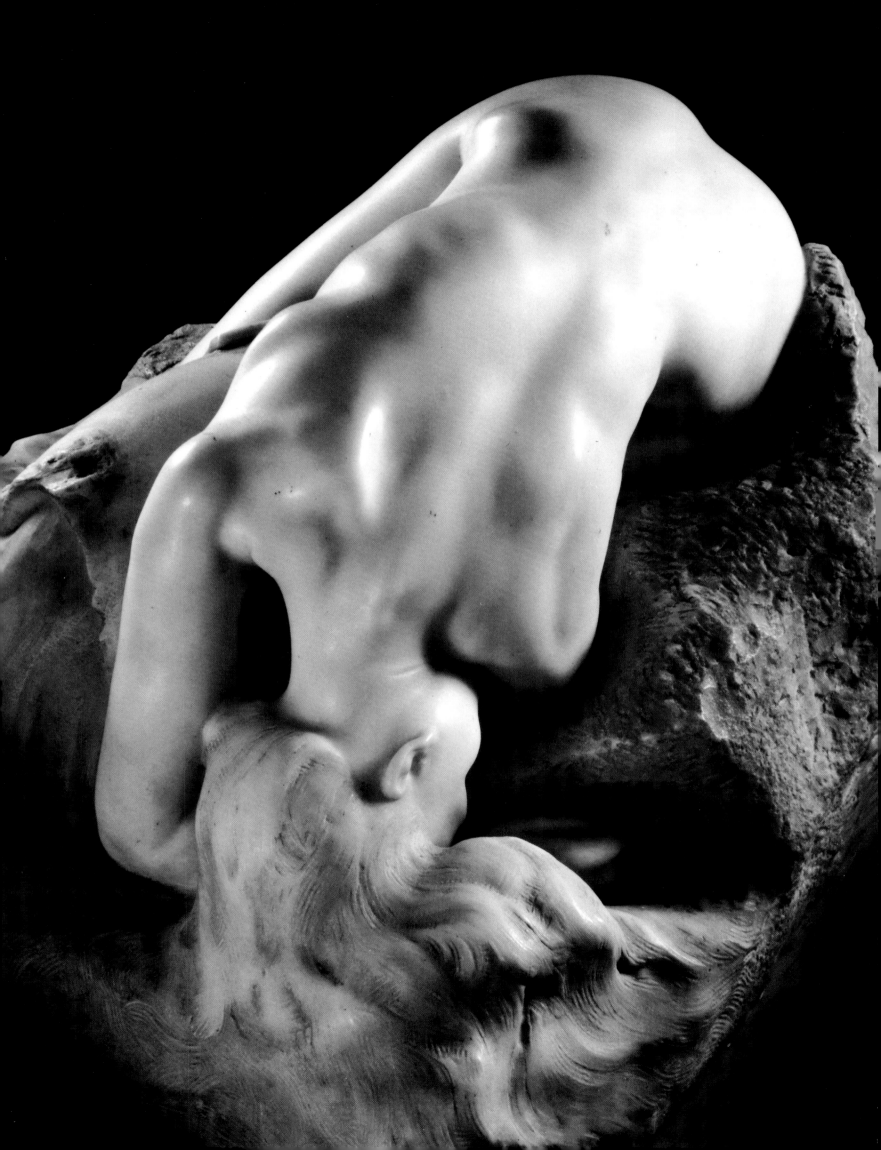

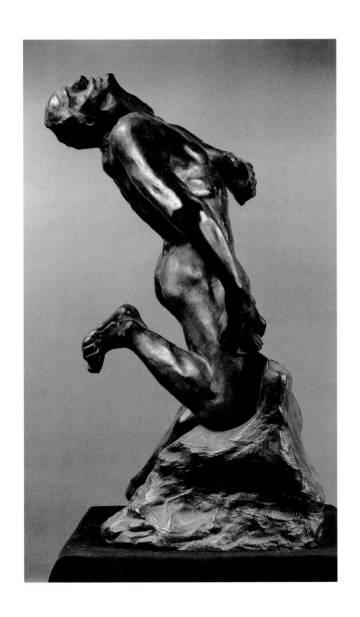

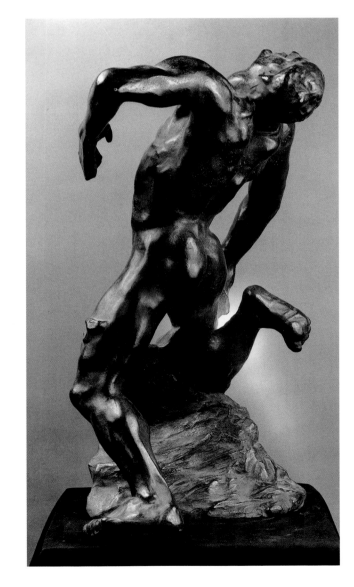

31

Falling Man
L'Homme qui tombe
1882

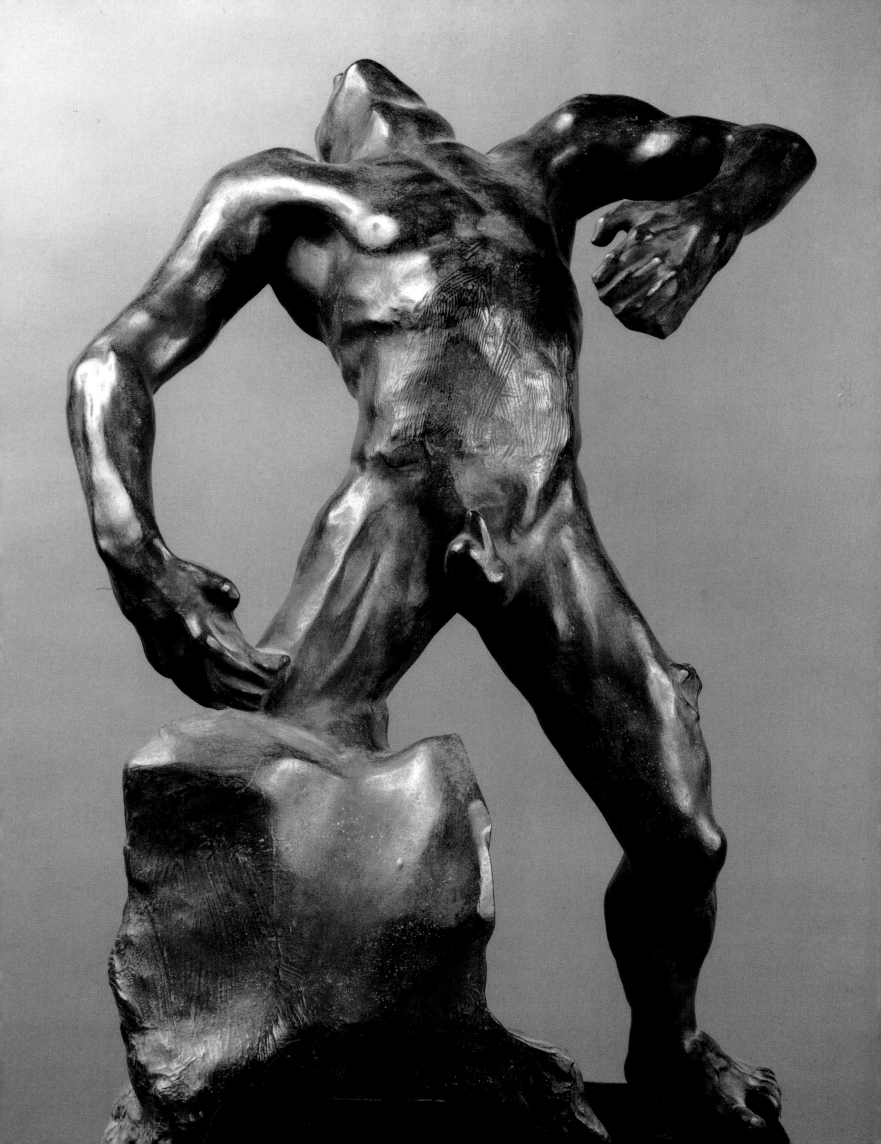

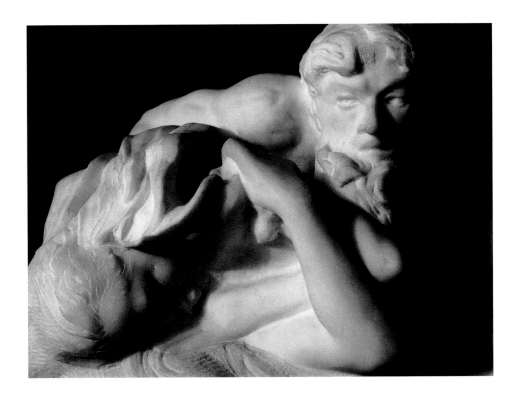

32

Psyche-Springtime · *Psyché-Printemps*
1886 (?)

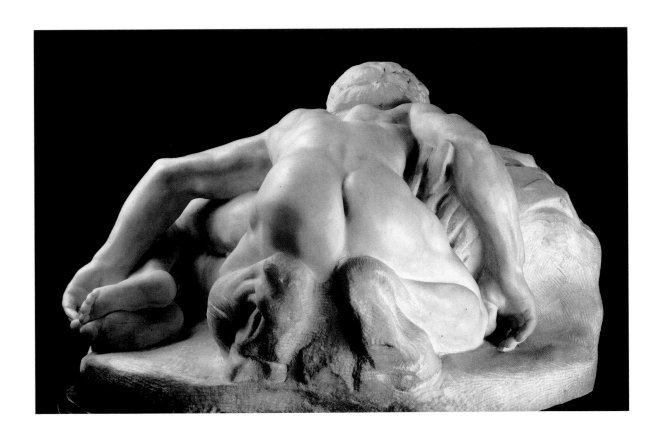

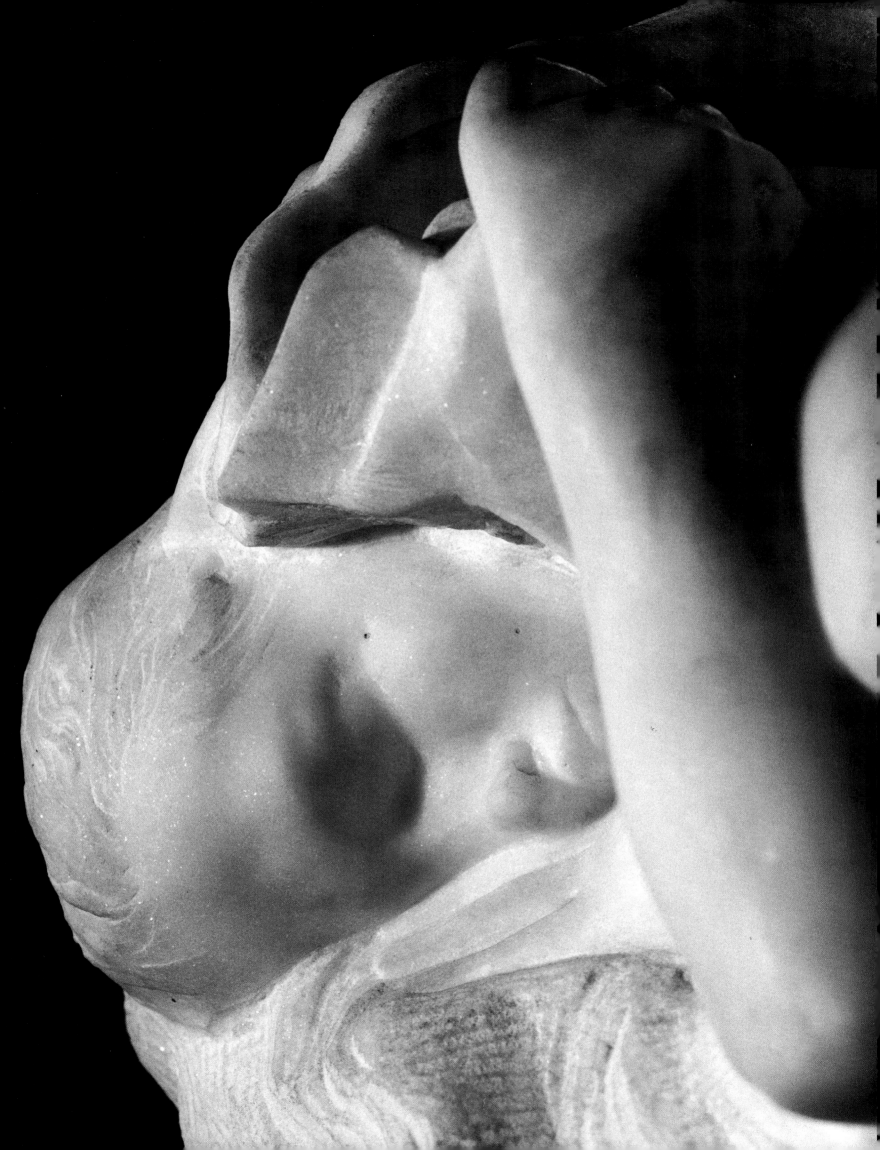

33

Project for the "Monument to Eugène Carrière"
Projet de monument pour Eugène Carrière
1912

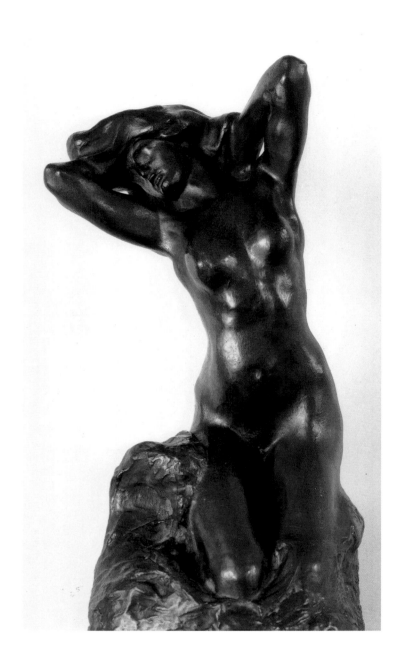

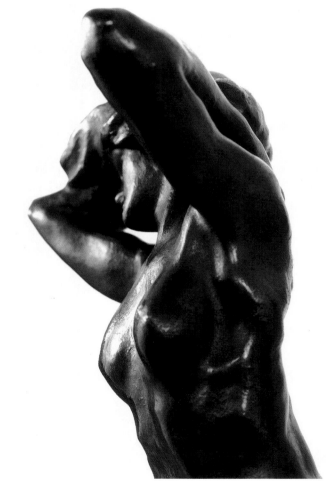

34

Awakening
La Toilette de Vénus
1885

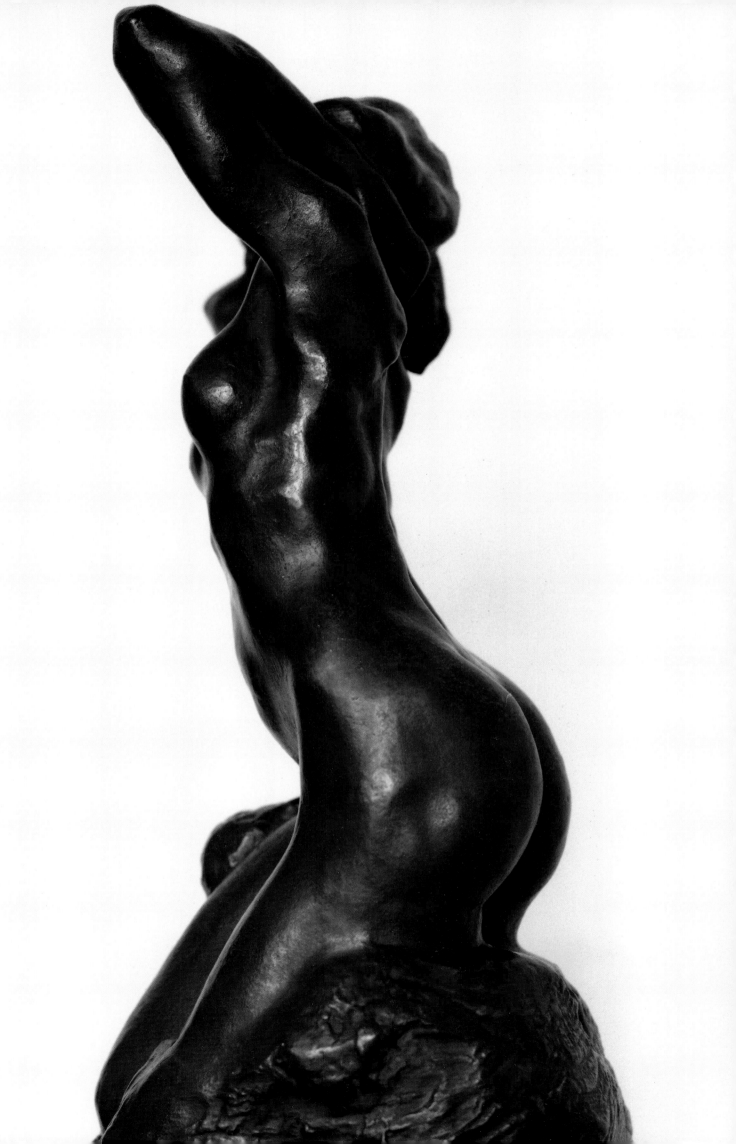

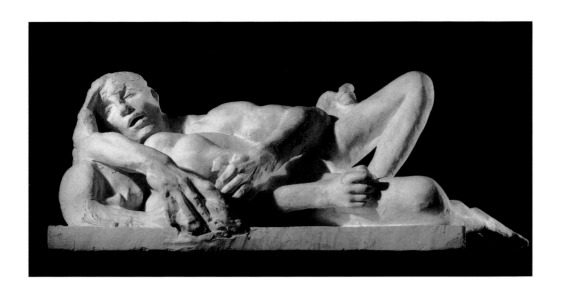

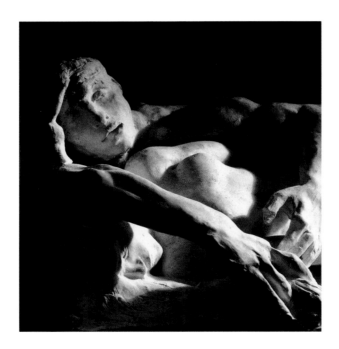

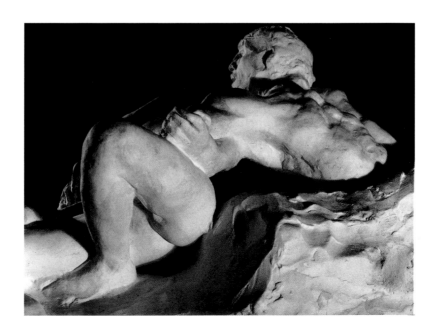

35

Avarice and Lust
L'Avarice et la luxure
1881

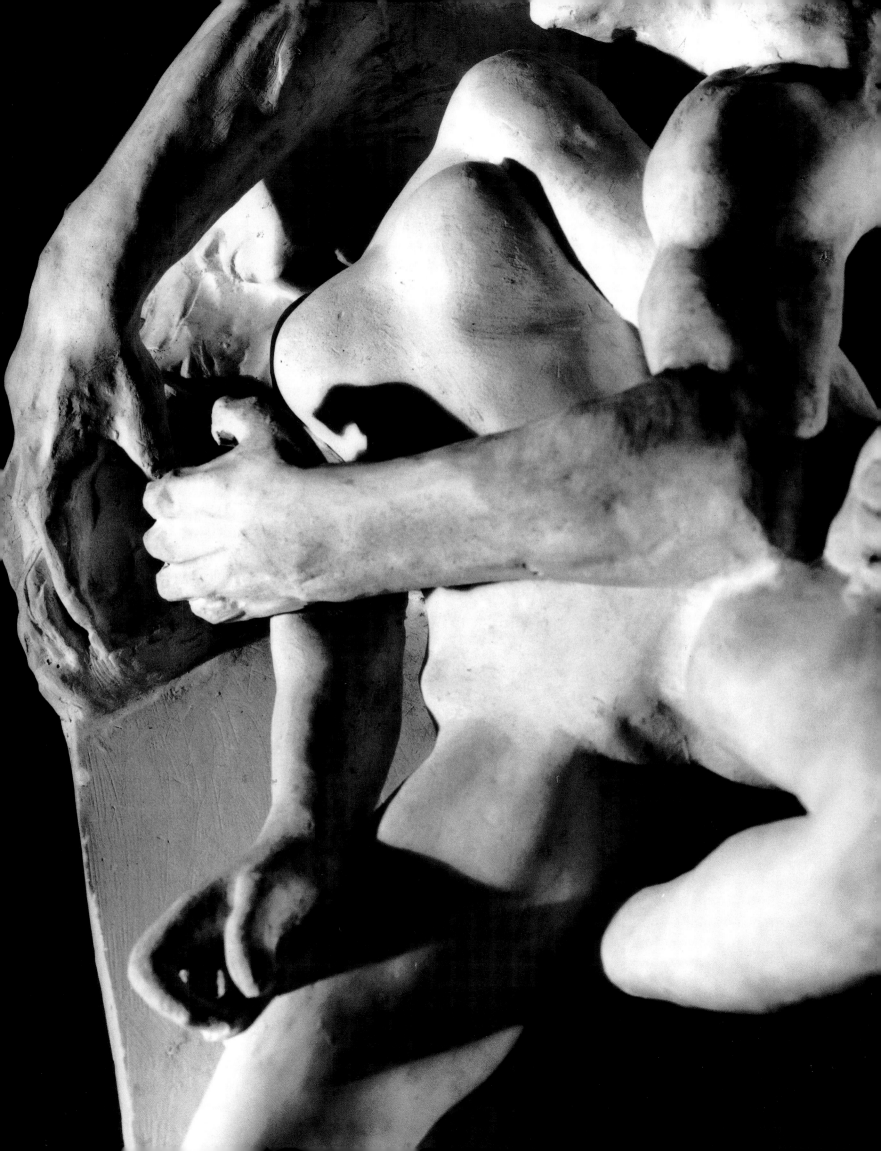

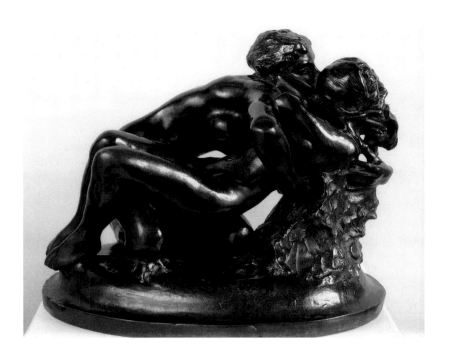

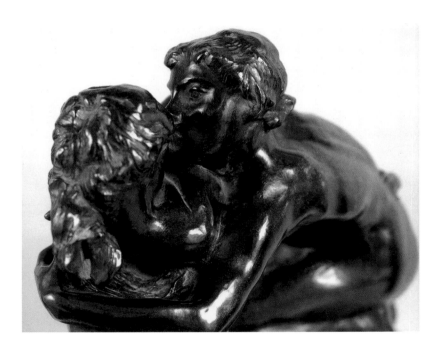

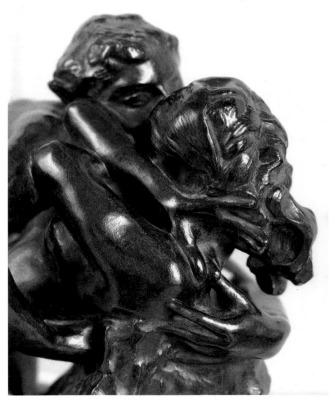

36

The Metamorphoses of Ovid
Les Métamorphoses d'Ovid
c. 1885 (?)

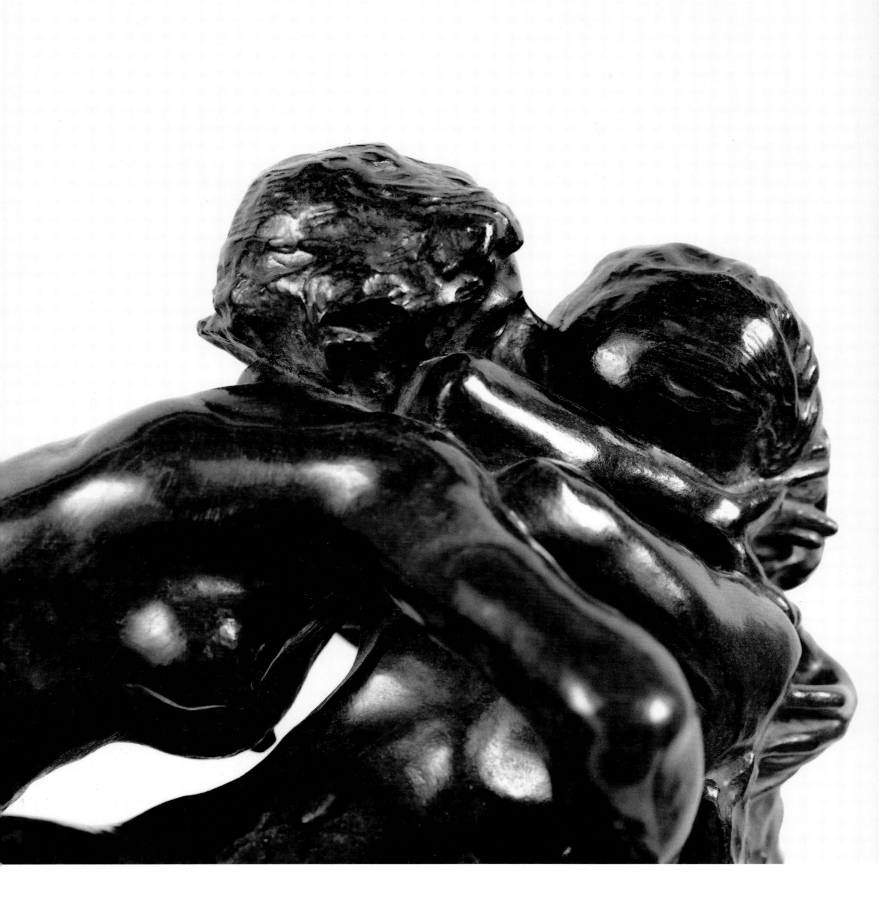

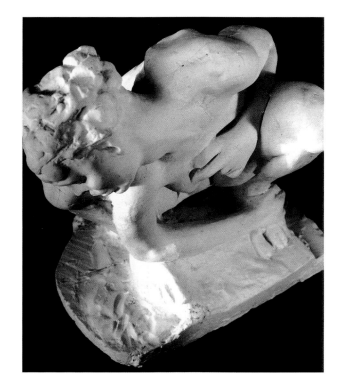

37

The Crouching Woman
La Femme accroupie
1880-82

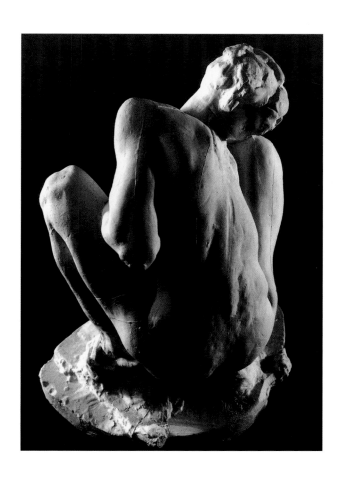

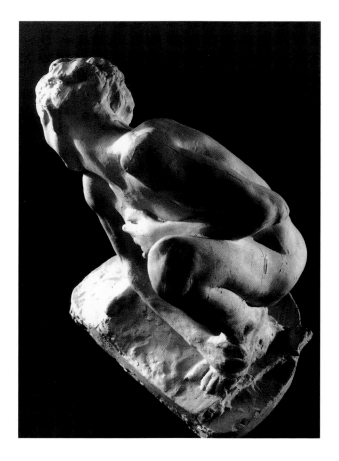

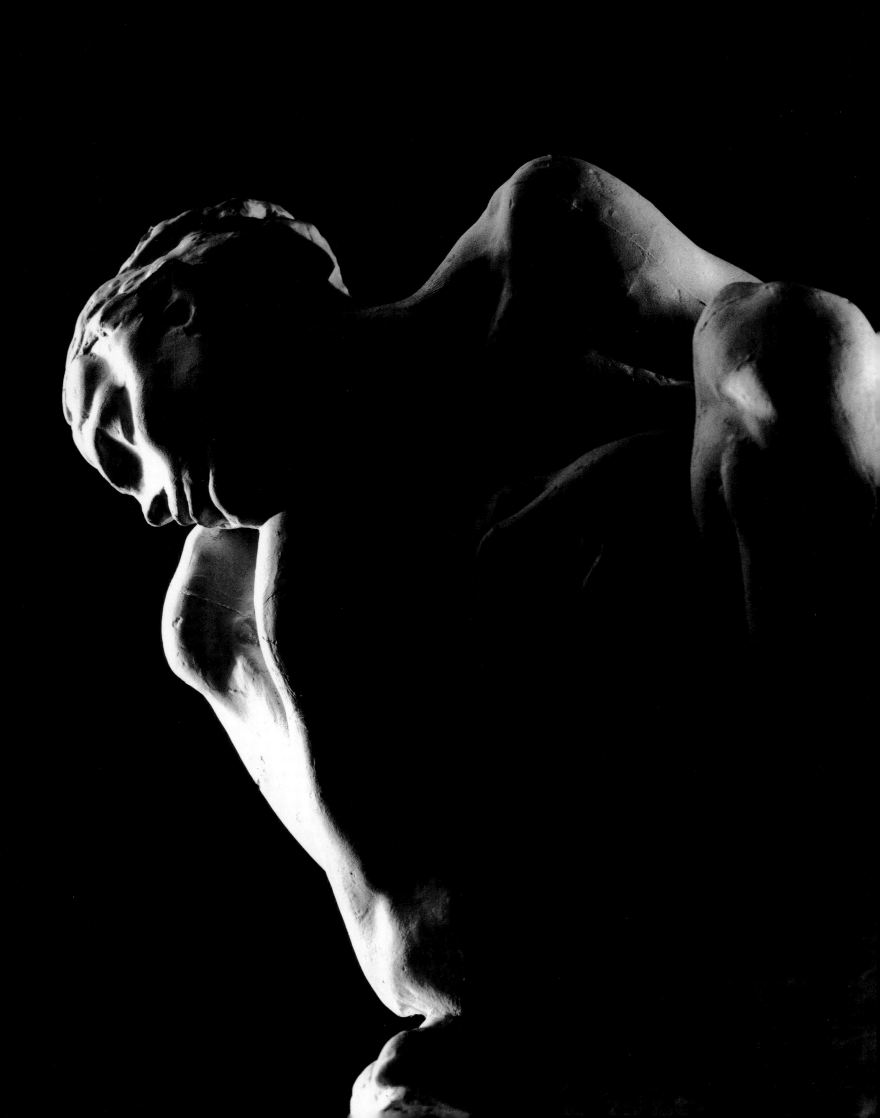

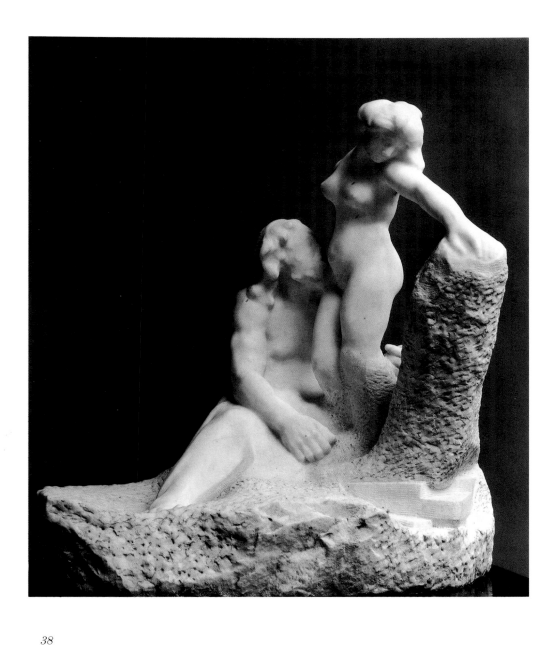

38

Pygmalion and Galatea · *Pygmalion et Galathée*
1908-9

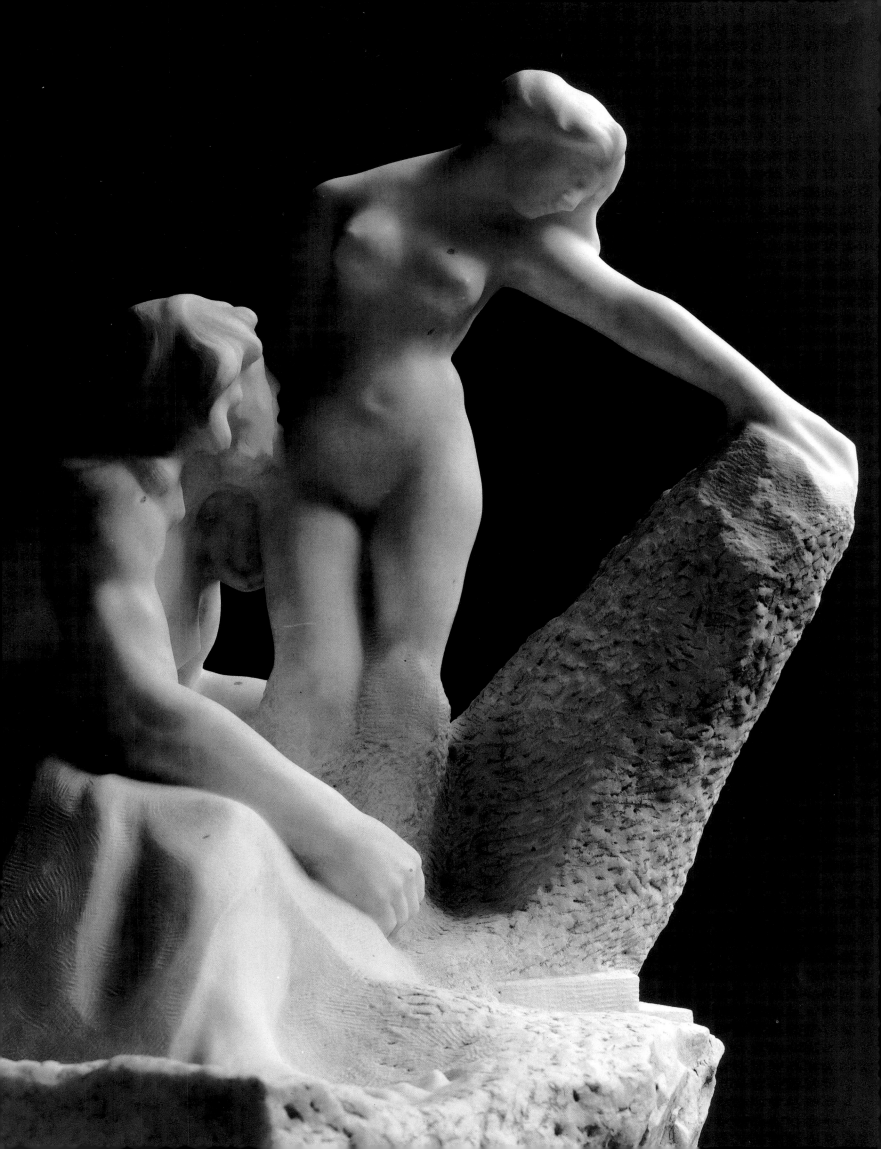

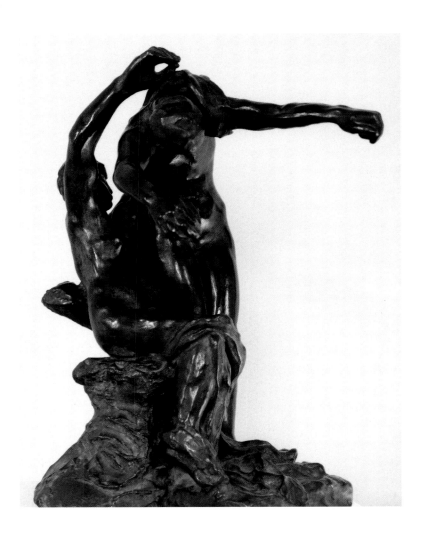

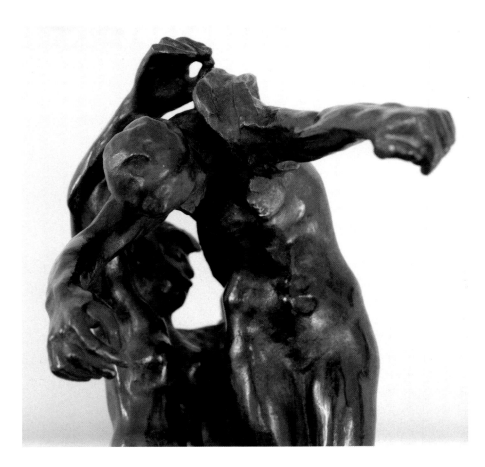

39
Exhortation
1903

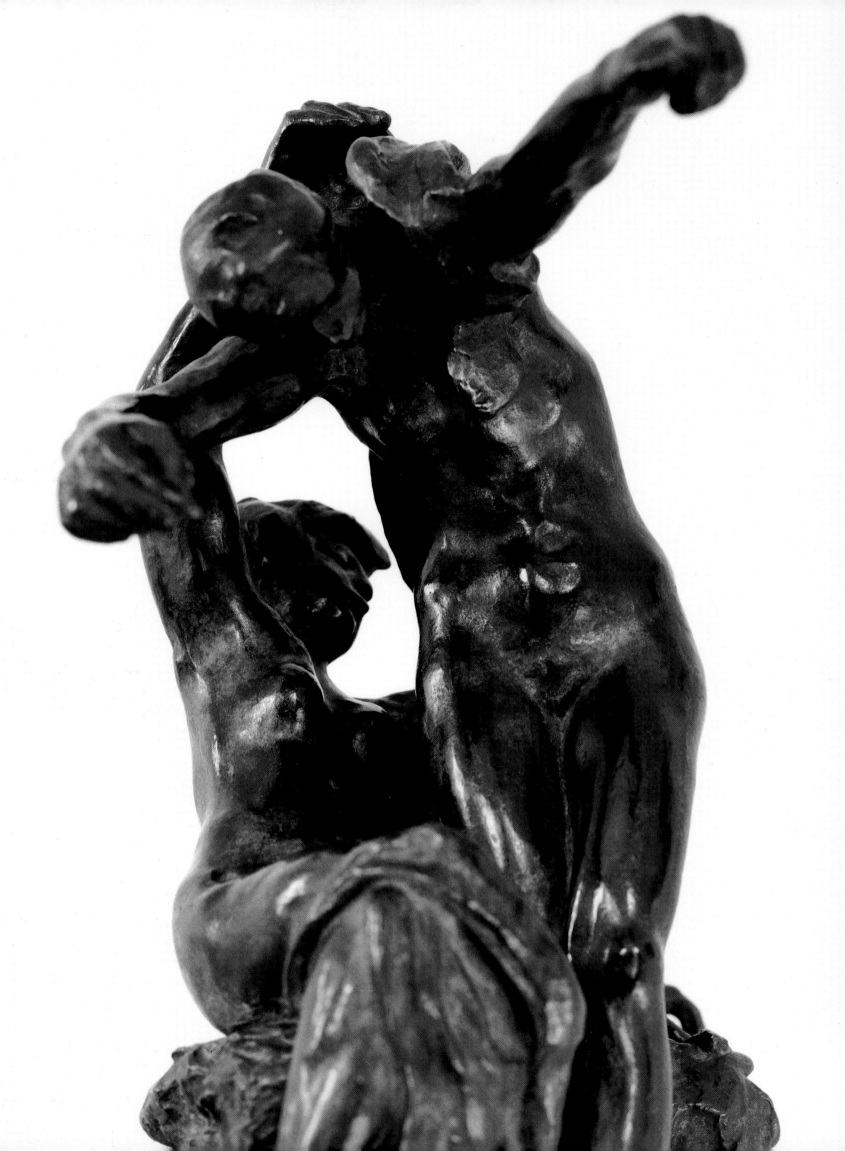

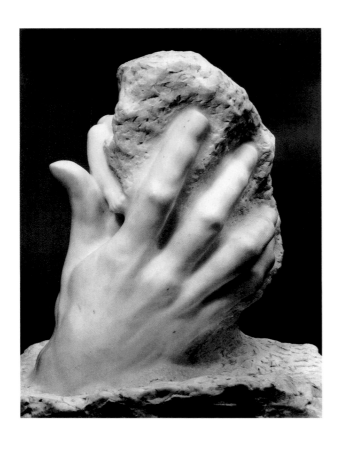

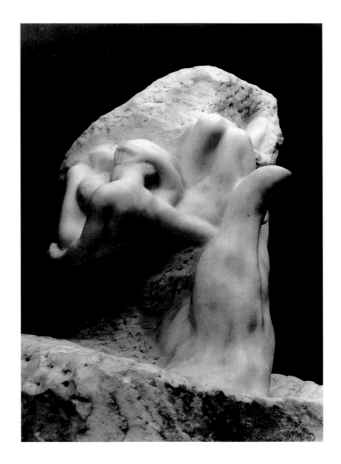

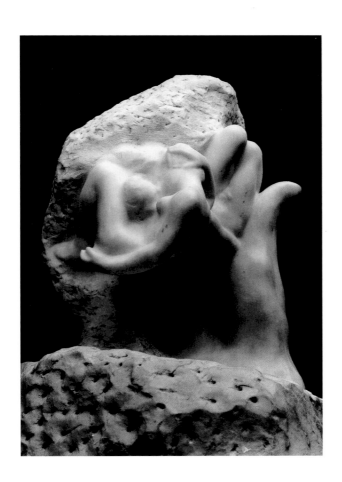

40

The Hand of God
La Main de Dieu
1902-8

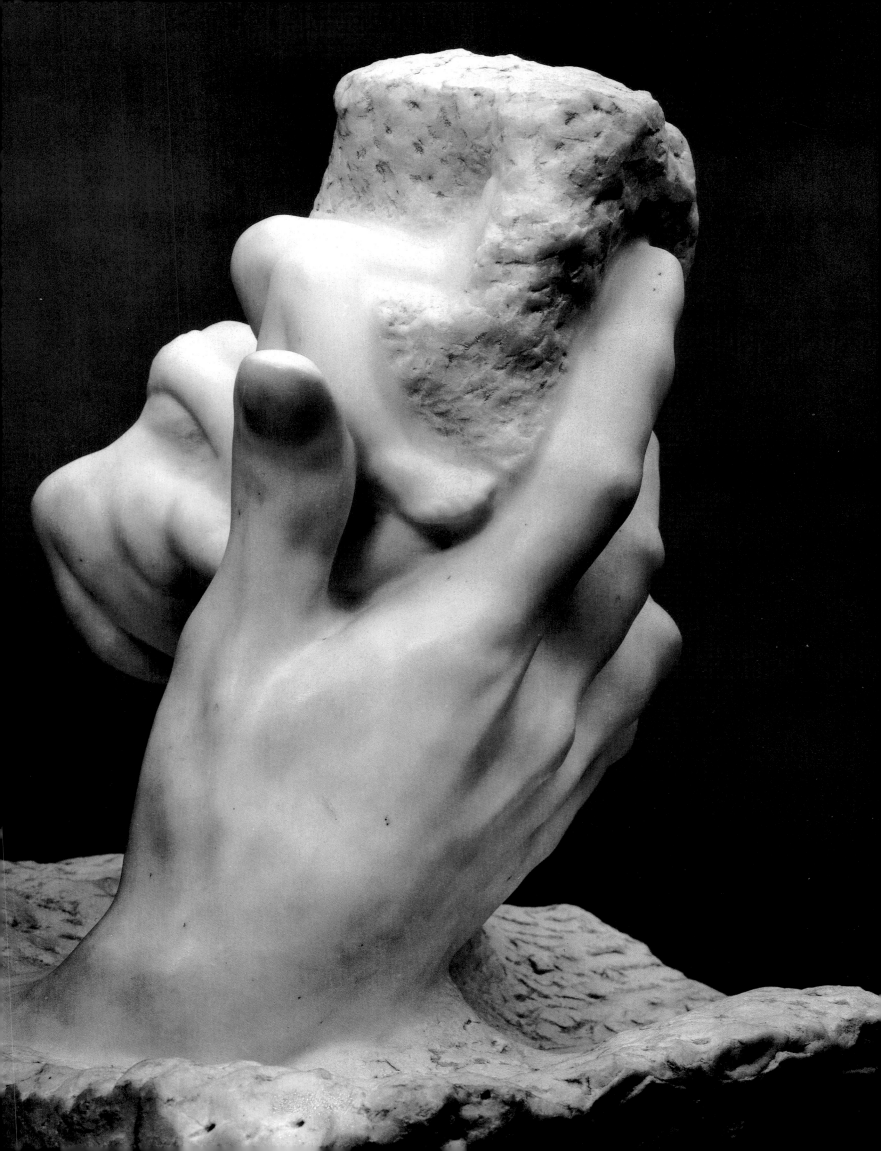

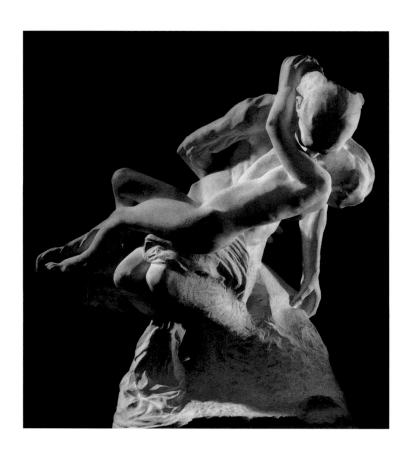

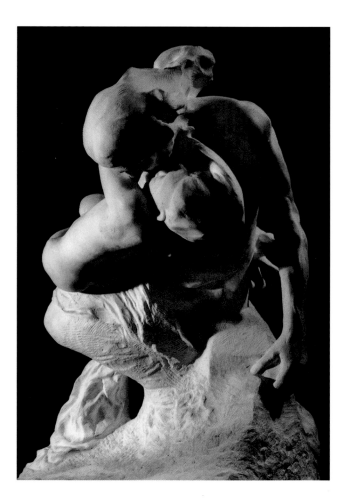

41

Youth Triumphant
La Jeunesse triomphante
1894

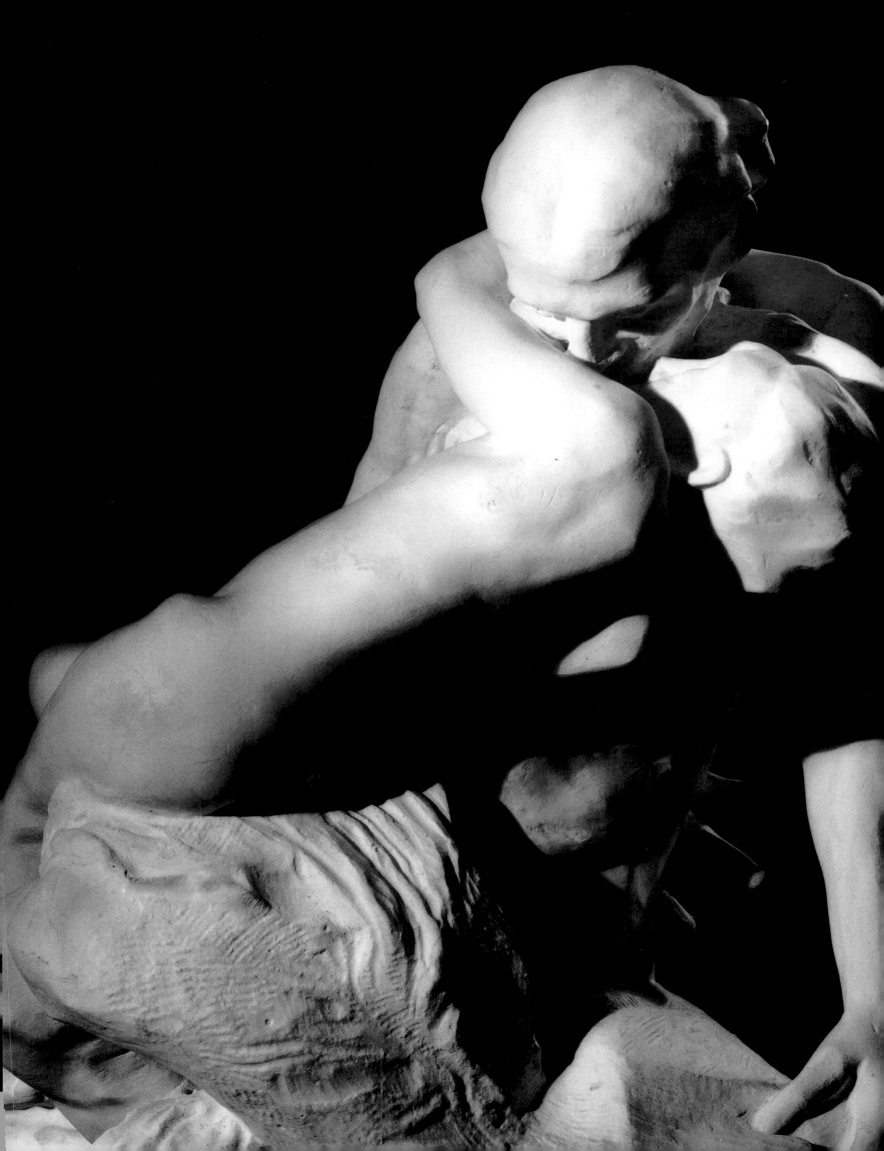

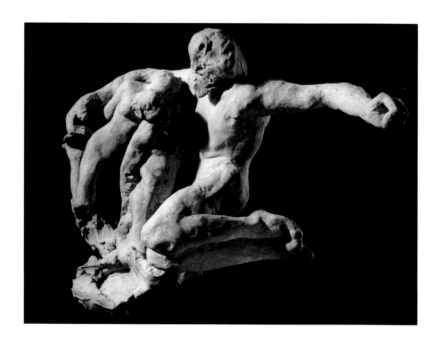

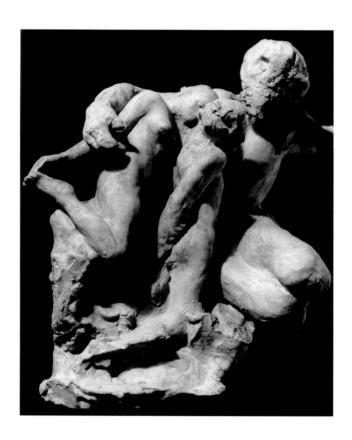

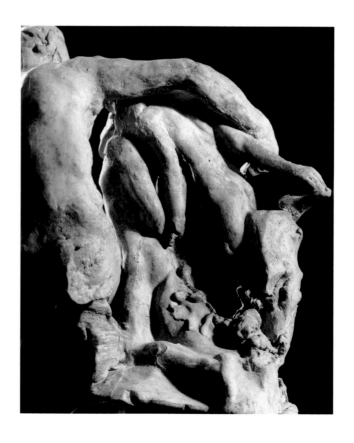

42

The Creation
La Création
date unknown

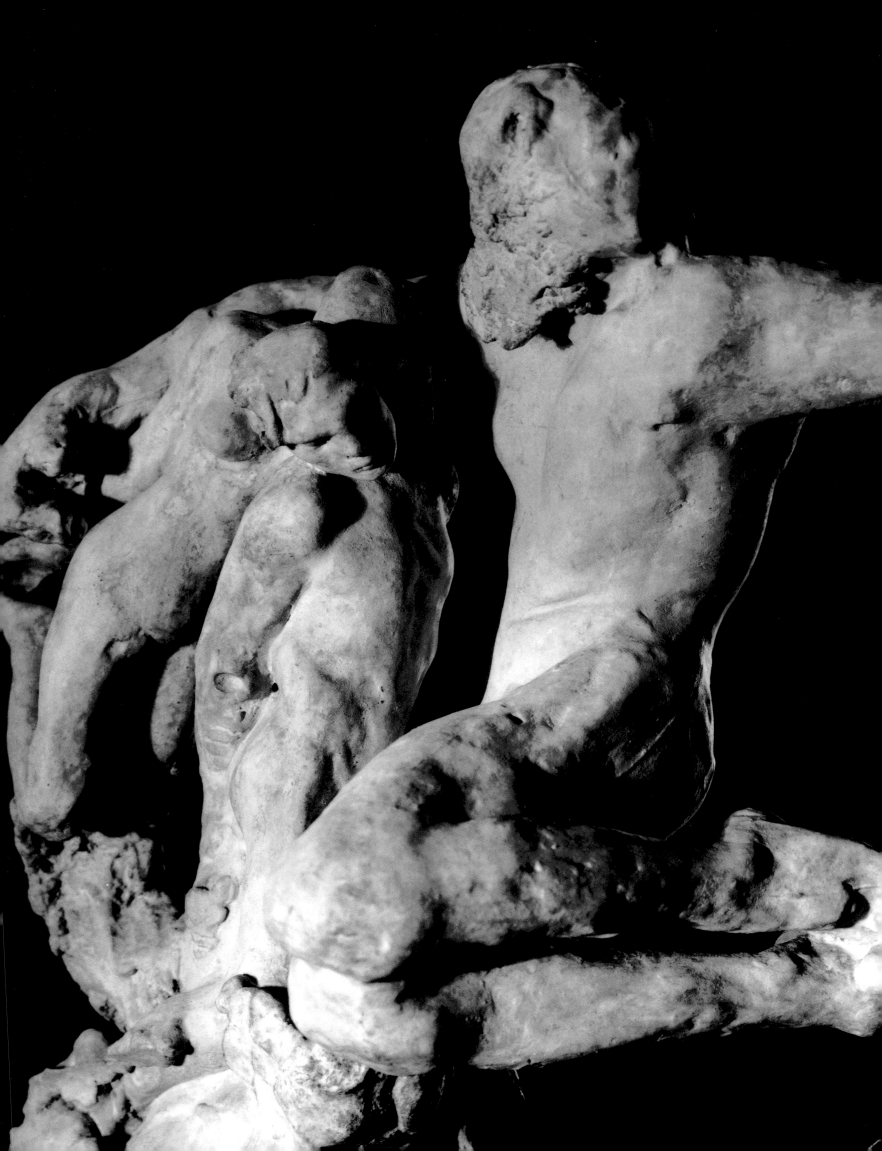

43

Jean de Fiennes
1885
(right)

Jean de Fiennes
(second maquette)
1885
(below)

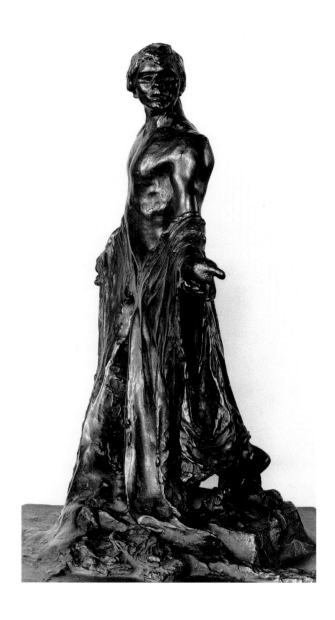

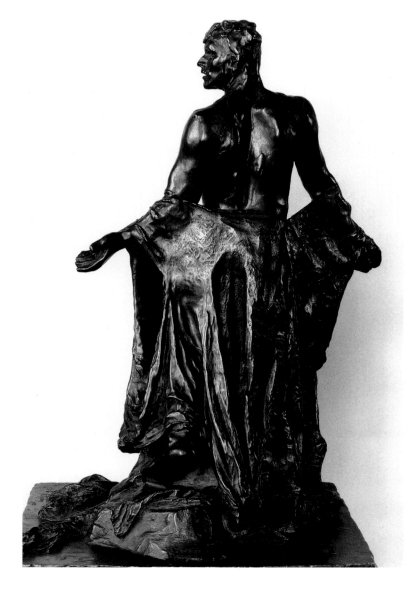

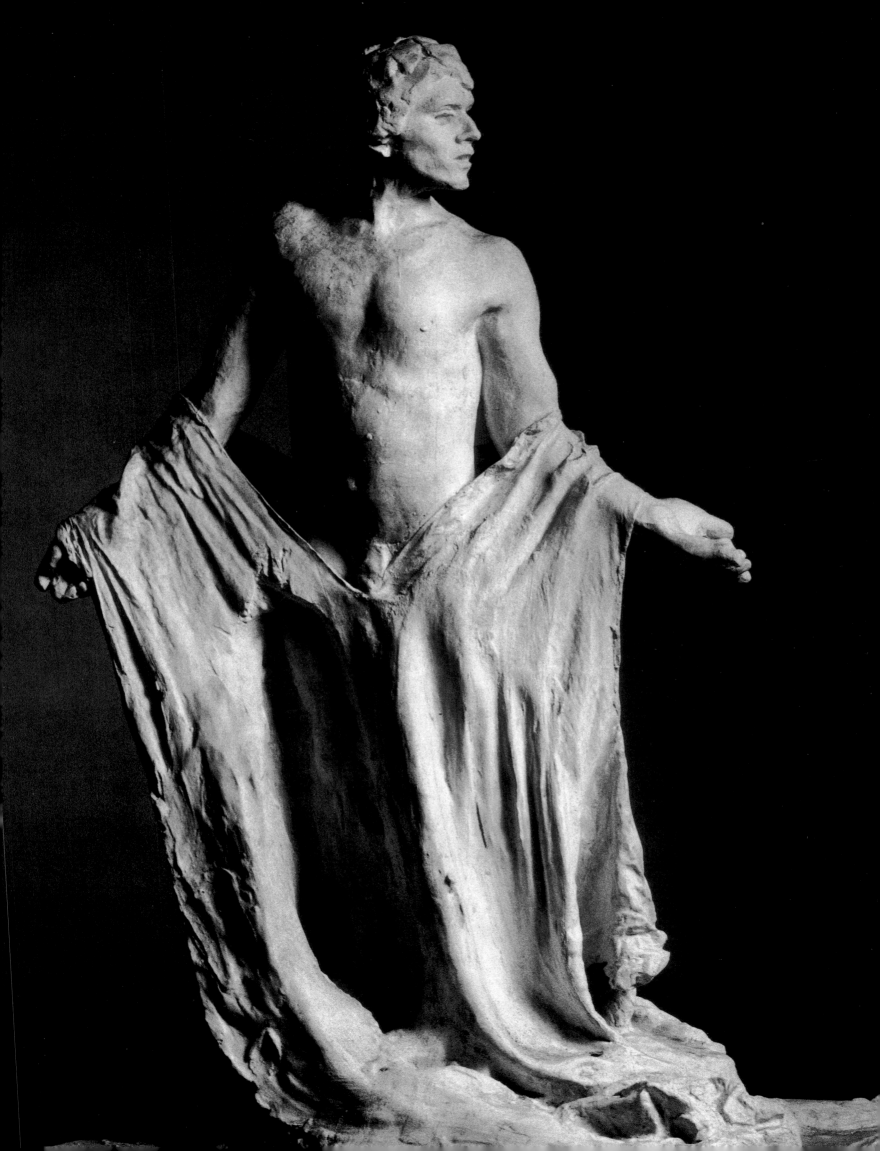

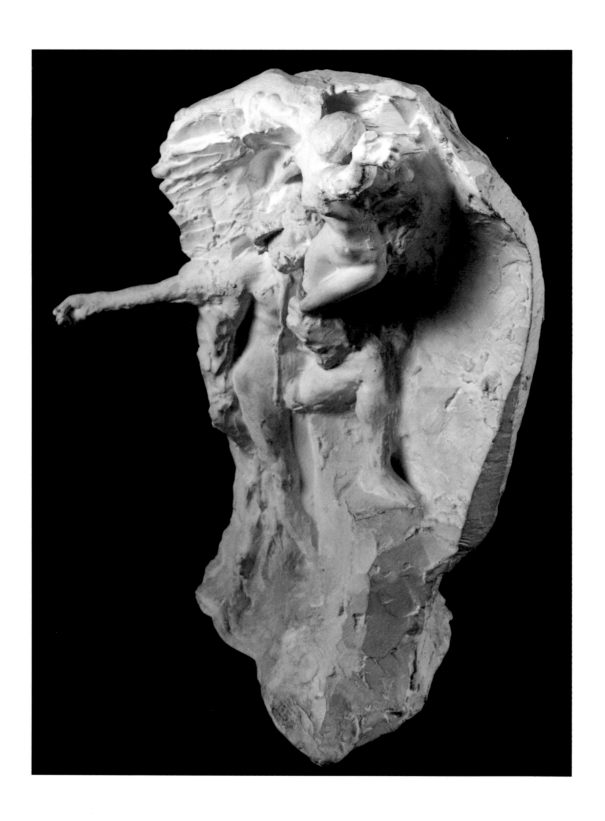

44

The Poet and Love
Le Poète et l'amour
c. 1896

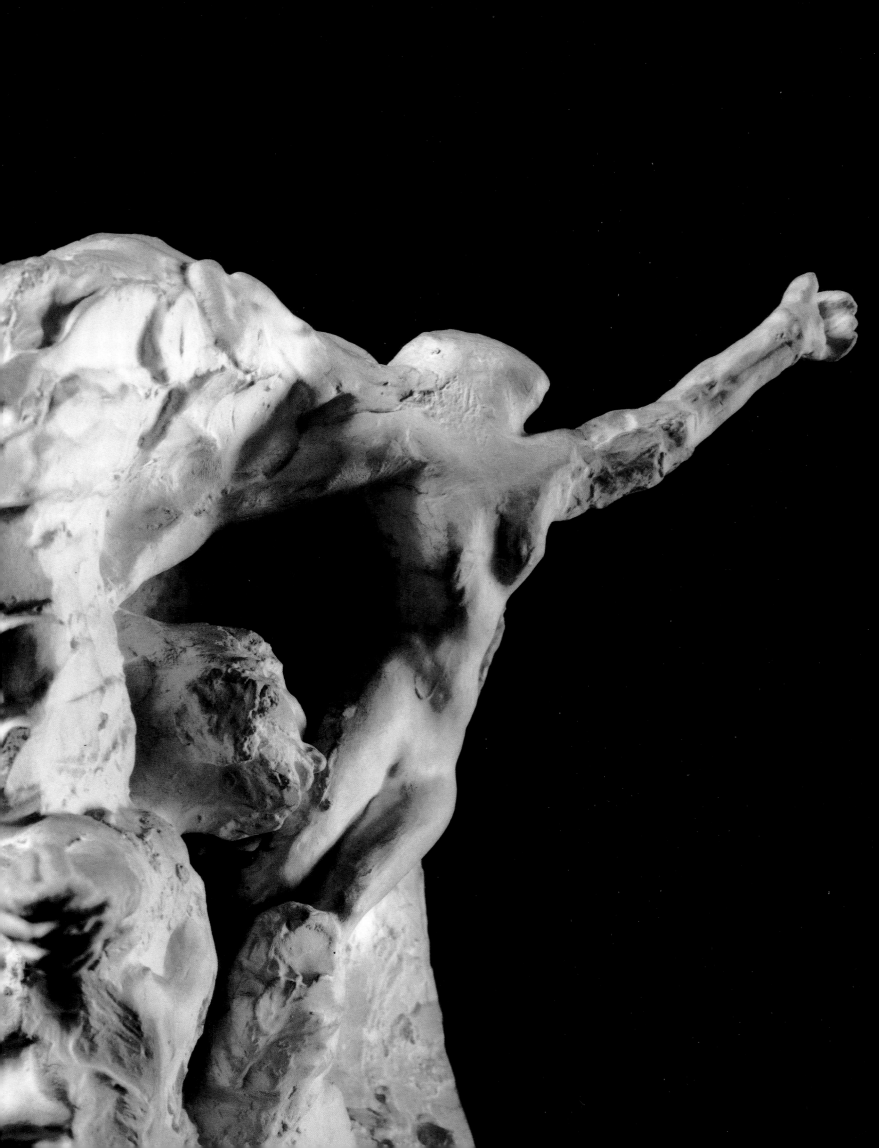

Claudie Judrin

Rodin's "Scandalous" Drawings

Where does scandal begin? Where does it end? What aroused indignation in Rodin's time would go unnoticed today. We must take into account how people looked at art in the past, without forgetting either our own experience or the fact that each period cultivates its particular scandals and forms its own criteria as to what is excessive, titillating, or merely indecorous.

Rodin as Seen by his Contemporaries

As far as audacity is concerned, the sculptor of *The Kiss* (plate 13) was more ahead of his times than the sketcher of the erotic drawings. Dante and his *Inferno* may often have inspired Rodin's pencil, but the embracing couples of the 1880s are unsexed, and it is difficult to distinguish Paolo and Francesca from Dante swooning in Virgil's arms. Rodin, surrendering totally to his imagination, does not see the bodies of his models in the ink hatching of his drawings.[1]

Success finally came to the artist around 1900. At the same time, he began to manifest a strong attraction for women and their bodies, which he now dared to indulge as much as he wished, with money and glory acting as a double lure. With the publication of the *Album Fenaille* in 1897, the series of romantic, "black" drawings came to an end, and the person of Octave Mirbeau, who had written the preface to the *Album*, ushered in a new era: Dante's *Inferno* gave way to Mirbeau's *Le Jardin des supplices* (The Torture Garden). Rodin's figures basked in the broad light of day and generous applications of light-colored wash. The artist no longer held back. The "Damned Women" that he drew in the corner of a page of Baudelaire's *Les Fleurs du mal* for the collector Paul Gallimard became the model for the "Sapphic Couples" (see plates 46, 54, 72, 73) whose praises were sung by Pierre Louÿs and Renée Vivien.[2] Enthralled by the female form, Rodin would draw two, sometimes even three figures on a single sheet (see plates 65, 63). The titles he insisted on giving them, or having his friends give them, speak for themselves. We can follow them from exhibition to exhibition,[3] starting in 1907 at the Galerie Bernheim, where his drawings first won acclaim: *Sappho, Faunesses, Temple of Love, The Embrace, Glorious Possession, The Girlfriends, The Caress, Maenad, Eros, Female Satyr, Bacchante, Amorous Struggle, Kissing, Lust, Breasts, La Culotte*, and so forth. In 1908 Rodin sent forty-nine drawings of Psyche (see plate 68) to Hugo Heller's Kunstsalon in Vienna. In his eyes, this mythic figure from Apuleius' *Golden Ass* presented a strange blend of modesty and daring, of divinity and sensuality. Rodin's skilled hands endowed the boldest poses with a natural appearance. Erotic or mythological themes, such as the Serpent coiling around Eve (plate 66),[4] the Swan embracing Leda, Danaë receiving the Shower of Gold (plate 53),[5] witches astride brooms,[5] or the ram's fleece on a female Satyr's legs,[6] were so many opportunities to reveal woman in her various guises and to show her in every possible pose.

How were these drawings greeted by the public in France and elsewhere?

Curiously enough, no reference was made to indecency in the reviews of the 1899 exhibitions in Brussels and Rotterdam, or at the Pavillon de l'Alma in Paris in 1900. Catholic and Protestant critics, however, began to voice their indignation in, respectively, Rome in 1902 – "lewd, embracing human bodies making disgusting gestures"[7] –

and especially in 1906 in the aristocratic town of Weimar, where Rodin's drawings caused a veritable scandal. The story of the latter is worth retelling as an example of the prudishness that prevailed among the public of the time.[8]

Count Harry Kessler, director of the Grand Duke's museum at Weimar, had been responsible for the awarding of an honorary doctor's degree to Rodin by the University of Jena. In the artist's Meudon studio, he selected fourteen drawings that were to be presented to Grand Duke Wilhelm of Saxony-Weimar. These works were somehow mislaid in the studio, and Rodin himself made a second choice of drawings, which were presented to the Weimar museum in June 1905 for an exhibition that was to be held from January through March of the following year. Thirteen of these drawings are still in the town's museum; the fourteenth seems to have remained in the Grand Duke's family. It was a prestigious gift indeed, for certain drawings had been shown in Paris in 1900: for example, the crouching nude seen from behind that originally bore the dedication, "In homage to His Royal Highness, a series of drawings: Auguste Rodin." Another drawing, depicting two female figures, had been used by Rodin in his illustrations, lithographed by Auguste Clot in 1902, to Mirbeau's *Le Jardin des supplices* as a visual commentary on the sentence, "A splendid creature that I had loved the night before." Others had been on display in Prague in 1902 and in Düsseldorf in 1904. Inoffensive as these drawings may seem to us today, in Weimar they became the target of an outraged attack by the painter Hermann Behmer. On February 17, 1906, he wrote: "The works displayed are so shocking that we must warn our wives and daughters not to visit this exhibition It is insolent of this foreigner to have presented our sovereign with such things, and irresponsible of the organizers to have shown these disgusting drawings."[9] Faced with these charges, however unjustified they may have been, Count Kessler was obliged to resign from his position as head of the museum's administrative board.

In France an outcry was raised over the marvelous color lithographs illustrating *Le Jardin des supplices*: "Lesbianism, frenzy, and paroxysm of sadism – nothing has been left out: the passionate souls of Octave Mirbeau and Auguste Rodin here fraternize."[10] Reviewing the exhibition at the Galerie Bernheim in 1907, one critic noted that each vignette in the book featured a "woman showing her —."[11] Another wrote in 1910 of the "mystical, desperate poem of the flesh, a flesh crazed for action, clutching at the pleasure of its every sensation, writhing with lust."[12] In 1912, on the occasion of an exhibition in Lyons, *Le Salut public* reported that Rodin had "provoked the Archbishop's Palace, for he is a master at exploiting scandal with ... studies of nudes, nudes of a kind that those who attempted to sell them openly would certainly be accused of dealing in pornography – and by the very people who have organized this exhibition."[13]

Rodin as Seen by our Contemporaries

This vehemence surprises us today as much as the innocence of the works that caused such a storm of indignation. Roughly one hundred drawings were listed in the inventory of the Musée Rodin under the heading "private collection" or "musée secret," although only about ten deserve the label "erotic" – and these were completely unknown to Rodin's contemporaries, as were his paper cutouts. The manifestations of his daring, of his curiosity about the more intimate parts of female anatomy that developed in his old age – these he kept tucked away in his portfolios.

One such drawing (Fig.1), drawn on letterhead paper from 77, rue de Varenne in Paris (the Hôtel Biron, part of which Rodin rented from 1908 onward), may be dated with certainty to the 1910s.[14]

Ten drawings out of some eight thousand: is that enough to warrant so scandalous a reputation, one that persists even today?

Unfortunately, forgeries may be responsible in part for this state of affairs. Odilon Roche, the Musée Rodin's commercial agent from 1919 through 1926, cleverly exploited the erotic vein in the fake drawings with which he flooded the European art market.

There also seems to be confusion in the public's mind between form and content, style and subject matter. Genius is bold by nature, for it creates a new language. The truth is that, today as in the past, people have difficulty in accepting works of art that seem carelessly executed, present an unfinished appearance, disregard traditional academic standards. It takes a long time for them to recognize precisely what it is that disorients them. Crudity is in the manner of saying something, not in the thing said, and art is never indecent. On this point there is no better spokesman than Rodin himself: "And Dance, which has always had the prerogative of eroticism in our society, is today finally beginning to be considered a worthy adjunct to the other arts, of which it is the distillation. In this, as in other expressions of the modern spirit, women are responsible for the renewal."[15] Manet's *Déjeuner sur l'herbe*, after all, was only Giorgione's *Concert champêtre* adapted to nineteenth-century taste, and *The Kiss*, too, was not without its antecedents. Yet as late as 1910 Rodin still feared that his contemporaries would misunderstand his drawings: "What I say here is in no way intended to lead to the noisy promotion of my drawings. On the contrary, they should be gently protected so that the public will not be roused to indignation."[16] The present-day viewer of Rodin's drawings would do well to bear these words in mind.

Fig. 1 *Hand on Genitals*, 1910-20. Pencil on paper, 7¹⁄₁₆ x 5³⁄₁₆″ (18 x 13.2 cm). Musée Rodin, Paris (D. 6048)

Notes

1 A drawing in Philadelphia is particularly instructive in this regard: *Couple Embracing*; pencil, ink, and gouache, 6⁵⁄₁₆ x 3⁹⁄₁₆″ (16 x 9 cm); Rodin Museum, Philadelphia Museum of Art.

2 Several drawings in the Musée Rodin are inscribed "Bilitis," a reference to Louÿs's *Chansons de Bilitis*. Rodin sculpted a marble bust of Vivien in 1904.

3 *Les Dessins de Rodin*, Paris, Galerie Bernheim, October 10-30, 1907; *Great Modern French Masters*, Budapest, National Salon, December 3, 1907; *Zeichnungen und Radierungen*, Vienna, Kunstsalon Hugo Heller, January 1908; *Dessins de Rodin*, Paris, Galerie Devambez, October 19-November 5, 1908.

4 See also *Woman and Snake*; pencil and watercolor, 12⅝ x 9¾″ (32.1 x 24.8 cm); The Museum of Modern Art, New York.

5 *Sabbath*; watercolor and pencil, 12¹³⁄₁₆ x 9¾″ (32.5 x 24.8 cm); Metropolitan Museum of Art, New York.

6 *Female Satyr*; pencil, 9¾ x 15½″ (24.8 x 39.5 cm); Metropolitan Museum of Art, New York (apparently acquired by Alfred Stieglitz at the exhibition held at the 291 gallery, March 31-April 18, 1910).

7 Luigi Callari, "Exposition: Blanc et noir," *Le Monde catholique illustré*, November 30, 1902.

8 The present account is based on that by Claude Keisch, in *Rodin*, exhibition catalogue (Berlin, Staatliche Museen, Nationalgalerie, May 16-August 12, 1979), p. 68 ff.

9 *Ibid.*, p. 69.

10 Louis Vauxcelles, "Salon d'automne de 1905," *Gil Blas*, October 17, 1905.

11 Anon., "Les Dessins de Rodin," *Cri de Paris*, September 29, 1907.

12 Léon de St Valéry, "Gil Blas 1910," *Revue des Beaux-Arts*, October 30, 1910.

13 Anon., "Indécente exhibition," *Le Salut public* (Lyons), May 11, 1912.

14 See also Claudie Judrin, *Musée Rodin: Inventaire des dessins*, vol. 1: *Etude liminaire* (Paris, 1987), pp. XXXVI-XXXVII.

15 Rodin, "Fresques de danses," *Montjoie*, nos. 1-2 (January-February 1914), pp. 1-2.

16 Rodin, in *Rodin*, exhibition catalogue (Paris, Salle des Fêtes du Gil Blas, October-November 1910), p. 16.

45

Female Nude in the Studio
Femme nue à l'atelier

46

Sapphic Couple in Profile
Couple saphique de profil

47

Hand on Genitals
Main sur un sexe

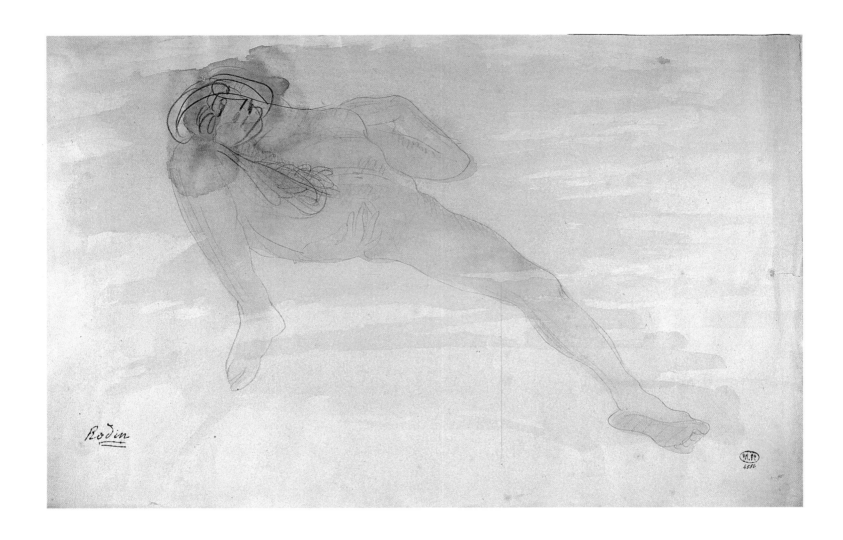

48

Reclining Female Nude, Caressing Herself with Hand under Thigh
Femme nue allongée se caressant avec une main passée sous la cuisse

49

Female Nude in Profile, Back Arched
Femme nue de profil et cambrée

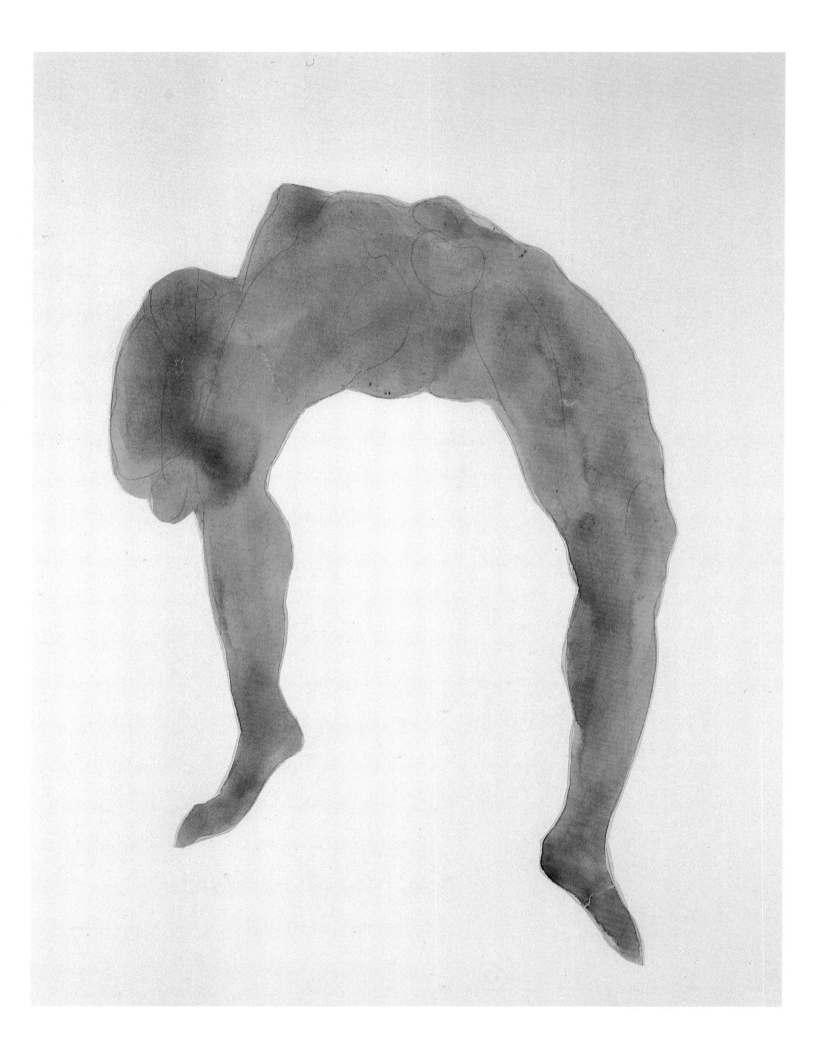

50

Female Nude, Front View, Lying on Back, Legs Spread
Femme nue de face, renversée sur le dos et jambes écartées

51

Seated Female Nude, Arms Raised
Femme nue assise de dos, les bras levés

52 *overleaf*

Female Nude on All Fours, Rear View, Dress Lifted to Hips
Femme à quatre pattes, de dos et le vêtement relevé sur les reins

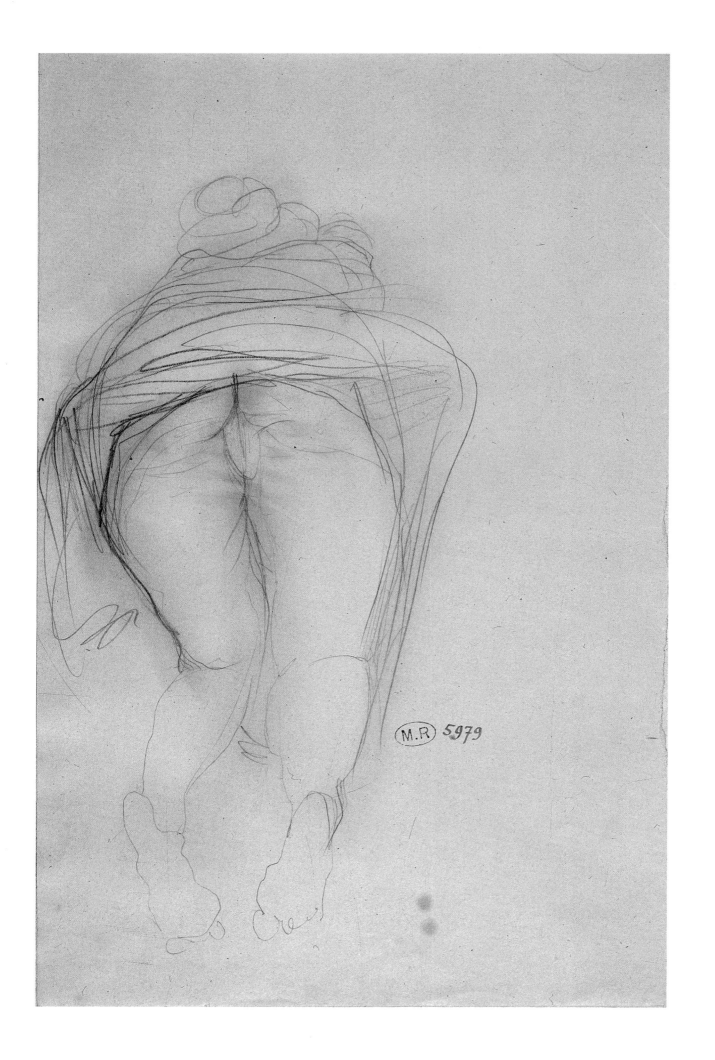

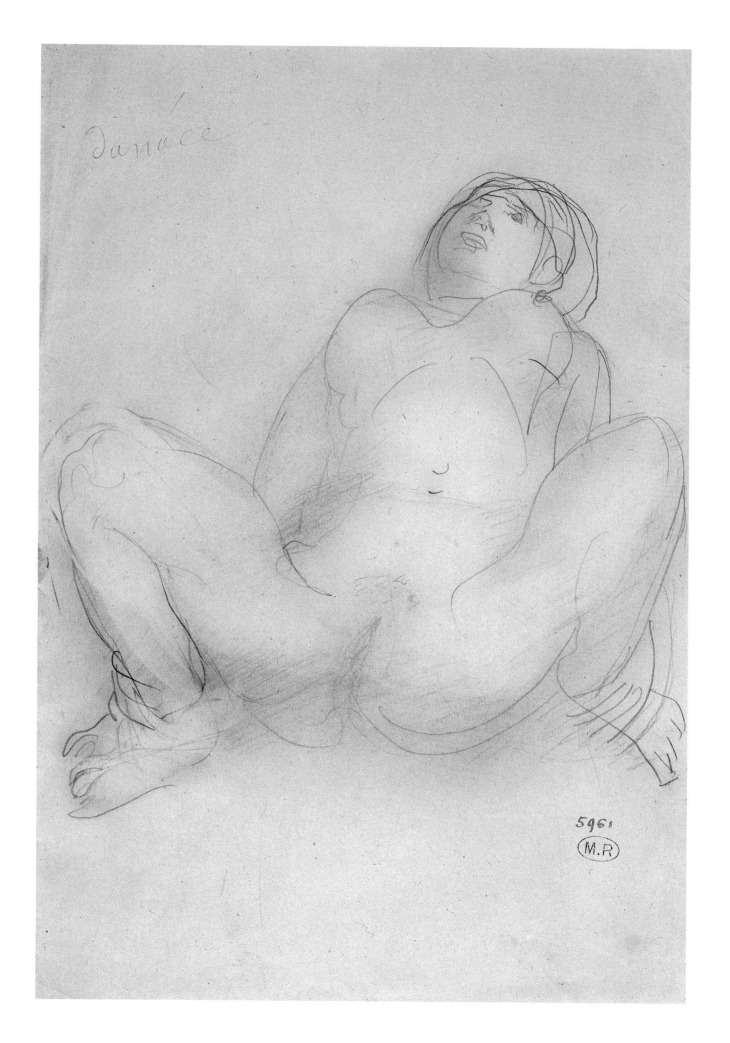

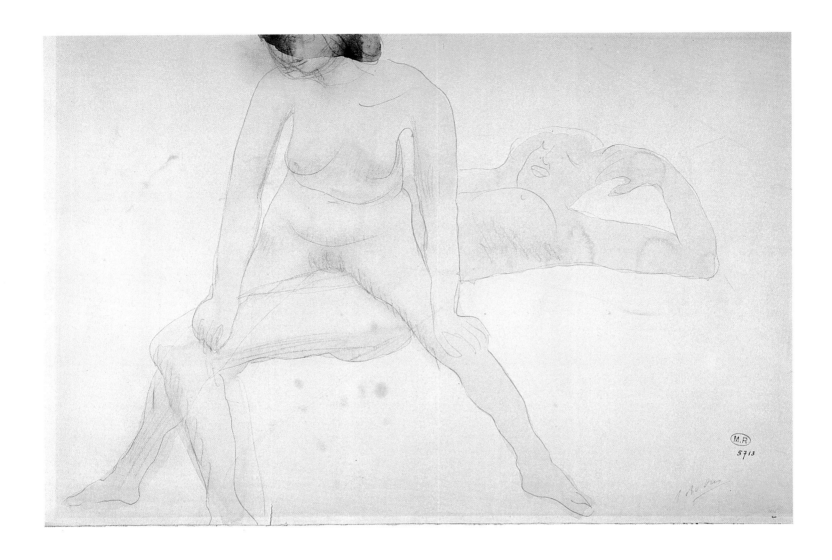

53 *previous page*

Danaë · *Danaé*

54

Sapphic Couple
Couple saphique

55

Reclining Female Nude in Profile,
Leg Raised and Bent
*Femme nue allongée de profil,
une jambe haute et repliée*



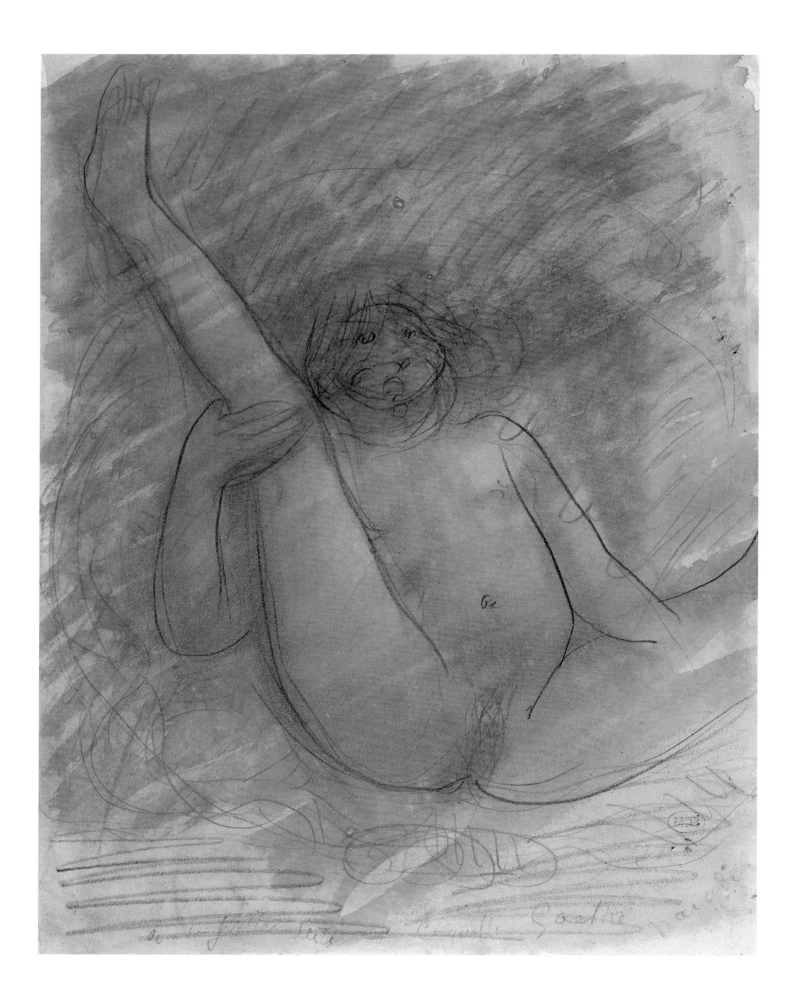

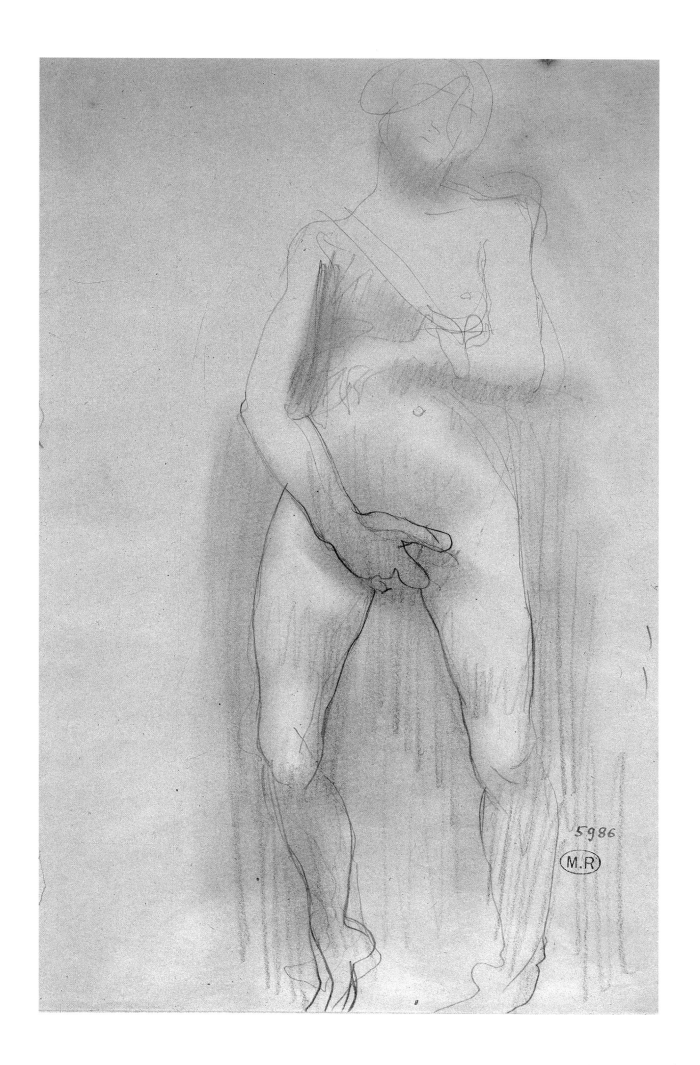

5986

M.R

57 previous page

Standing Female Nude, Hand between Thighs
Femme nue debout, une main entre les cuisses

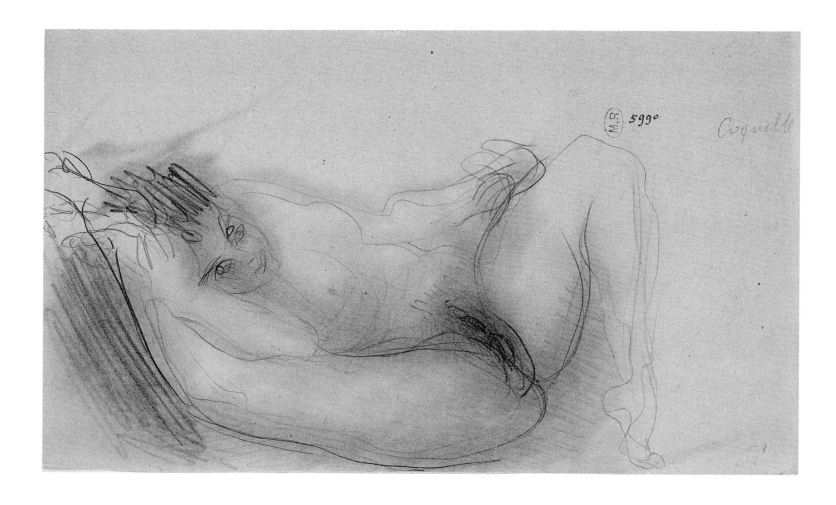

58

Shell
Coquille

59

Two Female Nudes, Arm in Arm, Back to Back
Femmes nues enlacées dos à dos

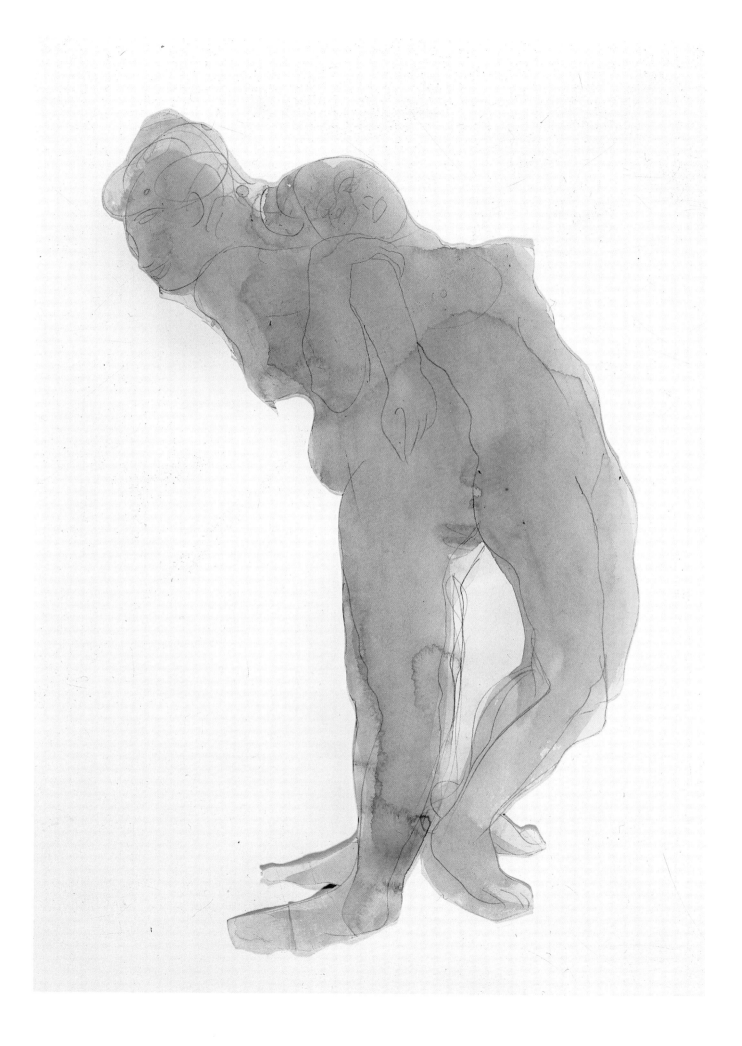

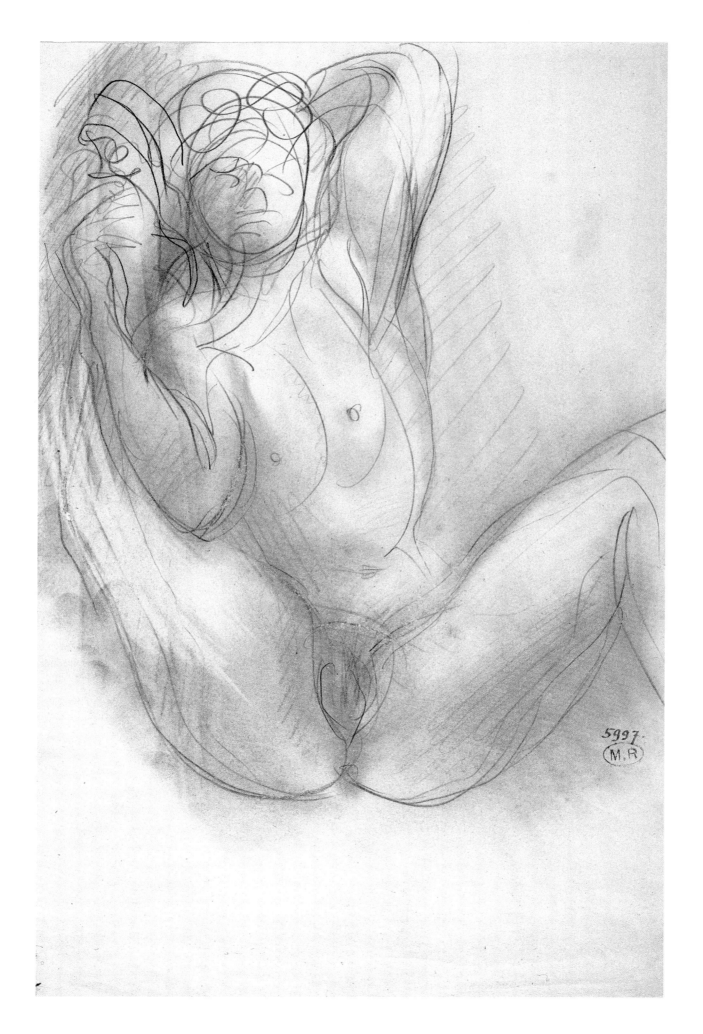

60

Female Nude,
Thighs Spread
and Raised
*Femme nue
maintenant
les cuisses
hautes et
écartées*

61

Kneeling
Female Nude
*Femme nue
agenouillée*

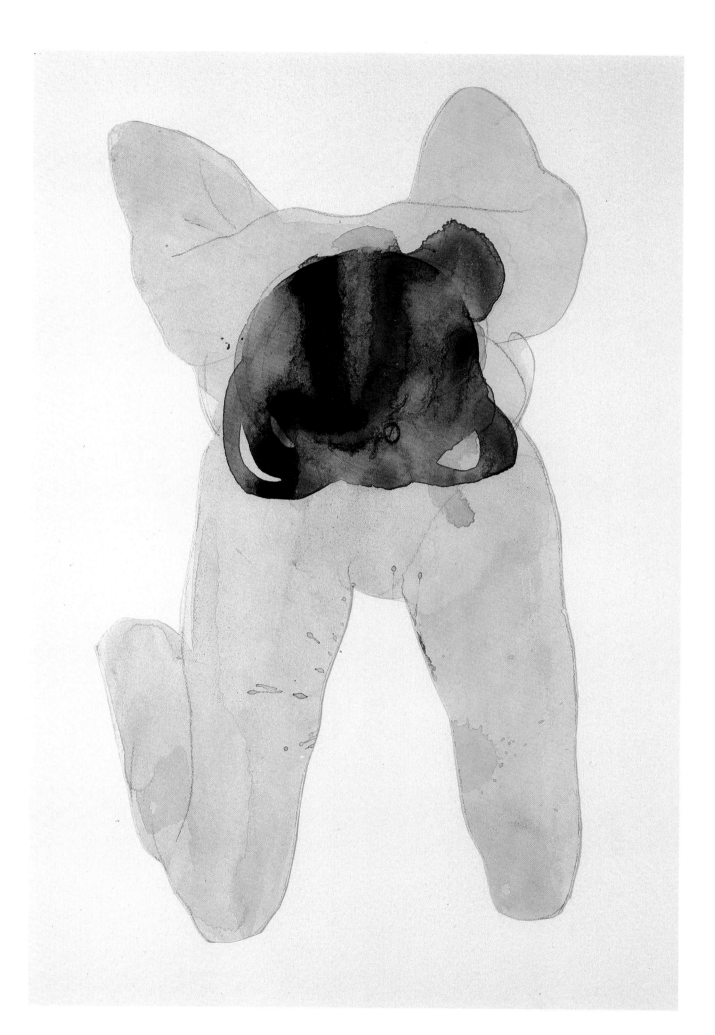

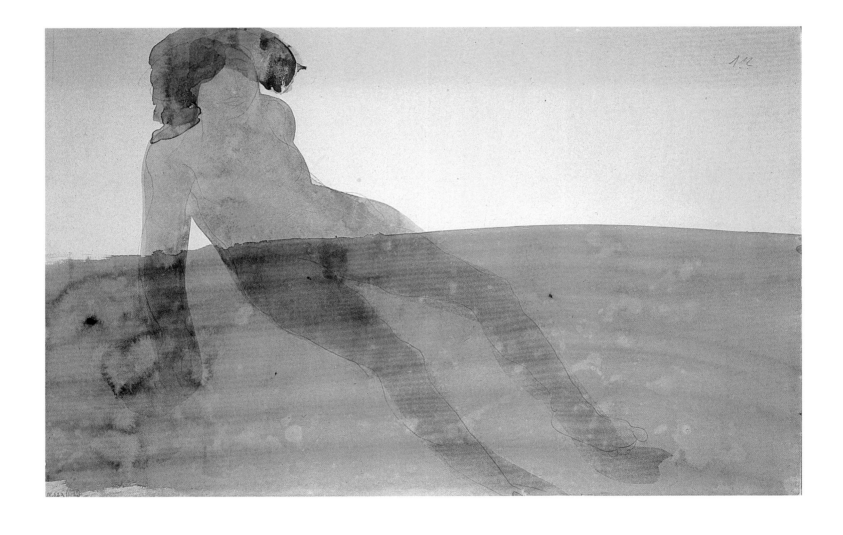

62

Woman in the Sea
Femme dans la mer

63

Three Women Embracing
Trois femmes enlacées

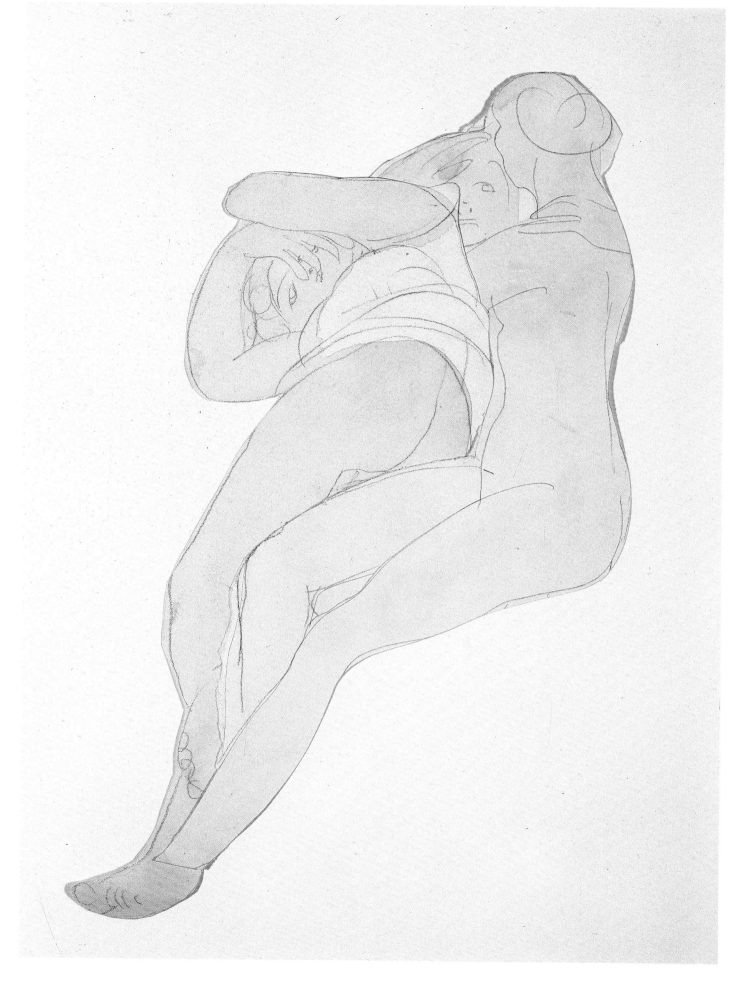

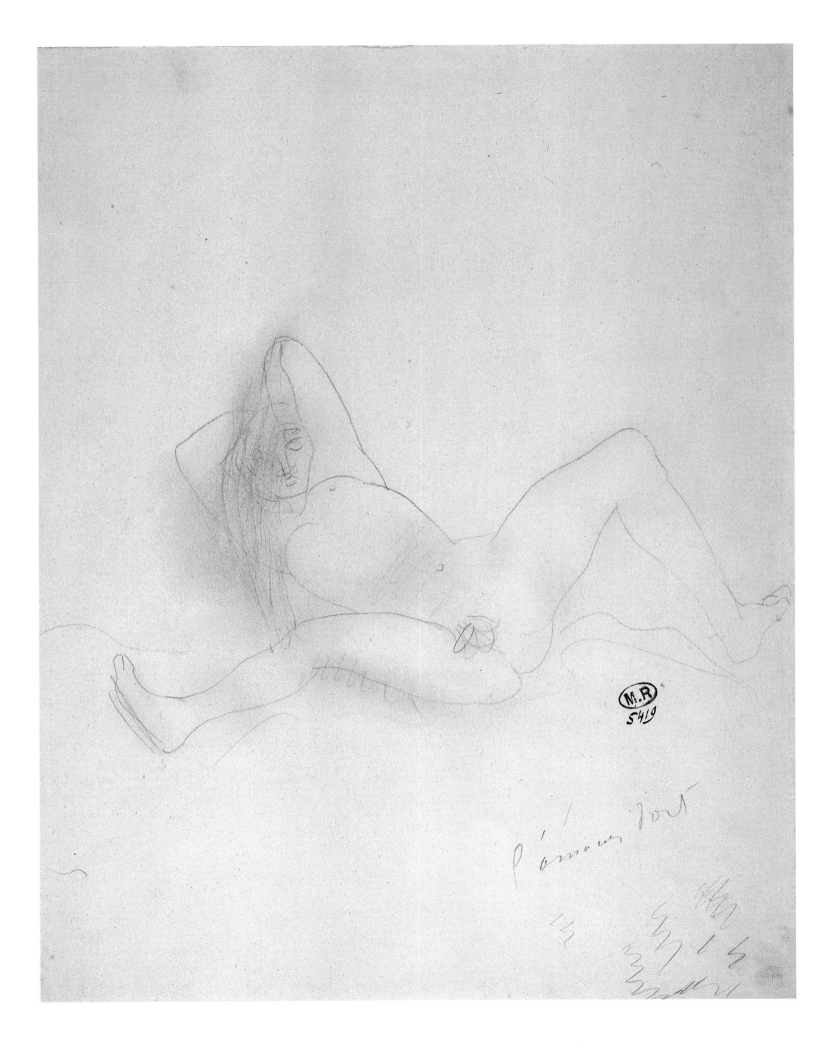

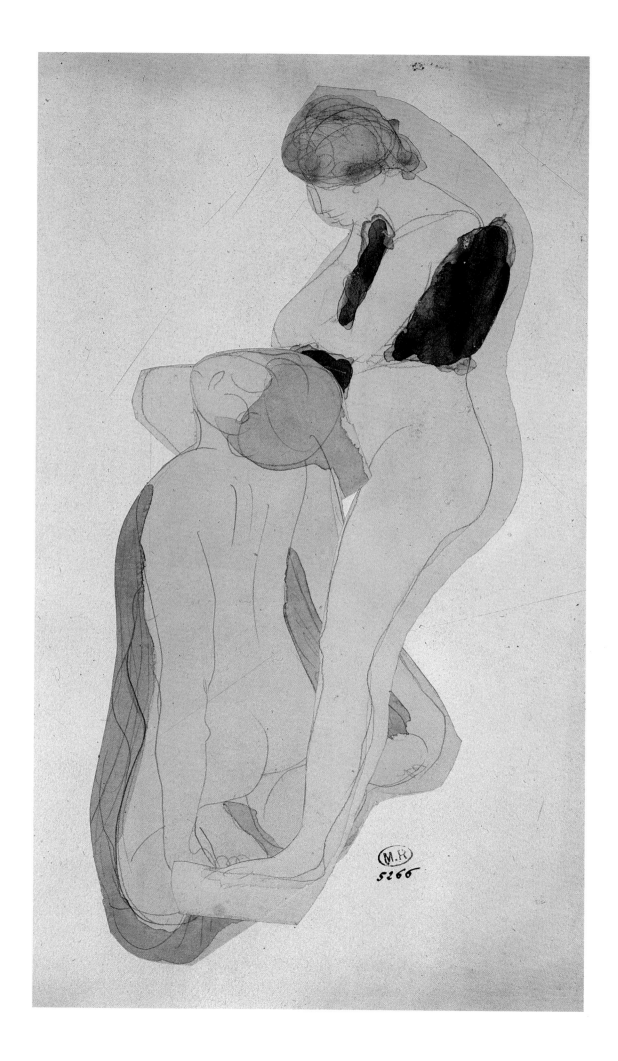

64

Love Asleep
L'Amour dort

65

Female Nude Inclining
toward a Kneeling
Female Nude
Femme nue penchée
sur une femme
agenouillée
vue de dos

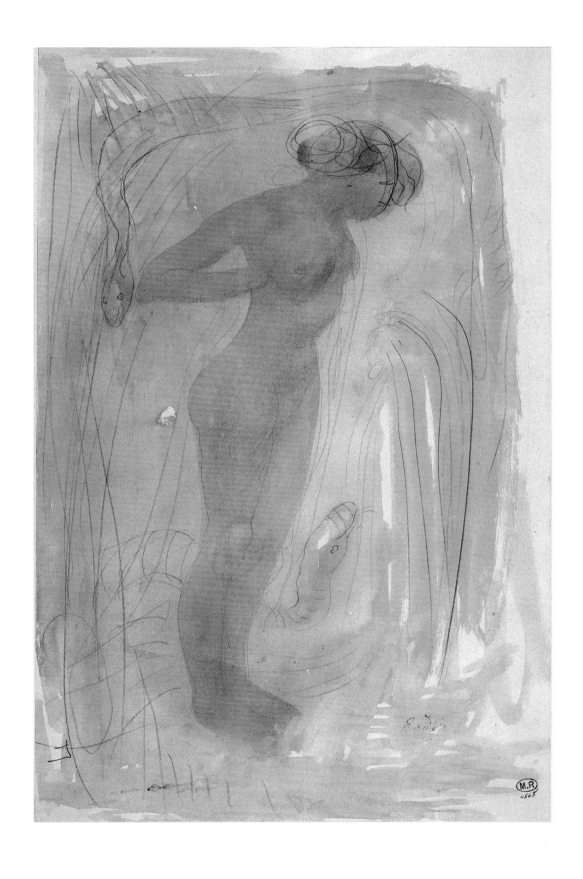

66

Standing Female Nude with two Snakes
Femme nue debout auprès de deux serpents

67

Inspiration

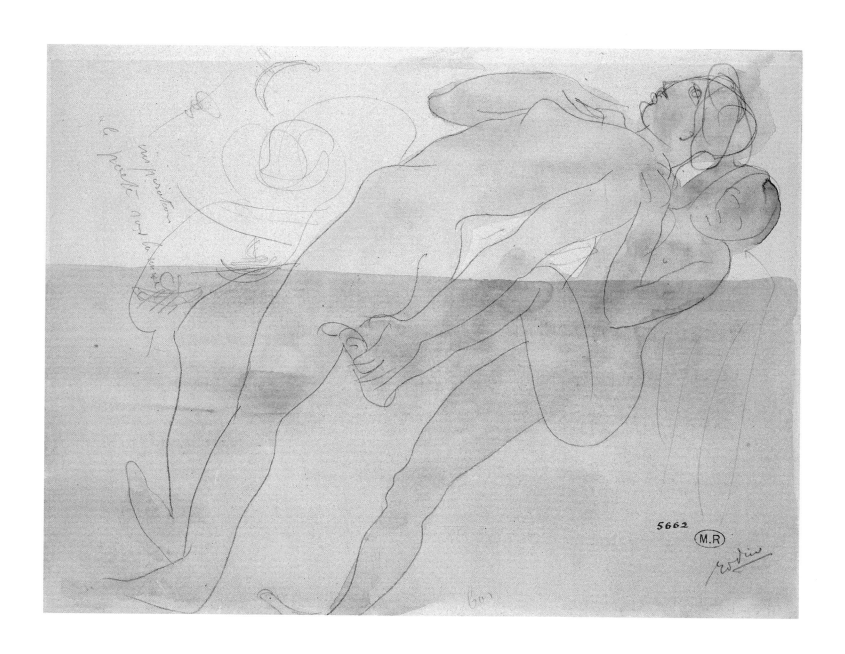

5662
(M.R)

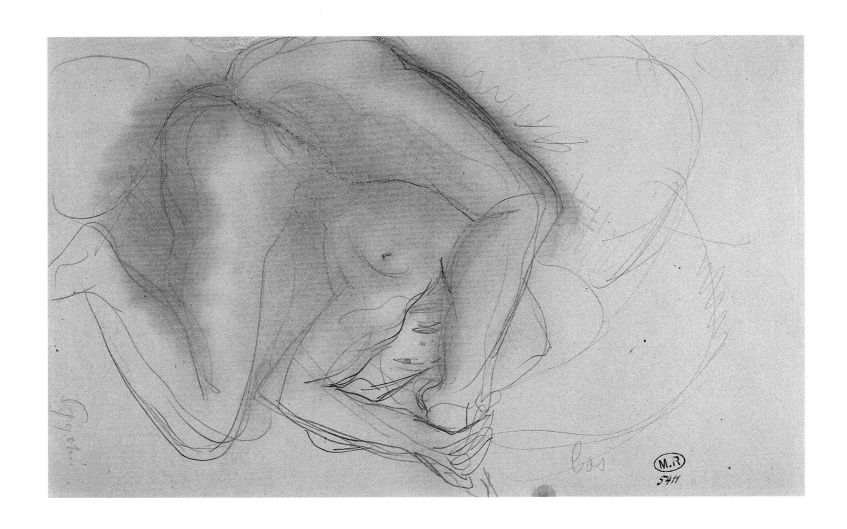

68

Psyche · *Psyché*

Two Women Embracing
Deux femmes enlacées

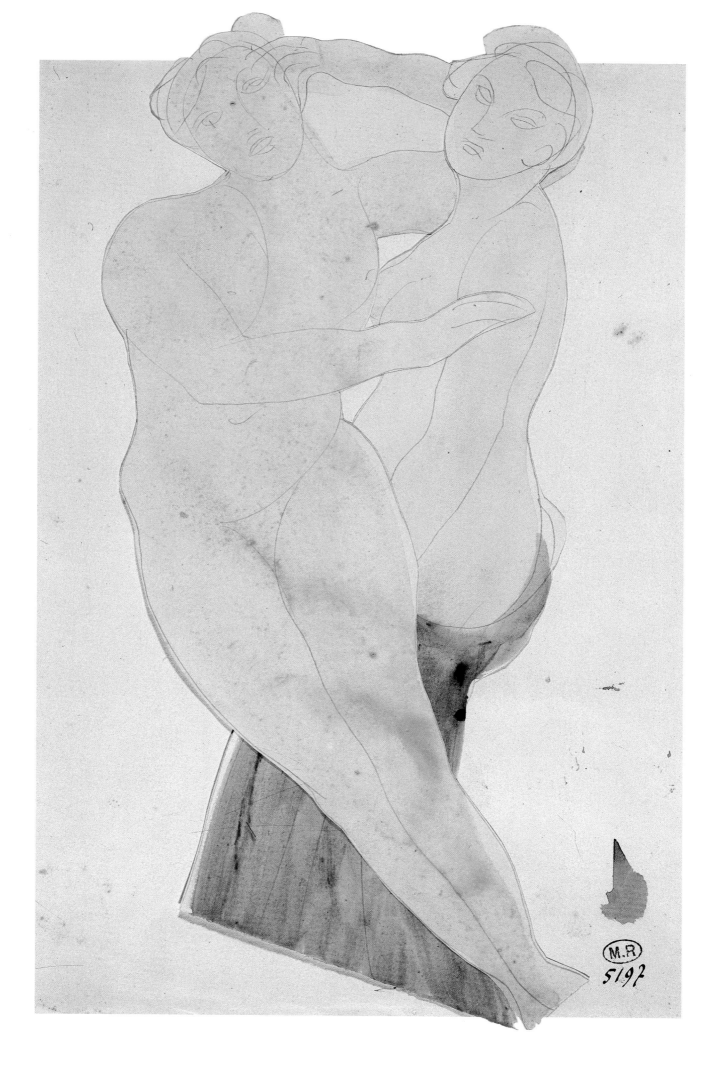

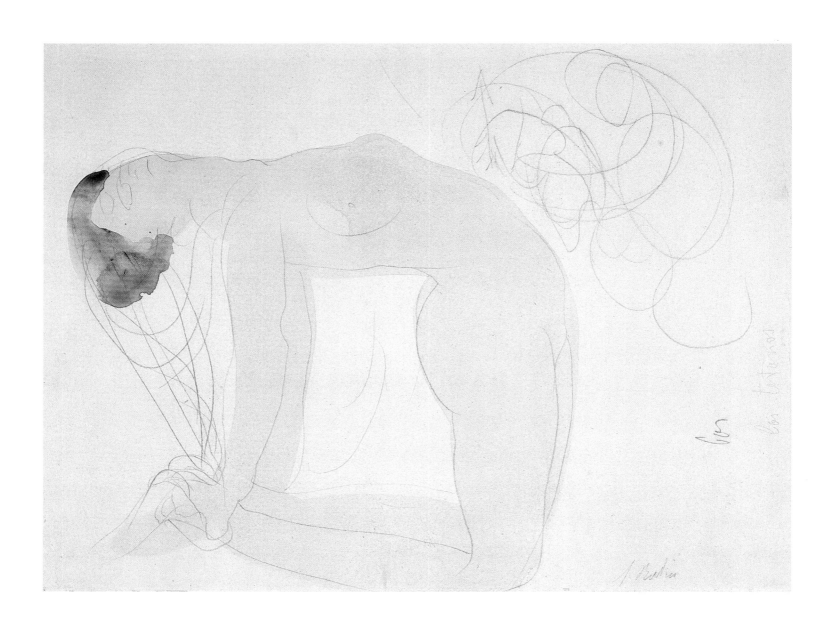

70

Kneeling Woman, Leaning Backward
Femme à genoux, penchée en arrière

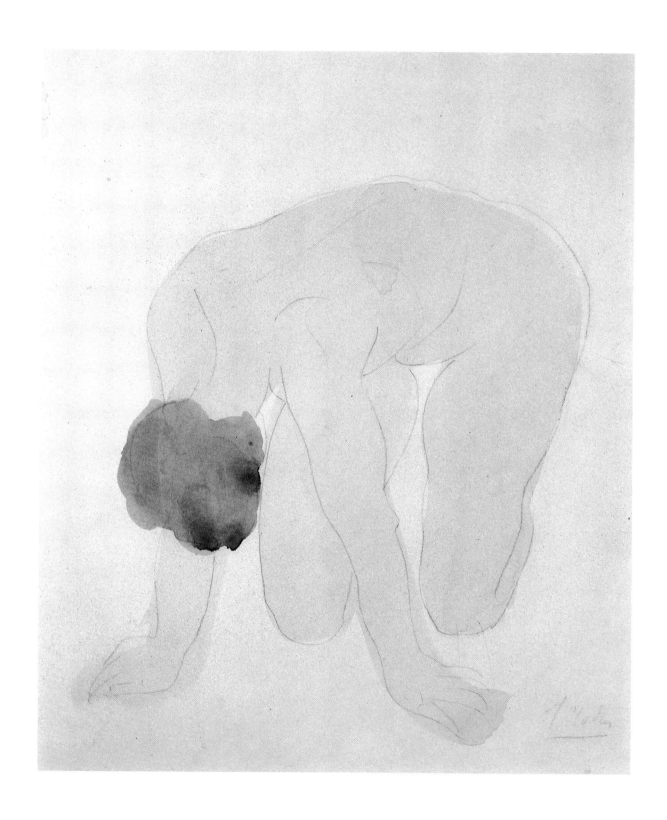

71

Kneeling Woman
Femme agenouillée

72 *overleaf*

Sapphic Couple · *Couple saphique*

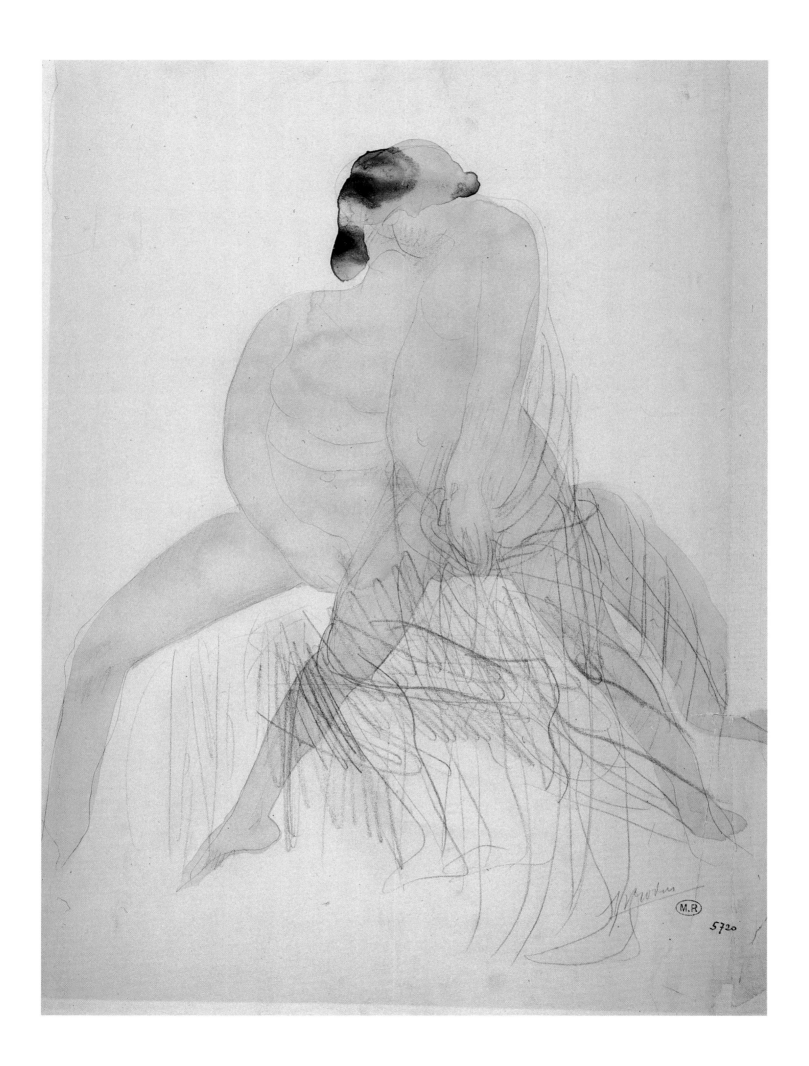

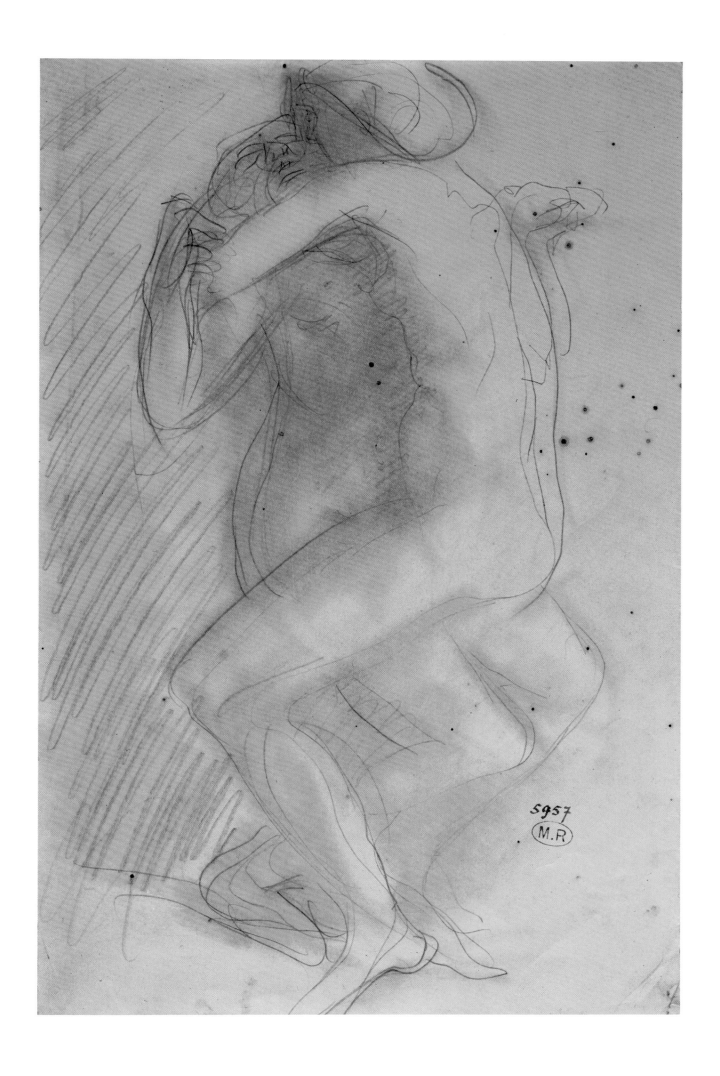

73 previous page

Sapphic Couple · *Couple saphique*

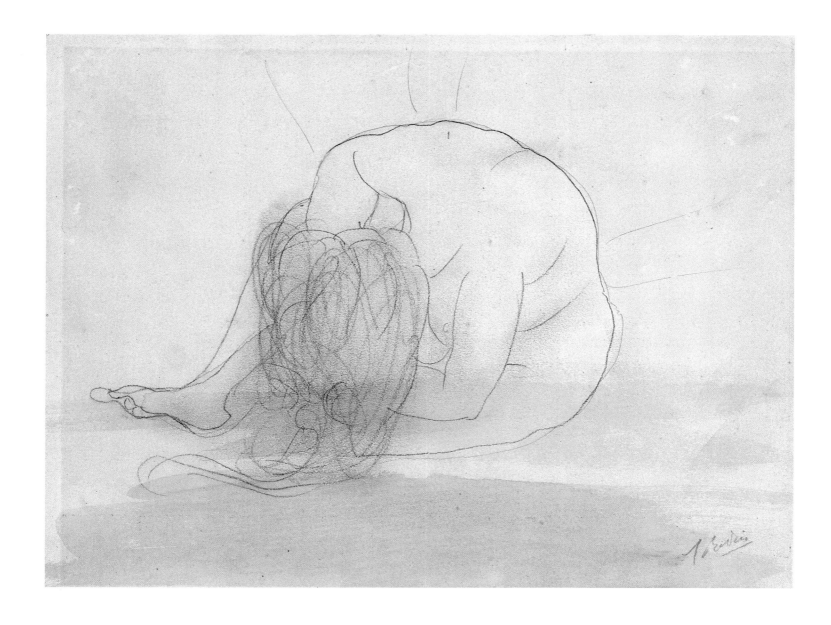

74

Female Nude, Seated on the Ground, Head between Arms
Femme nue, assise sur la terre, la tête entre les bras

75

Reclining Female Nude, Front View
Femme nue allongée, de face

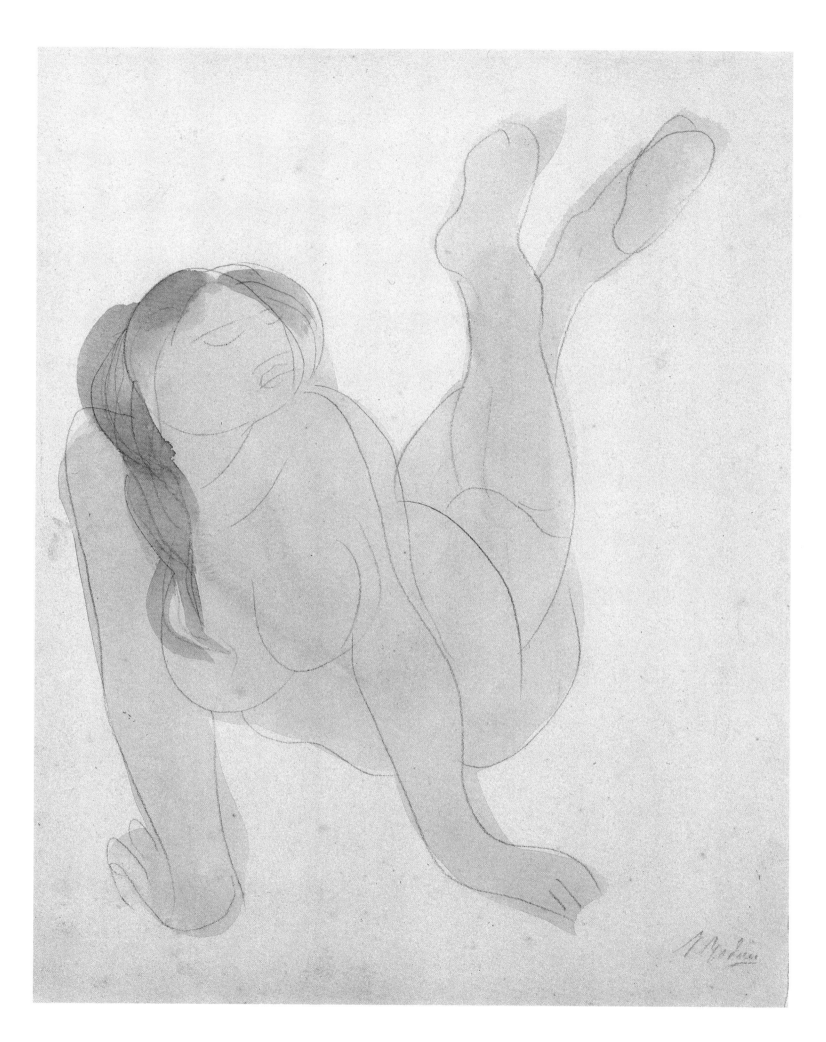

76
Sleeping Girl
Fille dormante

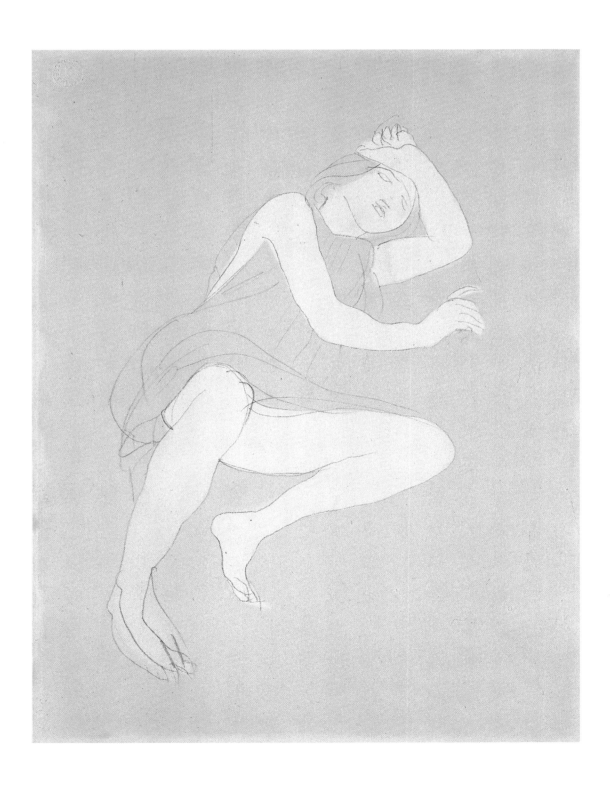

List of Plates

SCULPTURE

1

Eternal Springtime
L'Eternel printemps

1884
Bronze
25½ x 26¾ x 13½"
(64.5 x 68 x 34.5 cm)
Musée Rodin, Paris (S. 989)

2

Meditation
(The Inner Voice)
Méditation
(*La Voix intérieure*)

1896-97
Patinated plaster
57¾ x 30 x 21¼"
(147 x 76 x 54 cm)
Musée Rodin, Paris (S. 1125)

3

I Am Beautiful
Je suis belle

1882 (?)
Plaster
27½ x 13 x 13½"
(70 x 33 x 34.5 cm)
Musée Rodin, Meudon (S. 1292)

1882
Bronze
27¼ x 12¼ x 12½"
(69 x 31 x 32 cm)
Ateneum, Helsinki,
Antell Collection

4

The Sirens
Les Trois Sirènes

1886
Bronze
17 x 18¼ x 12½"
(43.5 x 46.5 x 32 cm)
Musée Rodin, Paris (S. 1069)

5

Assemblage of a Female
Torso and Coiled Snake
*Assemblage: Torse féminin
et serpent lové*

1895-1905
Plaster and wood
8¾ x 9 x 8¾"
(22 x 23 x 22 cm)
Musée Rodin, Meudon (S. 3615)

6

Assemblage of the Head of
Pierre de Wissant and
a Female Nude
*Assemblage: Tête Pierre
de Wissant et nu féminin*

after 1900
Plaster
9 x 6¾ x 5"
(23 x 17 x 13 cm)
Musée Rodin, Meudon (S. 404)

7

The Creation of Woman
La Création de la femme

1894
Marble
35½ x 22½ x 18¼"
(90 x 57 x 46.5 cm)
Musée Rodin, Paris (S. 1111)

8

Iris

1903
Plaster
63 x 37½ x 23¾"
(160 x 95 x 60.5 cm)
Musée Rodin, Meudon (S. 176)

9

Naked Balzac
*Balzac, étude de nu dite
un athlète*

1896
Bronze
36½ x 17 x 13¾"
(93 x 43.5 x 35 cm)
Musée Rodin, Paris (S. 1080)

10

Nijinsky

1912
Bronze
6¾ x 3½ x 2"
(17 x 9 x 5 cm)
Musée Rodin, Paris (S. 803)

11

Fallen Angel
Chute d'un ange

c. 1895
Marble
16½ x 32 x 32¾"
(42 x 81 x 83 cm)
Musée de Lille

12

Ecclesiastes
L'Ecclésiaste

before 1898
Plaster
10½ x 10¼ x 11¾"
(27 x 26 x 30 cm)
Musée Rodin, Paris (S. 453)

13

The Kiss
Le Baiser

1888-98
Marble
72 x 43½ x 46½"
(183 x 110.5 x 118 cm)
Musée Rodin, Paris (S. 1002)

14

The Martyr
La Martyre

1885 (?)
Bronze
16½ x 58¾ x 39½"
(42 x 149.5 x 100.5 cm)
Musée Rodin, Paris (S. 1160)

15

The Age of Bronze
L'Age d'airain

1875-76
Bronze
70¾ x 23½ x 23½"
(180 x 60 x 60 cm)
Kunsthalle, Bremen

16

Meditation
(The Inner Voice)
without arms
*La Méditation
(La Voix intérieure)
sans bras*

1896-97
Bronze
57½ x 23¼ x 17¾"
(146 x 59 x 45 cm)
Musée Rodin, Paris (S. 792)

17

Christ and the Magdalen
Le Christ et la Madeleine

1894
Plaster
40¼ x 25½ x 28¼"
(102 x 65 x 72 cm)
Musée Rodin, Meudon (S. 1136)

18

Fall of Icarus
Chute d'Icare

1896
Marble
24½ x 37¾ x 20"
(62 x 96 x 51 cm)
Musée Rodin, Paris (S. 1385)

19

The Good Spirit
Le Bon Génie

c. 1900 (?)
Bronze
28 x 25½ x 19¾"
(71 x 65 x 50 cm)
Musée Rodin, Paris (S. 1099)

20

Andromeda
Andromède

1885
Marble
10¼ x 11¾ x 8¼"
(26 x 30 x 21 cm)
Musée Rodin, Paris (S. 811)

21

Torso of Adèle
Torse d'Adèle

1882
Plaster
6¼ x 19¾ x 7½"
(16 x 50 x 19 cm)
Musée Rodin, Meudon (S. 1223)

22

The Walking Man
L'Homme qui marche

1900
Bronze
33½ x 11 x 22¾"
(85 x 28 x 58 cm)
Musée Rodin, Paris (S. 495)

23

The Eternal Idol
L'Eternelle Idole

1889
Patinated plaster
29¼ x 15¾ x 20½"
(74 x 40 x 52 cm)
Musée Rodin, Meudon (S. 3136)

181

24

The Hand of the Devil
La Main du Diable

c. 1902
Marble
15 x 25¼ x 20¾″
(38 x 64 x 53 cm)
Musée Rodin, Paris (S. 1107)

25

Reclining Man, Back Arched
(Kneeling Man)
Homme à genoux

before 1889
Patinated plaster
13¼ x 5 x 4¼″
(33.5 x 12.5 x 11 cm)
Musée Rodin, Meudon (S. 824)

26

Kneeling Fauness
Faunesse à genoux

c. 1884
Bronze
22½ x 8¾ x 11″
(57 x 22 x 28 cm)
Musée Rodin, Paris (S. 488)

27

Two Women Embracing
Deux femmes enlacées

Date unknown
Plaster
9½ x 12½ x 9″
(24 x 32 x 23 cm)
Musée Rodin, Paris (S. 705)

28

Monument to Victor Hugo
(second maquette)
*Monument à Victor Hugo
(deuxième projet)*

1890
Bronze
15 x 11 x 13¾″
(38.5 x 28 x 35 cm)
Musée Rodin, Paris (S. 1073)

29

Orpheus and Eurydice
Orphée et Eurydice

1893
Marble
50 x 30 x 28″
(127 x 76 x 71 cm)
The Metropolitan Museum
of Art, New York,
Gift of Thomas F. Ryan, 1910

30

Danaid
La Danaïde

1889-90
Marble
14¼ x 28 x 20¾″
(36 x 71 x 53 cm)
Musée Rodin, Paris (S. 1135)

31

Falling Man
L'Homme qui tombe

1882
Bronze
23¼ x 14½ x 11½″
(59 x 37 x 29 cm)
Musée Rodin, Paris (S. 963)

32

Psyche-Springtime
Psyché-Printemps

1886 (?)
Marble
11¾ x 19 x 15¾″
(30 x 48 x 40 cm)
Musée Rodin, Paris (S. 1116)

33

Project for the " Monument
to Eugène Carrière "
*Projet de monument pour
Eugène Carrière*

1912
Plaster
16¼ x 7 x 7¾″
(41 x 18 x 20 cm)
The Rodin Museum,
Philadelphia Museum of Art

34

Awakening
La Toilette de Vénus

1885
Bronze
17¼ x 7¾ x 7¾″
(44 x 20 x 20 cm)
Musée Rodin, Paris (S. 37)

35

Avarice and Lust
L'Avarice et la luxure

1881
Plaster
9¾ x 22 x 19¾″
(25 x 56 x 50 cm)
Musée Rodin, Meudon (S. 2152)

36

The Metamorphoses of Ovid
Les Métamorphoses d'Ovid

c. 1885 (?)
Bronze
12½ x 15¾ x 10¼″
(32 x 40 x 26 cm)
Musée Rodin, Paris (S. 1145)

37

The Crouching Woman
La Femme accroupie

1880-82
Plaster
13 x 10¾ x 8¾″
(33 x 27.5 x 22.5 cm)
Musée Rodin, Meudon (S. 2396)

38

Pygmalion and Galatea
Pygmalion et Galathée

1908-9 (first maquette, 1889)
Marble
38¼ x 35 x 30″
(97 x 89 x 76.5 cm)
The Metropolitan Museum
of Art, New York,
Gift of Thomas F. Ryan, 1910

39

Exhortation

1903
Bronze
15¾ x 9½ x 15¾″
(40 x 24 x 40 cm)
Musée Rodin, Paris (S. 774)

40

The Hand of God
La Main de Dieu

1902-8 (clay maquette 1897-98)
Marble
29 x 23 x 25¼″
(73.5 x 58.5 x 64 cm)
The Metropolitan Museum
of Art, New York,
Gift of Edward D. Adams, 1908

41

Youth Triumphant
La Jeunesse triomphante

1894
Plaster
20¾ x 19¾ x 12½″
(53 x 50 x 32 cm)
Musée Rodin, Meudon (S. 1149)

42

The Creation
La Création

Date unknown
Terracotta
7¾ x 10 x 4¼″
(20 x 25.5 x 11 cm)
Musée Rodin, Meudon (S. 266)

43

Jean de Fiennes

1885
Plaster
28 x 17¼ x 17¼″
(71 x 44 x 44 cm)
Musée Rodin, Meudon (S. 432)

Jean de Fiennes
(second maquette)
*Jean de Fiennes
(deuxième maquette)*

1885
Bronze
28¼ x 19¼ x 17¼″
(72 x 49 x 44 cm)
Musée Rodin, Paris (S. 396)

44

The Poet and Love
Le Poète et l'amour

c. 1896
Plaster
16¾ x 11 x 6″
(42.5 x 28 x 15 cm)
The Rodin Museum, Philadelphia
Museum of Art

DRAWINGS

It is difficult, if not impossible, to date Rodin's late drawings precisely. Virtually all the works reproduced here date from after 1900.

45

Female Nude in the Studio
Femme nue à l'atelier

Pencil and watercolor
12⅜ x 8¼″
(32 x 21 cm)
Szépmüvészeti Muzeum, Budapest
(1935-2777)

46

Sapphic Couple in Profile
Couple saphique de profil

Pencil and watercolor on cutout
buff-colored paper
12⁵⁄₁₆ x 6⅛″
(31.3 x 15.6 cm)
Musée Rodin, Paris (D. 5254)

47

Hand on Genitals
Main sur un sexe

Pencil on buff-colored paper
7⅞ x 12³⁄₁₆″
(20 x 31 cm)
Musée Rodin, Paris (D. 5996)

48

Reclining Female Nude,
Caressing Herself with
Hand under Thigh
*Femme nue allongée se
caressant avec une main
passée sous la cuisse*

Pencil, watercolor, and gouache on
buff-colored paper
12¹³⁄₁₆ x 19¹³⁄₁₆″
(32.5 x 50.3 cm)
Musée Rodin, Paris (D. 4556)

49

Female Nude in Profile,
Back Arched
*Femme nue de profil
et cambrée*

Pencil and watercolor on cutout
buff-colored paper
10¹¹⁄₁₆ x 9⁵⁄₁₆″
(27.2 x 23.7 cm)
Musée Rodin, Paris (D. 5207)

50

Female Nude, Front View,
Lying on Back, Legs Spread
*Femme nue de face,
renversée sur le dos et jambes
écartées*

Pencil and watercolor on cutout
buff-colored paper
12³⁄₁₆ x 7⅞″
(31 x 20 cm)
Musée Rodin, Paris (D. 5223)

51

Seated Female Nude,
Arms Raised
*Femme nue assise de dos,
les bras levés*

Pencil and watercolor on
buff-colored paper
12¹¹⁄₁₆ x 19⁵⁄₁₆″
(32.3 x 49.1 cm)
Musée Rodin, Paris (D. 4559)

52

Female Nude on All Fours,
Rear View, Dress Lifted to
Hips
*Femme à quatre pattes,
de dos et le vêtement relevé
sur les reins*

Pencil on buff-colored paper
12³⁄₁₆ x 7¹³⁄₁₆″
(31 x 19.9 cm)
Musée Rodin, Paris (D. 5979)

53

Danaë
Danaé

Pencil on buff-colored paper
12¹⁄₁₆ x 8″
(30.7 x 20.3 cm)
Musée Rodin, Paris (D. 5961)

54

Sapphic Couple
Couple saphique

Pencil and watercolor on
buff-colored paper
12¹³⁄₁₆ x 20″
(32.5 x 50.8 cm)
Musée Rodin, Paris (D. 5713)

55

Reclining Female Nude in
Profile, Leg Raised and Bent
*Femme nue allongée de
profil, une jambe haute et
repliée*

Pencil, watercolor, and gouache on
buff-colored paper
9¾ x 12¹³⁄₁₆″
(24.8 x 32.6 cm)
Musée Rodin, Paris (D. 4947)

56

Naiad
Naïade

Pencil and watercolor on
buff-colored paper
12¹³⁄₁₆ x 9⅞″
(32.5 x 25 cm)
Musée Rodin, Paris (D. 5717)

57

Standing Female Nude,
Hand between Thighs
*Femme nue debout, une main
entre les cuisses*

Pencil on buff-colored paper
12³⁄₁₆ x 8″
(31 x 20.3 cm)
Musée Rodin, Paris (D. 5986)

58

Shell
Coquille

Pencil on buff-colored paper
8¼ x 12¼″
(21 x 31.1 cm)
Musée Rodin, Paris (D. 5990)

59

Two Female Nudes, Arm in
Arm, Back to Back
*Femmes nues enlacées
dos à dos*

Pencil and watercolor on cutout
buff-colored paper
12¹⁄₁₆ x 6⅜″
(30.6 x 16.2 cm)
Musée Rodin, Paris (D. 5209)

60

Female Nude, Thighs Spread
and Raised
*Femme nue maintenant
les cuisses hautes et écartées*

Pencil on buff-colored paper
12⅜ x 7⅞″
(31.4 x 20 cm)
Musée Rodin, Paris (D. 5997)

61

Kneeling Female Nude
Femme nue agenouillée

Pencil and watercolor on cutout
buff-colored paper
9⅞ x 5½″
(25 x 14 cm)
Musée Rodin, Paris (D. 5212)

62

Woman in the Sea
Femme dans la mer

Pencil and watercolor
12¹³⁄₁₆ x 19¾″
(32.5 x 50.2 cm)
Národní Muzeum, Prague
(K 18.623)

63

Three Women Embracing
Trois femmes enlacées

Pencil and watercolor on two
pieces of cutout paper
14³⁄₁₆ x 7¹⁄₁₆″
(36 x 18 cm)
Musée Rodin, Paris (D. 5196)

64

Love Asleep
L'Amour dort

Pencil on buff-colored paper
12¹³⁄₁₆ x 9¹⁵⁄₁₆″
(32.6 x 25.2 cm)
Musée Rodin, Paris (D. 5419)

65

Female Nude Inclining
toward a Kneeling Female
Nude
*Femme nue penchée sur une
femme agenouillée vue de dos*

Pencil, watercolor, and gouache on
two cutout pieces of buff-colored
paper
13⁹⁄₁₆ x 5⅞″
(34.5 x 15 cm)
Musée Rodin, Paris (D. 5266)

66

Standing Female Nude with
two Snakes
*Femme nue debout auprès
de deux serpents*

Pencil, watercolor, and gouache on
buff-colored paper
19⁵⁄₁₆ x 12⅜″
(49.1 x 31.5 cm)
Musée Rodin, Paris (D. 4563)

Rainer Crone · David Moos

Introduction to the Essays

Gathering together essays by various authors on a single topic inevitably leads to a multiplicity of viewpoints, each of which provides powerful insights – through a combination of knowledge and style – into the treatment of the designated subject matter. From the following selection of essays what emerges as remarkable is both the specificity and diversity with which each addresses eroticism and the notion of genius as applied to Rodin and his work. From even a cursory perusal of the essays the reader will obtain glimpses of both a divergent and convergent overall reading. If a single unified viewpoint is to be gleaned from this selection, then it will be formulated by the individual reader, rather than by us as compilers.

Few relevant areas of interest are left untouched. *Kirk Varnedoe* divides Rodin in half, taking his pre-1900 drawings as indicative of a studied progression and development of the erotic and regarding the later drawings as igniting paths to a radicality that is as complex in meaning as it is reduced in form. The essence of a lesbian embrace is glimpsed, understood, and tasted to the fullest in visual terms that rely upon a consummate merging of line, watercolor, cutout, and collage. Through these intricacies we grasp the essence of Rodin's drawn forms, which exceed their two-dimensionality, becoming, as Varnedoe writes, "not ... transparent vehicles for transmitting a transcendent truth, but representational devices whose own nature and history are enmeshed in the meaning of the work."

It is this meaning – how the erotic seeks its most refined definition in and through genius – that *Ginger Danto* addresses in her essay, which takes the reader on a tour of the French countryside from Paris to Meudon. Her sensitive, highly evocative writing enables us to understand the genesis of artistic reason and emotion drawn from a landscape so rich in connotations that it inspired Rodin with the confidence to challenge nature itself. We are taken on a detour into a creative landscape in a study that bypasses the sublime in favor of focusing on how Rodin situated people – human forms – within his immediate surroundings. The boundaries of the artist's studio in Meudon are blurred into the rolling landscape of France and the winding streets of Paris, breeding a vision of ecstasy that plunders the divine while pursuing the sordid dissolution of beauty.

Alain Kirili, speaking with the voice of a sculptor who embodies today a creative spirit similar to that of Rodin, informs us of Rodin's methods of working, of how he created human form without paying homage to any particular body available to him at the time. Indeed, Rodin's most remarkable formal invention in sculptural method was precisely his ability to shift between a variety of models in one image. We learn from Kirili, from entering the mind and hands of the creator, that no single human form could ever entirely fulfill what the artist envisioned for his sculpture. "Rodin put a premium on freedom of sensation; he freed artistic creation from its enslavement to the single model and from the particular psychological effect it could have on the artist," Kirili observes. In fact, it is by examining Rodin's relationship to models – rather than to "the" model – that we are best able to grasp exactly what he intended his sculpture to embody.

This totalizing vision of human and sculpted form has exerted a major influence on twentieth-century artists. *Siegfried Salzmann* traces this impact, mentioning the obvious cases of Constantin Brancusi, who sought sculptural vocabulary in the abstract as a way of accessing movement and emotion in the human figure, and Henri Matisse, whose bold sculptural trials were affected by an exertive tension that cannot fail to be reminiscent of Rodin. Salzmann's wide-ranging essay embraces such unexpected instances of the erotic as the early drawings of Joseph Beuys, who, we discover, drew visions of indulgent union before he departed into a conceptual realm. Such is the immense potential of Rodin's art that it will undoubtedly influence facets of future art in ways that it is impossible to foresee. The kind of genius embodied by Rodin is so all-encompassing that we find it difficult to situate twentieth-century artists in any comparable category of mastery.

Jacques de Caso examines the *Album Fenaille*, a seminal book of drawings by Rodin published in 1897. This unique volume offers profound insights into the ideas underlying Rodin's thinking as a creative artist. Starting with a discussion of certain specific themes to be found among the drawings, de Caso develops a subtle referential system of analysis that sheds light on a number of the artist's major sources of inspiration. He observes that Rodin gleaned from the poet Victor Hugo not only formal and aesthetic ideas, but also a conceptual framework that he would exploit throughout his career as sculptor and draftsman. The esteem in which Rodin held Hugo cannot be overemphasized; it is well attested by the various versions of monuments that he created in the poet's honor (see plate 28). Hugo's talent was an en-

compassing one, capable of illustrating and annotating, in drawings of remarkable technical skill, that which his genius created in words. It was this fluid, pervasive agility that attracted Rodin. De Caso explains how the organization of the drawings in the *Album Fenaille* embodies Rodin's interpretation of Dante's *The Divine Comedy*, noting the primary emphasis placed on the *Inferno*. He goes on to locate the *Album*'s drawings in the context of Rodin's views on religion, of his development from a pious Christian in the 1860s to the apostate of the 1890s who unleashed critical tirades against the Catholic church in many drawings in the *Album*. Seen through this book of drawings, Rodin's powers as artist emerge in their full force and with absolute clarity, inhabiting a Baudelairian region of erotic extremes, where the lives of saints are confused with the fates of fallen angels.

Finally, the essay by *Ursula Heiderich* on Camille Claudel traces, in a subtle, indirect fashion, the development of Rodin's much-publicized affair with Claudel – probably his most ambitious pupil – in both the private and the artistic sphere, from the time when the 43-year-old artist engaged the 19-year-old as assistant in his studio. Heiderich attempts to distinguish between the influence of Rodin on Claudel's work and that of Claudel on Rodin's – for what, after all, is a teacher without pupils.

Inevitably, there are gaps in the portrayal of Rodin's genius. We would like to have included, for example, a discussion of the rare, yet explosive, instances of homoerotic content in certain major sculptures (see plates 25, 31, 43) and in numerous watercolors of lesbian couples (see plates 46, 54, 72, 73). Early masterpieces, such as *The Age of Bronze* (1875-76; plate 15), and later monumental works, such as the torso of a man excerpted from *The Walking Man* (plate 22; torso cast in bronze in 1911), provide striking and antithetical sculptings of male sexuality. The lithe, effeminate early work stands in sharp contrast to the muscular, hulky, and almost brutally hacked-off late torso. The polarities illustrated by these designs of the male body would have afforded a valuable opportunity for scholarly exploration of the ways in which Rodin conceived of the male form – the body of man as necessary foil to the feminine, vision of a god that the artist strove to supersede.

Another topic beyond the scope of this selection of essays is Rodin's cultural milieu – that Paris which was desperately exploiting its own underworld in an attempt to discover a direction from which to approach the impending twentieth century. Rodin's transgressive instincts with regard to sexuality, morality, and religion would be greatly animated through an account of the experiences available to him in late nineteenth-century Paris. Exoticism and decadence ran rife through the night, while spectacles of indulgence and entertainment beckoned in Montmartre that make the Place Pigalle of today seem a faint spark of those gas-green-lit fires, a mere hallucination of the unconscious in comparison to the devouring might of one hundred years ago. It remains for a cultural historian to portray the intricacies of this consumptive, desirous society driven to enact the arcane through pursuit of the purest pleasure. Rodin's exposure to novel erotic practices would come into sharp focus through such a study.

Eroticism as a theme finds itself in a shadowed light in many of the essays, sometimes acquiring an exploitative, oppressive, even pessimistic undertone. Each author has expressed, either overtly or by suggestion, the view that Rodin's erotic drive concluded in an aura of duress, lacking the sensitivity that is born of enjoyment rather than of indulgence. Yet such a portrayal was not our intention. We had hoped that the erotic would emerge strongly as a guiding force, as an enrichment of the routine of daily life, allowing the reader to reflect optimistically upon the erotic inclinations so evident in Rodin's work. When compiling the essays, we maintained the belief that the erotic would crystallize out of them as a force for life in a world from which passion and true emotion seem too often absent. Contrary to our initial expectations of fashioning an inclusive and comprehensive version of the erotic, these essays, through their contingent interaction, have produced a unity still awaiting addition and further participation. So it is with gratitude to the contributing authors that we invite you to indulge the erotic genius of Auguste Rodin, to make of his impressive vision what you will.

Siegfried Salzmann

Innovative Energies in the Work of Rodin

"I am a bridge between the past and the present"

The past few decades have seen major advances in both the quantity and the quality of art-historical research on the work of Rodin, making it possible to recognize the full extent of his tremendous creative genius. The monographs by Albert E. Elsen, Denys Sutton, John L. Tancock, and J. A. Schmoll gen. Eisenwerth, and the recent work of

Fig. 1 Joseph Beuys, ——— ?, 1957.
Diluted blood, iodine, and pencil,
11¾ x 8¼" (29.8 x 21 cm).
Wilhelm-Lehmbruck-Museum, Duisburg,
on permanent loan from the Marx Collection

187

Manfred Fath,[1] have shown that the magnetic fascination that Rodin held for his contemporaries has persisted throughout the twentieth century: successive generations of artists have looked to him as a source of inspiration, and his art continues to unleash new creative energies. His extraordinarily inventive artistic ideas, which were far ahead of their time, were not only taken up and investigated by such pioneers of modernism as Constantin Brancusi, Alberto Giacometti, Wilhelm Lehmbruck, Henri Matisse, Edvard Munch, Pablo Picasso, and Egon Schiele; they also found adherents in the subsequent, "middle" generation of modern artists, such as Henry Moore, Germaine Richier, and Ossip Zadkine. After World War II, the painters and sculptors of the *Art informel* and Automatist movements cited Rodin as the precursor of their own experiments in the suggestive transformation of movement and dynamic energies, as they began to probe the transitory elements and forces contained in seemingly inchoate matter. The continuing influence of Rodin, right up to the present day, is apparent in the work of numerous internationally renowned artists: one need only think of Joseph Beuys, Jürgen Brodwolf, Hans Haacke, Alain Kirili, Per Kirkeby, and Günther Thorn, each of whom has investigated Rodin's oeuvre in his own individual way. Given that the luster of Rodin's genius has so far remained undiminished, it seems safe to predict that his star, like that of Michelangelo, will continue to be in the ascendant in the future.

In the wealth of recent publications on the reception of Rodin, the name of Joseph Beuys is never mentioned. However, at the time in the 1950s when Beuys was struggling to develop his own creative potential to the fullest, he embarked on a careful study of Rodin's work, surmounting the barriers of history and contriving to bridge the gulf between his own artistic temperament and that of the French master. This encounter with Rodin cannot be dismissed as an incidental episode, for it holds considerable importance for Beuys's work as a whole. His lifelong friend Franz Joseph van der Grinten was the first person to reveal that Beuys became aware of Rodin – "via Rilke" – at an early age.[2] In addition to Rodin, van der Grinten mentions three other artists whom Beuys greatly admired in his youth: Lehmbruck, Munch, and William Turner.

This interest in Rodin is reflected in the female figures that Beuys produced in the 1950s, especially in the drawings and watercolors of female nudes. Regardless of whether Beuys had seen pictures of women by the "satyr of Meudon" in the original or only in reproductions, it is evident that he was deeply impressed and fascinated by the combination of sensual immediacy and spiritualization in Rodin's sculptures of women. This is indicated by the fact that Beuys took up a number of Rodin's technical, formal, and compositional ideas and incorporated them in his own visual universe. In some instances the ideas are assimilated directly, while in others they are developed and refined. One example of Rodin's influence can be found in Beuys's carefully calculated use of isolated elements of collage.[3] A further affinity between the two artists consists in the device, which both employ extensively, of mixing widely differing graphic media and techniques. In his efforts to render the naked bodies of his models in pictorial terms, Rodin used all kinds of techniques, including pencil, crayon, pen and ink, India ink, watercolor, and gouache, often adding washes and smudging the contours of the figures with his finger. Beuys adopted a similar approach, combining a wide range of possibilities in respect of both technique and materials. However, as well as such traditional graphic materials as pencil, ink, and watercolor, he used new substances, such as staining fluid, gelatin, blood, and fat.

A noticeable common feature of the two artists' work is the calculated element of randomness in their painting technique, allowing patches and little islands of color to form at will.[4] In some of his watercolors Beuys follows Rodin's example by letting the colors run freely over the paper in such liberal quantities that they become completely absorbed in the ground of the paper; thus, a process of desubstantiation is set in train

Fig. 2 Joseph Beuys, *Girl*, 1957.
Pencil and watercolor,
8⅛ x 5¹¹⁄₁₆″ (20.6 x 14.5 cm).
Franz Joseph and Hans van der Grinten
Collection, Kranenburg

which intensifies the picture's translucent qualities to the utmost (see Fig. 2). As in Rodin's *Kneeling Woman, Her Head Thrown Back*,[5] incidental colored outlines and forms that arise automatically in the course of the drying process present themselves to the viewer and invite him to endow them with figurative significance. Even if they are only flecks of dirt on the paper, such random traces and relics of predetermined processes generally constitute the decisive stimulus that leads Beuys to take up the pencil or brush and commit his ideas to paper. His work, like that of Rodin, is characterized by a high level of spontaneity in reacting to particular situations; one also finds the same open spheres of color with blurred, flowing edges, and the same range of tonal values, combining acutely intense, glowing chromatic concentrations with transparent particles of color that almost merge into the ground. A certain inner affinity between the two artists can also be detected in their respective approaches to the reduction of the female torso, notably in those works by them that depict women's bodies in terms of vases or other closed vessels.[6] A further point of comparison is to be found in the theme of woman as animal, which both artists addressed, albeit from quite different angles: Rodin's ideas on this subject were still largely circumscribed by traditional religious and mythological thinking. The images of women by Beuys and Rodin frequently carry a sexual connotation, and one finds that, in the aspect of their work to which Kirili refers as "dealings with the female pudenda,"[7] they are quite unembarrassed: ignoring bourgeois propriety, their depictions of the female genitals are remarkably blunt and unambiguous. Beuys, for example, drew pictures of menstruating women with their legs spread wide apart, and gave them a semi-animal appearance (see Fig. 1) that makes them look like victims of ritual slaughter. In their savagely exposed nakedness, the figures distantly echo the dramatically exaggerated movements of Rodin's sculpture *Iris, Messenger of the Gods*. Nevertheless, despite all these analogies and points of resemblance, there are a number of fundamental differences between the artistic intentions and aims of Beuys and Rodin.

Beuys's women and girls evoke the expressive power of purportedly universal pictorial signs that seek to remain detached and mysterious. The lines are hesitant and questing, constantly searching for the contours before coming to an abrupt standstill; they not only appear fragile, they *are* fragile. The effect of Beuys's lines, and of his seemingly immaterial, achromatic colors, is to create "structures which are at once delicate and drab, poetic yet devoid of sensual appeal.... Beuys makes his point quietly, with just enough emphasis to avoid misunderstandings. Giving body and resonance to sounds that are virtually inaudible, he ferrets out the details buried deep below the surface."[8]

Rodin's female figures intend the very opposite of this: they invariably have a definite physical and sensual presence, suggesting unstinted erotic power and desire. At the same time, they express, with passionate emphasis, the specific erotic and sexual potency of their creator. Remarking on the animated sensuality of Rodin's sculptures, one critic has observed that the artist sought "to perpetuate an ambivalence between the living and the sculptures. What he is to his sculptures, he wants to be to women."[9] This also applies without reservation to Rodin's later drawings and watercolors, from the period after 1897.

The present essay is not an appropriate context in which to explore the further, more complex ramifications of the relationship between Rodin and Beuys. Suffice it to say that, in addition to the specific similarities in terms of artistic form, there are also a number of parallels between the ideas about life, as well as art, of these two major geniuses. Among other things, they were both immensely productive: their respective oeuvres run to several thousand works. They had a boundless appetite for work, amounting to a positive mania, which each of them enshrined in his own personal motto: Rodin's "toujours travail" is echoed by Beuys's "Weekends? I don't know the

Fig. 3 *The Burghers of Calais*, 1884-95. Musée Rodin, Paris

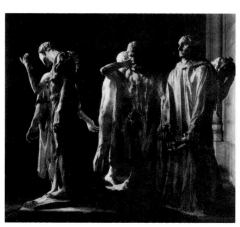

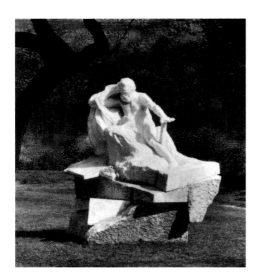

Fig. 4 *Monument to Victor Hugo* in the gardens
of the Palais Royal, Paris.
Photograph by Adolphe Braun

Fig. 5 *Bust of Victor Hugo* in the columned
portico at Meudon

Fig. 6 *The Martyr*, 1885. Bronze,
length 61½″ (156 cm).
The Metropolitan Museum of Art,
New York, Gift of Watson B. Dickermann

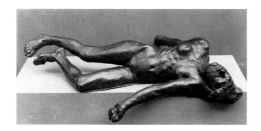

meaning of the word!" Moreover, although both artists achieved worldwide fame and
recognition in their own lifetime, the two of them also experienced the bitterness of
rejection, even of categorical negation. The resistance or open hostility of the general
public to their work is partly the consequence of their own striving for artistic totality,
seeking to heal the breach between life and art.

Apart from the direct lines of kinship or influence that link Rodin with the art of
our century, there is a further, more important relationship at a structural level, in
respect of two particular forms of modern sculpture whose future significance was
recognized by Rodin. Translating these artistic insights and inventions into sculptural
practice, he staked out an entirely new territory on which subsequent generations were
able to develop and realize their own ideas. With his exceptional boldness of vision and
his intuitive genius, Rodin succeeded in liberating sculpture from traditional con-
straints. He spied out a new terrain, the existence of which even he himself was initially
unaware of, defining his own position with the celebrated saying, " I am a bridge
between the past and the present."

Two of the most important innovations in twentieth-century sculpture are the
abolition of the traditional base or plinth[10] and the advent of the small-scale "table"
sculpture. It was not until the 1960s that the rejection of the base became widespread,
but this dominant feature of contemporary sculpture was anticipated by Rodin in *The
Burghers of Calais* (Fig. 3) and in a number of his other works. Indeed, his plan to set
up *The Burghers of Calais* at ground level, with the intention of "giving the public an
opportunity to penetrate to the heart of the proceedings,"[11] can, in a sense, be regarded
as the *fons et origo* of modern freestanding floor sculpture. Here, the sculptor elimi-
nates the traditional lines of demarcation between the aesthetic object and the viewer
and replaces distance by the immediacy of physical proximity. Rodin activates the
individual bodily experience of the beholder, who becomes a kind of fellow-participant
in the construction of the work, and leads him toward an awareness of, and an
identification with, his own physical nature. This form of orientation toward one's
own body, becoming aware of its specific movements and dimensions, evokes a height-
ened sense of individual proportion. Thus, the illusionistic effect of the sculpture's
visual appearance is radically attenuated. This is underlined by the way in which the
limbs of the human figures reach out into space,[12] by the expressiveness of their
exaggerated gestures and movements, whose fascination is almost impossible to resist,
since the figures stand on the same level as the viewer. A further characteristic feature
of floor-mounted sculpture is its all-round visibility: the traditional compositional
device of the principal view is abolished, and the work can be looked at from all sides
and from any angle that the beholder chooses. This quality can be found in nearly all
Rodin's sculptures: it is especially apparent in the groups of figures, such as *The
Burghers of Calais*.

Where the viewer is no longer tied to the principal view but is required to walk
round the sculpture and examine it from a variety of different positions, the idea of
movement as continuous process assumes new importance, as becomes apparent, for
example, in the analogous principle of "hollows and bulges" that governs the actual
shaping of the sculpture. Different views, all having an equal status, can be juxtaposed
in both spatial and temporal terms. In this context, it is particularly interesting to
consider the original – pre-Cubist! – base, made of bare rock, that Rodin created for his
monument to Victor Hugo when it was installed in the gardens of the Palais Royal in
1909 (see Fig. 4). Several art-historians have claimed that the placing of the group,
allowing it to be viewed from all sides, is contrary to Rodin's general aims, but this is
far from being the case: in fact, the work is mounted in a way that follows the shift
toward a total opening of sculptural space. Having conferred an element of fragility
on the ensemble by setting it on the slant, Rodin piled up the blocks of natural stone in a

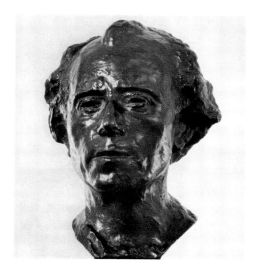

Fig. 7a *Gustav Mahler*, 1909. Bronze, height 13½″ (34 cm). Rodin Museum, Philadelphia

Fig. 7b Gustav Mahler. Photograph

Fig. 7c *Mozart*, 1910-11. Marble, height 12½″ (32 cm). Musée Rodin, Paris

disorderly heap to create an overall spatial situation that is characterized by a sense of openness and all-round visibility. Moreover, the figure of the poet, appearing to grow directly out of the rough-hewn stone, seems almost to float in space, defying gravity.

It is possible to discern a number of parallels between this spatial opening of sculpture and the content of Rodin's art. Rodin was fond of playing games with double and multiple meanings: abhorring all forms of thematic limitation or circumscription,[13] he prized the ambiguities that arise where different ideas intersect. He never tired of exploring terms and concepts, mainly in connection with religious and mythological themes; he was forever pushing ideas this way and that in every conceivable direction, and reading new meanings into them. On occasions, he even went so far as to abrogate the time-hallowed principle of individual autonomy, and invented figures which combined different personalities.[14] For example, he saw the head of Gustav Mahler as combining the features of Frederick the Great, Benjamin Franklin, and Wolfgang Amadeus Mozart (see Fig. 7 a-c), thereby denying the very notion of individual personality; and in one of Michelangelo's slaves he discovered the face and the destiny of Ludwig van Beethoven.

Let us return, however, to the discovery of freestanding floor sculpture. Rodin's *The Martyr*, made in 1885, was the first of his sculptures to dispense with the base, applying this innovative principle with greater rigor than in any of his subsequent works: the various versions of the work were plainly intended to lie directly on the floor, unsupported by any kind of plinth (see Fig. 6 and plate 14). A further important aspect of this type of sculpture is the emergence of the overhead view. Rodin employs this device in numerous sculptures – for example, *Despairing Man* and *Danaid* (plate 30), both of which were made in the second half of the 1880s.

Rodin's alternative plan for the installation of *The Burghers of Calais*, suggesting that the figures should be mounted on a two-story tower, might appear to be at cross-purposes with his first bold steps toward the abolition of the base, but this is not in fact so. The artist's aim, in this case, was to distance the viewer from the sculptural event: to the same end, he frequently mounted his smaller sculptures on oversized pillars and pilasters when exhibiting them. Although this practice is somewhat reminiscent of Gothic cathedral sculpture, with its emphasis on the notion of transcendence, one suspects that, in his mind's eye, Rodin already had a prototype image of a future form of weightless sculpture that would be entirely liberated from material constraints. The German-born conceptual artist Hans Haacke, who now lives in New York, has characterized *The Burghers of Calais* thus: " If one lifts it [the group] off the ground and up

Fig. 8 *Monument to Puvis de Chavannes*, 1899. Plaster

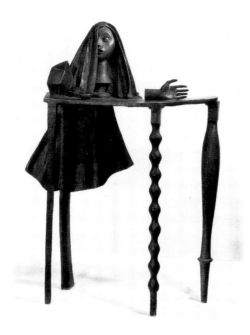

Fig. 9 Alberto Giacometti, *Surrealist Table*, 1933. Bronze, height 56¼″ (143 cm). Musée National d'art moderne, Centre Georges Pompidou, Paris

into the air, the figures seem to lose their shackles: it's as if they had been liberated."[15] With his notion of distancing sculpture and allowing its inner potential to unfold in an entirely open space, Rodin seems to anticipate the ideas of his successor Alberto Giacometti, who declared that "sculpture rests in a void."

The same perspective governs Rodin's attempts to liberate figures from their own weight and place them in a state of suspension. This applies to the multitude of figures, seemingly defying the laws of matter, in *The Gates of Hell* (Fig.5, p.11), to the gesturally expressive figures of people dancing or flying, and to *Iris, Messenger of the Gods*, a hieroglyphic symbol of extreme physical torment, in which the body is stretched to breaking point. The expressive, ecstatically exaggerated movements in this work, occurring in a series of dramatic contrasts with frequent shifts of direction, lend it the appearance of an energetic "figure of process" suspended in space; it is an early precursor of the spatial sculptures of an artist such as Norbert Kricke.

Rodin also made an initial contribution to the development of a further genre in twentieth-century sculpture. The work to which I refer is his proposal for a monument to Puvis de Chavannes. Rodin submitted the proposal in 1899, a year after the death of the painter, whom he greatly admired, but the work was never executed. In the model (Fig.8) a number of heterogeneous objects are assembled on a low plinth. On the left there is a table with two plinthlike elements, including a classically inspired capital, on which the bust of the dead painter stands. This section of the sculpture, with its clear tripartite vertical order, is offset by the fragility of the two diagonal lines formed by the branch of an apple tree and the body of a naked youth, the *génie du repos éternel*. The branch, bearing fruit, and the figure of the young man, captured in a pose that reminds one of the images of mourners on classical funerary stelae, almost fall outside the central axis; but, at the same time, they quietly align themselves with the general architectonic structure. The seemingly random arrangement of individual and autonomous plastic signs is not without an element of deeper meaning. As a whole, the sculpture forms a still life with the character of an inanimate object: the austere form of the table, resembling a monument, is dominated by the head of Puvis de Chavannes, and the spirit of the dead man appears, as it were, to preside over the work. By way of contrast, the images of nature and man to the right of the table are combined in an almost playful manner. The table remains an integral part of an overall arrangement that resembles a still life and puts one in mind of Art Nouveau craft objects.[16] However, in the assembly of things that differ widely in terms of both character and expression, one detects an element of the surreal, which is a typical feature of twentieth-century "table" sculpture. Comparing Rodin's monument with a work such as Giacometti's *Surrealist Table* of 1933 (Fig.9), one notices certain analogies between the two artists: for example, in the use of figurative images that are in themselves autonomous but are brought together to form a tissue of citations. Even in the most abstract forms of modern table sculpture, in works such as Anthony Caro's "Table Pieces," a lingering sense of the surreal persists. Rodin's first steps in the direction of this new genre supplied the initial impulse for a long series of works by such twentieth-century sculptors as Brancusi, Giacometti, Fernando Botero, Reiner Ruthenbeck, David Smith, and Günther Uecker.

These observations serve to underline the importance of Rodin's work as a source of inspiration for twentieth-century art as a whole, and for the art of Beuys in particular.

Although it would be grossly inappropriate to apply Beuys's "extended concept of art" and his notion of "social sculpture" to the work of Rodin, it is possible to discern certain elements in Rodin's thinking that, in retrospect, can be regarded as preparing the way for the theories of Beuys. In this context, Rodin's comments to Paul Gsell concerning the value of work as the "goal" of social existence take on a new and persuasive meaning. Rodin declared: "For this marvelous change [in society] to

occur, all that would be needed would be for all men to follow the example of artists, or rather that they all become artists themselves."[17] With the benefit of hindsight, it is impossible to overlook the positively prophetic character of this hopeful statement, which clearly anticipates Beuys's vision of a future in which everyone would be an artist.

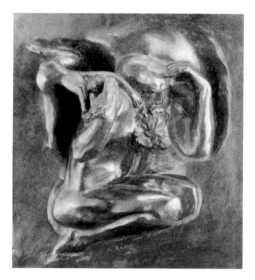

Fig. 10 *The Creator*, c.1900. Bronze, height 16¼" (41 cm). The Metropolitan Museum of Art, New York, The B. Gerald Cantor Collection

Notes

1 Albert E. Elsen, *Rodin* (New York, 1963); Denys Sutton, *Triumphant Satyr: The World of Auguste Rodin* (London, 1966); John L. Tancock, *The Sculpture of Auguste Rodin: The Collection of the Rodin Museum, Philadelphia* (Philadelphia, 1976); J. A. Schmoll gen. Eisenwerth, *Rodin-Studien: Persönlichkeit – Werk – Wirkung – Bibliographie* (Munich, 1983); Manfred Fath, "Auguste Rodin und die moderne Plastik," in *idem*, with J. A. Schmoll gen. Eisenwerth (eds.), *Auguste Rodin: Das Höllentor – Zeichnungen und Plastik* (Munich, 1991), pp. 47-58.

2 Franz Joseph van der Grinten, "Das Malen mit den Wasserfarben," in *Joseph Beuys: Aquarelle und aquarellierte Zeichnungen 1936 bis 1976*, exhibition catalogue, Düsseldorf, Kunsthalle, 1986, p. 8.

3 See the catalogue of the exhibition of Beuys's drawings titled *The secret block for a secret person in Ireland*, Berlin, Martin-Gropius-Bau (Munich, 1988), vol. 2, nos. 222, 230.

4 For example, there are interesting comparisons to be drawn between Beuys's *Eskimo Women* (1951-52) or *Nude + ½ Nude* (1954; *The secret block*, nos. 34, 54) and Rodin's *Kneeling Woman, Her Head Thrown Back, Vase Woman* (Musée Rodin, Paris [D.4772, D.4771]; Ernst-Gerhard Güse [ed.], *Auguste Rodin: Drawings and Watercolors* [New York, 1984], nos. 132, 133), or *Seated Nude, Leaning Forward with Her Hands Folded* (Kunstsammlungen, Weimar [KK 1275]).

5 Güse (ed.), *Rodin*, no. 132.

6 For instance, one may compare Rodin's *Vase Woman* (Güse [ed.], *Rodin*, no. 133) with Beuys's *Vessel-Shaped Sculpture* (1949) and *Woman Collecting Honey* (1953; *Beuys: Aquarelle*, nos. 66, 184).

7 Present volume, p. 211.

8 Franz Joseph van der Grinten, cited in Heiner Stachelhaus, *Joseph Beuys* (Düsseldorf, 1987), p. 161.

9 John Berger, "Rodin and Sexual Domination," in *idem, About Looking* (New York, 1980), p. 182.

10 For further information and comment on this trend in modern sculpture, see Siegfried Salzmann (ed.), *Bodenskulptur*, exhibition catalogue, Bremen, Kunsthalle, 1986, and Eva Renate Meyer-Hermann, *Das Phänomen Bodenskulptur* (Bonn, 1991).

11 Cited in Bernhard Kerber, "Skulptur und Sockel: Probleme des Realitätsgrades," *Giessener Beiträge zur Kunstgeschichte* 8 (1989), p. 114.

12 See Werner Hofmann, *Die Plastik des 20. Jahrhunderts* (Frankfurt am Main, 1958), p. 114.

13 "When all is said and done, you should not attribute too much importance to the themes you interpret." Cited in Rodin, *Art: Conversations with Paul Gsell* (Berkeley, 1984), p. 75.

14 See the essays by Siegfried Salzmann, "Mona-Lisa-Verfremdungen und -Metamorphosen in der Kunst des 20. Jahrhunderts," and Udo Kultermann, "Interpersonale Figurationen: Zu George Deems *Mona Lisa Washington*," in *Mona Lisa im 20. Jahrhundert*, exhibition catalogue, Duisburg, Wilhelm-Lehmbruck-Museum, 1978, pp. 78 ff. and pp. 112 ff.

15 Edward F. Fry, *Hans Haacke* (Cologne, 1972), p. 42.

16 See Schmoll gen. Eisenwerth, *Rodin-Studien*, p. 71.

17 Rodin, *Art*, p. 106.

Ginger Danto

Rodin: Erotic Inspiration in Nature

"It is as though Rodin liked best to sense
the female face as part of her beautiful body,
as though he wished its eyes to be the eyes of the body,
its mouth to be the body's mouth."

Rainer Maria Rilke[1]

Some twelve kilometers southwest of Paris, toward Sèvres and Saint-Cloud, where the suburbs split into small hillside towns atmospherically remote from the capital, panoramic views take in the winding circuit of the Seine, and the city flanking it, from Saint-Germain to Trocadéro. Save for their staggering perspectives, these peripheral towns of asphalt houses and narrowly circumscribed gardens offer little out of the ordinary. Days are measured by the tinny rattle of trains on viaducts, their monumental arches rising perpendicular to the land, and nights by the twilight influx to a central market square. Sundays, marked by mass attendance at early church service and the clatter of midday meals, fall silent by afternoon, when families engage in the perennial rituals of their otherwise disparate lives. In flat surroundings, these towns might hardly be distinguished from hundreds across the country – towns shrouded in the self-sufficient temper of their resident middle class, whose collectively modest existence unfolds within the homogeneous architecture of humble visions.

Of these enclaves ennobled by their height, Meudon, from the upper reaches of its gradual, road-spliced slope, claims perhaps the most dramatic vista. While modern transportation and the proximity of Paris have combined to make Meudon a commuters' annex, the area has failed to disinherit fully the oddly rural ambience of its past. One easily imagines how stately villas once graced land now given over to groups of houses, and private parks ground that now subdivides into tidy, well-tilled tracts. One

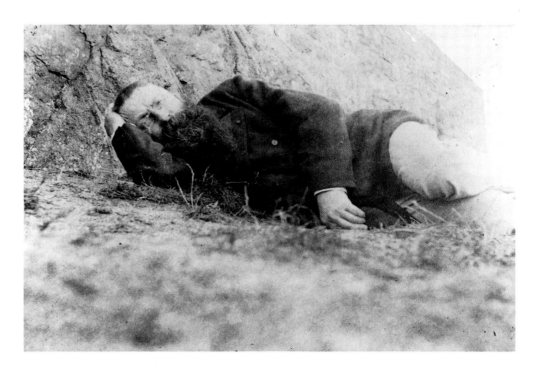

Fig. 1 Rodin on Guernsey, 1897

Fig. 2 The Villa des Brillants, Meudon

Fig. 3 Rodin and Rose Beuret with their dogs in the garden of the Villa des Brillants

sees, as well, how one such estate sat all but isolated on the hilltop, on a swathe of level earth wrested from adjacent fields and chalk pits, and bisected by a tree-lined driveway from road to house. Inelegant but for its site and name, the Villa des Brillants (Fig. 2) was an unseeming hybrid of architectural styles, from Louis XIII to the then latest in suburban housing. The quirky vision of a sculptress – who, in settlement of a judiciary matter, sold the property soon after its completion – the red brick "villa" was orphaned in the early 1890s, but did not remain long on the market. The successful bidder, who had recently taken up residence in the nearby town of Bellevue, was Auguste Rodin.

Many things attracted Rodin to this retreat, from its easy access to Paris, where he maintained studios on the Rue de l'Université, to the view, which rendered the urban world so remote as to remind him of the hills of Tuscany. A skylit studio and other outbuildings mitigated an otherwise awesome expanse, and may have brought reassurance to an artist who showed such concentration amid clutter. Furthermore, he had brought, as he would his dogs, his lifelong companion, Rose Beuret (see Fig. 3), a former seamstress who, from Rodin's early days toiling in an unheated attic to those of his solvent glory as a renowned sculptor, had clung through more material and spiritual poverty than most. Though Rose was still in the shadows, where she had always been sequestered, usually barred from participation in Rodin's increasingly distinguished public life, she could by now enjoy a less illusory feeling of belonging to the man she had so sacrificially bound herself to, and that man could, in turn, check a mounting sense of self-persecution regarding her.

Yet more than by its value in appeasing Rose – whose pleasure at Meudon surfaced in accordance with the dim memories of her country childhood – Rodin was struck by something so vital that he took to the place spontaneously upon discovering it during an afternoon walk. For Rodin, who equated man's genius with an ability to make something of nature, Meudon constituted the ideal milieu for nurturing his particular claim to genius – that is, through art. Lush and abundant, nature ran wild here but for the occasional efforts of gardeners to thwart the resilient vines and grasses from taking over. The scenery was so unkempt that one visitor was induced to describe the flora as so much fur, so impenetrable as to render invisible the busy intermingling of field, flower, and fruit tree. To Rodin, however, the setting was rife with well-defined images that would offer him endless inspiration. In nature he discovered not only images of men and women, but also entire, often erotic, scenarios between them, so that a landscape seen through Rodin's eyes literally came to life, and any movement within it became equated with aspects of desire. "The tall trees are tipped with sunlight," Rodin noted of the once similarly "unsightly" grounds of the Hôtel Biron in Paris, which he would intermittently occupy a few years later (see Fig. 5). "The sun has not yet reached the little avenue of oaks; the landscape has not yet seen her lover, who is already there, behind, but gives less to her than to others." Putting on his spectacles, he added: "I see the thousand facets of the acacia like a mast whose vessel is at anchor upon the waters in fine weather which the wind stirs gently."[2]

Rodin, who sought "to represent only what reality offers me spontaneously,"[3] was not interested in imposing propriety on nature, whether in his garden or in his studio, where by now models were made to roam freely before his eyes, rather than strike unnaturally static poses. At last, material circumstances allowed him to lay claim to a universe that had hitherto eluded him, a universe that he had known, with instinctual immediacy, all along. For nature, from its most global analogy in human or, indeed, animal behavior to its most generic reference in a linear blade of grass, was Rodin's ultimate guide and arbiter in art. Nature, to Rodin, was truth, and he saw it as incumbent upon artists to respect and replicate that truth via their chosen medium. Had he been a writer, Rodin would have striven to write that truth and, in turn, would

Fig. 4 Guests in the garden of the Villa des Brillants. Rodin is to the left of the column

Fig. 5 The Hôtel Biron in Paris, now the home of the Musée Rodin, seen from the garden, c. 1910

Fig. 6 *Balzac* in the garden of the Villa des Brillants. Photograph by Jacques-Ernest Bulloz, 1908

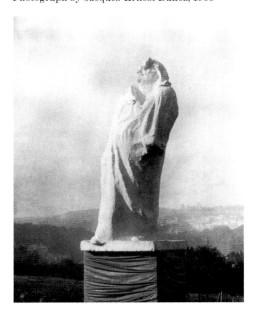

have been condemned, along with his fellow nineteenth-century sensualists, for evoking it in variously shocking detail. As a man and a lover, he endeavored to possess, to the frequent detriment of those taken, a truth about women through that which they unwittingly unfolded from their bodies. Notwithstanding a quasi-maternal attachment to the long-suffering Rose, who may have supplied the first tangible images of *volupté* and, subsequently, *maternité feminine*, Rodin's well-documented amours thus affected dozens of women, leaving them like so many shards from the birth of a magnificent sculpture, or, as a tormented Gwen John wrote in the course of a notably epistolary episode: "I am but a little piece of suffering and desire."[4] As an artist, however, Rodin applied passionate and practical research of nature to the artform that can be, in dimension and stature, most imitatively representative of its subject – sculpture. His place of work, or of contemplation of work, became a kind of laboratory for seeking the truth.

Eventually, Meudon took on the contemplative and somewhat chaotic quality of its proprietor, its grounds overrun with the eclectic elements of Rodin's autodidactic affection – from remnants of Antique statuary and the reconstructed pavilion built for his retrospective at the 1900 Exposition Universelle in Paris to the facade, rescued from demolition, of the château at nearby Issy-les-Moulineaux. Rodin collected all these treasured fragments of abandoned statues and buildings in his garden "for conversation"[5] – a museum to those discarded things, which, like himself, had known neglect and disenfranchisement, and which would have been lost forever but for an artist intent on preserving them as so many meritorious symbols of beauty. From the random rows of sculpted heads and torsos, the disjointed bits of bodies that Rodin considered complete works, emerged a symbolic panorama of the artist's commingled private and public life – "the whole of his bitter life, all the injustices and all the hates with which he was assailed," as his onetime secretary, Gustave Coquiot, reported in his chronicles.[6] Here, too, was Rodin's *Balzac*, rejected in its final form by its commissioners at the Société des Gens de Lettres, who saw in the statue only a silhouette of unflattering breadth, apparently unsuitable for the eternal effigy of a literary master. Swathed in a great gown, all of Balzac's heft and haughty features are gathered up into an incisive gaze that is directed, by way of the tangled garden at Meudon, toward eternity (Fig. 6). He thus enjoyed the very view that endlessly enraptured his creator, who wrote: "Every morning I go and admire a new country The fog formations in this area are admirable. At every instant the trains discharge smoke into small clouds. And one has a sense of infinity."[7]

Rodin, by his fifties, could better view his career with satisfaction, and his struggles as so many invaluable apprenticeships, in a place of his own that both suited and stimulated his particular aesthetic. On arrival at the Villa des Brillants, he continued working on major commissions, from *The Burghers of Calais* (Fig. 3, p. 189) and elements for *The Gates of Hell* (Fig. 5, p. 11) to a monument to the Argentinian hero Domingo Faustino Sarmiento. In time, however, he was turning out diminutive sculptures of playful nudes and of sensually acrobatic dancers (see Fig. 8), whose imprecise grace denotes a movement somewhere between classic dance exercises and erotic foreplay. And while he invested all his drive and dexterity in treatment of detail in the noble effigies of heroic men, the freestanding female figures, cast in all the private, provocative poses of uninhibited pleasure that Rodin could envision, brought out a more heightened sensuality that was virtually without parallel in contemporary art. These figures found their counterparts in the drawing to which Rodin increasingly devoted himself toward the end of his life. Less sculptural or anatomically exact studies than quick sketches that often directly confront women's sexuality, these libidinal drawings chart the denouement of Rodin's systematic progression toward an erotic essence. As always, the vicissitudes of Rodin's romantic life, his continued

flagrant courtship of women, influenced his art. His vigorous extracurricular pursuits gained for Rodin the somewhat inglorious epithet "sultan of Meudon," a slightly more pointed name than the simple "érotique" that he had come to be called in Paris by a public alerted to his appetite. By the turn of the century, however, Rodin's artistic reputation had become commensurate with his sexual one, and Meudon was the place where man and myth came together.

Rodin's own sense of this fusion may have indirectly inspired a series of sculptures on the theme of creation, from *The Hand of God* (plate 40) – which shows Eve curled as in a womb, anchoring a less well-defined Adam on their joint trajectory to existence – to its conceptual corollary, *The Hand of the Devil* (plate 24). In these works of 1902 through 1908, Rodin played not merely mortal "érotique," but the artist as accomplice to God, the pulse of all creation and, subsequently, of damnation. And while the eroticism here is subsumed by allegory, it reflects how Rodin saw in the hand, as in other parts of human anatomy, a power to express independently a tension that the face, or for that matter the genitals, might have conveyed more easily, if more superficially, to the viewer. Elsewhere, two isolated right hands, for example, symbolize a lovers' union just as effectively as the hands poised on waist, thigh, and shoulder in the chaste embrace of two full-bodied lovers in *The Kiss* (cf. Fig. 14 and plate 13).

Where there are neither bodies nor a gracefully circumscribed negative space between limbs that are about to interlock, there is often matter, matter symbolizing the great rough-hewn rocks deposited here and there within the maelstrom of creation and, thus, the foundation of nature from which Rodin worked so conscientiously. On the other hand, all movement in nature – day yielding to dusk, wind rising from still air, waves washing against the shore, or flowers emerging from their buds – took on the aspect of human bodies. Each of these observed, intemporal acts was for Rodin an act of need, an innate propulsion that, for him, implied the inexorable course of human desire.

To wander through the now properly tame and tailored gardens of the Villa des Brillants is to witness belatedly the stuff of Rodin's inspiration, to recognize how he corroborated nature's cues with his own creations during daily dawn walks to see and smell and awaken his senses to the ambient beauty that he would attempt to transfer to his work. "Art is contemplation," he said. "It is the delight of the mind that penetrates nature and divines the spirit by which nature itself is animated."[8] For Rodin, woman's body was the most "penetrable," malleable symbol of nature, and vice versa, so that each was reflected in the other and Rodin used the image of one to personify the other.

"Beauty is everywhere. It's not beauty that is missing from our sight, but our eyes that fail to perceive it," Rodin told Paul Gsell, a frequent visitor to Meudon who later published the conversations he had had with his host:

Beauty is character and expression. Now, there is nothing in nature that has more character than the human body. It evokes through its strength or its grace the most varied images. At one moment, it resembles a flower: the bending of the torso imitates the stem, while the smile of the breast, head, and gleaming hair corresponds to the blooming of the corolla. At another moment, it recalls a supple liana, a shrub with a fine and daring camber At another time, the human body curved back is like a spring, like a beautiful bow from which Eros aims his invisible arrows. Yet another time, it is an urn. I have often had a model sit on the floor and turn her back to me with her legs and arms drawn before her. In this position, only the silhouette of the back, which narrows at the waist and widens at the hip, appears, and this forms a vase with an exquisite contour: the amphora that holds the life of the future in its flanks.[9]

If the above is a definition of how Rodin worked, proceeding from that which he perceived in nature's own inimitable atelier, it also constitutes a defense against the attacks invariably leveled at the degree to which sexuality influenced his oeuvre. While Rodin's work is now regarded with enlightened enthusiasm, a puritan sensibil-

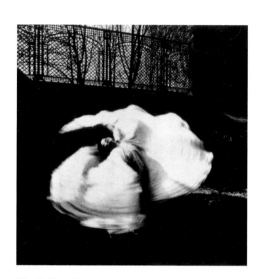

Fig. 7 Loïe Fuller dancing in the garden of the Hôtel Biron, c. 1913

Fig. 8 *Dance Movement A*, c. 1910-11.
Bronze, height 26″ (66 cm).
The Metropolitan Museum of Art, New York,
The B. Gerald Cantor Collection

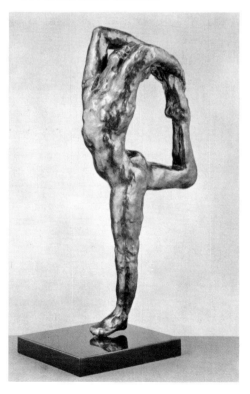

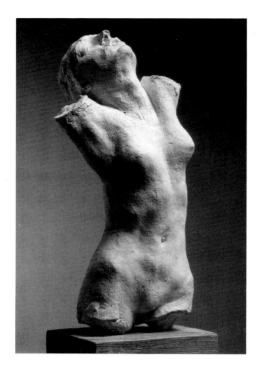

Fig. 9 *Torso of "The Centauress"*, c. 1884.
Terracotta, height 8½″ (21.5 cm).
Musée Rodin, Paris (S. 990)

Fig. 10 Rodin with his statue of Adam.
Photograph by Gertrude Käsebier

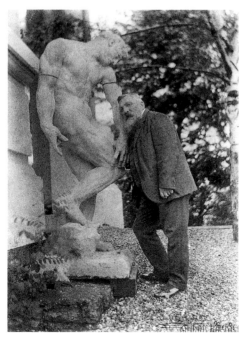

ity marked some of the criticism that condemned it in his day. Critics grappled dimly with the high quotient of sexuality by questioning whether it was good or bad, relevant or inappropriate, determining where it should have been absent, where it was demeaning, or even where it was apt in its omnipresence, in its allegiance to that which is inherent in everything in nature.

For Rodin, the issue of sexuality was simple in art, even if in his life it was manifested throughout in endless complex and inconclusive liaisons. He understood sexuality and its more spiritual expression, eroticism, in the broadest sense: that is, life and that which life springs from, a kind of motor for the perennial cycles of desire that spin across, and thereby propagate, the natural universe. The fact that desire gone awry leads to damnation provided Rodin, via the poetic scope of Dante's *Inferno*, with further inspiration for even more violently expressive figures. Deployed against the vertical vortex of the Gates of Hell, these agile souls, whose eternal future is penance for misguided lust, denote an eroticism so imaginative and diverse as to ward off any aesthetic preoccupation with its biological points of origin.

Rodin did, however, intermittently attend to just that in his oeuvre. For example, his audacious incarnation of Iris (Fig. 6, p. 213) shows a dancing nude whose choreography is suspended, with one leg outstretched to reveal her crotch. *Iris, Messenger of the Gods*, among whose alternative titles was *Endless Tunnel*, was to have accompanied a sculpted portrait of Victor Hugo, in whom Rodin recognized an artist who, like himself, drew much of his spiritual livelihood from women. *Iris'* carnality was too overt for the time, however, and in his monument (plate 28) Hugo was ultimately shown without her, his inspiration left to be inferred from so many pleats and furrows in his downcast brow, rather than from the splayed limbs of a lasciviously rendered muse. Though publicly unappreciated, *Iris* was exponentially immortalized by its creator, for whom it prefigured not only sculpted dancers (see Fig. 8), but also drawings that placed the female sexual organs in the foreground. In such sketches, however, the dark core etched in deft pencil strokes seems to ground the one-dimensional women, whereas Iris appears to take flight.

Furthermore, while Rodin's image of eroticism is not governed by the phallus, whether inert, absorbed into matter, or modestly effaced by a fig leaf, it is at least boldly emphasized once, in a less than life-size rendition of Balzac (Fig. 11 and plate 9). In this nude, among hundreds that Rodin wrought in his consuming search for the writer's essential image, the entire upright body is focused on the hand poised on the penis, every muscle directed toward a protracted pleasure that is clearly reaching its final ebb. This, to the voyeuristic imagination, is erotic, but to Rodin it was perhaps scarcely so at all, for it implied imminent resolution. For much of his sculptural population of men and women – mythic and mortal, alone, coupled and/or emerging from the chiseled blocks that bind them – that which is most erotic is the moment depicting the agonizingly fine-tuned pitch of unattained desire. Indeed, the portrayal of lovers – whether woman with man, woman with woman, or individuals cast from each other's arms but still somewhere or somehow connected, if only metaphysically – remained Rodin's prime context for exploring all the exalted and insoluble aspects of passion, as he drew his images from a sentimental inventory of art, Antiquity, allegory, and experience. That Rodin was especially successful with what Octave Mirbeau described as "accursed lovers, ever entwined and never appeased,"[10] who are seen tumbling precariously from Hell, reveals an essentially pessimistic assessment of romance in both literature and life.

Among the much analyzed examples is the couple in *Fugit Amor* (Fig. 13), whose adulterous attraction represents lust vainly overriding reason. Propelled by the presumably harsh winds of Hell's second circle, these two figures, however much they strain toward one another, never connect, for they are not meant to. They are placed

back to back, each arching back; he reaches over his head toward her, as she reaches away from underneath him. That they are eternally arrested in this extraordinary alignment makes their struggle all the more poignant and illustrative of the banal axiom that, the more one attempts to grasp something, the more it surreptitiously slips away. Elsewhere, these figures are shown alone. Of the male placed upright in *The Prodigal Son* (Fig. 12) Rodin said that he wanted the thrust of each muscle to show sorrow, and the accent of anatomical lines to express an exalted spiritual state. Yet the figure's torment, as it implores the skies in a paroxysm of solitary prayer, does not attain an impact comparable to that when it is attached to, and attempting to harness the affection of, its elusive lover.

Inasmuch as eroticism is an idea invested in that which we desire, it disappears, or at least diminishes, when that desire is quenched. Eroticism unbound, as in idolizing love, has all the more power, then, since it maintains in the realm of fantasy an idea that is forbidden physical realization. This may be the predicament of the lovers in *The Eternal Idol* (plate 23), the unbalanced composition of which suggests unreciprocated affection, and the melancholy of which denotes resignation to an impossible love. He kneels before her, his hands held back to plant a reverent kiss between her breasts. She, too, kneels, reclining her torso as if she would rather move away than toward him, but remains passively bound within reach of him by some invisible elastic force.

This theme of attracting and repelling in the dance of would-be lovers attains its most abstract representation in both the title and the form of *The Cathedral* (Fig. 14), in which two freestanding right hands form a concave space, as in a nave, above which the fingers do not actually touch. The lovers here are invisible, but in these isolated appendages we see all their hesitance and desire. The hands do not meet palm to palm, so the bodies are not merged skin to skin; but we imagine them very close, allowing for the heat and the draw of the erotically interminable moment of approach. Here, Rodin did not merely simplify anatomy at the service of an idea, but dispensed with virtually all contextual features as a way of emphasizing that idea. While this exercise heralded much of modern sculpture, it also underscored Rodin's view of the remnants of mutilated Antique figures in his possession as complete works.

Thus, Rodin's eroticism is as much in the hands, the feet, the neck – sometimes with a suggestive envelope of hair – and in the whole underlying inventory of muscle and

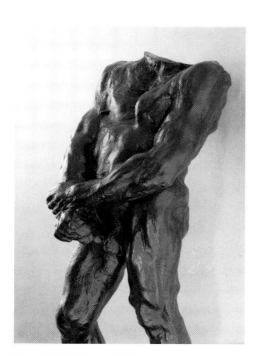

Fig. 11 *Naked Balzac*, 1896.
Bronze, height 36½″ (93 cm).
Musée Rodin, Paris (S. 1080)

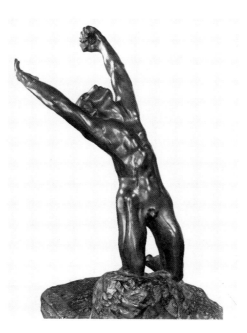

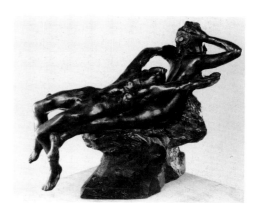

Fig. 12 *The Prodigal Son*, 1885-87.
Bronze, height 106¼″ (270 cm).
Musée Rodin, Paris (S. 1130)

Fig. 13 *Fugit Amor*, 1887.
Bronze, height 15″ (38 cm).
Musée Rodin, Paris (S. 598)

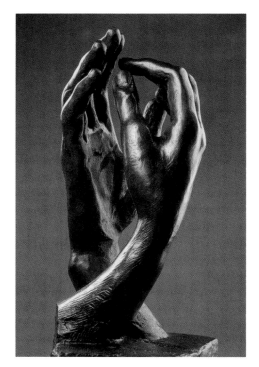

Fig. 14 *The Cathedral*, 1908.
Bronze, height 25½" (65 cm).
Musée Rodin, Paris (S. 478)

bone that bends and yawns in motion and repose, articulating desires that issue from a realm somewhere between cognizance and unconsciousness. Rodin's sculptures appear to think, or at least to have thought, before their molten minds yield to the primal progress toward often illicit action. In other words, they think – or desire mentally – before they act. Their eroticism is concerned, above all, with that which one cannot see, but imagines one sees, or might be able to see, in the aftermath of a glimpse of an ephemeral moment, frozen by translation into amazingly fluid forms.

In his effort to harness the ephemeral, Rodin was, up to a point, in harmony with the chief artistic current of the time, Impressionism, and in 1889 he even shared an exhibition with the movement's master, Claude Monet. The Impressionists strove to capture "l'état passager," the transitory moment that they believed was more faithful pictorially to reality than the protracted studio pose, and they documented their era through subjects that lent themselves to flux: the haze of rain on city boulevards, the shifting fog over seascapes, the thick sweep of ballgowns, or the swift, blurred bolt of racehorses. Rodin never subscribed fully to any one artistic movement, but seized on those ideas produced by the aesthetic evolution of his time that corresponded to the development of his personal style. He agreed with the Impressionists' theory, but he distilled its illustration, since for him all movement was practicable in art via the human body. In the alchemy of Rodin's eyes, a landscape appeared as the contours of the body, and earth's elements – water, vegetation, sun and moon – as bodily forms. " I will not say that woman is like a landscape that is constantly modified by the position of the sun," he said, "but the comparison is almost right."[11] Thus, Rodin's own erotic inclination led him to represent ephemera through the fleeting moments of a lovers' embrace, rather than through images of, say, clouds in a changing sky (see Fig. 15).

Not that Rodin stood apart from the course of nineteenth-century art, with its fascination not simply with women, but with nudes, and with its exploration of all themes that intimated the erotic through the image of naked or partly naked women. "The nineteenth century witnessed the gradual denuding of the nude," noted French art historian Michèle Haddad. "*A posteriori*, the century seems obsessed with the sexualized representation of the female nude."[12]

Much contemporary literature duly expressed the same concerns, with the likes of Emile Zola, Georges-Charles Huysmans, and the Goncourt brothers even making heroines of those experts in the most fundamental sexual exchange – prostitutes. Thus, the solidarity that Rodin lacked among fellow artists, critics, patrons, an often puzzled

Fig. 15 *The Birth of Venus from the Waves*,
before 1885.
Pencil and gouache over photograph,
4 x 5½" (10 x 14.2 cm).
Musée Rodin, Paris (Ph. 1053)

Fig. 16 Illustration to "Le Poison"
in the edition of Baudelaire's
Les Fleurs du mal published by Gallimard
in 1918

Fig. 17 *Seated Woman, Opening her Robe,*
after 1908 (?). Pencil on buff-colored paper,
21½ x 16″ (54.6 x 40.7 cm).
Musée Rodin, Paris (D. 5097)

public, and an institutional milieu that eagerly commissioned works from him only to be disenchanted with the results, he found among writers preoccupied with his preferred themes. Maupassant espoused an idea of love lived as something impossible, while Gustave Flaubert's sensual treatment of Salome conjured, for Gustave Moreau, "a woman walking nonchalantly, in a vegetal and animal fashion, in the garden."[13] And Hugo's poem "Le Sacre de la Femme" (The Rite of Woman) represented Eve as the summit of divine creation,[14] an order encapsulated in Rodin's sculptures on this same subject.

It was Charles Baudelaire, however, who was the most suitable successor to Dante as a kindred spirit in Rodin's world of thought centering on doom, and who shared the sculptor's predilection for the related themes of sin, solitude, and individual and female perversity. According to Rilke, Rodin found in Baudelaire's verses "passages that did not seem written, but sculpted; words and groups of words that had been smelted in the poet's burning hands; lines with the texture of a relief and sonnets bearing the burden of a fearful thought like columns with labyrinthine capitals." In the poet himself, Rodin "sensed ... one who had gone before him, who had ... sought bodies, in which life was greater, crueler and more restless."[15] Moreover, Baudelaire's nature was, like Rodin's, one of images available to an artist's eyes: "Nature is a temple where living columns sometimes allow corresponding words to emerge. Man passes through it in a forest of symbols that watch him with a friendly look."[16] Rodin, who once said that he passed through life happily seizing nature's need for beauty, might easily have been this symbol-seeking man.

To Octave Mirbeau, who championed Rodin in his popular journalistic chronicle of the art world, the sculptor was "the great preacher of *volupté*,"[17] a title the writer might have assigned himself, as emissary of the emergent erotic genre whose fellow practitioners included Pierre Louÿs and Georges Bataille. Like Rodin, however, Mirbeau apparently applied his personal experience to art, in literary portrayals of the psychosexual perversity of human nature. This affinity led Rodin to illustrate Mirbeau's most celebrated work, *Le Jardin des supplices* (The Torture Garden), with a series of drawings that corresponded only loosely to the text, as some were studies for existing or envisioned sculptural works. He contributed to a private edition of Baudelaire's *Les Fleurs du mal* in the same fashion (see Fig. 16). Regardless of the disparity between illustrations and texts, these quasi-collaborations reveal how much the artists' minds were in accord in their mutual obsession with sexuality and the emotional implications of carnal pleasure. Ultimately, they also nurtured Rodin's latent graphic talent, and the aging artist increasingly took to drawing as a finite form of expression, rather than as an outline for further elaboration in sculpture.

Rodin professed a "veritable cult of the nude,"[18] and this was no less manifest in his drawings than in his sculpture: among some eight thousand existing drawings the predominant image is that of the female body, adorned now and again by an allegorical or atmospheric prop. The latter serve symbolist themes or indicate aspects of the universe and cosmos that woman is intended to incarnate. In art woman is, for Rodin, more moon than the moon itself, more twilight than the amorphous fading shades of day. She is *Shooting Star*, she is *Fleeting Night*, she is *Fauness, Cicada, Eve* (see plate 5), and, in one depiction, aflame in red watercolor, she is even *Hell*. There is little in Rodin's aesthetic universe that woman is not, and in every incarnation, whether good or evil, she is part temptress.

Where the woman is meant merely to tempt and nothing more, where she is spared all symbolic duties save that of proffering ripe and ready flesh, she is shown in the most sexually vulnerable configurations of impassive invitation that merge the aesthetic with the obscene (see Fig. 17). Now languid in repose, now tense with pent pleasure, overturned to show her underside, upright to show her figure, half swathed in a

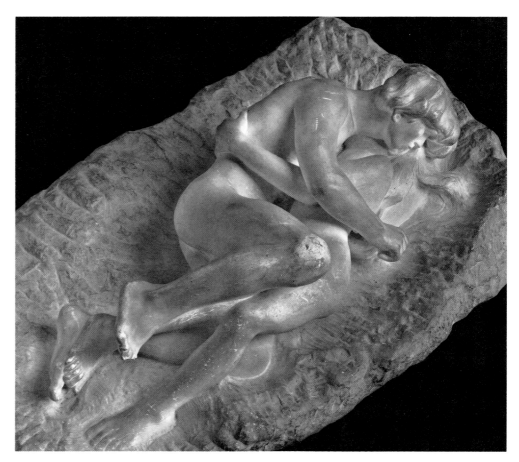

Fig. 18 *Cupid and Psyche*. Marble. Dimensions and whereabouts unknown

Notes

1 Rainer Maria Rilke, *Rodin*, trans. Robert Firmage (Salt Lake City, 1979), p.53.
2 Quoted in Frederic V. Grunfeld, *Rodin: A Biography* (New York, 1987), p.553.
3 Rodin, *Art: Conversations with Paul Gsell* (Berkeley, 1984), p.11.
4 Musée Rodin, Paris, Archives (Correspondence).
5 Gustave Coquiot, *Rodin à l'Hôtel Biron et à Meudon* (Paris, 1917).
6 *Ibid.*
7 Paul Gsell, *Entretiens réunis* (Paris, 1911).
8 Rodin, *Art*, p.4.
9 *Ibid.*, pp.51-52.
10 Octave Mirbeau, *Des artistes* (Paris, 1896).
11 Rodin, *Art*, p.49.
12 Michèle Haddad, *La Divine et l'impure: Le Nu au XIXᵉ Siècle* (Paris, 1990), p.9.
13 Musée Gustave Moreau, Paris, Archives (Cahiers).
14 As in the following passage: "Mais, ce jour-là, ces yeux innombrables qu'entr'ouvre / L'infini sous les plis du voile qui le couvre, / S'attachaient sur l'épouse et non pas sur l'époux / Comme si, dans ce jour religieux et doux, / Beni parmi les jours et parmi les aurores / Aux nids ailés perdus sous les branches sonores / Au nuage, aux ruisseaux, aux frissonnants essaims, / Aux bêtes, aux cailloux, à tous ces êtres saints, / Que de mots ténébreux la terre aujourd'hui nomme, La / femme eût apparu plus auguste que l'homme!"
15 Rilke, *Rodin*, p.26.
16 "La Nature est un temple où de vivant piliers / Laissent parfois sortir de conformes paroles / L'Homme y passe a travers des forêts de symboles / Qui l'observent avec des regards familiers." *Spleen et Idéal* IV.
17 Octave Mirbeau, *Auguste Rodin et son œuvre* (Paris, 1897).
18 Gsell, *Entretiens*.

garment that leaves her bottom partly unveiled, lying back so that not her eyes, but the lines and lips of her genitals look without – the one-dimensional women in these drawings exhibit every kind of pose from the coyly modest to the most brazen.

While these late drawings have been celebrated as Rodin's most erotic work, they reveal more the obsessive male reluctantly sensing his sexual vigor, and the practicability of desire ebb with age, than the artist reaching his apex in an ambitiously explicit genre. Indeed, the speed with which Rodin sometimes drew – as many as seven sketches in an hour, rarely glancing from the model to the paper – seems to owe less to visual inspiration than to the frantic fear of vanishing virility. As such, the often superficial lines represent a betrayal of the studied depth of anatomical action in Rodin's sculpture, in which, moreover, he was open to the intimate pairing of bodies. He seems to want these paper women for himself, and so there is no one but the artist (who is out of sight) before a woman lying languidly on some uncharted plane, her hand between her legs, calling up erotic imagery through her solitary pleasure.

That so many of the successfully sculpted couples were cast against the backdrop of Hell was, perhaps, Rodin's way of acknowledging in art a life that was unsusceptible to enduring passion, and this charged his work with an intensity that it might have lacked had it dealt merely in beatitude and sentimental fulfillment. This is what stands out, what one recognizes in Rodin, so that one is moved to say, "this is so real," for the work captures a moment that mimics not only motion but feeling, and, within that feeling, the myriad erotic impulses that push one person fatefully toward another. And all that constitutes a kind of genius that goes beyond art, a genius for breathing life into inanimate masses of matter variously categorized as marble, plaster, or stone.

Kirk Varnedoe

Modes and Meanings
in Rodin's Erotic Drawings

Fig.1 *Nude with Legs Spread*, c. 1908.
Pencil. Private collection, Paris

Rodin has often been praised, in loose parallel with Freud, for "unmasking" the centrality of the erotic in human experience. In such a view, the triumph of the modern outlook involved the bold removal of a crust of accumulated convention, in order to reveal "timeless" truths beneath. Lately, however, we have become more skeptical about this kind of either/or opposition between "natural" or unchanging aspects of humanity and time-bound, contingent aspects that are shaped by a particular culture and material circumstances. Freud himself, after all, can be read as saying something quite contrary: that our erotic behavior and even our erotic mental life, like everything else about us that may seem spontaneous and "natural," is always, and inextricably, the determined product of the contingencies of early individual experiences, and of the cultural constraints that surround us. His followers have gone even further in examining the unconscious as culturally structured, rather than primal and preexisting.

The erotic in Rodin's art, then, may better be thought of as something made, rather than something simply found or discovered; and the forms in which eroticism appears in his work might profitably be examined, not as transparent vehicles for transmitting a transcendent truth, but as representational devices whose own nature and history are enmeshed in the meaning of the work. In this context, the artist's later pencil and watercolor drawings of nudes are central. They contain the boldest and most frequent representations of sexual display (see Fig.1), masturbation, and lesbian intimacy in the artist's oeuvre; and, at the same time, everything about their conception – the random, unposed motion Rodin encouraged in his models, the rapid-fire way he initially drew without looking at the sheet on which he was working, and the extreme simplicity of the one-line contours and one-tone watercolor wash – seems to embody aspirations toward purified simplicity, and spontaneous freedom from convention, that are central to early modern ideals of art's power to refresh our vision of the world.

The erotic in these works is as much a part of the dream of its time as of the specific inner history of its author. If we rethink the relation of these innovative images to the earlier drawings that most fully record Rodin's development and education as an artist, we can establish a subtler set of linkages between Rodin and Freud, and also connect Rodin's later focus on the erotic with the motivations of Paul Cézanne, Georges Seurat, and others, stressing a powerful, shared conviction central to early modern ideals: the conviction that a powerful new art was to be made neither by merely imitating the ideal forms culture gave us from the past, nor by rejecting them entirely, but by rediscovering their truth in forms of immediate experience that had previously been marginalized or thought too ephemeral and chaotic to bear any significance.

Rodin drew constantly in almost every phase of his career, and in a bewildering panoply of styles. Finally, however, the central concerns of his draftsmanship, and the vast majority of all the drawings, can be seen to lie in two basic modes: the imaginative drawings that preoccupied him from his earliest years through the 1880s and the life drawings to which he devoted himself from the mid-1890s until his death.[1] Although

Fig. 2 *Ugolino: The Cruel Repast*,
c. 1870-80. Pencil, pen and ink,
6 x 7¾″ (15 x 19.5 cm).
Rodin Museum, Philadelphia Museum of Art,
Given by Jules Mastbaum

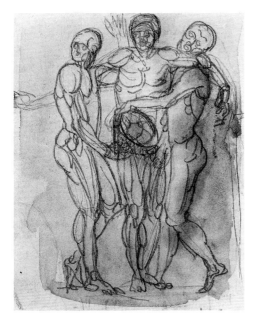

Fig. 3 *Three Nude Male Figures with
Tambourine*, c. 1880-82.
Pencil and watercolor wash,
5 x 3¾″ (13 x 9.5 cm).
Rodin Museum, Philadelphia Museum of Art,
Given by Jules Mastbaum

they may seem totally disparate, it is clear that we can approach a coherent under-standing of the artist only by studying these bodies of work together, as complemen-tary expressions of a single mind.

There are telling procedural similarities. When each mode of drawing is seen *in extenso*, what become striking are the constant operations of reconsideration, the massive repetitiveness, and the dogged attention to sets of gestures, themes, and ideas. In both the imaginative and the life drawings, an initial execution marked by quick impulse was offset by an extraordinary ongoing patience, a determination to exhaust the possibilities of each form. The two seemingly opposed paces of production form a· rhythmic interlock between two psychological poles of creation: first scattering and diversity, and then regrouping, analysis, and narrow shaping.[2] In both major modes of drawing, too, Rodin was first led to the expressiveness of a particular gesture by intuitive attraction; his choice of motif preceded any conscious consideration of literary meaning. Then, the selected gesture was adapted and readapted to multiple literary/mythological/symbolic associations. This order of procedure acted as certain-ly on a huddled mourner from an early entombment scene as it did on a model seized later in the passing rush of a dance.

The most important bond joining Rodin's early and late draftsmanship, though, has less to do with procedure than with basic meanings of style, and will require a more lengthy elucidation. Unlike other fashions of drawing Rodin used from time to time, these two major modes were not just inflections of rendering, but manners of concep-tualization that held personal expressive values. These ways of drawing, in inseparable conjunction with what was drawn, made statements about what sculpture should be, not only visually but morally and spiritually as well. If we examine the visual differences, we will be led steadily into the other realm of ideas.

Joining the two modes in one history, we can find at work a pendulum process with regard to line and value, each mode beginning with the linear and progressing toward a concern for tone and light. The imaginative drawings begin as airless, shadowless delineations (see Figs. 2, 3). As they are reworked, their contours become heavier and

join with added backgrounds. Eventually the "black" drawings seem like grottoes, their figures illuminated selectively in dark enfolding caves of space (analogous to the drapery-like "caves" with which Rodin surrounded his sculptures when he drew them in the 1880s; see Fig. 4). The internal articulation of the figure is first seen as a schematic map of muscles; but the volumes are subsequently bound together by ink shadows and then by more generalizing masses of white gouache highlights (see Figs. 5, 6). These processes need not have happened over years. In the maturity of the style, a single day's elaboration of a pencil work might have recapitulated the history of the mode. It was also a process Rodin could and did reverse, by taking from a gouached image a linear tracing, thus returning the form to its simplest state.

The later drawings, instead of growing out of the painterly vision of the fully developed "blacks," radically overthrew it. Linearity again dominated, but in a wholly different framework. The body was not schematically divided, but sweepingly unified, both by an initial lack of internal definition and by the subsequent application of a watercolor wash. The tonal pattern of the early drawings was thus reversed – to dark figure on light ground – and with it the relation of the figure to atmosphere (see Fig. 7).

The basic change was from a conceptual to a visual mode, and not just in the banal sense that this is circumstantially the way the respective drawings were made. Though the imaginative drawings were often actually based on visible models, their basic *écorché* (flayed) treatment of the body was explicitly antivisual, analytic in the fashion of an x-ray. The later figure drawings by contrast, more than simply done from life, were meant to be true to an experiential model of vision. Rodin described the final watercolors as embodying the look of a figure seen at a distance against a twilight sky;[3] they refer to the physical limitations of sight (not the powers of the mind) as the determinants of style. Moreover, the original rapid life drawings on which they were based were (in opposition to the clarifying "far" vision of the watercolors) explicitly about the deformations of near vision, in a very special way, having to do with a figure's interaction with space.

The early drawings characteristically employed a very restricted depth, as if the personae were lined up before a wall, and pressed back by a transparent picture plane. Some of their archaic, frustrated power derives from that compression (see Fig. 2). In the later life drawings, the sheet is felt more as a permeable block of space. The models push their limbs into its depth, out to its face, and against or through its lateral and vertical boundaries. The negative spaces between the figure and the boundaries of the imagined volume – the interactions of contours with the edge of the page – play a

Fig. 4 *Burial*, before 1897.
Pen and ink, ink wash, and gouache,
5½ x 6½" (14 x 16.5 cm).
From the *Album Fenaille* (Paris, 1897)

Fig. 5 *Charity*, c. 1884. Pen and ink and gouache on buff-colored paper,
4¾ x 4⅜" (12 x 11 cm).
Fitzwilliam Museum, Cambridge, Bequeathed by Charles Haselwood Shannon, 1937

Fig. 6 *Charity*, c. 1880.
Watercolor, ink, and gouache,
6½ x 5½" (16.5 x 14 cm).
Rodin Museum, Philadelphia Museum of Art,
Given by Jules Mastbaum

Fig. 7 *Nude with Draperies*, c. 1900-5.
Pencil and watercolor wash,
17½ x 12⅜″ (44.5 x 31.5 cm).
The Art Institute of Chicago,
The Alfred Stieglitz Collection

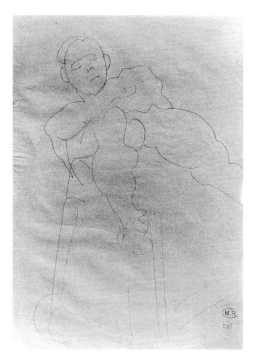

Fig. 8 *Male Nude on a Wheeled Platform*, c. 1898.
Pencil, 12¼ x 8″ (31 x 20.5 cm).
Musée Rodin, Paris (D.587)

central role both in evoking the power of movement and in signifying the artist's presence. In their cropping, perspective, and placement on the page, these figures aggressively refer to the artist's choice of proximate vantage (see Figs. 8, 9). This spatial feature is worth pursuing, for its basis is more extraordinary than may at first be evident.

On the one hand, the contours of these figures were drawn with the experience of a lifetime's modeling. As it flows, the line springs and swells in constant kinesthetic sympathy with the play of muscles and gravity in the pose – a response possible only because of haptic knowledge so decisively set in the artist's spirit that it can command his fingertips without recourse to the conscious mind. Simultaneously, however, the model is also seized as an overall volume, by an eye of watchful innocence rather than experience, constantly attentive to the unpredictable, aberrant shapes formed in momentary congruences of pose and viewpoint. The latter shapes, their overlaps and foreshortenings synthesized into unitary silhouettes, later find their ultimate expression in cutouts (see Fig. 10). Drawing in this fashion demonstrates enormous confidence: first in letting the instinct of the hand have its way, and second in defeating the (normally involuntary and tyrannical) perceptual censorship of ideas of "correct" proportions, scale constancy, and basic intelligibility. The figures are drawn at once knowledgeably/sculpturally, in the absorbed elaboration of the line itself, and "naively"/optically, in the receptiveness to unexpected, perspectivally deformed configurations (see Figs. 8, 9, 11).

With these considerations in mind we can reexamine more meaningfully the basic distinction between conceptual and visual in the early and late modes of drawing. The early drawings were done from memory and are about what memory does; they are at base static, analytic schemata of the figure produced by mental condensation and reformulation over time. The later drawings, by contrast, are about defeating memory by immersion in the lived instant and thus opening the way to a counteranalytic (more Bergsonian)[4] perception of form in transition, taken in its optical, experiential reality rather than its ideated form.

On the level of larger meanings which we thus approach, we would do well also to reexamine in more specific terms the apparent truism that the imaginative/"black" drawings are by and large serious, and the life drawings light and playfully exuberant. The early drawings extrapolated their basic poses of conflicted counterrotation and their constricted spaces from the inherited codes of the Western artistic tradition. The poses that then intuitively attracted Rodin seem most frequently to have been associated with (and subsequently readapted to) themes of anguish and struggle, and tragedies of limits, ends, and constraints. Rituals of death had a privileged place; and gestures of aggrieved consciousness, even more than contortions of physical suffering, seem to have moved the artist. There are, for example, no crucifixions in the imaginative works, but the entombment is a constantly repeated motif;[5] and the tendency in such images is to focus on, and increase the number of, attendant spectators. *The Thinker* (Fig. 6, p. 11), Rodin's earliest conception of the creator/poet, is far more than coincidentally derived from the lineage of these mournful watchers at the tomb. The repeated appearance of a two-figure group comprising a massive parent and helpless child is also characteristic. By the multiple manipulations of the drawings themselves, this motif becomes an ambivalent emblem of civilization; the protective role of paternal authority and/or maternal love (see Figs. 6, 12); the conflict between man's natural/animal condition and the constraints of his humanity/morality (*Ugolino*; Fig. 13); and the symbolic drama of infanticide (*Medea*; Fig. 14)[6] which may stand for the relentless process of time consuming its own creations.

In the life drawings, there seems no question of such issues. Instead of being drawn from tradition, poses originate in random movement, in patterns of instinct and

spontaneity rather than ritual. Yet such works do not simply bespeak a frivolous escape from concern for human meaning. They constitute instead a declaration of belief, highly consistent with the time of their creation, that the basic significance of life is latent in its ephemeral, seemingly random, and unguarded manifestations. As early as the later 1870s, when he rejected Michelangelo's poses in favor of studying without prejudice his models' natural movements, Rodin implicitly affirmed that one does not equal the past by imitating it, and that the secrets of great creations must be rediscovered at their source rather than in venerated representations.

In a letter to the sculptor Emile-Antoine Bourdelle, written after 1900, Rodin explained how, after a delay of almost two decades, the later life drawings of his models freely moving, without pose, had actually been the fruit of his encounters, in the 1870s, with the sculpture of Michelangelo: "Michelangelo gave me some invaluable perceptions," he said, "and I copied him in my spirit, in certain of my works, before understanding him. Once I understood, I saw that this movement existed in nature, and that I had only to avoid losing that in my models that this movement was something natural, not something I could impose artificially; from that point originated my drawings, which came a long time afterwards, however, and in which one will find Michelangelo again, in such a natural form that one will not suspect it."[7]

Freud's contemporaneous understanding of the significance of the apparently arbitrary, and his belief that the inherited representations of myth and religion are only reflections of basic human experiences recoverable from our own unconscious lives, should be cited in juxtaposition.

Both major phases of Rodin's draftsmanship were thus motivated by a concern for significant gesture; but the worlds of meaning to which the two modes addressed themselves were opposed. The earlier drawings returned again and again to the dilemma of civilization, expressed in the interlock between the power of the heroic and noble and the agony of consciousness of contradictions, guilt, and mortality. The later drawings dealt instead with the natural energy of movements determined in subjective centers beyond the reach of social discipline, historical memory, or constraining doubt. The difference in emotional tone and underlying idea corresponds in many respects to the different ideas of creation manifest in *The Thinker* and *Balzac* (Fig. 6, p. 196) respectively.

The flayed nudity in the early drawings is a traditional attribute of knowledge (the *écorché* as sign of science and medicine) and mortality (the *écorché* as *vanitas* motif).

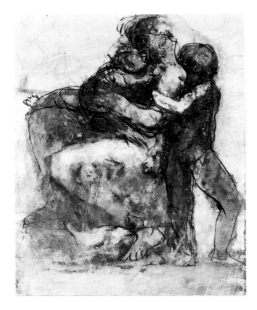

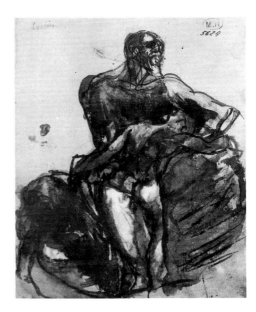

Fig. 12 *Mother and Children*, c. 1880.
Pen and ink and gouache,
7⅛ x 5⅛" (18 x 13 cm).
Rodin Museum, Philadelphia Museum of Art,
Given by Jules Mastbaum

Fig. 13 *Ugolino*, c. 1880.
Ink and gouache, 7½ x 5⅞" (19 x 15 cm).
Musée Rodin, Paris (D. 5624)

Fig. 14 *Medea*, c. 1880.
Gouache and sepia over pencil,
7½ x 5⅛" (19 x 13 cm).
Mrs. Jefferson Dickson Collection,
Beverly Hills

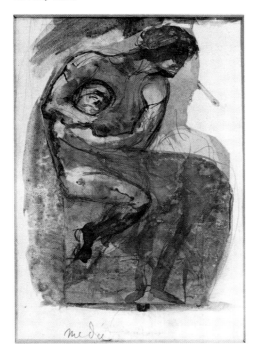

The nudity of the later figures, purified to extreme simplicity, is an invented correlative of the freedom of uncensored instinctual life, not just in the models but also in the artist. The reduction of means and the renunciation of analysis in favor of dynamic summary, permit the unconstrained flow of the artist's hand and the participation of his own instinctive gesture in response to the model's. If the heavily masculine early drawings are romantic meditations on the epic suffering of civilized man, the later drawings provide the obverse: a feminine, labile world of unrestrained feeling and liberated, omnidirectional movement. In the earlier work, recurrent poses of self-address (*The Age of Bronze* [plate 15] and *The Thinker* reflect them) give expression to internal conflicts and blockages; but the later poses return to forms of self-caress that (like Balzac, as he grasps himself under his cloak) manifest narcissism and the unchecked flow of erotic energy.

The earlier imaginative world is that of man after the Fall (the sculptures *Adam* and *Eve* belong to it), while the latter is, more than pagan, pseudo-Edenic in its celebration of unashamed sexuality. The realm of the mind, of the museum, of inherited culture is replaced by the false garden of the artist's studio, the privileged space in which the cloaks of society can be removed and fundamental truths enacted. The artifice of this later naturalness is constantly written between its lines, nudity and gesture now deriving from the context of performance, the artist's presence, and the figures' unconcealed roles as models.

In these late drawings, as in the earlier ones, the movement of the body and the manner of its presentation refer together, in league, to a belief structure regarding the appropriate concerns and purposes of art and the role of the artist's mind in creating it. In their progression from tragic history to a celebration of unconscious immediate experience, Rodin's two stages of draftsmanship not only illuminate his own development but also parallel a fundamental pattern of intellectual evolution in early modern culture. The early drawings wear the weight of their part of these meditations more openly, in individual images. The later drawings, seemingly casual and licentiously playful, only assume their full valence when taken in the multiplicity of their production, with the principles of their conception understood.

Taken individually, many a late erotic drawing by Rodin may seem the titillating self-indulgence of a voyeur. When the drawings are seen in great number, though, the frequency of such investigations acts to change their meaning, and it becomes clear that these are only more pointed instances of the consuming erotic curiosity that is a

mainspring of the entire mode. The nude women in the later drawings wheel, dance, and stretch in a dizzying kaleidoscope of poses, with a seemingly inexhaustible inventiveness of movement; but again and again, this freedom of motion pivots around, and refers to, the fixed axial center of their sex (see Figs. 15, 16). In a sequence of drawings, this centering phenomenon can be surprising, or amusing. In several hundred, it becomes impressive. In several hundred more, and several hundred more beyond that, it can become by turns astonishing, tedious, numbing. Finally, passing from sheet to sheet through these later watercolors and drawings, in day after day of research, over hundreds of drawings after hundreds of drawings after hundreds of drawings drumming with unrelenting insistence on this same note of sexualized vision, I find all my skepticisms defeated, inadequate; and I am moved. These are not documents of idle self-indulgence, but of heated, driving fascination, the displaced locus of the same intense seriousness that motivated Rodin's draftsmanship from its beginnings. The recurrent themes of death and the conflicts of consciousness that compelled the young man's work have here been supplanted, in the spirit of the aging artist, by an ecstatic obsession with the mystery of creation taken at its primal source.

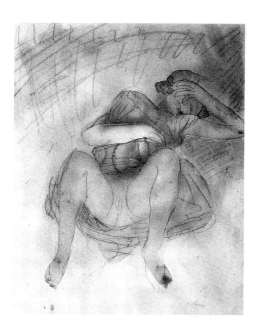

Fig. 15 *Reclining Woman with Legs Spread and Hand Across Face,* c. 1900. Pencil and watercolor, 12⅝ x 9⅝″ (32 x 24.5 cm). The National Museum of Western Art, Tokyo, Matsuka Collection

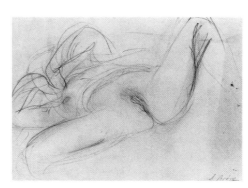

Fig. 16 *Nude Figure,* c. 1905. Pencil, 9¾ x 12³⁄₁₆″ (24.7 x 30.9 cm). Courtauld Institute of Art, London, Witt Collection

Notes

This essay initially appeared as the introduction to a chronological examination of Rodin's drawings, in the catalogue of the exhibition *Rodin Rediscovered* (Washington, D.C., National Gallery of Art, 1981). The initial paragraphs have been rewritten to stress the ways in which the essay's concerns accord with those of the present publication.

1 See "Rodin as Draftsman: A Chronological Perspective," in Albert Elsen and J. Kirk T. Varnedoe, *The Drawings of Rodin* (New York, 1971).
2 See Anton Ehrenzweig, *The Hidden Order of Art* (Berkeley, 1967).
3 The appearance of Rodin's later watercolors – a fine, wiry contour and a single tone of wash – was an expression of his most advanced thinking about sculpture. It corresponded to his attempt to achieve what he described to Camille Mauclair as "a drawing of movement in the air." This kind of sculpture "was to obey the natural principles of sculpture made to be seen in the open air, that is, the search for contour and for what the painters call *value.* In order to understand this notion exactly, one should think about what one sees of a person stood up against the light of the twilight sky: a very precise

silhouette, filled by a dark coloration, with indistinct details. The rapport between this dark coloration and the tone of the sky is the value, that is to say, that which gives the notion of material substance to the body …. All we see essentially of a statue standing high in place, and that carries, is its movement, its contour, and its value." Mauclair, "L'Art de M. Auguste Rodin," *Revue des revues* (June 15, 1898), pp. 597-99.
4 Henri Bergson's *Essai sur les données immédiates de la conscience* first expounded his idea, widely popular in the early twentieth century, that one could grasp reality only as a flow, outside of standard analytic reflection. The essay was published in 1888.
5 Rodin did draw two very peculiar crucifixions, one with a live lion roaring from the cross to which it is nailed, and the other showing lion skeletons on crosses. Neither of these seems connected to the main body of the imaginative and/or "black" drawings.
6 For a Rodin drawing of Medea, see Elsen and Varnedoe, *The Drawings of Rodin,* fig. 18, p. 44.
7 Cited in Elizabeth Chase Geissbuhler, *Rodin: Later Drawings* (Boston, 1963), p. 20.

Alain Kirili

The Scandal of Rodin and his Models

Rodin completely revolutionized the traditional concept of the model. The word comes from the Italian *modello*: the object to be represented or imitated serves as an archetype, a canon, a basis for comparison. The model therefore imposes its own criteria of visual imitation, and in the past many artists became enslaved to the model as the ideal image of a human figure. Today, however, the absence of the model is a commonplace of artistic creation. The very idea of a female presence has been totally rejected as superficial, obsolete, pointless, ridiculous. The contemporary artist is often a highly serious person, one who views the least hint of futility or levity with disapproval, even castigating it as politically reactionary and socially dubious. This is hardly surprising in a world that dreams of egalitarianism to the extent that differences between the sexes are supposed to be eliminated in favor of a unisex, nonsexual, or, at best, androgynous state. Under these circumstances, the model, in its relationship to the artist, cannot but amount to a provocation. Such a mechanistic and dogmatic abolition of sexual differentiation and opposition in the name of equality stems from a strongly puritanical vision. In contrast, Rodin, by eroticizing artistic creation, revealed an equality of the sexes through the glorious communion of sensual pleasure – a true sublimation of the sexual act.

At the outset of his career Rodin had a model pose for the sculpture *The Age of Bronze* (see Fig.2), but by the end of his exceptionally long creative life he had undermined the status of the individual model. Traditionally, artists would choose one model for a particular work and then live in fear of losing him or her through illness or for some other reason, for it was deemed essential that the same model be used from beginning to end. With Rodin, the single model abandoned its individuality to a multiplicity of models, to the visual blending of several bodies. Rodin put a premium on freedom of sensation; he freed artistic creation from its enslavement to the single model and from the particular psychological effect that it could have on the artist. He viewed his models in motion, as they composed an erotic frieze not unlike the sculptures on Indian temples. It should also be mentioned that artists often had their "favorites," and there was a veritable war in which artists tried to steal each other's models. Rodin, however, even called the professional model into question. He often hired acrobats because their poses had a freshness and an unexpectedness that were at odds with the conventional poses of academic aesthetics. Their bodies suggested contortions, interplays of balance and imbalance, harmony and disharmony, which fascinated Rodin. It would be impossible, for example, to understand the sculpture of Nijinsky (plate 10) without an appreciation of the revolution effected in choreography by that dancer. Over and above this, Rodin caused a scandal concerning the model and himself: he was accused of having been Nijinsky's lover, of being a lascivious old man unworthy of receiving favors from the State, which wished to set up a museum of his work in the Hôtel Biron.

With the changes wrought by Rodin in the role of the model, the nature of his work was transformed too: the body of drawings that he produced from about 1900 onward became one of the most important and influential of the twentieth century. The dissolution of the single model in the flow of dancing bodies in his studio permitted Rodin to work at a furious pace, in accordance with his innermost desires. Often he

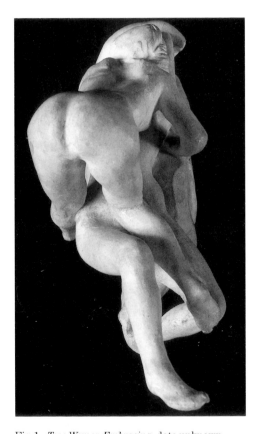

Fig.1 *Two Women Embracing*, date unknown. Plaster, height 9½″ (24 cm). Musée Rodin, Paris (S.705)

Fig. 2 a Auguste Neyt, the model for
The Age of Bronze, 1877.
Photograph by Elsa Marconi

Fig. 2 b *The Age of Bronze*, 1876.
Plaster, height 70¾″ (180 cm).
Photograph by Eugène Druet

Fig. 3 Rodin working with a model.
Photograph by Duchène (?)

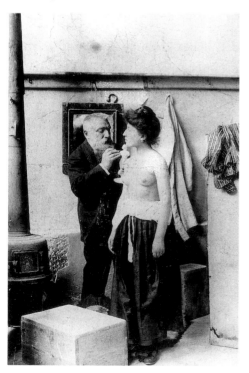

would draw without even looking at the paper. Erotic drawings, each one different, flew like autumn leaves from his hands, littering the floor of his studio. He produced them in a semiconscious rhythm that anticipated the automatic writing of the Surrealists and that had an – unacknowledged – influence on such major figures as Egon Schiele, Pablo Picasso, and Henri Matisse. Rodin's first paper cutouts (for example, plates 46, 49, 50) were a prefiguration of those from Matisse's last years. Rodin drew and cut directly into the colors, the scissors allowing him to give shape swiftly to the fleeting poses of the dancing models; he never took his eyes off the display of so many naked charms. If he courted the Cambodian dancers during their stay in Paris, it was not just out of a taste for exoticism, or for the brownish tint of their skin, but most of all because of the unpredictability of their movements and poses, because they revealed another life of the body from another civilization. He dispensed with professional models once and for all.

Rodin's drawings after 1900 show him devoting his observations primarily to female genitalia. They are always shown in the foreground, sketched either slowly or rapidly, with insistence, to be sure, but without obsession. The drawings give expression to a wholly natural attraction, one that, for Rodin, bore no associations with " the origin of the world," the title given to a long-lost work of Gustave Courbet's. Thanks to his models, Rodin concentrated first on what he could see close up: vaginas open and moist, with lips spread apart, flecked with blood or sperm. Surprisingly enough, Rodin was not concerned to grant a metaphysical dimension to his dealings with the female pudenda. He could drink his fill, yet remain untroubled. His delineation of the erotic is precise, yet never scientific, anatomical, or gynecological. The vaginal lips open to greet the phallic pencil or brush. The insistent pencil work on the sexual parts betrays the artist's emotion, but there is never any nervous excitation; the pencil lead does not break as a result of obsessional emphasis. Rodin was not Schiele, with regard either to age or to artistic situation. His studio was not a prison, and Paris was full of models only too willing to place themselves at the disposal of artists. The model in Rodin's studio is not kept at a distance (see Fig. 3), but brought close up, knee to knee, the artist even supporting himself on the model's body to capture every detail. The studio is the

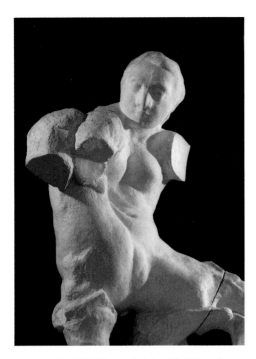

Fig. 4 *Iris*, 1903. Plaster, height 63″ (160 cm). Musée Rodin, Meudon (S.176)

Fig. 5 *Female Nude*.
Pencil on buff-colored paper,
12⁵⁄₁₆ x 7⅞″ (31.2 x 20 cm).
Musée Rodin, Paris (D. 5977)

place of mystery and secrets *par excellence*. Picasso's *Suite Vollard* prints show a sculptor's studio: the artist has one or more models, and passes naturally from the model to the muse. The model inspires the initial phase of creation, and ensures a presence at the end of the work. With Rodin, too, the model inspired the work beyond the period of its execution.

The creative urge – or necessity – is related to sexuality: Rodin's late work basks in a solar eros. He associates his models with the sun, with water, and with the joys of sexual fulfillment. " I have a veritable cult of the nude," the artist avowed.[1] In Rodin's work nudity appears as the fundamental embodiment of the French tradition. An artist, like a people or a civilization, is characterized by his or her concept of nudity. That is why Kenneth Clark, in his remarkable book *The Nude*, could say that " Rubens is the noblest refutation of Puritanism."[2] The same applies to Rodin. The crowds of bodies and female nudes in his work correspond to the breadth of his desires and not to the *fin de siècle* proclivity for Sapphic love, so often celebrated in nineteenth-century art. The iconographic realm of the Graces is not necessarily that of the lesbians. The number of women affected Rodin's creative impulse. His tastes ranged from the figure of the praying woman in his book *Cathedrals of France* to the dancing models who bared their bellies, breasts, and buttocks. These unbridled bodies were his response to the folly of puritanism, to all restriction of sensual pleasure, that unproductive force which modern advocates of profitability and rationalism write off as a pure loss.

Rodin said that, after 1900, he had freed himself of his timidity vis-à-vis women. I believe, too, that his fame at the time permitted him to risk scandal in a studio whose atmosphere was quite different from that of the studios in the Ecole des Beaux-Arts. His studio practices were wholly unacceptable to the prudishness of the Third Republic. Nude models dancing to the sound of Hebraic songs and to records of the Sistine Chapel choir? Rodin inviting a duchess to dance a bourrée? The press was not long in launching a campaign of character assassination: Rodin a homosexual, the lover of Nijinsky, the exploiter of Camille Claudel. Everything was done to discredit his work and reduce its significance by condemning his private life. Tactics such as these, the recourse of mediocrity, have been used in recent biographies of Picasso and Jackson Pollock in an attempt to reduce their importance. When an artist brings sexuality into play as an urgent creative impulse, he can be assured of a violent reaction.

No pains have been spared to censor the sexual dimension in Rodin's work. Until very recently, even the quantity of erotic drawings by him was kept secret, since they were stowed away in the portfolios of the Musée Rodin. This is a serious matter, for these works were known during the artist's lifetime. At his death, the drawings – the culmination of his art – were withdrawn from the public eye, subsequently to be glimpsed only in small quantities.[3] The aim seems to have been to reduce Rodin's stature to that of a nineteenth-century maker of bronzes. Yet in the sum of his studies of women's bodies he takes on a far more innovative creative stature, which conflicts directly with the *fin de siècle* mentality. Rodin strove to set free the femininity that is inherent in every man. He knew that only by bringing both male and female forces into play could an exceptional work of art be created. A work, however abstract, that is made today in the solitude of the studio and ignores the opposite sex runs the risk of monotony, of ascetic and eschatalogical repetition. In their function as models, women save artists from an obsession with "the end of art." Their salutary role is derived from the first, and greatest, model of all, as perpetuated in the Catholic cult of the Holy Virgin. When Rodin made love to a woman, he would close his studio and put up a sign that read: "Absent, visiting cathedrals." Rodin was rooted in the French Catholic tradition, as emerges clearly from his writings on the nature of the French, from his interviews, and from his *Cathedrals of France*. He was a keen observer of every aspect of femininity, a prime characteristic of the culture he belonged to.

By creating his finest erotic drawings so late in life, Rodin brought to the model's presence an extraordinary sexual memory. The French painter Eugène Leroy recently confided to me that painting is what is left in bed after a love affair. Rodin was the sculptor of the eroticized model and of precise sexual memory. This helps us to understand the moistness, the obscene fluidity of his watercolors. Rodin never colored. His splashes and drippings are the aftermath of lovemaking as recorded by an exact memory (see plate 61). The virginity of the paper is spotted by the watercolors like flesh given over to the artist's frenzy. The model is no longer there for the purposes of representation, but to stimulate sexual emotion and to serve as reminder of the traces left on the body by intercourse. The spots, blood, sperm, and moist vaginas are the erotic elements of a veritable transgression that all artistic creation, whether abstract or figurative, must never forget. Intimacy finally revealed – that is what sensual abstraction and figuration unreservedly bring into play. In this sense, Rodin stands out as the most modern of early twentieth-century artists, anticipating Freud in his strong intuition of the relationship between art and sexuality. His work had always caused scandals – his phallic, fountainlike *Balzac* (Fig. 6, p. 196), for example, was considered obscene – and his life as an artist shocked the public as much as the erotic universe of Picasso's later years. With age, erotic memories emerge with astonishing freshness and precision. This is the swan song of a long creative life that never stopped renewing itself, and so defied the ravages of time.

Rodin's heterosexuality is still more unsettling to us than it was to his contemporaries, for it is devoid of ambiguity: there were his models and him. His was the joyous celebration of great sexual and creative longevity. There were never enough drawings, never enough models. Rodin was part of the tradition represented by such eighteenth-century artists as Antoine Watteau – whom he adored – François Boucher, and Jean Honoré Fragonard. However, this marvelous resurgence of French taste (which, incidentally, should not be overlooked today) came about as the result of a revolution in *mores*. The model was not only present for the artist's contemplation, but also had a right to her own enjoyment: the models caressed one another, played with themselves, had orgasms. Gone was the passive voyeurism of the Academy. The model was a modern woman, entitled to her own pleasure. Rodin's drawings thus anticipate the freedom that women were to gain in the twentieth century. In undressing and caressing herself, the model suggests the tactile quality of sculpted bodies. This tactility is almost forgotten today, yet knowledge of the relationship between caresses and an artist's marks is essential to living creation. Bodies so handled become buoyant with pleasure, soaring in numerous dancing configurations. The impetuosity of desire governs relationships in the studio. It is a place inhabited by the fire of ardent desires, as expressed by Matisse in *The Red Studio* and hinted at by Picasso in *Les Demoiselles d'Avignon*. The studio, with the artist and his models, is the center of all transgressions. Yet in reality this is rarely the case. Today, as in the past, the professional obsession of the artist rejects and kills this freedom, delivering it up to the irony and clever commentaries of "politically correct" historians, as they are called in the United States.

Steeped in scandal, Rodin and his models defy the prudishness of the righteous, creating a haven of freedom dedicated to the glory of woman.

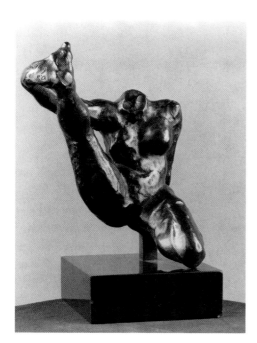

Fig. 6 *Female Nude (Iris)*, 1890-91 (?).
Bronze, height 7½″ (19 cm).
Musée Rodin, Paris (S. 1306)

Notes

1 Paul Gsell, *Entretiens réunis* (Paris, 1911).
2 Kenneth Clark, *The Nude* (Princeton, 1953), p. 297.
3 Most of the drawings that I selected for inclusion in Philippe Sollers and Alain Kirili, *Rodin: Dessins érotiques* (Paris, 1987), had never been published before.

Jacques de Caso

Image and Idea:
Rodin's *Album Fenaille*

In memory of André Chastel

LES DESSINS

DE

AUGUSTE RODIN

129 PLANCHES COMPRENANT 142 DESSINS

REPRODUITS EN FAC-SIMILE

PAR LA

MAISON GOUPIL

PARIS

JEAN BOUSSOD, MANZI, JOYANT & Cie
ÉDITEURS-IMPRIMEURS
21, Boulevard des Capucines, 21
1897

Fig. 1 Title page of the *Album Fenaille* (Paris, 1897). This copy, bearing a dedication to Roger Marx and the number 45, is now in the Bancroft Library, The University of California at Berkeley

Rodin's compulsion to draw is well known, and attested throughout his career. While his drawing production is as immense as it is varied, Rodin drew with an acute insight into the possibilities of the medium that few other artists have possessed. His corpus of drawings encompasses thousands of works in diverse modes and styles. I shall concern myself here with a single program, a self-contained ensemble of drawings that are as astonishing and unexpected in their style as they are in their subject matter. These are the drawings in the *Album Fenaille* (Fig. 1), which Rodin made public in 1897 by authorizing their reproduction in book form.[1] The originality of the drawings reproduced in the *Album*, the singularity of their look, and the high quality of the technical aspects of the reproduction process surprised Rodin's contemporaries[2] and still surprise us today. With the *Album Fenaille* Rodin called into question the conventions of the art of drawing as they were accepted by his contemporaries.

Two aspects of the *Album* are particularly significant. The first concerns the striking stylistic innovations resulting from Rodin's drawing techniques (I here use the word "style" as a term that encompasses expressive modes as well as technical execution). The second is an aspect of the *Album*'s system of signification the uniqueness of which needs to be addressed. This uniqueness is crucial both to the history and development of Rodin's thought and to his art.

In the nineteenth century the mere fact of reproducing in a book or an album drawings by sculptors – that is, artists for whom drawing is not a primary artistic objective – is in and of itself noteworthy. One searches in vain for published collections of the drawn oeuvre of, or even the preparatory drawings for sculptures by, established sculptors. By "drawn oeuvre" and "preparatory drawings" I mean drawn sketches and studies that are directly related to a given sculpture or to a program of sculptures, whether realized or merely projected.

Symptomatic signs of a transformation in attitude vis-à-vis the artistic status assigned to drawings done by sculptors do, however, appear around 1880. One notes the increasing importance accorded reproductions of sculptors' preparatory studies and of drawn sketches executed independently of specific sculptures. This change is evinced in the first monograph on Jean-Baptiste Carpeaux, which Ernest Chesneau published at this time.[3] Chesneau reproduced a large number of drawings that document Carpeaux's artistic culture, including his studies and interpretations after the masters. He also included several of Carpeaux's "first conceptions" for works that the sculptor subsequently abandoned, as well as studies related to the genesis of his sculpted group *Ugolino*. It is remarkable that these drawings, which are both partial and complete, should have appeared in the context of a monograph.[4]

There exists, however, a more significant inspiration for the corpus of Rodin's drawings. I have always been struck by the analogies, conceptual rather than representational, between the drawings in the *Album Fenaille* that resonate with Rodin's "black" drawings, some of them published prior to their appearance in the *Album* (see Fig. 2), and the drawing enterprise of Victor Hugo, the poet whose drawn production

TÊTE DE DAMNÉ.
Croquis d'Auguste Rodin, pour la porte monumentale
du Musée des Arts décoratifs.

Fig. 2 *Head of a Damned Man.* From *L'Art:
Revue hebdomadaire illustrée* 4 (1883)

Fig. 3 Victor Hugo, New Year's card, January 1,
1856. Pen and brown ink, watercolor, gouache,
charcoal, and lace imprint, 5 3/16 x 3 3/16″
(13.2 x 9.7 cm). The John Rylands University
Library, Manchester

could not have escaped Rodin's attention over the course of his formative and adult years.

We know that Rodin read, meditated upon, admired – and used – Hugo's poetics. In his writings and conversations, Rodin often cites Hugo, referring to him simply as "the poet." During the course of his life, Hugo attached exceptional importance to his drawn production. The codicil of his testament, written in 1881, begins with these words "God, the soul, responsibility, this triple notion is sufficient for me. It is the real religion. I have lived by it, and I die by it." And when Hugo comes to the second stipulation with regard to his intellectual legacy, he specifies: "I leave all my manuscripts and drawings to the Bibliothèque Nationale of Paris, which will one day be the Library of the United States of Europe."[5]

I shall discuss Hugo's drawings – there are thousands of them – only in terms of the legendary reputation that they enjoyed in Rodin's time and in terms of the provocative nature of their facture. We have become more familiar with these drawings only during the last few years, but we would misjudge the artistic culture of the end of the nineteenth century if we did not recognize that they were known and scrutinized by contemporaries of Rodin, who were well aware of Hugo's status as a visual artist. Rodin speaks admiringly in 1902 of what he calls Hugo's "plastic vision": "It is very intense, very original and personal. And I see a strong sense of the decorative. Hugo has the genius of the decorator."[6]

Rodin himself tells us that he, like the majority of his contemporaries, knew Hugo's drawings: "Everyone has seen a few of his drawings I know these drawings I took great pleasure in studying them."[7] Indeed, just after 1850 facsimiles of Hugo's drawings were published in several albums. As for the critical discourse, Théophile Gautier discussed Hugo's drawings in 1838, 1852, and 1862, and in 1859 Baudelaire celebrated "the magnificent imagination that flows in the drawings of Victor Hugo as the mystery flows from the sky. I am speaking of his china ink drawings, for it is too obvious that in poetry our poet is the king of painters of landscape."[8] Later, in 1888, Rodin's dealer, Georges Petit, showed drawings and manuscripts by Hugo at his gallery to benefit the subscription for the statue of the poet. On the occasion of this exhibition, the writers and critics Albert Wolff, Gustave Geffroy, Philippe Burty, Benjamin-Constant, Emile Verhaeren, and Edmond de Goncourt – some of whom belonged to Rodin's circle – saw Hugo's drawings and described them. Finally, in 1889 the Bibliothèque Nationale exhibited Hugo's manuscripts and drawings.

In Rodin's time it was generally known that Hugo had conceptualized drawing and experimented with its possibilities, and that he had often integrated drawing with his manuscripts. Sometimes he had separated the drawing from his text, making of the former a self-sufficient register, complementary to the poetic one. In diverse ways and to differing degrees, many nineteenth-century writers and poets – Goethe, Blake, and Stendhal among them – indulged in this practice.

It is difficult to determine which of Hugo's drawings Rodin could have seen. Hugo's production included compositions with a figurative basis (see Fig. 3) – these were the best known and most frequently reproduced of his works in Rodin's time – while others, certainly less accessible, experimented with non-figurative formal arrangements in which the effects of textures dominate (see Fig. 4). These drawings fired the imagination of those who, in the second half of the nineteenth century, described them (principally the first, more figurative type) and cited Goya, Rembrandt, and Piranese as Hugo's ancestors: "a drawing that has something gigantic and sinister, something solemn and strange, that seizes you and takes you to the realm of dreams," or "the antithesis – white and black – of superb, mysterious blots in which vague forms of castles, rocks, and stone structures characterize the poet's images. These are dramatic sets, full of macabre and mysterious conflicts."

The conditions and circumstances in which Hugo experimented with drawing, the techniques – well-established ones – that he adapted to his purposes, could not but inspire Rodin to emulation. The techniques Rodin systematically used in his "black" drawings are evidence of this. In the work of Hugo and Rodin (more so than in that of their predecessors) these techniques remain obscure. They filter out of a manipulation – in the literal sense of the word – of the organic possibilities of chaotic matter, often chance blots, that are then used as the origin and basis of the imaginative process. Hugo's critics described these techniques. Thus, Burty wrote in 1864: "Once the paper, the quill, the inkwell are brought to the table, Victor Hugo sits down and, without preliminary sketches … there he is drawing with an extraordinarily confident hand …. the entire composition will burst forth from the whiteness of the page with the precision and clarity of a photographic negative …. Then, that done, the draftsman will ask for a cup, and will finish his landscape with a shower of black coffee. The result is an unexpected drawing, powerful, often bizarre."

The techniques employed by Hugo over the course of several years, his use of ink and washes combined with blots obtained by folding stained paper, folding it again, and unfolding it, his use of rubbings, stencils, decals, and silhouetted forms cut out with scissors, his insertion of impressions of fragmented foreign matter (such as lace), all serving as prop and structure to the image – these perversions, one might say, of the traditionally defined identity of drawing and its functions inform Rodin's "black" drawings.

Today often inaccessible, the "black" drawings have not been examined in ways that might reveal the exact nature of the technical manipulations that produced them. Yet these unique manipulations deserve closer scrutiny. Whatever the means employed by Rodin, he has reevaluated the enactment of the painted image, its aims and means, for he invents that which constitutes the image's recognizability as such, its coming into being via newly defined artistic processes. Rodin, after all, was heir to the Romantic pursuit of the formless, which led to the disintegration of the work of art. His efforts stand as an emblematic statement of the ultimate impossibility of finishing a form and, by extension, of completing a work. In this process lies the tension between form and formlessness, between will and chance, a tension which is singularly exemplified by the primal chaos of an accidental inkblot thrown onto the page.[9] Rodin let the drawings invent themselves. Deployed at random are textures, the transference of foreign objects, and the effects of depth, in which planes, lines, and words (these inscribed or printed) organize fragments of natural and human species, things and beings – ultimately, "stories" – that do not exist.

Poussin's remarks in Balzac's *Le Chef-d'œuvre inconnu* when he contemplates what Frenhofer claims is a painting immediately spring to mind: "a chaos of colors, of tones, indistinct nuances, a sort of fog without form. I can see here only colors confusedly amassed and contained by a multitude of bizarre lines that are but a wall covered with paint."[10] Here, as with Rodin, the integrity of line and color, as they were conceived and accepted at the time, collapses. Along with the loss of that integrity, we witness the collapse of the conventions, genres, and functions that traditionally upheld line and color as the agents of narrative, of verisimilitude, of the measurable and the finite.

These practices, used repeatedly in the drawings of the *Album Fenaille*, and thus assigned a unique status, belong to the spiritual order that Hugo had inaugurated with his drawings. It is important to note these conceptual and material affinities, which Rodin put to work in his sculptures when he discovered the fragment and redefined relief and the notion of surface. Thus, in both realms of Rodin's endeavors, drawing and sculpture, we encounter a radical questioning of the accepted formulas of making. As we look at Hugo's drawings, however, we should not search for sources of Rodin's

Fig. 4 Victor Hugo, *Untitled*, 1853-55.
Watercolor and ink, with circular imprints of a paper disk, 14¹⁵⁄₁₆ x 9½" (37.9 x 24.1 cm).
Formerly Valentine Hugo Collection

"black" drawings, if "source" is understood in the narrow sense of imitative affinity. Hugo's drawings functioned as a source in a different way. Rodin's intellectual and artistic curiosity, always so acute, must have been aroused early and lastingly, less by the thematics of Hugo's drawings than by the example of a practice that called into question figurative coherence. It was thus that Rodin, in the *Album Fenaille*, made public his new ideas on drawing.

There is another salient and neglected aspect of the *Album Fenaille* that is of primary importance, since it is closely linked to Rodin's personal experience. This concerns the content of the *Album*, which is made precise by the titles that Rodin gave to the drawings. Taking into account the word, we understand the image better.

The *Album Fenaille* contains a printed table of contents in which the 129 titles are numbered in correspondence to the 129 plates. These are divided into three groups, "Hell," "Limbo," and "Studies," with the plates (a few of which contain several drawings) distributed as follows: eighty-two in "Hell," thirty-one in "Limbo," sixteen in "Studies."

We know little about the cooperation between nineteenth-century artists and the enterprises that published their drawings, though we can ascertain that the artists were involved in the publication process. We are better informed about Rodin's insistent scrutiny of the publication, reproduction, and exhibition of his works. It is certain that the choice of drawings reproduced in the *Album*, their grouping, the order in which they are placed, and their titles, were specified by Rodin. A letter from Fenaille to Rodin, written after the printing of the plates, testifies to Rodin's full control over the undertaking.[11]

Could a thematic intention be indicated by the *Album*'s table of contents? Certainly, Rodin presents us with an enactment in images and in captions of his reflections on Dante's *Inferno*. Commentators, both of Rodin's time and ours, on the Dantesque drawings have noticed that, in some cases, an inconsistency exists between the illustrative and narrative aspects of the text, revealing how little Rodin's visions respect the textual support.

Nonetheless, we notice in the table of contents a variety of repeatedly used generic titles (such as *Shade* and *Woman and Child*) or sometimes of metaphorical and allegorical titles (*Blasphemy, Rain, Circle of Boredom*). One would expect these titles to act in a traditional manner, that is, as devices to assist the viewer in identifying an image. However, the meaning of the images is not clarified by the titles nor by the inscriptions occasionally to be found on the drawings. The titles are, in fact, intentionally opaque.

Another intriguing problem presents itself to the viewer of the *Album Fenaille*: it is not paginated, and the order of the plates varies from copy to copy. Has Rodin playfully encouraged us to manipulate the sequence of plates? His deliberate omission of page numbers can be seen as another effort to undermine the expected conjunction of word and image, of text and vision.

The visual manipulations – that is, the indecisions, imprecisions, extrapolations, and conflations that Rodin arrives at from his reading of Dante – comprise nearly half the 142 titles listed in the table of contents. It is remarkable that the syncretism of his poetics in the *Album*, the visual reunion of notations and ideas from diverse origins that he orchestrates in it, is of the same kind as that which he had initiated, after 1880, in *The Gates of Hell* (Fig. 5, p. 11). Not only does one project inform the other, but it is as though Rodin, with the *Album*, found an occasion, a medium, and an audience that finally allowed him to visualize his obsession with Dante in a circumscribed and manageable form. His supposed inability to complete works – a criticism leveled at both *The Gates of Hell* and *Balzac* (Fig. 6, p. 196) – was proven false.

Significantly, the "black" drawings included by Rodin in the *Album*, and those to which he gives a title or a series of repeated titles in the table of contents, constitute a self-contained poetic structure and appear to manifest a teleology that can, in certain ways, be identified. To limit the analysis of the drawings to their literary source, as has been done, and to reduce Rodin's inspiration to exclusive reliance on the textual support of Dante, is too restrictive, for it does not take into account the drawings' historical locus, an issue to which I shall return.

If we examine the conceptual structure of Rodin's reading of Dante as he visualized it in the table of contents, we note that, like his French contemporaries who read Dante – be they poets, painters, or sculptors – his interest centers almost exclusively on the *Inferno*, where the effects of a divine will to punish sin are manifest. "Hell" is the title under which Rodin groups eighty-two plates of the *Album*, that is, about half the total number. The thirty-one plates of the second group all present images that evoke subjects related to the title, "Limbo." Limbo is the first of the nine Circles of Hell envisioned by Dante; here reside the souls of those who lived virtuously before the arrival of Christ, or who, although Christian, died without having been baptized. The third section of the *Album* contains only sixteen plates; Rodin includes here a variety of subjects under the title "Studies." These are images – and I limit myself to those that are most easily identified – on themes not mentioned specifically by Dante, either in *The Divine Comedy* or elsewhere. Venus, for example, and Castor and Pollux – both subjects that Rodin locates in "Studies" – are alluded to only allegorically in Canto IV of *Purgatorio*. Furthermore, "Studies" contains themes that are not related to Dante's text at all; rather, we find biblical subjects and ones concerned with pagan Antiquity or with a figure such as Michelangelo as sculptor.

Considering the inclusive structure of the table of contents, we immediately notice the unexpected visual and conceptual construction of Dante's *Inferno* that Rodin proposes. In his topographic vision of Hell he grants an exaggeratedly large place to "Limbo," whereas Dante himself devotes only one Canto to it. In addition, the thirty-one plates of "Limbo" evoke none of the figures that populate Dante's Limbo, which the poet describes as "an open space, bright and high."[12] Dante provides here a place for the Just, for Sages and Heroes, yet the only characters admitted to Rodin's Limbo are Icarus and Phaeton, then Beatrice – figures who are evoked by Dante in a completely different context. In significant contradistinction, Rodin populates his "Limbo" with characters who are given only three lines in Dante's description: "[sighs] which kept the air forever trembling; these came from grief without torments that was borne by the crowds, which were vast, of men and women and little children."[13]

It is in *Purgatorio* and *Paradiso*, not *Inferno*, that Dante elaborates on these anonymous inhabitants of Limbo: "There is a place below, sad not with torments but only with darkness, where the laments have no sound of wailing but are sighs; there I abide with the little innocents seized by the fangs of death before they were cleared of human guilt";[14] "but when the time of grace was come such innocence, without the perfect baptism of Christ, was held there below."[15]

With Dante's lines in mind, the way in which Rodin distributes his subjects – and images – in the thirty-one plates of "Limbo" becomes revealing: over half the images represent a woman – a mother – with a child, sometimes several children. These are titled as follows: *Woman Breastfeeding a Child* and, repeatedly, *Woman and Child* (in two instances the woman is replaced by a man). It is compelling to place these representations of maternity contrapuntally to a subject that Rodin turned to time and again in his sculpture: the Ugolino narrative, a theme whose repeated presence in the first part of the *Album*, the drawings of Hell (see Figs. 5, 6), is astonishing. The story of Ugolino is recounted in the famous episode in Canto XXXIII of Dante's

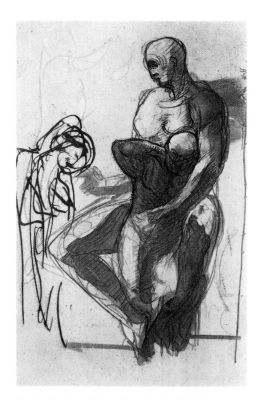

Fig. 5 *Ugolino. Album Fenaille*, I : "Hell," plate 82

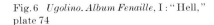

Fig. 6 *Ugolino. Album Fenaille*, I : "Hell," plate 74

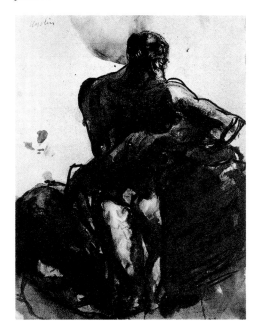

Fig. 7 *Woman and Two Children. Album Fenaille*, II : "Limbo," plate 93

Fig. 8 *Woman and Child. Album Fenaille*, II : "Limbo," plate 100

Inferno that describes the long agony of a father. It is a subject that is as much a metaphor of victimized childhood as it is a contemplation of paternity.

One cannot help noticing in the *Album Fenaille* evidence of a large number of obsessive, refractive images that are known to have occupied Rodin over a long period of time. Since they are ordered by the structure of the table of contents, the book acquires a conceptual coherence that must not be left out of account. It is as if Rodin, in 1897, had first wanted to come to terms with, or perhaps disassociate himself from, a long past by resuming his meditation on Hell and Dante. Yet the book also manifests a preoccupation that, I believe, is linked to remnants of Rodin's religious education and his moral beliefs. Here we enter the domain of Rodin's religiosity, which was sensed by all his biographers, and which informs several important sculptures.

The dominant place that Rodin accords Limbo in the Dantesque construction proposed by the *Album Fenaille* and, within this construction, the repetition and the specificity of images of a mother protecting her child(ren) (see Figs. 7, 8) seem to me to be a clear sign both of intent and of the *Album*'s engagement with its time. I see here evidence of Rodin's awareness of, and reflection on, a religious and social debate that he could not have ignored.

For several months in 1862-63, at the age of twenty-two and twenty-three, Rodin submitted and devoted himself to the rule of the Order of the Fathers of the Holy Sacrament.[16] His "religion" – and by that I mean the way in which, then and subsequently, he understood deism or Christianity, and expressed it in his drawings or sculptures – is beyond the scope of this study. It should be stressed, however, that Rodin received a solid Catholic education, and that it weighed on him, precisely because he later perverted it or dismissed the effects of its institutions. We must remember that a major religious controversy erupted in France around 1850. The issue at stake in this heated public debate was the intransigence of the Catholic church, which refused to revise the dogma dictating that children who die unbaptized are eternally deprived of the possibility of salvation. In subsequent decades this controversy furnished arguments for the anti-clerical activities of the Third Republic. Rodin, whether or not he was a believer at the time, could not have been blind to the debate on Salvation and to the attacks launched against the Catholic church.

It is inconceivable that Rodin did not hear the voice of Jules Michelet, the great historian and social thinker who expounded his beliefs in books that were extremely widely read. Michelet recalled the historical development of the Church's postures and repeatedly condemned the Church, proclaiming:

No original sin any more. No more the son punished for his father. The child is born innocent, and is not branded before birth by Adam's sin. The impious and barbarous myth now disappears. Justice and compassion have replaced the myth [...]. The entire Church teaches that *crime is hereditary.* All of us are born and live tainted by Adam's sin [...]. Terrible verdict! ... Unbearable for all mothers! ... "What! My child too? My angel in its crib? ..." Several theologians compromised, wanting to create for young innocents an intermediary place. While deprived of the sight of God, but exempt from physical punishments, these children would remain wailing for, crying for, and dreaming of their lost mother. Saint Augustine did not permit this. He declared: "Do not promise children that place between heaven and damnation [...]. Don't fool yourself into thinking that these children deserve solace. Hell alone waits them. This is what the Church firmly believes." [...] Today, May 1, 1868, I open the elementary catechism of the diocese of Paris, and I read this: "The sin of Adam has descended on his entire progeny, so that *they are born guilty* of the sin of the first father."[17]

I do not want to impose conclusions that would go beyond the limits of my declared endeavor – to reexamine the *Album Fenaille*. I believe, however, that my reflections can contribute to a more precise understanding of Rodin's attitudes vis-à-vis a latent religiosity that is unquestionably present, albeit couched in a variety of forms,

Fig. 9 *Woman and Child. Album Fenaille*, II :
"Limbo," plate 110

throughout his art and his thinking. The assertive and recurrent image of the tranquil, protective mothers in the *Album* attests this.

I should like to conclude on a more anecdotal, though nonetheless significant, note. In 1895 Rodin received a volume of verse strangely titled, in a Baudelairian manner, *Azur and Mud*.[18] One of the poems was about him, and was dedicated to him by the author of the book, a certain Father Gayraud, who had been a friend of Rodin in 1862 at the seminary and had subsequently become a priest in a little village in Normandy. Let us try to imagine the expression on Rodin's face when he read these unexpected lines:

> The artist, with his proud visions,
> Cannot give life to matter, unless his gaze
> Is turned at least once toward God.
> Do you recall, brother Augustine,
> Your mystical effusions
> As you lived in our sacred cloisters?
> As you meditated night and day,
> Enthusiastic and celestial soul,
> You made me realize that there are remnants
> In one's vision of that first moment of revelation
> And that an eternal work of art
> Always descends from the firmament.[19]

Notes

Ideas seminal to this essay were presented at the symposium "Rodin 150 Years Later," held at the Philadelphia Museum of Art, on May 11, 1991. My research has been supported by a grant from the National Endowment for the Humanities, Washington, D.C.

1 *Les Dessins de Auguste Rodin*, with a preface by Octave Mirbeau (Paris, 1897). Rodin's French predecessors (with the exception of David d'Angers and Jean-Baptiste Carpeaux) did not draw on any but the most superficial level. If they practiced the art of drawing, they did not, as Rodin did, seek to discover in it an autonomous register of artistic creation, distinct from the other procedures relevant to the practice of sculpture.

2 "His drypoints, his drawings, and, above all, his compositions, in which, using inks of various shades, he conjures up the most marvelous visions, show that he has very few superiors among painters, even including the Old Masters M.M.F. [Maurice Fenaille] ... has had them reproduced in the most perfect and sure techniques. The results obtained are truly extraordinary. With some of these drawings it is difficult even for the most experienced eye to distinguish between original and reproduction." "Les Dessins de Rodin," *Le Cri de Paris*, no.18, May 30, 1897.

The *Album Fenaille* contains nearly 150 drawings grouped in 129 plates. Printed with meticulous care, and utilizing a finely accurate reproduction technique, the *Album* is a bibliophile's enterprise. Its format is that of a large in-Quarto. Reproduced are pencil, ink, and gouache drawings that are often touched up with color; including minute drawings and simple notations, as well as more elaborate compositions, they offer a variety of dimensions, shapes, techniques, and styles. The work was published for subscription in a limited edition of 125 copies. Each copy includes a printed acknowledgment of the subscriber's name, Rodin's autograph signature, and his symbolic signature – a miniscule engraving in tailpiece of the head of *Man with the Broken Nose* (Fig., p.39).

3 Ernest Chesneau, *Le Statuaire J.-B. Carpeaux: Sa vie et son œuvre* (Paris, 1880).

4 The drawings are partial in that they present a fragment of the finished sculpture, and complete because they stand in both visual and conceptual terms as self-sufficient representations. Chesneau's concluding words describe Carpeaux's engagement with drawing and drawing techniques, and resonate with the visual challenges Rodin will confront: "A drawing enterprise of marvelous scope, full of freedom, of spirit, in which one does not detect the dry hand of pedagogy, and in which expression bursts forth spontaneously from the artist's hand." *Ibid.*, pp.149-50.

In the first lengthy study of Rodin's drawings published after the issue of the *Album Fenaille*, Léon Maillard introduced Rodin's drawn oeuvre with a discussion of Carpeaux's drawings: "So this sculptor can draw!" "Les Dessins," in *Etudes sur quelques artistes originaux: Auguste Rodin statuaire* (Paris, 1898), pp.87-103.

5 Testament of August 31, 1881.

6 Auguste Rodin, "Quelques opinions sur Victor Hugo: Hommes de lettres, artistes, philosophes," *La Revue hebdomadire*, 11/3 (1902), pp.464-66.

7 *Ibid.*, p.464.

8 This and the subsequent quotations pertaining to the circulation and reputation of Hugo's drawings are taken from the studies by Pierre Georgel, as recapitulated in "Le Peintre malgré lui," in *La Gloire de Victor Hugo*, exhibition catalogue, Paris, Galeries nationales du Grand Palais, 1985-86, pp.483-95.

9 On eighteenth- and nineteenth-century artists' use of blots, see Jean-Claude Lebensztejn, *L'Art de la tache: Introduction à la "Nouvelle méthode" d'Alexander Cozens* (Editions du limon, 1990).

10 Cited *ibid.*, p.399.

11 "If you wish to number the proofs and place them in a particular order in conjunction with a table of contents giving the title or caption of each plate, it would be best to use M. Mirbeau's copy. The table of contents should be returned together with Mirbeau's notes to make the printer's set of proofs complete." Fenaille to Rodin, March 5, 1897; Musée Rodin Archives.

12 *The Divine Comedy*, trans. John D. Sinclair (Oxford, 1939), *Inferno*, IV, 118-20.

13 *Ibid.*, *Inferno*, IV, 28-30.

14 *Ibid.*, *Purgatorio*, VII, 28-33.

15 *Ibid.*, *Paradiso*, XXXII, 82-84.

16 Judith Cladel, *Rodin: Sa vie glorieuse, sa vie inconnue, édition définitive* (Paris, 1936), pp. 83-85.

17 *Nos Fils* (1869), Livre premier: De l'éducation avant la naissance, Chapitre 1: L'Homme naît-il innocent ou coupable? Deux éducations opposées, ed. Paul Viallaneix (Paris, 1987), pp.367-371. Michelet had earlier alluded to the issue of the salvation of unbaptized children, and to the attitude of the Church, in *Le Peuple* (1846), Deuxième partie: De l'affranchissement par l'amour, V: L'Instinct naturel de l'enfant est-il pervers?, ed. Paul Viallaneix (Paris, 1974), pp.170-74.

18 *Azur et Fange par l'abbé Gayraud, Curé de Malleville-Les-Grès, Seine-Inférieure* (Fleury and Rouen, 1895).

19 "A M. A. Rodin: L'artiste, à la pensée altière / Ne peut, s'il n'a levé les yeux / Une fois au moins vers les cieux, / Animer la vie, la matière. / Vous souvient-il, frère Augustin, / De vos épanchements mystiques / Sous les cloîtres eucharistiques? / Méditant du soir au matin, / Ame enthousiaste et céleste, / Vous m'avez fait songer qu'il reste / D'un premier éblouissement / Quelques rayons dans la prunelle, / Et qu'une œuvre d'art éternelle / Descend toujours du firmament." *Ibid.*, p.34.

Ursula Heiderich

The Muse and her Gorgon's Head

On the Problem of Individuation in the Work of Camille Claudel

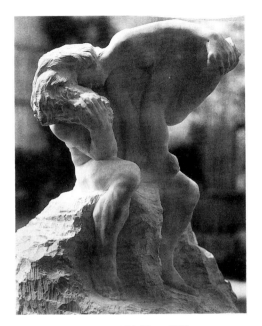

Fig. 1 *The Sculptor and his Muse*, 1892.
Limestone, height 26¼″ (67 cm).
Musée Rodin, Paris

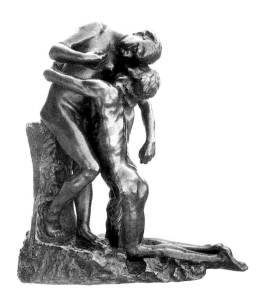

Fig. 2 Camille Claudel, *Surrender*, 1905
(small-scale version of *Sakuntala*, 1888).
Bronze, height 26″ (66 cm). Musée de Cambrai

"Where mighty trees cast their shadow, the ground beneath is barren." This was the realization that led Constantin Brancusi to flee from the influence of Auguste Rodin. Rodin's work and personality clearly had a highly oppressive effect, and this was all the more likely to be the case with a young woman artist, whose chances of acquiring a proper training were minimal, unless she took private tuition. In 1883, at the age of nineteen, Camille Claudel became Rodin's student; the master, aged forty-three, was on the threshold of his breakthrough to fame, and their relationship was already tinged with an unmistakable hint of eroticism. Two years later, in 1885, Claudel and her friend Jessie Lipscomb were accepted into Rodin's workshop. Claudel was given the status of a *praticienne* and entrusted with the task of executing works in marble. She rapidly earned Rodin's respect. The relationship between teacher and student soon turned into a love affair. In 1888 Claudel moved out of her parents' home and rented a workshop of her own; at the same time, she and Rodin took up residence together in a house known as Le Clos-Payen or La Folie-Neubourg. After spending several extended periods living with Rodin in Touraine, Claudel ended the affair in 1892. It had become all too apparent that Rodin was unwilling to sever the ties that bound him to his lifelong mistress, Rose Beuret, who was also the mother of his son. In 1898 Rodin moved out of Le Clos-Payen: the break with Claudel was complete.

In the dual roles of artistic collaborator and lover, Claudel became the epitomic embodiment of the muse in the life and work of Rodin, a muse whose inspirational power was such that the artist regarded it with thoroughly mixed feelings. His allegorical figure *The Sculptor and his Muse* of about 1892 (Fig. 1) shows the ambivalent reaction of the male to the forceful presence of the female spirit. The stimulus of erotic attraction not only served to fire Rodin's creativity; it was something that he also found deeply troubling. Paolo and Francesca, the two lovers in *The Kiss* (plate 13), are submerged in the ecstasy of their passionate embrace, but, at the same time, they are trapped in a kind of inferno, condemned to sustain their desire forever, even when they have passed into the realm of shadows. Several of Rodin's sculptures bearing the features of Claudel date from after the end of the couple's relationship: Rodin was able to exorcise the wedding of genius to the demonic in his artistic work. But for Claudel, this symbiosis was the fatal trigger that initiated a human and artistic catastrophe. From 1906 onward, she began systematically to destroy her own works. In 1913 she was confined to a psychiatric hospital, where she remained for the next thirty years. She never created a work of art again.

Only a small part of Claudel's oeuvre has been preserved, and several facets of her life and work are still shrouded in semiobscurity. A good deal of light remains to be shed on her collaboration with Rodin. A number of art historians have surmised that she influenced the master's work, and the relationship between Claudel and Rodin does indeed raise considerable problems of attribution. In the Kunsthalle in Bremen, for example, there is a bust titled *Giganti*, made by Claudel in 1885, which was incorporated into Rodin's oeuvre by the addition of his signature to the neck.[1] A second cast of the work is to be found in the Musée des Beaux-Arts in Cherbourg. This bears Claudel's name twice; the second signature, cut into the finished cast, testifies to

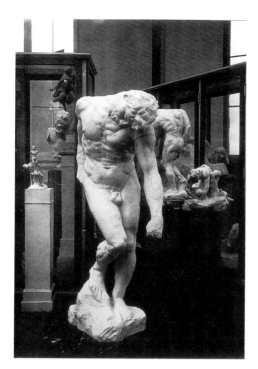

Fig. 3 *The Large Shade*, 1880.
Plaster, height 75½″ (192 cm).
Photograph by Jacques-Ernest Bulloz
of the sculpture in Rodin's Meudon studio

Fig. 4 Camille Claudel, *The Waltz*, 1892;
cast 1905. Bronze, height 18¼″ (46.4 cm).
Musée de la Ville de Poitiers et de la Société
des Antiquaires de l'Ouest

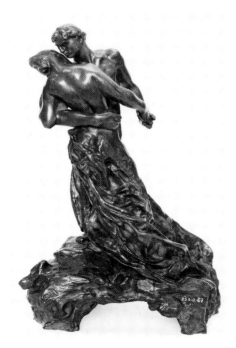

Claudel's righteous fury on realizing that Rodin was disputing her claim to be the creator of the sculpture. However, Rodin cannot be held responsible for the specific events that subsequently led to Claudel's wildly exaggerated, paranoid complaints of exploitation by her former lover. Claudel's difficulty in defining and maintaining her creative individuality renders the awkward business of distinguishing between the artistic ideas of the teacher and those of the pupil especially problematical.

In the course of her work with Rodin, Claudel made several sculptures featuring groups of figures which are clearly inspired by Rodin's manner of handling erotic themes, but which introduce a new, personal element into the dialogue with her teacher's work. The group titled *Sakuntala* (Fig. 2), which won Claudel her first "honorable mention" at the Salon des Artistes Français in 1888, has been compared by several critics with Rodin's *The Eternal Idol* (plate 23). Both works show a man kneeling in front of a woman, but, instead of invoking the idea of "perpetual adoration" suggested by Rodin's pair of figures, Claudel creates an image of warm affection, of forgiveness and reconciliation. The woman is meekly subsiding into the embrace of the man below her; her right hand covers her heart, and her left arm is limply outstretched toward her lover. The silhouette corresponds to the outline of Rodin's *The Large Shade* of 1880 (Fig. 3). The drooping head and the left arm form a descending curve that starts out from the right shoulder, at the apex of the body's ascending line. The kneeling figure of the man accepts the woman's passive surrender but offers her no support as she subsides into his arms. There is little actual physical contact between the couple: only their cheeks are touching. Nevertheless, the tenderness and delicacy of the gestures eloquently express their mutual desire.

The Waltz (Fig. 4) conveys an even stronger sense of erotic intensity. The work was made in 1892, shortly before the breakup of the artist's relationship with Rodin. In the first version, the dancing figures were both naked. The appearance of their unclothed, dizzily whirling bodies aroused the disapproval of Armand Dayot, the Inspector-General at the Ministry of Fine Arts, whose opinion was a decisive factor in the granting of state commissions. In his official report to the Minister, Dayot described the advice he had given to Claudel: he told her to clothe the figures, preferably in the First Empire style of the early nineteenth century, which would make it possible to expose the woman's shoulders and throat, and even one of her legs, without violating decorum.[2] The following year, Claudel made a revised version of the sculpture, showing the couple enveloped in swirling drapery.[3] In the subsequent version, made in 1895, the lower part of the woman's body is swathed in a robe that appears to issue directly from her hips. With its ruffled, crumpled appearance, almost resembling the intricately gnarled roots of a tree, the drapery stabilizes the upward spiral of the figure's movement. Paradoxically, then, this astoundingly modern piece of sculpture owes its creative inspiration to an act of downright censorship, imposing on a woman artist the same restrictions as those that applied generally to women in a public context. Male artists were not subject to sanctions of this kind. Rodin is a case in point: his sculpture *Sin* (c. 1888)[4] shows a couple locked in an embrace that is openly sexual and in which the woman is clearly the active partner. The inclusion of the little forked tail as a reminder of the Devil, the moralizing tone of the title, the reference to Adam pointing the finger of accusation at Eve after the Fall: such minor details evidently sufficed to satisfy the demands of propriety.

This dual standard of morality was a major obstacle to the training of nineteenth-century women artists and it severely narrowed their creative scope. The role of the woman was held to be fundamentally incompatible with that of the artist. Even the men who supported and encouraged Claudel regarded her as something of a freak, maintaining that "the woman of genius [is] contrary to nature."[5] Female sculptors were far more exposed to social and cultural pressures than women artists working in

other media. Nineteenth-century sculpture was oriented toward the public sphere, which meant that it was heavily dependent on official commissions. The possibilities for indulging in private experimentation were limited by the sheer cost of materials.

Maturity (Fig. 6), the largest group of figures in Claudel's sculptural oeuvre, is partly autobiographical and partly allegorical. The work is an artistic treatment of the break with Rodin and, at the same time, it indicates where all the paths of human life ultimately lead. Set on a plinth resembling the deck of a ship, the figures are arranged on three different ascending levels. The central figure of the man advancing toward old age is embraced by an old woman who lays her arms around him in a manner that is at once tender and fiercely possessive. Like a bird of prey claiming a victim, she dominates the silhouette of the male figure; her status is further emphasized by the fluttering drapery that surrounds the couple. With lowered head and limply dangling arms, the man surrenders helplessly to her embrace. His left hand is slipping from the grasp of a young woman who kneels on the ground, her body bent forward and her arms outstretched. Her gaze and her gestures follow the ascending diagonal line of the composition, which is interrupted by the hands as they drift apart. The young woman's naked body shows the first signs of pregnancy. This allegory of the three ages of humankind shows the man caught between youth and age, love and death. Made in 1898, the group was based on a series of preliminary studies that Claudel had begun three years earlier, and that anticipate both the forms of the individual figures and the manner of their arrangement. The kneeling woman is a further development of the sculpture *God Flown Away*, which Claudel had made in 1894.[6] This shows the naked figure of Psyche, the mortal female, kneeling and raising her arms imploringly toward

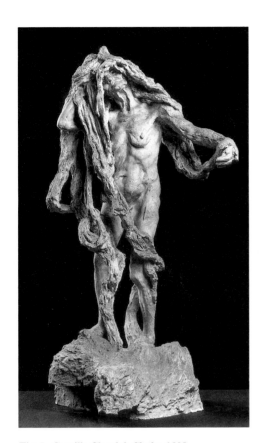

Fig. 5 Camille Claudel, *Clotho*, 1893.
Plaster, height 35½″ (90 cm).
Musée Rodin, Paris (S.1379)

Fig. 6 Camille Claudel, *Maturity*, 1898.
Bronze, height 45″ (114 cm).
Musée d'Orsay, Paris

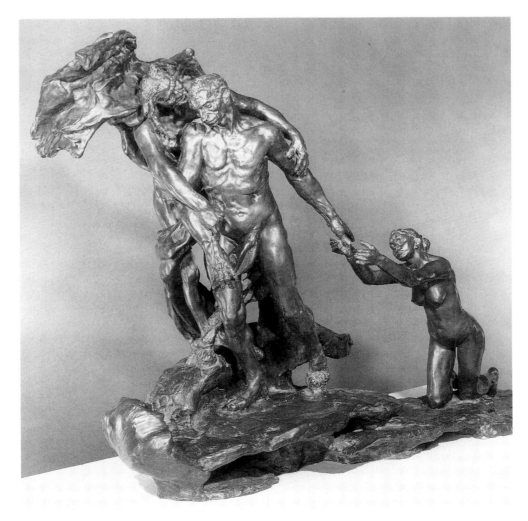

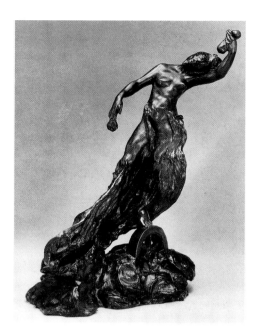

Fig. 7 Camille Claudel, *Fortuna*, 1900.
Bronze, height 19″ (48 cm).
Musée de la Ville de Poitiers et de la Société
des Antiquaires de l'Ouest

Eros, the god who has abandoned her: an image which dramatically exposes the theme of the death of love. The figure embodying the idea of old age in *Maturity* is anticipated by the various versions of *Clotho*, Claudel's sculpture of a naked old woman: one detects references both to the nude torso of Clotho[7] and to the full-length versions of the same figure (see Fig. 5), who is almost strangled by the swirling braided coils of her own hair.[8] This mercilessly realistic depiction of the aged female body is remarkable for its sober, matter-of-fact attention to detail; it entirely lacks the tone of high drama that characterizes Rodin's rendering of beauty devastated by age in *The Helmet-Maker's Wife*.[9] Renate Flagmeier has pointed out that *Clotho* is a self-portrait.[10] In this respect, the work is similar to the abandoned figure of Youth (intended for *Maturity*), although the autobiographical connection is less obvious than in the latter case. Entangled in her own hair, Clotho is like a living distaff, spinning the thread of life from her own mortal flesh. The hair, a powerful erotic image, is a symbol of fertility, the female equivalent of the male's potency, and of autonomous creativity. Following this line of interpretation, the figure of the goddess of Fate in Claudel's sculpture can be seen as corresponding to the image of the Muse in the work of Rodin – an image that Claudel was unable to adopt, since she herself was the woman to whom the role of Muse had been assigned.

Tracing the various stages in the making of *Maturity*, one sees that there are definite parallels with contemporaneous developments in the work of Rodin. Plastic inventions are tried out and varied, and figures that were originally conceived as individuals gradually form a coherent group. Toward the end of the 1890s, the direction of this process is reversed. Whereas Rodin was tirelessly experimenting with the assemblage of figures and fragments, and producing genuinely new effects by using collage techniques in his drawings, Claudel started to dissolve the groups in her sculptures, invariably isolating the female figure. In *The Implorer* (1899)[11] the kneeling young woman in *Maturity* (1898) is transformed into an image of utter misery, a despairing female supplicant robbed, like Psyche, of the presence and even the sight of her lover. The weakness and fragility of *Fortuna* (Fig. 7) and *Truth*,[12] both of which date from 1900, contrast sharply with the earlier figure of the dancer in *The Waltz*. With no partner to support her, Fortuna balances on her wheel above the waves, leaning backward at a precarious angle; the only thing that offers her any stability is her own shoulder, on which her head is resting. Instead of emerging from the well, as in the traditional version of the allegory, Claudel's figure of Truth seems to be on the verge of falling into the water; she is hovering at the brink. In 1905 Claudel made a marble sculpture titled *Vertumnus and Pomona*,[13] a scaled-down version of the group in *Sakuntala*. This work in marble served in turn as the model for the bronze sculpture *Surrender*.[14] *Wounded Niobe*,[15] which was made in 1906 and cast in bronze on a state commission the following year, is a sculpture of a solitary female figure: Niobe is portrayed clutching at the mortal wound inflicted to her heart by the arrow of Apollo, the patron of the Muses. Claudel's Niobe can be seen as a female variant on the *ecce homo* motif, while the pose of the figure, slowly sinking to the ground, is similar to that of Christ in traditional depictions of the Descent from the Cross. The swelling forms of the belly and breasts signify the sensual joy and beauty of pregnancy. The premature termination of Claudel's own pregnancy had a lasting destructive effect, traces of which are clearly evident in her work as an artist.

The female figure in *Sakuntala* is also portrayed as pregnant, at the moment of reconciliation with the man she loves. The sculpture is based on the plot of a drama by the fifth-century Sanskrit poet Kalidasa. While out hunting, King Dushyanta encounters the maiden Sakuntala, who is the issue of a union between a nymph and a mortal man. He contracts a summary marriage with her according to the Gandharva rite, which, in the sight of the gods, is just as binding as legal matrimony, and departs,

leaving his ring as a pledge. Sakuntala becomes pregnant and goes to the palace to visit the king, but he fails to recognize her because of a curse placed on her by the sage Durvasas. In the end, however, the king recovers his memory, whereupon he goes out to seek his lost love, and the pair are happily reunited.

It is obvious why Claudel found this story attractive: the heroine was a figure with whom she could readily identify in her yearning to be reconciled with Rodin, who had become blind to her love. The mortally wounded daughter of Niobe, on the other hand, can be seen as Claudel's obituary to her own ego.

This retreat from the group to the individual female figure with autobiographical connections finds its counterpart in a self-portrait that is manifestly the product of autoaggressive impulses. The head of Medusa in the group *Perseus and the Gorgon*,[16] which was created between 1898 and 1901, bears Claudel's own features. The prematurely aged face, with its demented, rolling eyes, once belonged to a beautiful young woman, whose severed, useless limbs are heaped up on the ground at Perseus' feet. Like the man in *Maturity*, Perseus stands between youth and age; he has effected the terrible break between mind and body.

Claudel was unable to follow Rodin's example in using art as a means of coming to terms with personal experience and thereby attaining a state of relative equilibrium. Balance and harmony failed to interest her. Her sculptures show a marked contempt for symmetry, and the figures lack a fixed center of gravity: they vertiginously defy the laws of physical possibility. The art of Camille Claudel testifies to her desperate striving to assert herself as an autonomous individual. In the end, she was unable to satisfy her hunger for wholeness by reconciling the demands of life and art: the rift between the two ran straight down the center of her being.

Notes

1 See Reine-Marie Paris and Arnaud de la Chapelle, *L'Œuvre de Camille Claudel* (Paris, 1991), pp.34, 109. The authors incorrectly claim that *Giganti* is still on show under the name Rodin. This is not the case: the sculpture, which was acquired in 1960, was thought – on account of the signature – to be by Rodin, but the mistake was rectified in 1967, when Claudel was conclusively identified as the artist.
2 See Paris and Chapelle, *L'Œuvre de Camille Claudel*, p.127.
3 Illustrated *ibid.*, p.128.
4 John L. Tancock, *The Sculpture of Auguste Rodin: The Collection of the Rodin Museum, Philadelphia* (Philadelphia, 1976), p.280.
5 Octave Mirbeau, cited in *"L'Age mûr" de Camille Claudel*, Les Dossiers du Musée d'Orsay 25 (Paris, 1988), p.62. For a general discussion of the ques-

tion of gender relating to the work of Claudel, see Claudine Mitchell, "Intellectuality and Sexuality: Camille Claudel, the fin de siècle Sculptress," *Art History* 12, no.4 (December 1989), pp.419-47.
6 Paris and Chapelle, *L'Œuvre de Camille Claudel*, no.44.
7 *Ibid.*, no.29.
8 *Ibid.*, no.31 (bronze version).
9 Tancock, *The Sculpture of Auguste Rodin*, no.7.
10 See Flagmeier's comments in *"L'Age mûr" de Camille Claudel*, pp.70-71.
11 Paris and Chapelle, *L'Œuvre de Camille Claudel*, no.43.
12 *Ibid.*, p.214.
13 *Ibid.*, no.62.
14 *Ibid.*, no.63.
15 *Ibid.*, no.65.
16 *Ibid.*, no.58.

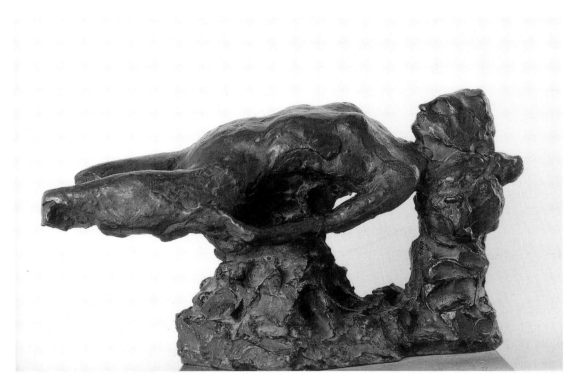

Damned Woman, Struck by Lightning,
c. 1884. Bronze, height 8¾″ (22 cm).
Musée Rodin, Paris (S.1157)

Select Bibliography

WRITINGS BY THE ARTIST

L'Art: Entretiens réunis par Paul Gsell.
Paris, 1911. Trans. Jacques de Caso and
Patricia B. Sanders, under the title *Art:
Conversations with Paul Gsell.* Berkeley, 1984.

Les Cathédrales de France. Paris, 1914.
Trans. Elisabeth Chase Geissbuhler, under the
title *Cathedrals of France.* Boston, 1965.

Correspondance de Rodin. Vol. 1, *1860-1899.*
Ed. Alain Beausire and Hélène Pichet. Paris,
1985.

BOOKS, EXHIBITION CATALOGUES,
AND ARTICLES

Barbier, Nicole. *Marbres de Rodin.* Paris, 1987.

Bartlett, Truman H. "Auguste Rodin, Sculp-
tor." In Albert E. Elsen, *Auguste Rodin:
Readings on his Life and Work*, pp. 13-109.
Englewood Cliffs, NJ, 1965. Originally pub-
lished in *American Architect and Building
News* 25, nos. 682-703 (January 19-June 15,
1889).

Berlin, Staatliche Museen, Nationalgalerie.
*Auguste Rodin: Plastik, Zeichnungen,
Graphik.* Exhibition catalogue. Ed. Claude
Kleisch. Berlin, 1979.

Cladel, Judith. *Auguste Rodin: L'Œuvre et
l'homme.* Brussels, 1908. Trans. S. K. Star,
under the title *Rodin: The Man and his Art.*
New York, 1917.

Elsen, Albert E. *Auguste Rodin: Readings on
his Life and Work.* Englewood Cliffs, NJ, 1965.

Elsen, Albert E. *In Rodin's Studio: A Photo-
graphic Record of Sculpture in the Making.*
London, 1980.

Elsen, Albert E. *Rodin.* New York, 1963.

Elsen, Albert E., and J. Kirk T. Varnedoe.
The Drawings of Rodin. New York, 1971.

Fath, Manfred, with J. A. Schmoll gen. Eisen-
werth (eds.). *Auguste Rodin: Das Höllentor –
Zeichnungen und Plastik.* Munich, 1991.

Geissbuhler, Elisabeth Chase. *Rodin: Later
Drawings.* Boston, 1963.

Grappe, Georges. *Catalogue du Musée Rodin.*
5th ed. Paris, 1944.

Güse, Ernst-Gerhard (ed.). *Auguste Rodin:
Drawings and Watercolors.* New York, 1984.

Laurent, Monique. *Rodin*, Cologne, 1989.

Lawton, Frederick. *The Life and Work of
Auguste Rodin.* London, 1906.

London, Hayward Gallery. *Rodin: Sculpture
and Drawings.* Exhibition catalogue.
By Catherine Lampert. London, 1986.

Mirbeau, Gustave. *Les Dessins de Auguste
Rodin.* Paris, 1897.

Rilke, Rainer Maria. *Auguste Rodin.* Leipzig,
1919. Trans. Robert Firmage, under the title
Rodin. Salt Lake City, 1979.

Schmoll gen. Eisenwerth, J. A. *Rodin-Studien:
Persönlichkeit – Werke – Wirkung – Biblio-
graphie.* Munich, 1983.

Sollers, Philippe, and Alain Kirili. *Auguste
Rodin: Dessins érotiques.* Paris, 1987.

Tancock, John L. *The Sculpture of Auguste
Rodin: The Collection of the Rodin Museum,
Philadelphia.* Philadelphia, 1976.

Washington, D. C., National Gallery of Art.
Rodin Rediscovered. Exhibition catalogue.
Ed. Albert E. Elsen. Boston, 1981.

Index of Works
by Rodin

Drawings

Index of Names

Photograph Credits

The Authors

Jacques de Caso is Professor of Art History at the University of California, Berkeley, a post that he has held since 1968. He is renowned for his numerous contributions to the study of nineteenth-century French sculpture and has written widely on the work of Rodin.

Rainer Crone is Professor of Twentieth-Century Art at Ludwig-Maximilians-Universität, Munich, and Adjunct Professor of Art History at Columbia University, New York. From 1987 to 1991 he was Vice-Director of the Kunsthalle, Düsseldorf. His publications include *Andy Warhol* (1970), *Francesco Clemente* (1984), *Similia/Dissimilia* (1987), and, with Joseph Leo Koerner, *Paul Klee: Legends of the Sign* (1991).

Ginger Danto is a writer and journalist specializing in the arts. She lives in Paris.

Ursula Heiderich is a freelance art historian who specializes in all aspects of nineteenth- and twentieth-century art. Much of her work has been devoted to artists of the early modern period, notably August Macke. At present she is preparing a catalogue raisonné of the sculptures in the Kunsthalle, Bremen.

Claudie Judrin is Chief Curator at the Musée Rodin, Paris, where she has worked since 1974. As the premier expert on Rodin's drawings, she has published widely on the subject. To date, four volumes of her catalogue of the more than seven thousand drawings in the artist's estate have appeared.

Alain Kirili is a sculptor who divides his time between Paris and New York, where he has exhibited regularly since 1972. In 1985 he was honored by the Musée Rodin, Paris, with an exhibition of his monumental sculptures. He has written a book on sculpture, *Statuaire* (1986), and, with French writer Philippe Sollers, coauthored *Rodin: Dessins érotiques* (1986).

David Moos studied the history of art and modern American literature at McGill University, Montreal, and is at present completing his doctoral dissertation in art history at Columbia University, New York. He has coauthored a number of publications with Rainer Crone, including *Objet/Objectif* (1989), *Painting Alone* (1990), *Kazimir Malevich: The Climax of Disclosure* (1991), and *Cordially Yours: Lee Jaffe* (1992).

Siegfried Salzmann, formerly Director of the Wilhelm-Lehmbruck-Museum, Duisburg, has been Director of the Kunsthalle in Bremen since 1985. His many notable contributions to the literature on twentieth-century sculpture have included studies of Constantin Brancusi (1971), Alberto Giacometti (1973), and Wilhelm Lehmbruck (1985). His most recent publication (1989) was devoted to the contemporary German sculptor Bernhard Heiliger.

Kirk Varnedoe is Director of the Department of Painting and Sculpture at the Museum of Modern Art, New York. He was formerly Professor of Art History at the Institute of Fine Arts, New York University. Among his many notable contributions to the study of early modern art is *The Drawings of Auguste Rodin* (1971), which he coauthored with Albert E. Elsen. His most recent publications include *A Fine Disregard: What Makes Modern Art Modern* (1990) and, with Adam Gopnik, *High and Low: Modern Art and Popular Culture* (1991).